6/11

Uncensored:
Views & (Re)views

Joyce Carol Oates

Uncensored

Views & (Re)views

An Imprint of HarperCollins*Publishers*

HarperCollins books may be purchased for educational, business, or sales promotional use. For information please write: Special Markets Department, HarperCollins Publishers Inc., 10 East 53rd Street, New York, NY 10022.

FIRST EDITION

Designed by Lovedog Studio

LIBRARY OF CONGRESS CATALOGING-IN-PUBLICATION DATA
Oates, Joyce Carol, 1938–
 Uncensored : views & (re)views / Joyce Carol Oates.—1st ed.
 p. cm.
 ISBN 0-06-077556-4
 I. Title.

PS3565.A8U53 2005
813'.54—dc22

 2004053266

 05 06 07 08 09 WBC/RRD 10 9 8 7 6 5 4 3 2 1

Contents

III. Homages 235

IV. (Re)Visits 325

For Barbara Epstein
Cherished editor, friend

Preface

Essays, reviews, and unclassifiable
"prose pieces" have always seemed to me elliptical forms of storytelling. Despite their evident objectivity, the most eloquently rendered aspire to a kind of curious lyricism. Certainly these difficult-to-define forms require the obvious strategies of art: selection of detail, enhancement or emphasis, tone. Where Cynthia Ozick and John Updike, to name two writer-friends who have speculated on the subject, are inclined to rank their non-fiction prose somewhat lower than their fiction ("essays seem a deviation, a diversion: the region of the trivial," says Cynthia Ozick in *Art & Ardor*; "writing criticism is to writing fiction and poetry as hugging the shore is to sailing in the open sea," says John Updike in *Hugging the Shore*), I've been inclined to feel that the "voice" of non-fiction, seemingly unmediated, un-invented, is an artful enough variant of fiction's voice, or voices. In the essay or review, the dynamic of storytelling is hidden but not absent.

For prose is a kind of music: music creates "mood." What is argued on the surface may be but ripples rising from a deeper, sub-textual urgency.

In virtually none of my prose fiction, with the possible exception of the novel *I'll Take You There*, and in that novel only intermittently, do I

allow myself to speak in my "own" voice, but in my non-fiction prose, it is always my "own" voice that speaks. For I think of non-fiction as a conversation among equals on impersonal issues; I am an individual with a high regard for literature addressing an (imagined, hoped-for) audience of individuals like-minded enough to wish to read about literature. Often I'm excited by what I've read, and want to talk about it with others; nearly always, I'm interested and engaged; years ago I discovered that when I feel most combative, disturbed, irritated and upset by another's writing, as in the case (long ago, in my early twenties) of D. H. Lawrence, it's probably a sign that I feel challenged, perhaps threatened, and need to carefully re-read, and re-think. (In the case of Lawrence, years were required.) As a young reviewer it was my practice to review nearly everything offered to me, for the *New York Times Book Review* (what a succession of editors, over the decades!), the *Saturday Review of Literature* (does anyone remember this wonderful, so diligently "literary" publication, with its regular contributors Granville Hicks and John Ciardi?), and the *Detroit News* (one of the few publications for which I wrote, not review-essays, but reviews), but in recent years I decline most offers of books to review. I hope to be as idealistic as a critic as I am, at least to myself, in other regards.

My governing principle as a critic is to call attention solely to books and writers that merit such attention, and to avoid whenever possible reviewing books "negatively" except in those instances in which the "negative" is countered by an admiring consideration of earlier books by the same author. (In assembling this collection, I immediately rejected all "negative" reviews on moral grounds, as unworthy of reprint, as, perhaps, they were unworthy of being written. How small-minded we seem to ourselves in retrospect, chiding others! Much better to have passed over such disappointments in silence. Then, as the pile of rejected pieces grew, I began to feel that I was too-primly censoring myself, and eliminating much that might be of interest despite its critical tone. Of the numerous "censored" reviews I retrieved only three, of short story collections by Patricia Highsmith and Richard Yates and a novella by Anita Brookner, all of which have been sufficiently praised elsewhere, in any case.) As our relations with others are essentially ethical encounters, so our relations with books, and with those individuals who have written them, whom perhaps we will never meet, are ethical encounters. Obviously, a critic who "likes everything" is a very bland personality hardly

to be trusted, but there might be a respectable category of critic who, disliking something, refrains from making public comment on it. In America, do we need to caution anyone against buying a book?

Though I've assembled several collections of review-essays over the years, I have never included a single "review" of the kind that most newspapers publish in their cramped "arts" sections. In another lifetime in Detroit, Michigan, 1962 to 1968, I reviewed regularly for the *Detroit News,* countless brief reviews as ephemeral as the newspaper pages on which they were printed, and of these, seemingly lost in time, one review recently surfaced: of Don DeLillo's first novel, *Americana* (1971). I include it here not with pride exactly but with extreme relief that, so long ago, I had a reviewer's good sense to lavishly praise a difficult work of fiction by a writer at that time wholly unknown.

—Joyce Carol Oates

I.

"Not a Nice Person"

Uncensored Sylvia Plath

The Unabridged Journals of Sylvia Plath
Edited by Karen V. Kukil

WHO IN FEBRUARY 1963 COULD HAVE predicted, when a thirty-year-old American poet named Sylvia Plath committed suicide in London, distraught over the breakup of her marriage to the Yorkshire poet Ted Hughes, that Plath would quickly emerge as one of the most celebrated and controversial of postwar poets writing in English; and this in a golden era of poetry distinguished by such figures as Theodore Roethke, Marianne Moore, Elizabeth Bishop, Robert Lowell, Richard Wilbur, Allen Ginsberg, Anne Sexton, John Berryman, May Swenson, Adrienne Rich, as well as W. H. Auden and T. S. Eliot? At the time of Plath's premature death she had published a single volume of poems that had received only moderate attention, *The Colossus* (1960), and a first novel, the Salingeresque *The Bell Jar* (which appeared a month before her death in England, under the pseudonym "Victoria Lucas"), in addition to a number of strikingly bold poems in British and American magazines; her second, stronger volume of poems, *Ariel,* would not appear until 1965, by which time Plath's posthumous fame assured the book widespread attention, superlative reviews, and sales that would eventually make it one of the best-selling volumes of poetry to be published in England and America in the twentieth century. Plath's *Collected Poems* (1982), assembled and edited by Ted Hughes, would win a Pulitzer Prize.

"I am made, crudely, for success," Plath stated matter-of-factly in her journal in April 1958. Yet Plath could not have foreseen that her success would be almost entirely posthumous, and ironic: for, by killing herself impulsively and dying intestate, she delivered her precious fund of work, as well as her two young children Frieda and Nicholas, into the hands of her estranged husband, Hughes, and his proprietary sister Olywn, whom Plath had perceived as her enemies during the final, despairing weeks of her life. As her literary executor, Hughes had the power to publish what he wished of her work, or to publish it in radically "edited" (that is, expurgated) versions, like *The Journals of Sylvia Plath* (1982); or, if he wished, he might "lose" or even destroy it, as Hughes bluntly acknowledged he had done with two of the journal notebooks written during the last three years of Plath's life. As the surviving, perennially estranged husband, Hughes excised from Plath's journals what he called "nasty bits" and "intimacies," as he had eliminated from *Ariel* "some of the more personally aggressive poems," with the excuse that he wanted to spare their children further distress. This new, unabridged and unexpurgated edition of the journals assembled by Karen V. Kukil, assistant curator of rare books at Smith College, is "an exact and complete transcript of the twenty-three original manuscripts in the Sylvia Plath Collection," that suggests that the person Ted Hughes most wanted to spare from distress and exposure was himself.

The *Unabridged Journals* document, in obsessive and exhausting detail, Plath's undergraduate years at Smith College and her term as a Fulbright fellow at Newnham College, Cambridge; her marriage to Ted Hughes; and two years of teaching and writing in Northampton, Massachusetts, and in Boston. With the exception of appendices and fragments from 1960 to 1962, the most vivid of which describes the birth of Plath's second child, Nicholas, in January 1962, the *Journals* break off abruptly in November 1959 as Plath and Hughes, their marriage undercut by Plath's suspicions of Hughes's infidelity, prepare to return to England to live. The last entry of the 1959 journal is enigmatic as a typical Plath poem: "A bad day. A bad time. State of mind most important for work. A blithe, itchy eager state where the poem itself, the story itself is supreme."

The most memorable of Sylvia Plath's incantatory poems, many of them written during the final, turbulent weeks of her life, read as if they've been chiseled, with a fine surgical instrument, out of Arctic ice.

Her language is taut and original; her strategy elliptical; such poems as "Lesbos," "The Munich Mannequins," "Paralytic," "Daddy" (Plath's most notorious poem), and "Edge" (Plath's last poem, written in February 1963), and the prescient "Death & Co." linger long in the memory, with the power of malevolent nursery rhymes. For Plath, "The blood jet is poetry," and readers who might know little of the poet's private life can nonetheless feel the authenticity of Plath's recurring emotions: hurt, bewilderment, rage, stoic calm, bitter resignation. Like the greatest of her predecessors, Emily Dickinson, Plath understood that poetic truth is best told slantwise, in as few words as possible.

By contrast, the journals are a tumult of words, and present a very mixed aesthetic experience for even the sympathetic reader. As a corrective to Hughes's "editing," a wholly unedited version of Plath's material would seem justified, in theory at least. Uncritical admirers of Plath will find much here that is fascinating. Other readers may find much that is fascinating and repellent in equal measure. Nor is the book easy to read, for its organization is eccentric: following journal entries for 1959, for instance, we revert jarringly back to a fragment for 1951, listed by the editor as Appendix I. It would have been more practical for scattered fragments to have been integrated chronologically with the journals. The *Unabridged Journals* is impossible to read without a reliable biography in tandem, for it lacks a simple chronology of Plath's life and the editor's headnotes are scattered and minimal.

A Bildungsroman in memorist fragments, Plath's journals contain marvels of discovery. As an eighteen-year-old Smith College student in November 1950, Plath records insights that seem, in their succinctness, to predict her entire life, and the dilemma of that life. " 'Character is Fate.' If I had to hazard three words to sum up my philosophy of life, I'd choose those." And, in December 1956, "Perhaps when we find ourselves wanting everything it is because we are dangerously near to wanting nothing." Plath's self-scrutiny is ceaseless, pitiless, exhausting; a classic over-achiever, Plath drove herself to a nervous collapse after her junior year at Smith, and no amount of precocious success was ever quite enough to sustain her. Manic flights of words lead to a calm resolution to kill herself by an overdose of barbiturates in August 1953: "You saw visions of yourself in a straight (sic) jacket, and a drain on the family, murdering your mother in actuality, killing the edifice of love and respect . . . Fear, big & ugly & sniveling . . . Fear of failing to live up to the

fast & furious prize-winning pace of these last years—and any kind of creative life." By a fluke, Plath is rescued, only to relive numerous times this demonic self-induced drama. Clearly, the fantasy of self-destruction was Plath's supreme self-definition; a decade later, though the mother of two children and a poet of high, acknowledged promise, Plath gloats in "Lady Lazarus," one of the final poems of her life: "Dying / is an art, like everything else. / I do it exceptionally well."

Plath's meticulously documented example suggests how precocity is not maturity, and may in fact impede maturity. Psychological "insight" is merely intellectual, bringing with it no apparent practical application: as a girl Plath laments, ". . . I am a victim of introspection"; as a mature woman:

It is as if my life were magically run by two electric currents: joyous positive and despairing negative—which ever is running at the moment dominates my life, floods it. I am now flooded with despair, almost hysteria, as if I were smothering. As if a great muscular owl were sitting on my chest, its talons clenching & constricting my heart.

Amid so much that is despairing, there are moments of ecstatic discovery. In Cambridge, Plath reads D. H. Lawrence and Virginia Woolf with intense excitement; both will influence her prose style, and thereafter the journal's language is enriched. ". . . I pick up the blessed diary of Virginia Woolf . . . Bless her. I feel my life linked to her, somehow. I love her—" And, "What is my voice? Woolfish, alas, but tough." It wasn't easy for the fanatically competitive Plath to be generous about her contemporary rivals, but she found good things to say about May Swenson, Anne Sexton, Stanley Kunitz, Adrienne Rich ("little, round and stumpy with . . . great sparkling black eyes"). She records a brilliant thumbnail sketch of Auden, whom she'd heard read his poetry at Smith, in April 1953: "Auden tossing his big head back with a twist of wide ugly grinning lips . . . the naughty mischievous boy genius."

Ted Hughes, of course, is the great love/hate of Plath's life; the "demigod" she'd fantasized in adolescence, made flesh at a drunken party in Cambridge in April 1956: ". . . That big, dark, hunky boy, the only one there huge enough for me . . ." "The one man in the room who was as big as his poems, huge, with hulk and dynamic chunks of words;

his poems are strong and blasting high wind in steel girders. And I screamed in myself, thinking: oh, to give myself crashing, fighting, to you." Seemingly within minutes of their meeting, Plath and Hughes are enacting an erotic scene of the sort Plath had frequently composed in her adolescent journal:

> . . . I was stamping and he was stamping on the floor, and then he kissed me bang smash on the mouth and ripped my hairband off . . . and my favorite silver earrings: hah, I shall keep, he barked. And when he kissed my neck I bit him long and hard on the cheek, and when we came out of the room, blood was running down his face . . . Such violence, and I can see how women lie down for artists.

As Plath famously declared in "Daddy": "Every woman adores a Fascist, / The boot in the face, the brute / Brute heart of a brute like you."

Less spectacularly, Plath records the petty deteriorations of a marriage entered into precipitately on both sides: Hughes is difficult, moody, reluctant to work for a living; disinclined to bathe, and with a most unromantic penchant for nosepicking. Even in her physical repugnance for Hughes, Plath never doubts his gifts as a poet, but his glamor is fatally lessened: "Ted looked slovenly: his suit jacket wrinkled as if being pulled from behind, his pants hanging, unbelted, in great folds, his hair black & greasy . . . He was ashamed of something." Suspected by Plath of having been unfaithful to her, Hughes is soon exposed as a "liar, a vain smiler, a twister . . . Who knows who Ted's next book will be dedicated to? His navel. His penis." And: ". . . in almost two years he has turned me from a crazy perfectionist and promiscuous human-being-lover to a misanthropist, and . . . a nasty, catty and malicious misanthropist." (No reader of Plath's journals would ever have characterized her as a "human-being-lover," but this image of herself seems to have been central to her conception of herself, along with that of innocent martyr-victim.)

Plath was a self-dramatizing woman of myriad, warring selves, a perpetual fascination to herself. This accounts for much of her fascination for others to whom the Romantic concept of the doomed, driven poet is sacrosanct. Yet Plath's elevation in the 1970s as a feminist martyr and icon is comically incongruous with her hatred of the female sex ("Being born a woman is my awful tragedy. From the moment I was conceived I

was doomed to sprout breasts and ovaries rather than penis and scrotum; to have my whole circle of action, thought and feeling rigidly circumscribed by my inescapable femininity (sic))"; her competition with women poets ("Read the six women poets in the 'new poets of england and america.' Dull, turgid. Except for May Swenson & Adrienne Rich, not one better or more-published than me. I have the quiet righteous malice of one with better poems than other women's reputations have been made by"; and, most chilling, her astonishing declaration of her hatred for her mother, Aurelia, which runs on for pages in the journal for December 1958: "In a swarmy matriarchy of togetherness it is hard to get a sanction to hate one's mother . . . So how do I express my hate for my mother? In my deepest emotions I think of her as an enemy: somebody who 'killed' my father, my first male ally in the world. She is a murderess of maleness. I . . . thought what a luxury it would be to kill her, to strangle her skinny veined throat . . . But I was too nice for murder." One would never guess from this hysterical outburst that Plath's father died of diabetes, her mother worked at two jobs to support Sylvia and her brother, Warren, and never remarried because "my brother and I made her sign a promise she'd never marry."

Plath is an indefatigable graphomaniac who could write as fervently of colds, fevers, nausea, cramps and nosepicking as of an idyllic honeymoon in Benidorm, Spain; she is an inspired hater, and thrills to malicious descriptions of long-forgotten, nameless individuals whose bad luck it was to live near her, or to have met her socially. Yet Plath was always a severe critic of her "real" work, and considered the journal a place in which she could reveal herself without the strictures of art. She discarded much of what she wrote and took care, for instance, to categorize *The Bell Jar* as a "pot-boiler" to distinguish it from her serious work. (She worked for years on novel drafts, always dissatisfied with what she'd accomplished; near the end of her life, she burnt hundreds of pages of a work-in-progress.) Confronted with a manuscript so uneven in quality as these journals, Plath would certainly have discarded hundreds of pages in preparation for its publication: lengthy, breathless adolescent speculation about boys, dates, classes, career ("Can I write? Will I write if I practice enough? . . . CAN A SELFISH EGOCENTRIC JEALOUS AND UNIMAGINATIVE FEMALE WRITE A DAMN THING WORTH WHILE?"); sketches and drafts of stories aimed for the lucrative women's magazine market, awkward early poems ("Down

the hall comes Mary, bearing sheets / Crisp squares of folded linen / And, dressed in green, she greets me / With a toothless morning grin"); countless reiterations of physical symptoms ("Woke as usual, feeling sick and half-dead, eyes stuck together, a taste of winding sheets on my tongue after a horrible dream . . ."); petty squabbles with Hughes, and the determination to be a good wife (". . . must *not* nag) . . . (ergo: mention haircuts, washes, nail-filings, future money-making plans, children— anything Ted doesn't like: this is nagging)." Plath's ceaseless anxiety over submissions to *Ladies' Home Journal, The New Yorker, Harper's,* the *Atlantic* and other magazines runs through the journals like a demented mantra; the mailman is both the blessing and curse of Plath's existence through the entire span of these journals. Surely such repetition might have been avoided.

Like piranhas devouring their prey, Plath's thoughts rush, churn, thresh—sheer demonic energy exhausting to observe, and suggesting that Plath's primary motive for suicide might have been the extinguishing of this piranha-voice. One can be sympathetic with Kukil's project of correcting Hughes's editing of Plath's journals while retaining some doubt as to the wisdom—and the ethics—of exposing a major writer's unrevised, inferior work. Even the grammatical errors and misspellings are faithfully preserved by the adulatory Kukil, as if Plath hadn't been an ambitious, vulnerable young writer eager to present her strongest work to posterity, and not a mummified goddess.

Like all "unedited" journals, Plath's may be best read piecemeal, and rapidly, as they were written. The reader is advised to seek out the stronger, more lyric and exhilarating passages, which exist in enough abundance through these many pages to assure that this final posthumous publication of Sylvia Plath's is that rarity, a genuine literary event worthy of the poet's aggressive mythopoetic claim in "Lady Lazarus"— "Out of the ash / I rise with my red hair / And I eat men like air."

"Restoring" Willie Stark

All the King's Men
Robert Penn Warren

LIKE SINCLAIR LEWIS'S *MAIN STREET* (1920) and F. Scott Fitzgerald's *The Great Gatsby* (1925), Robert Penn Warren's *All the King's Men* (1946) has come to be read as an emblematic, even an allegorical, text. The idealistic Carol Kennicott of Gopher Prairie, Minnesota, the romantic-minded and doomed Jay Gatsby (formerly James Gatz of North Dakota), and the charismatic southern politician Willie Stark have acquired the status of American archetypes, larger than the historically precise fictional worlds they inhabit; like outsized farcical-heroic figures in a painting by the American regionalist Thomas Hart Benton, they are more interesting for what they represent than for what they are.

The Great Gatsby, the most subtly nuanced of the three, as it is the shortest, sold only modestly at the time of publication,[1] while the cruelly funny *Main Street* and the shamelessly melodramatic *All the King's Men* were immediate, runaway bestsellers. *Main Street* was fueled by controversy: before Lewis, no one had written with such satiric verve and pitiless accuracy of small-town Protestant America. *All the King's Men* was fueled by its reputation as a scandalous roman à clef based upon the life and death of the flamboyant Louisiana politician Huey P. Long; high-decibel, operatic, shrewdly plotted as *Oedipus Rex* grafted onto a who-

dunnit, Warren's big, sprawling novel would seem to have been perfectly matched to its time. It was awarded a 1947 Pulitzer Prize, and in 1949 the screen adaptation was equally admired. Though Robert Penn Warren ranks somewhere below his coevals Ernest Hemingway and William Faulkner, in the bygone-bestseller limbo of James Gould Cozzens and Edna Ferber, and seems to be more highly regarded at the present time as a poet than as a novelist,[2] *All the King's Men* has long been regarded as an American classic and has been continuously in print since 1946. As its chatty narrator Jack Burden prophesies, or boasts, at the end of the novel, "We shall go . . . into the convulsion of the world, out of history into history and the awful responsibility of time."

INSPIRED BY the astonishing career and abrupt death of Huey P. Long (1893–1935), *All the King's Men* means to be much more than the sum of its disparate parts. Robert Penn Warren took pains to make it clear that the novel isn't a roman à clef merely:

> . . . if I had never gone to live in Louisiana and if Huey Long had not existed, the novel would never have been written. But this is far from saying that my "state" in *All the King's Men* is Louisiana, or that my Willie Stark is the late Senator. What Louisiana and Senator Long gave me was a line of "thinking and feeling" that did eventuate in the novel.[3]

A young Ph.D. who'd done graduate work at Berkeley and Yale, a former Rhodes Scholar at Oxford, Warren had accepted an assistant professorship of English at the University of Louisiana at Baton Rouge ("Huey Long University") in 1934, a year before the public murder of Senator Long by an enraged private citizen; he came to Baton Rouge from a farm near Nashville, Tennessee, as if stepping through a looking-glass into Long's political kingdom, which clearly fascinated Warren even as it repelled him. (In his youth, Warren fancied himself an Agrarian-aristocrat, a defender of the "culture and economy" of the South; he'd written an essay titled "The Briar Patch," defending racial segregation, which was included in the 1930 manifesto *I'll Take My Stand,* later to be repudiated by Warren.) Warren would live intermittently in Louisiana until 1942, absorbing by degrees the legend of Huey Long, whom he

contemplated in the light of European Fascism; the power of the "man of the people" for both good and evil is a theme that fascinates Warren's fictional alter ego Jack Burden as well.

This is the "fascination of the abomination" of which Joseph Conrad's Marlow speaks in *Heart of Darkness,* as Marlow journeys up the Congo in search of the demi-god/madman, Kurtz; *Heart of Darkness* is clearly a model, along with Conrad's *Lord Jim,* for Warren's more discursive and romantic novel. We are meant to trust Jack Burden as a man of conscience, as we are meant to trust the more gentlemanly Marlow. A more immediate model for *All the King's Men* may well have been William Faulkner's 1940 masterpiece *The Hamlet,* the first and strongest novel of Faulkner's Snopes family trilogy, which charts the rise, like a malevolent protoplasm or yeast, of the enigmatic Flem Snopes. Warren acknowledges farther-flung influences, including Elizabethan tragedy, Edmund Spenser, and Machiavelli, but the richness of his novel springs from his firsthand experience of Louisiana during the reign of Huey Long:

> There were a thousand tales, over the years, and some of them were no doubt literally and factually true. But they were all true in the world of "Huey"—that world of myth, folklore, poetry, deprivation, rancor and dimly envisaged hopes. That world had a strange, shifting, often ironical and sometimes irrelevant relation to the factual world of Governor, later Senator, Huey P. Long and his cold manipulation of the calculus of power.

Huey Long's followers were fanatically devoted to him even as the wealthy élite of Louisiana despised and feared him: "He was the god on the battlement, dimly perceived above the darkling tumult and the steaming carnage of the political struggle. He was a voice, a portent, and a natural force like the Mississippi River getting set to bust a levee."

In 1938, in Mussolini's Italy, Warren began working on a play titled *Proud Flesh* in which Willie Stark's earliest incarnation is a man named Talos: ". . . the fact that I drew that name from the 'iron groom' who, in murderous blankness, serves Justice in Spenser's *Faery Queene* should indicate something of the 'line of thinking and feeling' that led up to that version and persisted, with modulations, into the novel." In 1943, Warren began the novel that is "more realistic, discursive and documen-

tary in spirit (though not in fact) than the play." Yet the Willie Stark of *All the King's Men* is rather more a romantic idealist than a dynamic, still less a demonic figure; he isn't plausible as an American cousin of such psychopathic political leaders as Hitler and Mussolini, though Warren seems to have intended him to be so. Nor does Stark exude the mysterious and unnerving authority of Faulkner's intransigent Flem Snopes. There are numerous aspects of the historical Huey "Kingfish" Long that might have been developed by Warren to suggest a greater depth and originality than his Willie Stark possesses,[4] but Warren's imagination seems to have led him to simplified, if not stereotypical resolutions: Willie Stark is shot to death as a consequence of his love affair with a woman from an old "good" family (the daughter of former Governor Stanton, in fact), not for his political machinations, while Long was assassinated for purely political reasons, in more mysterious, quirkier circumstances. It's as if Warren's conventionally romantic sensibility couldn't conceive of political tragedy, only Hollywood melodrama in this climate in which, as Warren said of Louisiana in the 1930s, "melodrama was the breath of life."

THE FAMOUS, bravura opening of *All the King's Men* has not lost its power. We begin epic-style, in medias res, uncertain of our surroundings as of our destination, or who is in our speeding vehicle with us:

Mason City.
 You follow Highway 58, going north-east out of the city, and it is a good highway and new. Or was new, the day we went up it. You look up the highway and it is straight for miles, coming at you, with the black line down the center coming at and at you, black and slick and tarry-shining against the white of the slab, and the heat dazzles up from the white slab so that only the black line is clear, coming at you with the whine of the tires, and if you don't quit staring at that line and don't take a few deep breaths and slap yourself hard on the back of the neck you'll hypnotize yourself and you'll come to just at the moment when the right front wheel hooks over into the black dirt shoulder off the slab, and you'll try to jerk her back on but you can't because the slab is high like a curb, and maybe you'll try to turn off the ignition just as she starts the dive. But you won't make

it, of course. Then a nigger chopping cotton a mile away, he'll look up and see the little column of black smoke standing up above the vitriolic, arsenical green of the cotton rows, and up against the violent, metallic, throbbing blue of the sky, and he'll say, "Lord Gawd, hit's a-nudder one done done hit!"

This is our narrator Jack Burden at his most lyrical, neither breezily slangy and self-conscious nor pretentiously philosophical, giving us as much information as the cinematic scene requires, but no more: we are in the Boss's black Cadillac driven at seventy-five miles an hour by his chauffeur, "Sugar-Boy" O'Sheeanan, and with us are the Boss, Governor Willie Stark, his former schoolteacher-wife, Lucy, and his spoiled-rotten football player son, Tom; a serio-comic politico by the name of Tiny Duffy; and Jack Burden, failed journalist and failed historian, failed husband and failed lover, the bearer of another old "good" name who has become Willie Stark's improbable right-hand man, entrusted with the lethal task of digging up dirt on Stark's enemies. (When Jack wonders why he works for Willie Stark, Stark tells him: "You work for me because I'm the way I am and you're the way you are. It's an arrangement founded on the nature of things . . . There ain't any explanations. Not of anything. All you can do is point at the nature of things. If you are smart enough to see them.") Though we aren't meant to be aware of it at the time, the cinematic opening scene, indeed virtually all of the novel, is being viewed through the prism of time as Jack Burden tells his story retrospectively, at a time when Willie Stark has become a posthumous legend.

Jack Burden is one whose heightened sense of irony has handicapped him for life. He's paralyzed—burdened—by the "enchantments of the past," both his own past and that of his class (of former slave-owning southern whites). He's ashamed of his seductive mother "out of the scrub country of Arkansas" who has married numerous times, for money and social prestige; he's ashamed of the quixotic, ineffectual gentleman he believes to be his father, whom he calls with quaint derision the Scholarly Attorney; he loses his respect for the gentleman he calls the Upright Judge, who is in fact his father, and whom he inadvertently drives to suicide, in his role as Willie Stark's vengeful agent. In his diminished sense of his own manhood in a contemporary South governed by ambitious, amoral "hicks" like Willie Stark, Jack Burden is reminiscent

of Faulkner's equally eloquent, and ineffectual, attorney Gavin Stevens, an appalled witness to perversions of nature like the gangster Popeye (of the lurid *noir* romance *Sanctuary*) and the ever-burgeoning Snopes clan of *The Hamlet, The Town,* and *The Mansion.* Both Jack Burden and Gavin Stevens are highly educated, intelligent men from "good" families, stricken by a Prufrockian impotence in the face of a rapidly changing South. By the novel's end, however, after enough plot complications, or contrivances, to fuel a Dickens novel, Jack Burden throws off his lethargy, survives both the suicide of his father, Judge Irwin, and the murder of his boss, Willie Stark, reclaims his love for Anne Stanton despite the fact that she has been Willie Stark's "mistress," and comes to a belated realization of his essential worth:

> This has been the story of Willie Stark, but it is my story, too. For I have a story. It is the story of a man who lived in the world and to him the world looked one way for a long time and then it looked another and very different way. The change did not happen all at once. Many things happened, and that man did not know when he had any responsibility for them and when he did not. There was, in fact, a time when he came to believe that there was no god but the Great Twitch . . . But later, much later, he woke up one morning to discover that he did not believe in the Great Twitch any longer. He did not believe it because he had seen too many people live and die.

(Note, in the third sentence especially, the Hemingway prose rhythms, simple, declarative, disingenuous; as if Truth, when it is realized, must be so ploddingly and explicitly stated that the slowest of readers will comprehend.)

Before his epiphany, however, Jack Burden is a man of painfully self-conscious irony, something of a caricature. We see him in tantalizing fragments, never as a whole: Willie Stark's secretary/mistress, Sadie Burke, characterizes him as "a box of spilled spaghetti. All elbows and dry rattle." Fifteen years earlier, as a young man of twenty-one, Jack Burden sees himself without illusions as a

> rather tall, somewhat gangly, slightly stooped youth . . . with a bony horse face, a big almost askew hook of a nose, dark unkempt hair, dark eyes (not burning and deep like the eyes of Cass Mastern, his

great-uncle, but frequently vague or veiled, bloodshot in the morn-
ings, brightening only with excitement), big hands that worked and
twisted slowly on his lap . . . a youth not beautiful, not brilliant, not
industrious, not good, not kind, not even ambitious, given to ex-
cesses and confusions, thrown between melancholy and random vio-
lence, between the cold mire and the hot flame, between curiosity
and apathy, between humility and self-love, between yesterday and
tomorrow.

In its ungainly admixture of tones and its rhetorical excess, this passage
is characteristic of Jack Burden, for whom we feel both sympathy and
impatience, admiration and exasperation. At times, this mediation is il-
luminating, as in this protracted, verging-upon-the-surreal description
of Willie Stark working himself up to an impromptu speech:

You saw the eyes [of Willie Stark] bulge suddenly . . . as though
something had happened inside him, and there was that glitter. You
knew that something had happened inside of him and thought: *It's
coming.* It was always that way. There was the bulge and the glitter,
and there was the cold grip way down in the stomach as though
somebody had laid hold of something in there, in the dark which is
you, with a cold hand in a cold rubber glove. It was like the second
when you come home late at night and see the yellow envelope of the
telegram sticking out from under your door and you lean and pick it
up, but don't open it yet, not for a second. While you stand there in
the hall, with the envelope in your hand, you feel like there's an eye
on you, a great big eye looking straight at you from miles and dark
and through walls and houses . . . and sees you huddled up way in-
side, in the dark which is you, inside yourself, like a clammy, sad lit-
tle foetus you carry around inside you. The eye knows what's in the
envelope, and it is watching you to see you when you open it and
know, too.

Pursuing a decades-old political scandal, discovering long-buried
facts about his (unacknowledged) father the "upright" Judge Irwin, Jack
Burden, not unlike his impetuous predecessor Oedipus, gains self-
knowledge at the expense of others' pain, and his own. The political ge-
nius Willie Stark has no need to invent scandal, he simply unearths it and

blackmails or destroys his enemies, with Jack Burden as his instrument of destruction. Yet Jack Burden is conscience-stricken, trapped in a moral dilemma:

> I wondered if what I had dug up were true.
>
> I looked across at [Judge Irwin], and didn't want it to be true. And I had the sudden thought that I might have his drink of gin and tonic, and talk with him and never tell him, and go back to town and tell the Boss that I was convinced it was not true . . .
>
> But I had to know. Even as the thought of going away without knowing came through my head, I knew that I had to know the truth. For the truth is a terrible thing. You dabble your foot in it and it is nothing. But you walk a little farther and you feel it pull you like an undertow or a whirlpool. First there is the slow pull so steady and gradual you scarcely notice it, then the acceleration, then the dizzy whirl and plunge to blackness. For there is a blackness of truth, too. They say it is a terrible thing to fall into the Grace of God. I am prepared to believe that.

Yet there are passages in *All the King's Men* that reveal so crude, so coarse, so fulsome and bombastic a sensibility, one has difficulty reconciling them with the high-toned Jack Burden. There are too many of these to ignore:

> [Anne Stanton's] eyes were glittering like the eyes of a child when you give a nice surprise, and she laughed in a sudden throaty, tingling way. It is the way a woman laughs for happiness. They never laugh that way just when they are being polite or at a joke. A woman only laughs like that a few times in her life. A woman only laughs like that when something has touched her way down in the very quick of her being and the happiness just wells out as natural as breath and the first jonquils and mountain brooks. When a woman laughs that way it always does something to you. It does not matter what kind of a face she has got either . . . [That laugh] is a spray of dewy blossom from the great central stalk of All Being, and the woman's name and address hasn't got a damn thing to do with it. Therefore, that laugh cannot be faked. If a woman could learn to fake it she would make Nell Gwyn and Pompadour look like a cou-

ple of Campfire Girls wearing bi-focals and ground-gripper shoes and with bands on their teeth.

Abruptly we seem to be in folksy Norman Rockwell America, in the presence of some of the most bombastic prose ever committed by any writer of stature in our history.

> [Adam Stanton] smiled at me not because I was what I was but because I was the friend of his youth. The friend of your youth is the only friend you will ever have, for he does not really see you. He sees in his mind a face which does not exist anymore, speaks a name—Spike, Bud, Snip, Red, Rusty, Jack, Dave—which belongs to that now non-existent face but which by some inane and doddering confusion of the universe is for the moment attached to a not too happily met and boring stranger. But he humors the drooling doddering confusion of the universe and continues to address politely that dull stranger by the name which properly belongs to the boy-face and to the time when the boy-voice called thinly across the late afternoon water or murmured by a campfire at night or in the middle of a crowded street said, "Gee, listen to this—on Wenlock Edge the woods in trouble, his forest fleece the Wrekin heaves—" The friend of your youth is your friend because he does not see you anymore.

Even the weather isn't spared Jack Burden's astonishing rodomontade:

> It was a beautiful morning in middle May . . . The season was like the fine big-breasted daughter of some poor spavined share-cropper, a girl popping her calico but still having a waist, with pink cheeks and bright eyes and just a little perspiration at the edge of her tow hair (which would be platinum blond in some circles), but you see her and know that before long she will be a bag of bone and gristle with a hag-face like a rusted brush-hook.

Fawning in his tireless admiration for the priggish Dr. Adam Stanton, the friend of Jack's youth, and for Stanton's younger sister Anne, the love of Jack's youth, Jack Burden is capable of shocking coarseness when al-

luding to categories of human beings to whom his penchant for windy romanticizing doesn't extend:

> [The Scholarly Attorney] lived . . . above a spick restaurant, and nigger children played naked in the next block among starving cats, and nigger women like great sacks of bloated black blubber sat on the steps after the sun got low and fanned right slow with palm-leaf fans.

Though Robert Penn Warren repudiated his 1930 essay defending racial segregation, it's clear from such offhand remarks by his protagonist Jack Burden that Warren assumed an unquestioned racial superiority. And his contempt regarding women not of Anne Stanton's class is equally transparent:

> As long as I regarded Lois [his first wife] as a beautiful juicy, soft, vibrant, sweet-smelling, sweet-breathed machine for provoking and satisfying the appetite . . . all was well. But as soon as I began to regard her as a person, trouble began. All would have been well, perhaps, had Lois been struck dumb at puberty. Then no man could have withstood her. But she could talk, and when something talks you sooner or later begin to listen to the sound it makes and begin . . . to regard it as a person.

Except for the Stantons, and others of their social class, the characters of *All the King's Men* incline toward caricature. In particular, such allies of Willie Stark as his secretary/mistress, Sadie Burke, who flies repeatedly into jealous rages when she learns that Willie Stark has been unfaithful to her:

> Sadie burst out of the Boss's door about the way one of the big cats, no doubt, used to bounce out of the hutch at the far end of the arena and head for the Christian martyr. Her hair was flying with distinct life and her face was chalk-white with the pock marks making it look like riddled plaster, like, say, a plaster-of-paris mask of Medusa which some kid has been using as a target for a BB gun. But in the middle of the plaster-of-paris mask was an event which had nothing whatsoever to do with plaster-of-paris: her eyes, and they were a

twin disaster, they were a black explosion, they were a conflagration. She was running a head of steam to bust the rivets, and the way she snatched across the floor you could hear the seams pop in her skirt.

Willie Stark's loyal chauffeur and bodyguard, Sugar-Boy, is another comic strip character, a sucker of sugar cubes with "twisted black little teeth" and "thin little mystic Irish cheeks" whose speech is reducible to, " 'The b-b-b-b-b-' he would manage to get out and the saliva would spray from his lips like *Flit* from a *Flitgun*. 'The b-b-b-b-bas—tud— he seen me c-c-c-' and here he'd spray the inside of the windshield, 'c-c-coming.' " Willie Stark's football player son is the insufferably self-centered Tom, who "knew he was the nuts, as you could tell from one look at his slick-skinned handsome brown face, with the jawbone working insolently and slow over a little piece of chewing gum and his blue eyes under half-lowered lids working insolently and slow over you, or the whole damned world." Predictably, the insolent football hero will one day be struck down on the football field, paralyzed for life.

Tom's mother, Willie Stark's ex-schoolteacher wife Lucy, is one of Warren's "good" women, blandly and flatly characterized:

Lucy looked at me with a confident bird-like lift of her head, as though she had proved something to me. The secondary glow of the light above the circle of light was on her face, and if I had wanted to I could have guessed that some of the glow was given off softly by her face as though the flesh had a delicate and unflagging and serene phosphorescence from its own inwardness.

Well, Lucy was a woman, and therefore she must have been wonderful in that way that women are wonderful.

Willie Stark, too, begins as caricature in Jack Burden's bemused eyes:

Fate comes walking through the door, and it is five-feet ten inches tall and heavyish in the chest and shortish in the leg and is wearing a seven-fifty seer-sucker suit which is too long in the pants so the cuffs crumple down over the high black shoes, which could do with a polishing, and a stiff high collar like a Sunday School superintendent . . . and a gray felt hat with the sweat stains showing through the band. It comes in just like that and how are you to know?

How are you to know, Jack Burden means, that this unprepossessing self-taught country lawyer will rapidly rise through the ranks of county, then state politics; that he will re-invent himself after an early ignominious defeat, like the historical Huey P. Long, a master politician governed not by the extravagant passions he can arouse in his constituency but by an altruistic, unswervingly rationalist vision of what he can do, as governor and as senator, for his people:

> The Boss, meanwhile, was making that hospital his chief waking thought. He took trips up East to see all the finest, biggest ones, the Massachusetts General, the Presbyterian in New York, the Philadelphia General, and a lot more. "By God," he would say, "I don't care how fine they are, mine's gonna be finer, and I don't care how big they are, mine's gonna be bigger, and any poor bugger in this State can go there and get the best there is and not cost him a dime.

Warren's dramatizing of Willie Stark's impassioned public performances is convincing, granted that any attempt to convey the delirium of a crowd scene is virtually impossible in prose:

> I would wait for the roar. You can't help it. I knew it would come, but I would wait for it, and every time it would seem intolerably long before it came. It was like a deep dive . . . There is nothing like the roar of a crowd when it swells up, all of a sudden at the same time, out of the thing which is in every man in the crowd but not in himself. The roar would swell and rise and fall again, with the Boss standing with his right hand raised straight to Heaven and his red eyes bulging. And when the roar fell away, he said, with his arm up, "I have looked in your faces!"
> And they would yell.
> And he said: "Oh, Lord, and I have seen a sign!"
> And they would yell again.
> And he said: "I have seen dew on the fleece and the ground dry!"
> And the yell.
> Then: "I have seen blood on the moon!" Then: "Buckets of blood, and boy! I know whose blood it will be." Then, leaning forward, grabbing out with his right hand as though to seize something in the air before him: "Gimme that meat-axe!"

It could as easily be a lynching that Willie Stark is rousing his followers to commit, as a more abstract assault upon the monied elite of the State.

In the interstices of his flamboyantly scripted public life, in the presence of the ubiquitous Jack Burden, Willie Stark reveals himself as mordantly eloquent: "Man is conceived in sin and born in corruption and he passeth from the stink of the didie to the stench of the shroud. There is always something." By which Stark means there is always dirt in an individual's life, if you know where to dig, and don't mind whom you destroy in the digging.

We expect to learn that Stark is a sham, a manipulator of credulous voters, but in fact Stark is respectful of his rowdy redneck constituency, as he's sincere in his vision of a State in which education and free medical care would be available for all. In this curious blend of buffoonery and Utopian vision, Huey Long is clearly Warren's model for Stark; but Warren doesn't explore Long's courageous, adversarial relationship with the Ku Klux Klan, whom he publicly repudiated, nor Long's political relations with Negroes, who overwhelmingly supported him in elections. (Long believed in both segregation and "equal" opportunities for Negroes, virtually alone among white Louisiana politicians of his time.) Set beside Huey Long, Warren's Willie Stark, while far more than a caricature, is a generic creation manipulated by the author in the service of a plot that becomes anticlimactic after his death, as Jack Burden, now married to Anne Stanton, re-assesses his life and begins at last to write the book he has long deferred, about his great-uncle Cass Mastern.[5]

Though *All the King's Men* is a busy, noisy novel, resembling those mid-twentieth-century CinemaScope extravaganzas that boasted of "casts of thousands," its core cast is minuscule: Anne Stanton, Jack Burden's beloved, improbably becomes Willie Stark's mistress; Adam Stanton, Jack's old friend, is improbably the sole doctor in the state capable of running Willie Stark's dream hospital, though he seems to have had no administrative experience and his medical speciality is the long-since discredited quack procedure "pre-frontal lobectomy").[6] The Stantons' father, aristocratic ex-Governor Stanton, was a friend and political crony of the corruptible Judge Irwin, Jack Burden's father. After a football injury, Stark's son Tom is operated on by Adam Stanton; and Adam Stanton returns as Willie Stark's assassin, to be shot down by Sugar-Boy, Stark's bodyguard. Warren's model for such claustrophobic hyperactivity may have been Greek tragedy but his execution is sheerly melodra-

matic. One is left with a sense of the faintly absurd, as in a low-budget theatrical production in which a very small cast of energetic actors must perform multiple roles.

IN THEORY, the "restoring" of classic literary texts would seem to be an excellent, even heroic effort. In recent years literary scholars have given us not one but two competing "corrected" texts of James Joyce's *Ulysses,* neither of which has come into popular usage, let alone replaced the 1922 edition of the novel, and a misguided if well-intentioned newly assembled text of F. Scott Fitzgerald's unfinished final novel, *The Last Tycoon,* awkwardly retitled *The Love of the Last Tycoon: A Western.* To peruse these earnest texts is to feel oneself in the presence of Nabokov's Charles Kinbote of *Pale Fire,* the madman-scholar who re-invents his text as he edits it, intruding himself on every page. Is the intention to "restore" the original work, or to appropriate it? Or defeat it?

In this new, "restored" edition of *All the King's Men,* Noel Polk, professor of American Literature at the University of Southern Mississippi, argues that Warren's original version of the novel, before its considerable editing at Harcourt, Brace, was, or is, superior to the 1946 and subsequent editions:

> The typescript (among the Warren papers in the American Literature Collection at the Beinecke Library of Yale University) differs in hundreds of particulars, major and minor, from the published novel, thanks to the original editors who, with all good intentions, altered the novel in ways that made it considerably less than the novel Warren wrote.

"Considerably less" is a dubious, if not frankly erroneous claim; the more reasonable claim is "different." Readers are likely to disagree on the worth of Polk's edition, and most admirers of *All the King's Men* will probably resent it, for Polk's bold re-naming of "Willie Stark" as "Willie Talos."

The manuscript of *All the King's Men,* typed by Robert Penn Warren and others over a period of years, in a variety of places and on more than one typewriter, is a "ragged composite" comprised of different kinds of paper "from high-quality bond to the cheapest of yellow newsprint and

second sheets of the sort normally used for carbon copies." Both the author and his several editors wrote on the manuscript pages, and many pages are composites, having been glued or taped together, suggesting that Warren never revised the novel from start to finish, but only piecemeal. When he began writing *All the King's Men* in 1943, he sent early chapters to Harcourt, Brace, and editorial consultation seems to have been immediate. Among the major editorial changes Polk identifies is the removal of Warren's repeated colons when introducing Jack Burden's speech ("I said: 'What for'?") and the substitution of commas ("I said, 'What for'?"). Polk argues that, collectively, the colons characterize Jack Burden's aggressive narrative style, his "cockiness" and general attitude; to remove them lessens the impact of Warren's text. Perhaps this is so, though a reading of the new text in tandem with the 1946 text doesn't indicate that much was lost of any significance; indeed, the reader has more than enough of Jack Burden's hyperventilated voice, and ends up wishing that Warren's original editors had blue-penciled more of his prose, including every labored metaphorical conceit and vapid philosophical digression. A paragraph intercalated into the text by Professor Polk, in chapter V, is not only badly written but, in its context, nonsensical:

> (But, look here, gentle reader, mon semblable, mon frère, you needn't get upstage with me about it, for you were happy to read that Philip Sidney had pimples, that Jesus Christ may have been sweating from T.B., that Plato was merely defending the interest of his economic class, and that George Washington had false teeth. And Robert E. Lee has never been your favorite hero.)

The scene reads much more smoothly without this passage, which Professor Polk seems to have "restored" simply because he found it amid the shambles of Warren's manuscript. Warren was hardly a careful writer, let alone a stylist in the mode of Joyce, Proust, Woolf, whose every quirk and swerve of language might be defended as sacrosanct; contrary to Polk's criticism of Warren's editors, we're left with the distinct impression that they were quite competent overall, if inclined toward the priggish at times (substituting "callous-rumped" for "callous-assed," for instance), and that Warren was prudent in acceding to their suggestions.

The most radical alteration Polk has made to Warren's text is the sub-

stitution throughout *All the King's Men* of the name "Talos" for "Stark," on the grounds that Warren's initial choice of a name for his character is superior to the name "Stark," though it's likely that Warren himself chose this name for its sound and symbolism. Polk quotes Warren's editor disapprovingly:

> [Talos] represents an ambiguity in pronunciation, and in addition carries a foreign flavor that suggests a different background for the man than is actually the case. I recognize some metaphorical overtones in the word Talos that may be important to you, but I think this criticism of the name has some point on the practical level.

But why is this poor advice? "Talos" is a pretentious name in the "Stephen Dedalus" tradition, while "Willie Stark" is effective without being an outright nudge in the ribs. In the course of writing *All the King's Men,* Warren obviously outgrew his interest in the mythological Talos figure, the "mechanical man" of "murderous blankness" who lacks human volition as he lacks a soul; "Talos" simply doesn't apply to Willie Stark the Utopian idealist, grieving father of a crippled son and alleged lover of Anne Stanton. Polk seems not to understand that it isn't uncommon for writers to change the names of characters and the titles of novels as they progress, but a sign rather of their deepening assimilation of their material. Since Warren completed his novel using the name "Stark," and since in the course of his long lifetime (1905–1989) he made no attempt to restore the original "Talos," it seems an act of high-handed zeal to bring into print in 2001 what amounts to a text to compete with the 1946 text prepared under the author's guidance. It's naive to assume that even a writer of genius can't profit from the intervention of astute editors; if nothing else, an editor's query provokes a writer to re-think something of which he may have had initial doubts. Any serious writer wants to bring into print the very best text of which he's capable; simply to defend what he has written, because he has written it, is hardly the point.

It's a measure of the enduring worth of *All the King's Men* that Willie Stark has entered our collective literary consciousness, amid the company of Captain Ahab, Huck Finn, Jay Gatsby, Holden Caulfield, Rabbit Angstrom, and very few others. Set beside this Willie Stark, "Willie Talos" hasn't a chance.

Notes

1. The first edition of *The Great Gatsby* sold about 25,000 copies, far less than Fitzgerald's first two, considerably inferior novels, *This Side of Paradise* and *The Beautiful and Damned*. By 1927, two years after the publication of *Gatsby*, Fitzgerald's books earned only $153; by 1929, only $32. Shortly before his death in 1940, *Gatsby* had been dropped by the Modern Library because of poor sales.

2. Warren's later poetry, from *Incarnations* (1968) to *Altitudes and Extensions* (1985) is generally considered his finest work. In 1958 Warren received a Pulitzer Prize for *Promises*.

3. Introduction to *All the King's Men* by Robert Penn Warren (Time, Inc., 1963), p. xi.

4. See the definitive biography *Huey Long* by T. Harry Williams (Knopf, 1969).

5. Cass Mastern, whose letters and journal Jack Burden has inherited, was a visionary anti-slavery pacifist who nonetheless wore the Confederate uniform and died a hideous gangrenous death as a result of a wound suffered in the Civil War. Positioned midway in *All the King's Men,* at a point at which Jack Burden has come to an emotional stasis in his recounting of the "enchantments of the past," the Cass Mastern section has the feel of being older material Warren has brought into his narrative for thematic purposes, and has frequently been criticized for impeding the novel's movement. Yet Cass Mastern is a more engaging character than Jack Burden; the very antithesis of the activist Willie Stark; he's enigmatic as one of Faulkner's doomed yet indomitable heroes, like Colonel Sartoris. Warren seems not to know what to do with Cass Mastern, except to present him as a rebuke to Jack Burden; all that Jack Burden, or Warren, can do is to comment upon Mastern at a respectful distance:

> Cass Mastern lived for a few years and in that time he learned that the world is all of one piece. He learned that the world is like an enormous spider web and if you touch it, however lightly, at any point, the vibration ripples to the remotest perimeter . . .
>
> But how could Jack Burden, being what he was, understand that? He could read the words written many years before in the lonely plantation house after Cass Mastern had freed his slaves . . . Jack Burden could read those words, but how could he be expected to understand them?

They could only be words to him, for to him the world then was simply an accumulation of items, odds and ends of things like the broken and misused and dust-shrouded things gathered in a garret. Or it was a flux of things before his eyes (or behind his eyes) and one thing had nothing to do, in the end, with anything else. [p. 267]

6. In this altogether curious interlude, Dr. Stanton operates on a "catatonic schizophrenic" with the intention of giving him a "different personality." Though lobotomies were discredited as legitimate medical procedures by 1963, when the Time, Inc., edition of *All the King's Men* was published, Warren didn't use the opportunity of a new edition to excise this absurd material; nor does he even comment upon it in his introduction. The allegedly admirable Dr. Stanton proceeds in this way:

. . . Adam took a scalpel and cut a neat little cut across the top of [the patient's] head and down at each temple, and then just peeled the skin off the bone in a neat flap forward. He did a job that would have made a Comanche brave look like a tyro with a scalping knife. Meanwhile, they were sopping up the blood, which was considerable.

Then Adam settled down to the real business. He had a contraption like a brace-and-bit. With that he drilled five or six holes—burr holes they call them in the trade—on each side of the skull. Then he started to work with what he had told me earlier was a Gigli saw, a thing which looked like a coarse wire. With that he sawed on the bone till he had a flap loose on each side of the front of the head and could bend the flap down and get at the real mechanism inside . . . [pp. 443–4]

Catherizing Willa

Willa Cather & the Politics of Criticism
Joan Acocella

Willa Cather: The Writer and Her World
Janis P. Stout

W.H. AUDEN SAID IT MOST MEMORABLY, and bluntly: "The words of a dead man / Are modified in the guts of the living" ("In Memory of W.B. Yeats"). The metaphor is a striking one, and if we pursue it, disturbing. For "art" is here perceived as something to be consumed by the survivor, digested, "modified," and presumably excreted. The living make pragmatic use of the past, taking what can be modified and appropriated, and discarding the remainder. There is no art in itself, only appropriated art, now an attribute of the living.

How particularly apt Auden's metaphor seems to us in terms of literary criticism, in recent decades the most fickle, if not ephemeral and subjective, of academic "disciplines." Joan Acocella, not an academic, best known for her dance criticism and her occasional pieces in *The New Yorker,* has written a cogently argued, persuasive, and often very funny overview of the work of Willa Cather and the congeries of literary critics that have followed in her wake, beginning in the first decades of the twentieth century when Cather published her early work and ending at approximately the present time, when Cather has been "rediscovered"—

if not resuscitated—by theorists armed with feminist and political jargons brandished like clumsy weapons. "The problem with these critics' writings," Acocella argues, "is not that they contain politics, but that they contain almost nothing else."

Acocella, a longtime admirer of Willa Cather, is a reasonable, rational critic. Her claims for this still rather underrated but surely "major" American writer are not outsized or radical, but rather more gently polemical and illuminating when she writes of Cather's meticulously crafted prose, and amusingly combative when she writes of certain of the bizarre uses which have been made of Cather's prose in the name of political agendas. Acocella's concern isn't only with willful misreadings of Willa Cather but with the purpose of criticism itself. In questioning the relevance and logic of a passage from Judith Butler's Lacan-inspired *Bodies That Matter,* Acocella asks:

> Should we care? After all, most people will read *My Ántonia* without the help of Butler's gloss and will see Cather's scene for what it is. But shouldn't we also worry about literary criticism? Criticism is the story of one imagination (the critic's) meeting another (the author's)—an enterprise that has been going on for over two thousand years. Surely it does matter if criticism is now redesigned in such a way that the second imagination, the author's, is wholly swept aside and the text used merely, in artfully chosen snatches, to illustrate the critic's idea of what is wrong with Western culture.

Willa Cather (1876–1947), like her younger contemporary Edith Wharton (1862–1937), had the misfortune, so far as literary reputation is concerned, of being born female in America, and of publishing much of her fiction in an era of robust macho realism. Set beside the foursquare moral realism of William Dean Howells and the subtle, ever-refracted and obsessively masticated prose of late Henry James, Willa Cather's early novels *O Pioneers!* (1913) and *My Ántonia* (1918) struck critics as "great epics" of the American plains; set beside the hard-hitting naturalism of such writers as Jack London, Theodore Dreiser, John Dos Passos, e.e. cummings, above all Ernest Hemingway, Cather's ambitious novels of the 1920s (*One of Ours, A Lost Lady, The Professor's House, Death Comes for the Archbishop*) came to seem strait-laced, conventional in concept and execution, well-crafted "but rather

dull" [p. 22, Acocella], "spinsterish." *One of Ours* (1922) particularly in-
furiated male critics since here Cather dared not only to write from the
perspective of a young soldier, but to send this exemplary individual into
battle in the Great War and to allow him some measure of unfashionable
idealism. The highly influential H. L. Mencken dismissed *One of Ours*
as women's writing, of the level of a serial in *Ladies' Home Journal,*
while Edmund Wilson and Heywood Broun were even more critical.
Young Ernest Hemingway, roused to indignation by a woman writer
trespassing into the war zone, wrote to Edmund Wilson in a letter fre-
quently quoted by Cather's biographers:

> Wasn't that last scene in the lines wonderful?
> Do you know where it came from? The battle scene in *Birth of a Na-
> tion*. I identified episode after episode, Catherized. Poor woman, she
> had to get her war experience somewhere.
>
> [*Willa Cather: A Literary Life*, James Woodress]

One of Ours was a bestseller and won a Pulitzer Prize, for which a gen-
eration of male literary commentators never forgave Cather.

There were reasons other than misogyny for the abrupt decline of
Cather's reputation, as Acocella indicates. Cather was middle-aged
when she began to publish her serious fiction, while her male detractors
were at least two decades younger. "She was old enough," Acocella
points out, "to be their mother." And it was mothers, even more than fa-
thers, against whom the Lost Generation was rebelling. Though Cather's
austere, lyrical, and elliptical prose could never be mistaken for the over-
ripe sentimental prose of nineteenth-century women's romance, yet the
"nobility" of her characters and a certain stolidness and predictability in
their behavior suggested the psychology of an earlier, less cynical and
therefore naive Victorian era. Perhaps the most striking contrast between
Cather and her male coevals is the absence in her entire oeuvre of erotic,
sensuous, sexualized behavior. At times, her fiction suggests the sani-
tized quality of "young adult" writing. Even when Cather's characters
are presented as fecund, like the rhapsodically idealized Ántonia, they
seem somehow incomplete, unconvincing:

> [Ántonia] lent herself to immemorial human attitudes which we rec-
> ognize by instinct as universal and true . . . It was no wonder that

her sons stood tall and straight. She was a rich mine of life, like the founders of early races.

Yet these very qualities of reticence and prudery made Cather attractive to large numbers of readers, the majority of whom were, and are, women, who read fiction not to be disturbed, shaken, or offended, still less to admire stylistic virtuosity, but for comfort of one kind or another. Heartwarming short stories like "Neighbor Rosicky" (1928) and "Old Mrs. Harris" (1932), as well as Cather's bestselling, rather statically composed *Death Comes for the Archbishop* (1927) and *Shadows on the Rock,* both of which celebrate an idealized, non-politicized Roman Catholicism, would hardly seem to have been written during the same years as the great works of modernism by James Joyce, D. H. Lawrence, William Faulkner, and Hemingway. That Cather was also capable of writing powerful works of fiction like "Paul's Case" (her best, and most anthologized story, 1905), *The Song of the Lark* (1915), and the idiosyncratically structured *The Professor's House* (1925), seems to have been ignored by her hostile critics. Despite a dark vision of the contemporary, debased world, Cather was labeled early on as an "affirmative" writer; she celebrated what is known in some quarters today as "family values." Could any label be more damning-dull? Equally reprehensibly, Cather disdained literary experimentalism as she disdained Franklin D. Roosevelt and the New Deal. Her 1936 essay collection was titled *Not Under Forty:* a defiant warning that no one under forty need trouble themselves to read it. With age she became grumpily conservative, if not reactionary, even as her "affirmative" books were championed by the right-wing, piously Christian press.

"Catherized" is a cruel but not inaccurate term to suggest the curious commingling in this writer of sharply observed, lyric detail and narrative richness with a rigidly controlled, censorious denial of imagination. Cather's fiction seems often to stop short before its fullest realization, so that the reader is left with a sense of a forced, not entirely earned closure. There are awkward pleats and gaps in time, as in the nostalgic conclusion to *Lucy Gayheart,* to which Cather's more defensive critics have given the term "vacancies in time" (see Janis P. Stout, *Willa Cather: The Writer and Her World,* p. 192) but which seem, to the neutral observer, simply awkward writing. Bringing a work of fiction to its inevitable, yet somehow unexpected ending is the most challenging task for the writer,

which Cather may have wished to disdain. She put much emphasis upon "the thing not named" as in her pretentiously titled essay "The Novel Démeublé" (1922), in which she aligns herself with Jamesian and Woolfian aestheticism:

> Whatever is felt upon the page without being specifically named there—that, one might say, is created. It is the inexplicable presence of the thing not named, of the overtone divined by the ear but not heard by it, the verbal mood, the emotional aura of the fact or the thing or the deed, that gives high quality to the novel or the drama, as well as to poetry itself.
>
> [*Willa Cather: Double Lives,* Hermione Lee]

Yet Cather's most characteristic mode is statement, if not overstatement. "Vacancies in time"—"vacuoles"—seem rather more lapses in authorial skill and "the thing not named" an unimagined, unearned absence.

The early, passionate *The Song of the Lark* is a *Künstlerroman* of the coming-of-age of a musically gifted girl from Moonstone, Colorado (a small-town variant of Red Cloud, Nebraska, where Cather spent her formative years) who becomes a successful, obsessive opera singer; it's a powerful portrait of a woman artist, an unsentimental vision of the price one must pay for a public career. But this price is paid willingly by Thea Kronberg, as by Willa Cather. "Who marries who is a small matter, after all." Yet, notoriously, Cather was no feminist, and took a dim view of the possibility of female bonding vis-à-vis male dominion. Though one day, as in a nightmare scenario of reversed wishes, lesbian literary theorists would eagerly claim Cather as a (closeted) sister, Cather's conservatism was patriarchal, and unsparing, in revulsion from the inferiority of the "second" sex, to which she happened to belong as if by error. As an adolescent in Red Cloud, Willa Cather preferred to be known as "William" and "Willie" and certainly appeared, judging from photographs, as "masculine" in a sporty, smirky way; there was little that was "feminine" about her, especially her disinclination to domestic life, her determination to get a good university education (at the University of Nebraska) and to be self-supporting as a journalist, editor, and, in time, fiction writer. Like George Eliot recoiling in horror from "silly" lady novelists, Cather was blunt in her denunciation of women writers:

I have not much faith in women in fiction. They have a sort of sex consciousness that is abominable. They are so limited to one string and they lie so about that. They are so few, the ones who really did anything worth while.

What of George Eliot, Jane Austen, Charlotte Brontë and Emily Brontë? In such self-protective pronouncements Cather wished to exclude herself from the sub-species female, and to ingratiate herself with a literary (male) readership. Her heroes were Virgil, Flaubert, and Henry James.

Willa Cather & the Politics of Criticism is a deft, concisely argued essay. Freed of the smothering weight of biographical detail, Acocella concentrates upon predominant themes in Cather's fiction ("All the while that Cather is describing life's terrors, she never stops asserting its beauties") and the serio-comic saga of Cather's critics. After the disparaging misogynist commentary by Cather's contemporaries, there followed a hardly less discouraging interlude in the 1950s and 1960s when she was canonized by a mostly right-wing community of "faithful friends and true believers" and written off by everyone else. In the 1970s and 1980s, Cather was triumphantly rediscovered by feminists avid to assemble a "female canon." The problem was, feminists didn't just require first-rate writers, as Acocella points out, "they needed them to be feminists." Later, a sub-category of feminists, lesbian theorists, would need their subjects to be lesbians, and their prose styles to reflect biologically based "instinctive" female processes. The unfortunate result, as Acocella sees it, was that Cather, who had thought to leave behind the subject of gender, was taken forcibly in hand and led back to it. Acocella speculates, like Hermione Lee in her 1989 biography *Willa Cather: Double Lives,* that Willa Cather was "homosexual in her feelings and celibate in her actions." In any case, Cather never wrote explicitly of lesbianism, as she never wrote of erotic love, and the only fairly clear homosexual portrait in her fiction, the (male) piano accompanist of heroic Sebastian Clement, of *Lucy Gayheart,* is a sinister, decadent figure responsible for Clement's death by drowning. Hardly encouraging for "queer theorists," one might think. Yet theorists were undaunted, for if Cather had been a lesbian, but never acknowledged lesbianism, she was therefore in "denial" of her lesbianism:

The feminists now had what they needed, the hidden conflict. Since it was homosexuality, it had to be very heavily defended. Hence the

surface of Cather's fiction could no longer be taken literally, it had to be read *through* . . . What before had seemed a surface of polished marble was now judged to be full of "gaps" and "fissures." Didn't Cather sometimes skip whole decades in her narrative? Didn't she sometimes interpolate long subtales into her main tale? What caused these strange disjunctures? What was hiding in these gaps? Clearly, it was either lesbianism or, more generally, some conflict about women . . . Cather studies exploded.

Where in actual life such avid prurience regarding the sexual, or asexual, behavior of strangers would be labeled deviance, and the perpetrators recommended to undertake psychotherapy, in literary studies it seems to have become a routine habit of "deconstruction." As an example, Acocello quotes the "queer theorist" Eve Kosofsky Sedgwick who, in an 1989 essay on *The Professor's House,* laboriously deconstructs the word "Berengaria," the name of an ocean liner, in the novel's concluding sentence. A "maelstrom of lesbian energies" is revealed beneath the novel's surface, suggesting Cather's rebellion against heterosexism. "[Sedgwick] apparently does not know," Acocella remarks, "that Berengaria was the name of a real ship."

Acocella concludes her witty little book with an appreciative analysis of Cather's crystalline prose, and an obligatory visit to "small, poor" Red Cloud, Nebraska, population 1,200 (it had been 2,500 in Cather's time). Ironically, yet perhaps unsurprisingly, the town's major industry in this dreary Midwestern setting has become Willa Cather.

OF THE literary genres, biography is perhaps the strangest. It is certainly the genre that contains the most replicated, recycled material. After the initial pioneering biography of a subject, subsequent biographies are obliged to repeat a very high percentage of the original biographer's historic facts and significant documents, with forays into "new" territory and interpretations to justify the new project. The same key photographs must be used, especially when the subject, like Willa Cather, lived at a time in which images were less plentiful and promiscuous than they are today. In some biographies the subject is viewed as in the crosshairs of a rifle scope; voyeurism and moralism conjoin in a seemingly respectful, even self-less undertaking of exposure. Like a disembodied eye the

omniscient biographer hovers about the unsuspecting subject, bringing to bear scrupulous moral standards (presumably practiced by the biographer) and the devastating power of hindsight to reveal the smallest hint of hypocrisy, venality, delusion. (If, for instance, one of Willa Cather's negatively portrayed Jewish characters arranges to avoid import duty on expensive purchases, the vigilant biographer will note that Cather herself was not beyond such maneuvers: "She, too, brought in alcohol in her luggage during Prohibition and on at least one occasion asked Blanche Knopf to have her New York grocer falsify the value of goods he was shipping to her in Canada in order to reduce the amount she would have to pay in Canadian taxes.") As Oscar Wilde wittily observed, biography lends to death a fresh horror.

Biographers, more than most writers, must contend with strategic problems of timing. The essential question a biographer should ask of herself is whether another biography of a subject is needed, and whether the "new" information and the "new" interpretations justify the inevitable repetition and recycling of predecessors' material. One could not guess from the earnestness with which *Willa Cather: The Writer and Her World* is presented by Janis P. Stout, a professor of English and administrator at Texas A & M University, that several solidly researched and thorough biographies of her subject already exist, among them the massive pioneering effort by James Woodress, *Willa Cather: A Literary Life* (1987); Sharon O'Brien's *Willa Cather: The Emerging Voice* (1987); and Hermione Lee's *Willa Cather: Double Lives* (1989). (An early, brief biography of Cather by E. K. Brown was published in 1953 by Cather's longtime publisher, Knopf.) Of these, Hermione Lee's is the most eloquently reasoned. Indeed, to set oneself the task of writing a new Cather biography in the wake of *Willa Cather: Double Lives* would seem to have been an act of audacity or naïveté, for Lee's Cather biography, like her magisterial 1996 *Virginia Woolf*, is one of those exemplary works that not only do justice to their subjects but enhance and expand the art of biography itself; as if, on this level of achievement, the essential biographies are metabiographies, meditations upon the genre.

By contrast, Janis P. Stout's *Willa Cather: The Writer and Her World*, is a wholly conventional biography. The structure is chronological as clockwork. Though Stout makes rather reckless claims for Cather's genius, she is cautious about entering the fray of impassioned feminist/les-

bian controversy: whether Cather had lesbian relations "in a physical sense can never be known." Though her admiration for Cather's work is unswerving, she brings to bear a timely, or trendy, consciousness on her subject, tracking Cather in the crosshairs of our politically correct sensibility. Was Cather an anti-Semite, as some have charged? No, not really. Though, to be sure, "Cather sometimes engaged in calumnies against Jews" and labeled a character in the 1916 story "The Diamond Mine" as a Greek Jew and a "vulture of the vulture race" with "the beak of one." But this isn't anti-Semitism exactly, rather more an expression of Cather's culture, in which such remarks were not uncommon, in some quarters at least. Was Cather a racist? Again, not really: "This is not to say that she was a racist, but that she participated in a racist culture." Yet here is Cather depicting a character in *My Ántonia* as having "a negro head . . . almost no head at all; nothing behind the ears but folds of neck under close-clipped wool" as he plays his "barbarous" piano. In *Sapphira and the Slave Girl* (1940), Cather refers casually to a black woman's "foolish, dreamy, nigger side," even as she maintains an authorial air of moral probity and virtue. Indeed, Cather would claim that she had known all the "colored people" in the novel and had been "very fond" of some of them.

On the first page of Stout's introduction the ominous drumbeat of a handy critical formula is sounded: Cather is a "deeply conflicted writer," and her work will be analyzed in terms of "conflict, evasion, and unresolved ambiguities." Cather isn't an old-fashioned nostalgist of the Plains but a "modernist"—that is, a "conservative modernist much like T. S. Eliot." Taking her cue from subtly reasoned passages in the work of Hermione Lee and Phyllis Rose, Stout gamely proceeds to discover in Cather's most stolid work elements of what she calls "conservative modernism"—and, of course, "conflict." It seems not to have occurred to Stout that all art, when not in the service of religion or the state, is generated out of "conflict." A Grecian urn may seem to express stasis and perfection, but all dramatic narratives turn upon imbalance, disharmony, "plot." Writers as diverse as Euripides, Ovid, Shakespeare, Laurence Sterne, Herman Melville, Emily Dickinson and Charles Dickens are arguably "modernists" but for accidents of history.

Willa Cather's most characteristic prose is comfortingly realistic, old-fashioned in its rhythms and assurances, and surely her ongoing value lies in the clarity and richness of this unambiguous, un-fractured vision:

It seemed as if the long blue-and-gold autumn in the Platte valley would never end that year. All through November women still went about the town of Haverford in the cloth tailored suits that were the wear in 1902 . . . The trees that hung over the cement sidewalks still held swarms of golden leaves; the great cottonwoods along the river gleamed white and silver against a blue sky that was just a little softer than in summer. The air itself had a special graciousness.

[*Lucy Gayheart*, 1935]

Compare with the celebrated opening paragraph of Hemingway's *A Farewell to Arms* (1929):

In the late summer of that year we lived in a house in a village that looked across the river and the plain to the mountains. In the bed of the river there were pebbles and boulders, dry and white in the sun, and the water was clear and swiftly moving and blue in the channels. Troops went by the house and down the road and the dust they raised powdered the leaves of the trees. The trunks too were dusty and the leaves fell early that year and we saw the troops marching along the road and the dust rising and leaves, stirred by the breeze, falling and the soldiers marching and afterward the road bare and white except for the leaves.

Surely the biographer does a disservice to her subject by persistently misreading her as a modernist (as if some particular virtue accrued to "modernism") when her writerly gifts so clearly belong to another era, far less steeped in the terse drama of irony. The novel Cather acknowledged she would most like to have written is Tolstoy's *War and Peace*, a very different work from Joyce's *Ulysses*.

As *Willa Cather: The Writer and Her World* proceeds through the decades, Stout sees Cather to be ever more "conflicted" and "ambivalent." Where Granville Hicks saw "supine romanticism" in *Sapphira and the Slave Girl*, Stout perceives a work that "seals Willa Cather's place not only within modernism but as an anticipator of postmodernism." Near the end of the biography, Stout has gone so far as to claim that the "inconclusiveness" of certain of Cather's weaker works of fiction isn't a sign of a waning of skill or imagination but proof that Cather is now writing "metafiction."

Metafiction! Willa Cather would have been scandalized and offended by the sort of playful/surreal experimental fiction that flourished in the 1960s and 1970s, work by Donald Barthelme, John Barth, Thomas Pynchon, and Robert Coover that repudiates "fine writing" and the creation of psychologically "real" characters whom Willa Cather cherished. To honor her great achievement it is advisable to see Cather as a poet of realism, one for whom realism was intrinsically bound up with a place, a time, a distinct way of being.

Merciless Highsmith

The Selected Stories of Patricia Highsmith

A Suspension of Mercy
Patricia Highsmith

> *The whole world wagged by means of attitudes,*
> *which might as well be called illusions.*
>
> **Patricia Highsmith,**
> **A Suspension of Mercy**

PATRICIA HIGHSMITH (1921–1995) IS THE author of twenty-two novels under her own name and one pseudonymous novel (*The Price of Salt,* under the name Clare Morgan) as well as five collections of short stories of varying degrees of ambition and quality. Always best known for her brilliantly conceived and flawlessly executed first novel, *Strangers on a Train* (1950), from which a popular Hitchcock film was made in 1951, Highsmith came to short fiction relatively late in her career with the publication of her first collection, *The Animal-Lover's Book of Beastly Murder* in 1975. A Texas-born expatriate who lived abroad for most of her adult life and died in Switzerland, Highsmith is a daunting figure in later photographs (by Jerry Bauer and Marian Ettlinger) like something crudely chiseled in stone; she stares past us or through us unapologetically plain, carelessly groomed and

truculent in expression, indifferent to our judgment. An unnerving amalgam of Edwin Gorey and Sade, with something of the gleeful heartless cruelty of Evelyn Waugh and Muriel Spark thrown in, Highsmith stands at the shadowy juncture between entertaining misanthropy and psychopathology.[1]

Highsmith's *Selected Stories* is prefaced by an undated foreword by Graham Greene, in which Greene describes Highsmith's fictional world as "claustrophobic and irrational," a place of "cruel pleasures" that lacks "moral endings." Greene, the supreme novelist-moralist of the twentieth century British novel, whose work constitutes a ceaseless meditation upon the moral life as an inviolable norm from which we stray at the risk of endangering our humanity, assesses rather than praises Highsmith for having created a fictional world very different, for instance, from the romantic-heroic world of her peers Raymond Chandler and Dashiell Hammett; in Chandler and Hammett, men of battered but stubborn integrity "triumph finally over evil and see that justice is done," while in Highsmith's world evil goes not only unpunished but, as the career of the dapper psychopath Tom Ripley demonstrates, rewarded. Greene speaks of Highsmith as the poet of "apprehension rather than fear," but seems to have missed her darkly playful side altogether.

The jocose macabre would seem to have been Highsmith's aim in her short fiction, not profundity, still less tragic moral drama. The titles of individual volumes—*The Animal-Lover's Book of Beastly Murders, Little Tales of Misogyny, Slowly, Slowly in the Wind, Mermaids on the Golf Course*—suggest a wicked drollery, not gravity. These sixty stories contain approximately 1.5 murders per story, most of these murders executed with surprising ease by murderers who go unpunished, and of course unrepentant. In *The Animal-Lover's Book of Beastly Murder*, written with manic exuberance and a remarkable attentiveness to detail that suggests the author's emotional identification with any species other than her own, a much-harassed circus elephant goes berserk, kills her cruel keeper and breaks free of her captivity, only to be shot down and killed ("Chorus Girl's Absolutely Final Performance"); a much-harassed camel kills his former cruel owner, but is rewarded by being claimed by a much kinder new owner, and the realization that "his anger, like a poison, was out of his blood" ("Djemal's Revenge"); The Baron, a seventeen-year-old dog whose beloved master has died and who is being mistreated by his present owner, rises against this tyrant and manages to

murder him by biting through the oxygen tube he is dependent upon when overcome by asthma attacks ("There I Was, Stuck with Bubsy"); a resourceful cat, threatened by his mistress's cruel lover, manages to murder him by causing him to fall down steep stairs ("Ming's Biggest Prey"); a truffle-hunting pig named Samson rises against his cruel owner and manages to murder him pig-fashion:

> The awful pink and damp nose of the pig was almost in Emile's face, and he recalled from childhood many pigs he had known, pigs who had seemed to him as gigantic as this Samson now crushing the breath out of him. Pigs, sows, piglets of all patterns and coloring seemed to combine and become this one monstrous Samson who most certainly—Emile now knew this—was going to kill him, just by standing on him . . . And Emile could not gasp one breath of air. Not even an animal any longer, Emile thought, this pig, but an awful, evil force in a most hideous form. Those tiny, stupid eyes in the grotesque flesh! Emile tried to call out and found that he couldn't make as much noise as a small bird.

In "Engine Horse" a mare named Fanny tramples to death a cruel master who has killed her kitten-friend; in "The Day of Reckoning," a somewhat comic chicken variant of Daphne du Maurier's "The Birds," abused chickens rise en masse against their cruel owner and peck him to death; in "Harry: A Ferret" and "Goat Ride," you can guess what Harry and Billy do to their enemies. "Hamsters vs. Websters" is no contest ("Julian's jugular vein had been pierced in two places, and he had lost a lot of blood by the time he arrived at the hospital. The doctors applied tourniquets and stitched. Transfusions were given. The process was slow. In came the blood and out it flowed. Julian died within an hour.") So repetitive, so predictable and so silly are these animal uprisings, each of them ending in mayhem for humans, one can only wonder what Highsmith intended in writing them, and what relationship the beast-stories have to her crime writing. Where drollery fails, an unmistakable ugliness emerges, as in "The Bravest Rat in Venice," in which a maimed rat takes revenge against tormentors by attacking their baby: "Cesare looked down at the shockingly red, blood-covered pillow of the baby. All the baby's nose—It was horrible! There *wasn't* any nose. And the cheek!"

Equally gleeful (and lethal) are *Little Tales of Misogyny,* which High-smith may have intended as satires of female types, savage in the way of Rabelais or Swift. These sadistic sketches, heavy-handed in sarcasm and virtually devoid of literary significance, make for painful reading: there is "Oona, the Jolly Cave Woman," a figure of revulsion because she is sexually attractive to men, and fertile; there is "The Coquette," killed in a single sentence "with various blows about the head"; "The Mobile Bed Object," a promiscuous young woman is summarily dispatched by a lover when he tires of her: "Mildred was bundled . . . into a mummy-like casting of stiff, heavy tarpaulin, and then ropes were tied around her. She was dumped into a canal and drowned." Contemptuous of amoral females, Highsmith is equally contemptuous of domestic females: one of the nastier tales is "The Breeder," a diatribe against maternal fecundity in a household of fourteen children in which "diaper-clad midgets played xylophones" and newborn triplets are made to swing in an "ingenious suspended playpen, there being absolutely no room on the floor for them." Other females incur contempt for being prudes, or feminists, or "perfect ladies"; for attempting to be artists ("Someone—it was later proven to have been an instructor—put a bomb under the School of the Arts") or religious mystics like "The Evangelist" ("Diana stood on the sill of her attic window, raised her arms to the setting sun, and stepped out convinced that she could fly or at least float . . . Thus poor Diana met her earthly end."). And there is "The Female Novelist," another contemptible individual who writes exclusively about her own, mostly sexual past, but fails to find a publisher for her manuscripts; her out-pourings, Highsmith equates with vomit. One is tempted to say that Highsmith's more mature short stories are improvements over these awkward efforts, except that by the time Highsmith published her first book of stories she was fifty-four years old and deep into her career.

Though Highsmith's crime novels are intended to be realistic, how-ever contrived their plots, most of the stories in this volume might be de-scribed as dark fantasy. In this genre, beasts with human characteristics and the power to punish human beings are not uncommon, and the bar-rier between the inner world of the imagination and the outer world is porous. Several of Highsmith's stronger stories are wholly in the dark fantasy vein, blessedly untouched by her penchant for satirical malice: these are sympathetic portrayals of grief that end in death, except in these instances the deaths are not punitive but sacrificial. In "The Pond,"

a young widow, mourning her husband, is irresistibly drawn to an omi-
nously dark, seething pond: "The brown and black mud swirled, stirring
long tentacles of vines, making the algae undulate . . . The vines were
even growing out onto the grass to a length of three feet or more." Even
after the widow's young son is killed by the pond, she continues to be
mesmerized by it; in time, she too succumbs to its dark lure, with unex-
pected relief: "*All things come from water.*" In a similar sympathetically
rendered dark fantasy of loss, "The Kite," an adolescent boy grieving for
his dead sister constructs a kite to carry him away into the "blue empti-
ness"; he's happy high above the earth until would-be rescuers in a heli-
copter interfere and he plunges to his death. Other darkly fantastic tales
are ambitious, but rather strained: in "Please Don't Shoot the Trees," an-
other variant upon du Maurier's "The Birds," well-to-do Los Angeles
suburbanites of an unspecified future (in which the car has been replaced
by the battery-operated helicopter, and children are semi-autistic from
too much TV) are attacked by trees "shooting inflammable sap . . .
Something like phosphorous or napalm." The fantasy logic here is that
Homo sapiens has endangered the environment, now the environment is
fighting back, but the conceit is mechanical and the writing merely func-
tional; we feel nothing for Highsmith's flat characters, and no surprise at
the ending. The most surpassingly beautiful, haunting story in this cau-
tionary vein remains Ray Bradbury's "There Will Come Soft Rains."

When Highsmith isn't too obviously venting her spleen at hapless tar-
gets, she can be mordantly funny. Monty Python might have enacted
"Old Folks at Home," in which, for no convincing reason, a middle-aged
couple suddenly decide to adopt an elderly couple, Mamie and Herbert,
nightmare senior citizens who gradually take over the household, watch-
ing TV continuously, losing their false teeth, wetting the bed. When the
middle-aged couple returns home one day to find the house on fire, they
rush inside to rescue their valuables, leaving Mamie and Herbert to die
in the blaze. This is a cheery resolution, in Highsmith's terms. Cheerful,
if not hebephrenic, is the mood of "Woodrow Wilson's Necktie," which
reads like an outtake from *Twilight Zone* or *Tales of the Crypt*: an ap-
prentice serial killer murders several employees of Madame Thibault's
Waxwork Horrors and trusses them up as exhibits, to be discovered, as
he looks on, by appalled customers. Clive drifts away, amused to a de-
gree. "That was good . . . That was all right. Not bad." In "The Stuff of
Madness," a husband objects to his wife's collection of "seventeen or

eighteen preserved cats and dogs and one rabbit, Petekin," deceased pets now positioned about the back yard; but the form his rebellion takes is to add to the necropolis a sentimental item of his own, the mannequin-likeness of a former lover with which—whom?—he can kiss and cuddle in the evening air. And there is the wicked curmudgeon of Coldstream Heights, Maine, who murders a disliked neighbor, and trusses up Old Frosby as a scarecrow in his cornfield ("Slowly, Slowly in the Wind"). A Highsmith signature but it isn't clear if, this time, it's meant to be funny.

As these summaries suggest, Highsmith seems to have had little patience, and perhaps little natural skill, for the short story. These are sketches, skits, anecdotes breezily told, with little at stake on the writer's part, or the reader's. The essence of a literary short story isn't that it's a "short" concatenation of sentences but that it's distilled, explosively condensed, like good poetry. An exacting patience is required simply in positioning the sentences of a short story, which ideally moves subtextually as well as on its surface, like a shadowy shape beneath the surface of water, glimpsed but not actually seen. In nearly all of Highsmith's stories there is no subtext, only surface; it's as if she conceived of the form as basically a gimmick, a firecracker set to explode in the reader's face in its final lines. Compare the horrific but subtly rendered short fiction of Highsmith's contemporary Paul Bowles[2] with her more garish efforts, to appreciate the difference between an energetic talent for the macabre and literary genius.

Nearing the end of her prolific career, Highsmith seems to have attempted more serious short stories in a realist vein. Her preoccupations with mortality, illusion and disillusion, and a stoic resignation to the limitations of an insular life are explored with a wryness of tone that suggests personal experience. In "The Cruelest Month," an unmarried, stylish but aging French teacher burdened with an elderly invalid father fantasizes a friendship with a British novelist to whom she sends admiring letters that are never answered; when she seeks out the novelist and registers the man's "profound exasperation with her," she recoils in humiliation and impulsively steps in front of a taxi; she is nearly killed, and she's disfigured; and yet: "Sometimes she felt almost glad that she had the scar, felt that it was a mark of honor, an announcement to the world that she had paid her dues." In the similarly elegiac "The Romantic," a young woman who has nursed an invalid mother for years is finally free to pursue romance after her mother's death, but discovers that she

prefers instead the safety of her fantasizing. And in "The Terrors of Basket-Weaving," a young housewife fears she has provoked a "schizoid atmosphere in her head" when she takes up a damaged woven basket and repairs it with what she believes to be an instinctive, inborn skill. Like a Doris Lessing character who suddenly realizes a primitive, atavistic self within, she begins to dissociate from her middle-class life, telling her unsympathetic husband: "I feel I'm not exactly myself—me—any longer. I feel lost in a way—*Identity*, I mean." Where in Highsmith's jocose-macabre fiction this atavistic self would shortly have wreaked havoc upon the woman's family and friends, in this more sober mode Highsmith allows her the dignity of revelation. She realizes that she's too timid to explore the self within, preferring the comforts of her bourgeois life:

> Three weeks after the burning of the basket, her crazy idea of being a "walking human race" or some such lingered . . . She would continue to pretend that her life counted for something, that she was part of the stream or evolution of the human race . . . For a week, she realized, she had grasped something, and then she had deliberately thrown it away . . . And in fact could she even put any more into words? No. So she had to stop thinking about it. Yes.

Highsmith is explicit in her epiphanies as if she were standing at a blackboard with a pointer.

SCATTERED THROUGHOUT the *Selected Stories* are sketchy tales of writers and would-be writers, most of whom come to grievous ends. The flawed hero of Highsmith's *A Suspension of Mercy*, originally published in 1965 and now reprinted, is a thriller-novelist and hack TV writer with the luckless name Bartleby who lives passionately in his banally sadistic imagination. Though Bartleby is hardly a flattering self-portrait, he shares his creator's fascination with the creation of a fictitious psychopath killer who gets away with murder repeatedly, as a consequence of brains and charm: where Highsmith has given us the five-book saga of the talented Mr. Ripley,[3] Bartleby is writing a TV series about an even more murderous character called The Whip who commits acts of violence with the aplomb of a comic book figure. Bartleby's wife, a painter

with a small private income, dismisses The Whip as silly and trite, as the reader is likely to do; she incurs Bartleby's wrath by failing to have faith in him. The weakness of *A Suspension of Mercy,* apart from its uninspired prose and the thinness of its characters, is Highsmith's ambivalence toward Bartleby. She seems unable to decide if the thriller-novelist is vapid and childish as he seems at the outset, or someone to be taken more seriously. Initially a kind of serio-comic Walter Mitty hoping to become a successful writer while living on his wife's income in a Suffolk village outside London, Bartleby quickly becomes nasty:

> . . . sometimes he plotted the murders, the robbery, the blackmail of people he and Alicia knew, though the people themselves knew nothing about it. Alex had died five times at least in Sydney's imagination. Alicia twenty times. She had died in a burning car, in a wrecked car, in the woods throttled by person or persons unknown, died falling down the stairs at home, drowned in her bath, died falling out the upstairs window while trying to rescue a bird in the eaves drain . . . But the best way, for him, was her dying by a blow in the house, and he removed her somewhere in the car, buried her somewhere . . .

Bartleby strikes Alicia once or twice, but doesn't have the courage to kill her; his murders are purely imaginary, at least until the end of the novel. Since *A Suspension of Mercy* is a suspense thriller, and not a mystery, the reader is allowed to know that when Alicia disappears, it's of her own volition; she hides in Brighton as a means of separating from her unloving husband, and out of a hope of casting suspicion upon him. In time, Bartleby begins almost to believe that he has killed his wife, carried her out of their house rolled up in a carpet and buried her in a forest. The novel takes on intermittent interest only when Highsmith delves into Bartleby's psychopathology, which may have engaged her as a variant of her own. Midway in the novel she begins to ascribe to him insights for which Bartleby doesn't seem suited:

> Crowds troubled him, a mass of people standing in a cinema lobby waiting to go inside troubled him emotionally. Their assemblage seemed to have some hostile intent, like the assemblage of men for

an army. Assembly did not seem to Sydney a condition normal people should desire. He was an ochlophobe.

Bartleby deconstructs the conventional beliefs of society as "attitudes," of no more consequence than pagan beliefs. Religion, morality, law and order and family unity: mere attitudes endorsed by society.

It made things so much clearer to call these things attitudes rather than convictions, truths, or faiths. The whole world wagged by means of attitudes, which might as well be called illusions.

But Bartleby's isolated existential notions are not linked to any coherent sensibility; he's a pallid re-run of Highsmith's more durable and far more interesting Tom Ripley, whose acts of improvised self-invention involve occasional murders. Ripley is a sociopath Jay Gatsby, a figure of American "innocence" abroad (in *The Talented Mr. Ripley,* he looks for a novel he thinks is titled *The Ambassador,* by Henry James, but fails to locate it) whose ambition for himself has a Jamesian grandeur:

He loved possessions, not masses of them, but a select few that he did not part with. They gave a man self-respect. Not ostentation but quality, and the love that cherished the quality. Possessions reminded him that he existed, and made him enjoy his existence. It was as simple as that. And wasn't that worth something? He existed.

How much more a twentieth-century American type is Tom Ripley than his predecessor Jay Gatsby, whose extravagant material acquisitions were made in thrall to a misguided romantic ideal; how much more credible an American expatriate Ripley strikes us, than the stoic Hemingway heroes of an earlier generation. But Ripley is also a kind of artist, who grows into his powers in his mid-twenties, as if discovering unguessed-at parts of himself, "talents" one might say for subterfuge, deception, and, in time, an appetite and a need for the violation of custom we call "crime." Ripley is in the grip of powerful fantasies:

His stories were good because he imagined them intensely, so intensely that he came to believe them . . . It was like a phonograph

playing in his head, a little drama taking place right in the living-room he was unable to stop . . . He could see and hear himself talking earnestly. And being believed.

In contrast, Bartleby of *A Suspension of Mercy* is finally not very interesting or credible, and the ease with which he gets away with murder gives the novel a fantastic, almost whimsical air, as if the plot were indeed Bartleby's own sadistic dream. In essence hardly more substantial than a short story, like many suspense thrillers that are primarily surface action with little depth, *A Suspension of Mercy* is one of Highsmith's lesser works.

Much-lauded for the "dryness" and "simplicity" of her prose, Highsmith is a less interesting stylist than her most notable successor in crime fiction, Ruth Rendell;[4] her language is basically reportage, and her narrative strategy is conventional, the telling of sometimes overly plotted stories from the most pragmatical authorial position. Where suspense is both the means and the end, distinctions of language are perhaps beside the point. Yet Highsmith's debut novel, *Strangers on a Train*, remains a classic of the genre, often dazzlingly written:

> There were moments when [Bruno] felt his whole being in some as yet inscrutable stage of metamorphosis. There was the deed he had done, which in his hours alone in the house, in his room, he felt sat upon his head like a crown, but a crown no one else could see. Very easily, and quickly, he could break down in tears. There was the time he had wanted a caviar sandwich for lunch, because he deserved the finest, big black caviar . . . He had eaten a quarter of the toasted bread, sipping a Scotch and water with it, then had almost fallen asleep staring at the triangle of toasted bread that finally had begun to lift at one corner. He had stared at it until it was no longer a sandwich . . . He had hit both his fists against the wall simultaneously, then seized the sandwich and broken its insolent triangular mouth and burnt it, piece by piece, in the empty fireplace, the caviar popping like little people, dying, each one a life.

The plot of *Strangers on a Train* is ingenious: two individuals, meeting by chance on a train, drink together, confide in one another how deeply unhappy they are with (1) an unloving, unfaithful wife who won't

grant a divorce to her architect-husband, who is in love with another woman; and (2) a tyrannical wealthy father who won't provide his alcoholic son with the money this son requires for his spendthrift life. It's the alcoholic son Bruno who suggests that he murder the architect Guy's wife, and Guy murder his father, in what would seem like a foolproof plan . . . Crime melodrama makes the implausible come to life in the way of bad dreams, which is why the genre adapts so compellingly to film, in which the very form mimics dreaming. *Strangers on a Train* is only a moderately engaging film by Alfred Hitchcock, however; a conventional thriller, it lacks the bravura of Anthony Minghella's film version of *The Talented Mr. Ripley*. And it lacks the subtlety of Highsmith's novel.

Where most Highsmith characters, in her later fiction, are made to behave like puppets, the duo young-man protagonists Guy and Hugo are distinct, fully credible personalities; there is nothing flat or perfunctory or even predictable about their relationship, which has the quality of being both accidental and inevitable, given a particular poignancy by way of its rigorously denied homoerotic intensity. (Highsmith's second novel, *The Price of Salt,* was rejected by her publisher because of its frank lesbian subject matter, even after the considerable success of her first novel; Highsmith consequently published it under a pseudonym.) A bold and inspired assimilation of Dostoyevsky set in vividly rendered American locales (Texas, Long Island), *Strangers on a Train* is an impassioned reimagining of Dostoyevskian themes of "doubleness," obsession, guilt, and resignation to one's fate. Though there are other novels of more than routine crime-thriller appeal among Highsmith's oeuvre,[5] this debut novel possesses a sensibility and a depth of perception which the author could not, or did not attempt to, match a second time.

Notes

1. According to biographical sources, Highsmith's childhood was a very unhappy one. Her mother allegedly drank turpentine in a futile attempt to abort her; her parents were divorced shortly after her birth; she hated both parents, and though she paid for her aging mother's nursing care, she refused to visit her. Highsmith lived in France and Switzerland in seclusion, and her final years were reclusive.

2. Bowles's most memorable short stories appeared in his first collection,

The Delicate Prey (1950), including "A Distant Episode," "Call at Corazón," "Allal," and the title story.

3. *The Talented Mr. Ripley* (1955), *Ripley Under Ground* (1970), *Ripley's Game* (1974), *The Boy Who Followed Ripley* (1980), *Ripley Under Water* (1992).

4. Ruth Rendell (born 1930) is the author of nearly fifty crime novels and story collections. Rendell is unusual in both the quality of her writing and its diversity. A detective series, police procedurals, "suspense thrillers," and, under the pseudonym Barbara Vine, novels that explore mystery in the psychologically realistic and richly detailed manner of mainstream literary fiction. Rendell's outstanding titles are *The Bridesmaid, Live Flesh, Harm Done, No Night Is Too Long, Heartstones, King Solomon's Carpet, Anna's Book, The Crocodile Bird, The House of Stairs,* and *Road Rage.*

5. Graham Greene spoke of *The Tremor of Forgery* (1969) as Highsmith's finest novel. Set in a feelingly rendered Tunisia, and dealing with themes of guilt, homoerotic attraction, and the crisis of identity of an idealistic young American writer on the margins of Arabic culture, this low-keyed suspense novel is in the vein of Highsmith's serious work, somber rather than yeasty with malice. Oddly titled, *The Tremor of Forgery* would seem to have been influenced by Paul Bowles, Albert Camus, and not least Greene himself, which adds to its appeal.

"Glutton for Punishment": Richard Yates

The Collected Stories of Richard Yates
Introduction by Richard Russo

THE PREDOMINANT IMAGE OF NINETEENTH-century American literature is Herman Melville's White Whale, Moby Dick, the emblem of nature's demonism and, for Melville, the "colorless all-color of atheism" from which we shrink in horror: the hunted creature turned hunter, who leads a motley crew of Americans to their deaths in the Atlantic Ocean. The predominant image of twentieth-century American literature has turned out to be a much more diminished emblem of American empire and yearning: the green light burning at the end of Gatsby's Long Island dock, in F. Scott Fitzgerald's romantic-elegiac *The Great Gatsby*. Where Moby Dick is an image of grandeur, of the mystery of nature and an elusive God, rendered in Homeric prose, Gatsby's green light is an image of pathos rendered in a conversational, subtly poetic style. Jay Gatsby, born Gatz, is an American parvenu who has fallen in love with a shallow young socialite whose carelessness and selfishness bring about his death. In Fitzgerald, there is no Homeric heroism; there is neither the solace nor the terror of nature, and anything approaching Ahab's (and Melville's) impassioned quarrel

with God is unknown. The nineteenth century presumably agonized over belief and agnosticism; the twentieth century seems to have given up metaphysics altogether.

Richard Yates (1926–1992) is the American writer most clearly descended from Fitzgerald. While Yates's prose fiction lacks Fitzgerald's grace and economy of expression, and his characters are far coarser and more limited in scope, his themes are purely Fitzgerald: the yearnings of middle-class Americans for an idealized romantic love and for the most naive sorts of "success"—adulation, fame, money. (Yates, like Fitzgerald, even spent time writing screenplays in Hollywood, none of which were made into films.) Yates is celebrated for the clarity with which he dramatizes the bleakness at the heart of human, or at least mid-century American dreams; his vision is pitiless and monochromatic, like a strident wallpaper design in a claustrophobic space. How many times, in how few distinctive ways, the reader comes to wonder, can Yates set up, expose, and demolish his foolish characters? It adds to the poignancy of Yates's fiction to learn, from Richard Russo's introduction to the *Collected Stories,* that a number of Yates's self-deceived characters, including the "counterfeit Fitzgerald" novelist/screenwriter Jack Field of "Saying Goodbye to Sally," are closely based upon Yates himself:

> [Jack] had tried for years to prevent anyone from knowing the full extent of his preoccupation with Fitzgerald, though a girl in New York had once uncovered it in a relentless series of teasing, bantering questions that left him with nothing to hide. ("Saying Goodbye to Sally")

Not Fitzgerald's prose but Fitzgerald's life is the preoccupation, unfortunately.

Like his idol, Yates struggled with alcoholism through his adult life, as well as with tuberculosis (diagnosed soon after his discharge from the U.S. Army in 1945) and manic-depression; he succumbed to emphysema at the age of sixty-six, after a lifetime of smoking four packs of cigarettes a day. Like Fitzgerald, though on a smaller scale, he enjoyed early success: the most admired of his books remain the first of his seven novels, *Revolutionary Road* (1961), and his first collection of stories, the strikingly titled *Eleven Kinds of Loneliness* (1964). And like Fitzgerald Yates seems to have evolved into a posthumous patron saint for (male,

alcoholic) losers as Sylvia Plath has become something of a patron saint for (female, depressive) losers. A dogged anatomist of failure, Yates might have enjoyed the irony of such a distinction.

This volume, including the entirety of *Eleven Kinds of Loneliness* and of *Liars in Love,* Yates's second story collection (1982), as well as nine stories not previously gathered into hardcover, might well have been titled *Twenty-Seven Kinds of Disillusion.* The stories are variants upon a single relentless theme, as if unconsciously written to formula. Yates's unreflective men and women, coming of age in the late years of the Depression and the 1940s, most of them city- or suburb-dwellers, are fated to fail at virtually everything they attempt, from marriage and parenthood to modest careers in business or the "creative arts." While Jack Field models himself naively upon Fitzgerald, young Bob Prentice of "Builders" models himself yet more naively upon Ernest Hemingway, though he has virtually nothing in common with Hemingway and is involved in a pathetic venture: ghost-writing the egregiously corny memoirs of a Manhattan taxi driver intent upon bestsellerdom. ("Builders" is anecdotal and rambling, and trails off instead of ending, as if, building upon autobiography, Yates couldn't discover a shape for his fiction.)

A typical Yates anti-hero, Walter Henderson of "A Glutton for Punishment" takes a perverse satisfaction in failing: the prevailing image of his life is "falling dead" ("For a little while when [he] was nine years old he thought falling dead was the very zenith of romance . . .") and when he's fired from his office job, he reacts with maddening resignation. Should the reader require amplification, Yates tells us that Walter's wife does her best

> to conceal her fear . . . that she was dealing with a chronic, compulsive failure, a strange little boy in love with the attitudes of collapse.

Perhaps "A Glutton for Punishment" was fueled by Yates's autobiographical urges, which might account for the emptiness at its core: what is missing here, as in numerous other stories in this volume, is a sense of Walter Henderson's significance apart from his failure.

The oddly titled "Fun With a Stranger" is a cartoon-like portrait of an unattractive grade school teacher named Miss Snell ("a big raw-boned woman with a man's face . . . [whose] clothes, if not her very pores, seemed

always to exude that dry essence of pencil shavings and chalk dust that is the smell of school") who believes she's being generous in her elaborately presented Christmas gifts to her students: dime-store erasers. (Another memoirist vignette?) A yet more painful portrait of a self-deceived woman is Helen of the aptly titled "Oh, Joseph, I'm So Tired," a divorced mother with artistic pretensions whose young son perceives her unsparingly:

> She wasn't a very good sculptor. She had been working at it for only three years, since breaking up her marriage to my father, and there was still something stiff and amateurish about her pieces . . . Her idea was that any number of rich people, all of them gracious and aristocratic, would soon discover her: they would want her sculpture to decorate their landscaped gardens, and they would want to make her their friend for life.

When, through a fluke, Helen has the opportunity to measure the head of President-elect Franklin Delano Roosevelt for a bust, she uses the occasion to inform Roosevelt smugly that she hadn't voted for him: "I'm a good Republican, and I voted for President Hoover." This silly, narcissistic woman, allegedly based upon Yates's own mother, who'd had pretensions of being a sculptor, recounts her meeting with Roosevelt with a shudder, for the man's physical disability is "ugly" to her (FDR was paralyzed from the waist down by polio) and his smile is "frightening": "His eyes don't change at all, but the corners of his mouth go up as if they're pulled by puppet strings . . . It makes you think: this could be a dangerous man. This could be an evil man." By the story's end, when Helen reveals herself as an anti-Semite ("All my life I've hated people who say 'Some of my best friends are Jews.' Because *none* of my friends are Jews, or ever will be") the reader has had more than enough of her and is likely to wonder why Yates has written about her: to evoke pitying laughter, or laughing pity? To invite commiseration with the narrator, for having endured such a childhood? (Helen, like other self-centered mothers in Yates's fiction, is also an alcoholic.) In the hands of a more skilled portraitist of comic self-delusion like John Cheever or Flannery O'Connor, "Oh, Joseph, I'm So Tired" might have been a powerful story emblematic of more than merely Helen, but in Yates's flat, affectless prose it's finally as tedious and unrewarding as Helen's monologues.

Yates's characters, divorcées like Helen, as well as World War II veterans, tuberculosis patients, would-be writers and their long-suffering wives, lack even the perverse energies of the "grotesques" of Sherwood Anderson's *Winesburg, Ohio,* which would seem to have been another of Yates's seminal influences. Prone to misunderstanding the motives of others as well as their own, they behave as if perpetually muddled and seriously lacking in common sense. Grace, a young secretary in "The Best of Everything," finds herself about to marry the "little *white worm*" who says "terlet" and "bastid" she'd disdained; the naive young Navy wife of "Evening on the Côte d'Azur" allows herself to be seduced by a suave Navy officer who cares so little for her he doesn't even tell her his real name; the garrulous Mr. Pollock of "The Comptroller and the Wild Wind" is puzzled that his wife has left him and shocked to overhear an office protegé speaking contemptuously of him, gets drunk and harasses a waitress before wandering off in a conclusion that applies, in essence, to virtually all of Yates's stories: "He walked four or five blocks before he realized, coming to a halt and looking around, that he had absolutely no idea where he was going." Less clear is why the reader should care for Pollock, when Yates himself so obviously despises him.

Where Fitzgerald's unmoored romantics have the swaggering glamor of figures in, say, the portraits of John Singer Sargent, Yates's men and women have the humdrum American anonymity of the mannequin-figures of Edward Hopper. The singular strength of Yates's prose fiction is his daring to explore areas of American middle- and lower-middle-class life that Fitzgerald would have shunned: his characters are UP reporters, small-town newspaper hacks, inept salesmen, public relations and advertising men, workers who share "cubicle-offices" in dreary high-rise buildings in a deglamorized Manhattan in which even the fabled Empire State Building turns out to be disappointing:

> You see it from a distance, maybe at sunset, and it's this majestic, beautiful thing. Then you get inside, you walk around a couple of lower floors, and it turns out to be one of the sleaziest office buildings in New York: there's nothing in there but small-time insurance agencies and costume-jewelry wholesalers. There isn't any *reason* for the tallest building in the world.

Yates knew the "timeless limbos" of tuberculosis wards in Veterans' Administration hospitals, and writes without sentiment of the moribund men warehoused there ("Out with the Old," "A Clinical Romance," "Thieves"), consumed by boredom: the only diversions are juvenile infractions of the rules, sudden hemorrhages, death. And there are the damp, smelly basement apartments of aspiring novelists with dripping showers that breed cockroaches (New York City) and worm-like creatures "sort of like a snail but without any shell" (low-rent Malibu) from which their daughters and lovers flee with cries of disgust. Even the child-protagonist of "A Private Possession," a gripping story, finds herself heartbroken and sobbing alone in a tool shed in which two half-gallon cans of paint arrest her attention with their very banality in the face of her grief: "Sherwin-Williams: White Lead. Sherwin-Williams: Forest Green." Eileen is a victim of adult myopia and stupidity but also of her own passivity in the face of mistreatment. She, too, a fourth grader, is preparing to be a "glutton for punishment"—one of Yates's kindred souls.

"Not a Nice Person": Muriel Spark

The Complete Short Stories
Muriel Spark

So IMMEDIATE WAS MURIEL SPARK'S AC-claim as one of the most original, imaginative, and audacious of mid-twentieth-century British novelists, with the publication of *The Comforters* (1957), *Memento Mori* (1958), and *The Prime of Miss Jean Brodie* (1961), the range and diversity of her subsequent work may go unremarked. Most renowned as a satiric novelist in the darkly comic mode of Evelyn Waugh, Spark has also written a considerable number of short stories as well as poetry, plays, essays, biographies (Mary Shelley, the Brontës, John Masefield), literary criticism and an autobiography, *Curriculum Vitae* (1992). To non-British readers, Muriel Spark as stylist, satirist, fantasist and Roman Catholic visionary is quintessentially British; yet, given the extraordinary heterogeneity of twentieth-century British fiction, the presence of such originals as Ivy Compton-Burnett, Henry Green, Iris Murdoch, Barbara Pym and Waugh, among others, to call Spark "quintessentially British" is clearly inadequate.

Spark, born in 1918 in Edinburgh, is the author of twenty-one novels, most recently last year's *Aiding and Abetting*. She is that awkward being: a contemporary who is also a classic. Her stories have been collected in their entirety several times, most recently in *Open to the Public: New & Collected Stories* (1997). There are also *The Stories of Muriel Spark*

(1985), and *Collected Stories: 1* (1968). These volumes, like the present *The Complete Short Stories,* invariably include the same core of twenty-one stories, arranged in differing orders. Instead of arranging the stories chronologically in the new volume, beginning with the earliest ("The Seraph and the Zambesi," 1951) and ending with the most recent ("Christmas Fugue," 2000), Spark has intercalated new stories with old in thematic clusters: stories set in Central African colonies and in Europe, for instance, are located together, as are a number of stories of the supernatural. One advantage of this unconventional arrangement is that Spark's more recent stories, which tend to be anecdotal and not so engaging as her earlier work, are strengthened by their juxtaposition with more substantial stories like "The Go-Go Bird," "The Portobello Road," and "The Fathers' Daughters," Spark's most subtle tale.

Where the 1968 *Collected Stories* contained twenty-one stories, beginning with the brilliantly imagined "The Portobello Road," Spark's most frequently anthologized story, and ending with the equally powerful African colonial story "The Go-Go Bird," the new *Collected* contains forty-one stories, beginning with "The Go-Go Bird" and ending with the mordant "The Hanging Judge" (1994). Over all, the arrangement is a practical one, though the inclusion of a number of breezily narrated prose pieces which originally appeared in such publications as *Harpers & Queen, The New Yorker, Country Life, Daily Telegraph,* and *Mail on Sunday* undermines the achievement of the more thoughtfully composed stories.

Though Spark has been celebrated as a satirist whose fictions have, from the first, extended or collapsed the distinction between "reality" and "dreams" (*Reality and Dreams* is in fact the title of a 1996 Spark novel set mostly in a London hospital), seemingly autobiographical elements in both her long and short fiction lend to the most disparate material a certain unity of tone and perspective. Predominant is the acerbic, unsentimental, rather malicious and frequently very funny Spark voice, which has not mellowed since *The Comforters* of 1957, in the person of the young Roman Catholic convert Caroline who judges a sister Catholic severely: "She sees that I am thin, angular, sharp, inquiring; she sees that I am grisly about the truth; she sees that I am well-dressed and good-looking. Perhaps she senses my weakness, my loathing of human flesh where the bulk outweighs the intelligence." This voice recurs through the short stories under different guises: a female consciousness acutely aware

of her surroundings and of the shortcomings of others, which often exasperate her into being rude, as in "Come Along, Marjorie," in which a young woman Roman Catholic convert introduces herself to sister pilgrims at a retreat as "Gloria Deplores-you": " 'It's a French name,' I said, inventing in my mind the spelling 'des Pleuresyeux' in case I should be pressed for it." Later, she concedes, in a rare weak moment, "Oh, the trifles, the people, that get on your nerves when you have a neurosis!" Where most writers take pains to present highly sensitive, idealized alter egos in their fiction, Muriel Spark is refreshingly unhypocritical in her irascibility and inability to suffer fools gladly, or otherwise.

Here is the impetuous "Needle" of "The Portobello Road," no less rebarbative for being a ghost: "I must say that I was myself a bit off-put by this news about [a friend's liaison with an African woman]. I was brought up in a university town to which came Indian, African, and Asian students in a variety of tints and hues. I was brought up to avoid them for reasons connected with local reputation and God's ordinances"; and, in a moment of candor, "Sometimes, in my impotence and need I secreted a venom which infected all my life for days on end and which spurted out indiscriminately on . . . anyone who crossed my path." In "The Snobs," an anecdotal prose piece of 1998, the indignant female narrator tells us, "Snobs are really amazing. They mainly err in failing to fool the very set of people they are hoping to be accepted by, and above all, to seem to belong to, to be taken for. They may live in a democratic society—it does nothing to help. Nothing." So fumingly self-righteous is this narrator, she reveals herself to the reader as hardly less snobbish than the objects of her contempt, a pathetic English couple who hope to be introduced to a non-existent Comtesse.

In a more substantial story, "Bang-Bang You're Dead," of 1961, a similarly impatient young woman narrator looks with similar contempt upon a married couple whose well-staffed domicile she visits frequently, in an unspecified African colony. Though Sybil dislikes the couple (the wife, Desirée, is often mistaken for Sybil) and is wracked with boredom in their company, she continues to be their house guest until an act of serendipitous violence frees her. Here, the complicity of the narrator in her seeming victimization is acknowledged, to a degree; revolting as Desirée and her exhibitionistically amorous husband are, Sybil is not blameless in her curious exploitation of others in which she "play-acts" with them initially, then confronts them with hurtful truths: "There is no

health, she thought, for me, outside of honesty." And, at the story's end, "Am I a woman, she thought calmly, or an intellectual monster?" Similar triangular relationships between an unattached woman narrator and a married couple recur in other stories, notably "The Fortune-Teller" and "The Twins"; in each, the woman narrator is made to feel uncomfortable by the couple, whose marriage is mysteriously riddled with "play-acting." One comes to wonder why Spark's disembodied female consciousness is forever taking up with people who disappoint her so intensely, but the answer is obvious:

> "What else can you do with people like that?" said Anne.
> "Put them in a story if you are me," I said. "And sell the story."
> "Can they sue?"
> "Let them sue," I said. "Let them go ahead, stand up, and say Yes, that was Us."

The strongest stories in the *Collected Stories* are those with African settings, predominantly "The Go-Go Bird," which ranks with *The Prime of Miss Jean Brodie* as Spark's most beautifully sustained work. The Sparkean tone of arch, self-conscious cleverness and malicious glee in others' foolishness has here been subordinated to a far more thoughtful, lyric, and finally elegiac evocation of a long-ago time and place. We are made to care about the orphaned Daphne du Toit as we are made to care about the "Edinburgh spinster" Miss Jean Brodie, through a selected accretion of images and impressionistic scenes: Daphne grows up in the British colony, never out of earshot of the "go-away bird" (the grey-crested lourie) with its unmistakable call of "go'way, go'way"; she leaves to spend time in England, and a disappointing time it is, though enlivened by a stormy, futile love affair with a novelist; finally, she returns to Africa, to her own foreshortened destiny. Like the despairing Lise of *The Driver's Seat* (1970), Daphne seems to succumb to a predestined fate, one awaiting her in the region of the go-away bird; but Daphne is more complex and sympathetic than the crudely drawn Lise. Unwisely venturing out into the African countryside after having been away too long, exhausted by the heat, Daphne succumbs to a moment's despair: "God help me. Life is unendurable." Perhaps she doesn't mean these words, but almost immediately she's shot by an old Dutch madman who has been tracking her since her childhood. It may be a gloss upon the

story to suggest that Spark's Roman Catholic theology operates subtextually here: despair is the unforgiveable sin.

In "The Curtain Blown by the Breeze," set also in Africa, a Mrs. Van der Merwe, whose husband has murdered a "twelve-year-old piccanin" (a native boy) for allegedly peeping in a bedroom window at her, is observed by very vigilant neighbors as perversely rejuvenated by her husband's absence from her life: she becomes "a tall lighthouse sending out kindly beams which some took for welcome instead of warnings against the rocks." In this story, the cool-eyed young woman narrator is initially mocking of Mrs. Van der Merwe, then comes rather to admire her. In "The Pawnbroker's Wife," set on the coast of the Cape of Good Hope in 1942, the young woman narrator is a witness to a family's collective delusion, which she doesn't dispel. And in "The Seraph and the Zambesi," an initially intriguing story set in 1946 near Victoria Falls veers off into unconvincing fantasy when a seraph appears at a Nativity masque, with comic results.

Unfortunately, Spark's supernatural tales tend to veer in the direction of whimsy. There are too many of these gathered in the volume to be discreetly overlooked. "The Portobello Road" is the shining exception, the most sustained of Spark's ghost stories and one of the two most accomplished British ghost stories of the twentieth century. (The other is Elizabeth Bowen's "The Demon Lover.") "The Portobello Road" is the narrative of the outspoken "Needle," murdered in a haystack for being unable to keep still, who returns to bedevil the man who has killed her. Like "The Go-Go Bird," its most effective scenes are set in Africa. Another compelling, if contrived ghost story is "The Girl I Left Behind," four deftly narrated pages that convey a mounting sense of unease. "The House of the Famous Poet" begins with great promise, in 1944 in bomb-threatened London, then collapses into disappointing fantasy, as if the author were frustrated with her own attempts to realize her evocative material: "The angels of the Resurrection will invoke the dead [poet] and the dead woman, but who will care to restore the fallen house of the famous poet if not myself? Who else will tell its story?" Yet more disappointing is "Harper and Wilton," a botched tale in which two caricatured "suffragettes" of the Edwardian era of whom the author tried to write in the 1950s appear, demanding to be fulfilled: "You cast the story away . . . We've been looking for you for some time. Now you've got to give us substance otherwise we'll haunt you." "Another Pair of Hands,"

"The Leaf-Sweeper," "The Pearly Shadow" and "The Executor" are similarly feeble fantasies presumably meant to amuse, like the recently written "The Young Man Who Discovered the Secret of Life," in which a garrulous ghost is told by his hauntee, "I can't think of any more mindless occupation than to be a ghost in that post-mortem way you have in coming and going. So very unnecessary. I could have you psychoanalyzed away." In "Miss Pinkerton's Apocalypse," dating back to 1955 and needlessly reprinted, silly people prattle on at length about (literal) flying saucers piloted by "tiny [men] half the size of my finger." Tales of the supernatural are most effective when they verge with the surreal, where the sighting of "supernatural" beings or images might be plausibly interpreted as psychological events, as in Henry James's classic "The Turn of the Screw." When presumably real ghosts populate fiction, at least Muriel Spark's sketchy efforts, the adjectives that most accurately apply are monosyllabic: cute, fey, twee, coy.

The last story in the collection, "The Hanging Judge," has the tone of a macabre parable in the vein of Roald Dahl or Patricia Highsmith: an elderly English judge who has sentenced numerous men to be hanged has a startling, spontaneous sexual reaction while delivering the sentence to a good-looking young male serial killer; following the judge's retirement, he moves into the hotel in which the serial killer had been staying at the time of his last murder, arranges to be seated at the killer's table in the dining room, and gazes at a woman at a nearby table who resembles the killer's final victim "—transfixed in a dreamy joy, as if he had seen a welcome ghost."

Of short story collections of recent years, Muriel Spark's is perhaps not so distinguished as those by William Trevor, Bernard Malamud, and Paul Bowles; apart from the several excellent stories included here, Spark's finest work is in the novella form. And Spark's idiosyncratic talent, scintillant rather than illuminating, fueled by a seemingly inexhaustible zest for satirizing very vulnerable targets, is perhaps over all a minor one. Still, *The Collected Short Stories* of Muriel Spark does justice to her reputation as one of the most original of twentieth-century British writers who, we might infer, has proclaimed through the irascible woman-writer narrator of *Loitering With Intent,* "I wasn't writing poetry and prose so that the reader would think me a nice person, but in order that my set of words should convey ideas of truth and wonder, as indeed they did to myself as I was composing them."

II.

Our
Contemporaries,
Ourselves

Irish
Elegy

The Hill Bachelors
William Trevor

Twentieth-century Irish literature has been a phenomenon. No more ambitious and original novels than James Joyce's *A Portrait of the Artist as a Young Man, Ulysses,* and *Finnegans Wake* have been written in any language, and it might be claimed that *Ulysses* is the greatest novel in the English language. In poetry, William Butler Yeats is surely the greatest poet of the century writing in English. In drama, John Millington Synge and Sean O'Casey are major world playwrights. (And there is Samuel Beckett, sui generis, writing in French but Irish-born and arguably, in the cadences of his unique voice, never other than "Irish.") Yet it would seem that the short story is the blessed Irish genre, on the evidence of the sheer number of brilliant Irish short story writers of the twentieth century: Joyce, Mary Lavin, Frank O'Connor, Sean O'Faolain, Elizabeth Bowen, Benedict Kiely, William Trevor, Edna O'Brien, Desmond Hogan, Colum McCann.

Among these, William Trevor (born 1928 in County Cork) has the unusual distinction of being as accomplished in longer forms of fiction as in shorter. Dauntingly prolific, Trevor has published twelve novels and two novellas, the play *Scenes from an Album,* a children's book, *Juliet's Story,* and the non-fiction *A Writer's Ireland,* in addition to eight collections of stories and, in 1992, his *Collected Stories.* Since this massive

Collected (eighty-five stories, 1,261 pages), Trevor has published the story collection *After Rain* and two well-received novels in what might be called a literary-suspense mode, *Felicia's Journey* and *Death in Summer*. His new story collection *The Hill Bachelors* consists of twelve stories in a distinctly elegiac, meditative mode, set mostly in Ireland; if the two recent novels are cinematic in pacing and tone, and earlier stories have been more vigorously imagined, these stories have the shimmering and elusive quality of watercolors executed by a master artist for whom understatement and ellipsis have become second nature.

To speak of William Trevor's prolificacy is not to suggest that the world of his literary imagination is thinly layered or lacking in a remarkable generosity of spirit. There may be no "typical" Trevor fiction in the sense that a Trevor fiction is predictable, but one is usually assured of entering a fully imagined, historic world in which "small gestures matter" (as an elderly Protestant minister observes in "Of the Cloth," from *The Hill Bachelors*), as one enters the consciousnesses of fully imagined individuals. There are prolific writers—Balzac, for example—whose numerous, oversized characters are less individuals than sociological types, lacking psychological subtlety; there are prolific writers—Henry James, for example—whose characters are so immersed in the shifting webs of interior consciousness, so under the spell of the flood of psychological impressions sweeping upon them, that we can't step back to "see" them, and we scarcely "know" them at all. By contrast, in Trevor's strongest work his characters are rendered with naturalistic precision that links them to a specific time and place, and makes of their individual stories something archetypal as a ballad. If a Trevor novel displays the taut dramatic unity of a short story, a Trevor story often displays the amplitude, by synecdoche, of a novel. What is notable about Trevor is the astonishing variety of characters for whom he feels, not merely a writerly interest, but a genuine human sympathy. How vividly portrayed the fat, sinister, fated Mr. Hildrich of *Felicia's Journey*, and the maddening girl Pettie, the impulsive babysnatcher of *Death in Summer*; how convincing the deftly drawn portraits of the seedy journalists of "Events at Drimaghleen," one of Trevor's most brilliantly realized stories, from the recent collection *Family Sins*.

In this story of rural Ireland in the mid-1980s, reminiscent of thematically related stories in *The Hill Bachelors,* the McDowds of Drimaghleen endure a family tragedy of scandal and mystery only to see it

crudely exploited by a British Sunday supplement. Reporters, one of them from Dublin, offer an irresistible fee to the impoverished Mc-Dowds and, under the guise of helping to clear up the mystery, vilify the McDowds' murdered daughter Maureen in print, and insult the entire community of Drimaghleen: "*The scene of the mystery is repeated all over rural Ireland. From Cork to Cavan, from Roscommon to Rosslare you will come across small, tucked-away farms like the Butlers' and the McDowds'* . . . *These simple farm folk of Europe's most western island form limited rural communities that all too often turn in upon themselves.*" The invasion of predatory urban strangers presages an invasion of "media"—and a new way of commerce—that is destined, in time, to transform all of Ireland. (The reader will think, how greatly the economy and culture of "Europe's most western island" has already changed since the time of this story, 1985.) The voice of conscience of "Events at Drimaghleen" is a priest who understands what is happening, if the dazed victims themselves do not:

> There was confusion now in Drimaghleen, in Kilmona and Mount-croe; and confusion, Father Sallins believed, was insidious. People had been separated from their instinct, and other newspaper articles would follow upon this one. More strangers would come. Father Sallins imagined a film being made about Maureen McDowd, and the mystery that had been created becoming a legend . . . For ever until they died her mother and her father would blame themselves for taking the money their poverty had been unable to turn away.

In such stories, as in Trevor's bizarre, operatic title story from *Beyond the Pale* (1981), there is a mystical connection between character and place, as if the soul of a people truly is formed by the soil from which they spring. If this is a Romantic concept, Trevor expands it to involve politics as well.

So too in this new collection, especially in the solemn title story and others set in rural, remote Ireland, individuals seem to have been created by the narrow worlds into which they were born, lacking the freedom of will, or the volition, to establish themselves elsewhere. The Protestant minister in "Of the Cloth" senses himself not only out of touch with Catholic Ireland, but with the rest of the world, which he hasn't attempted to explore; Ennismolach is "granite country and Grattan Fitz-

maurice had a look of that grey, unyielding stone . . . Thin, and tall, he belonged to this landscape, had come from it and had chosen to return to it. Celibacy he had chosen also." A story of belated political awakening, "The Mourning" begins and ends in Dunmanway Road in County Cork; its suspenseful middle section follows a twenty-three-year-old Irish laborer, Liam Pat Brogan, as he's drawn reluctantly into plotting with an Irish terrorist group (presumably the IRA) to bomb a target in London. The young Irishman has been recruited to finish a mission left uncompleted by another young recruit: "It hadn't worked the first time. A Sunday night then too, another boy, another bus. Liam Pat tried to remember that boy's name, but he couldn't. 'Poor bloody hero,' his father said."

In the most dreamlike story of the collection, "The Virgin's Gift," Trevor attempts, less successfully, to find a language appropriate to a religious mystic named Michael whose entire, credulous life has been determined by three visions of the Virgin Mary. At the age of eighteen, Michael is instructed by the Virgin to abruptly leave his father's farm and present himself at an abbey; at the age of thirty-five, he's instructed by the Virgin to abruptly quit his life as a monk and to "find solitude," living alone on "the highest crag" of a mountain; years later, the Virgin appears a final time, instructing him to return home: "She did not smile and yet was not severe in the serenity that seemed to spread around her." As in a fairy tale, the unquestioning Michael walks through the Irish countryside as a wandering beggar, arriving home after decades of absence: "They answered his knock and did not know him. They gave him bread and water, two decrepit people he would not have recognized had he met them somewhere else . . . Their clothes were rags. 'It is Michael,' suddenly she said." Though "The Virgin's Gift" appears to be without irony, it's difficult that Trevor means the reader to take Michael's visions as literally as he himself takes them; Michael is a simple-minded individual, sheerly instinctive, lacking in intelligence. Are his visions "real," or has this solitary man wasted his life? Or, from a perspective of detachment, are delusions and religious transfiguration identical? These are serious themes, unexplored here. In fairy tales, human beings are reduced to single gestures and attitudes, rather more resembling cartoons than literary creations, like Michael's aged, not-very-believable parents who appear immediately rejuvenated by his arrival, not struck by wonder, dread, and grief as most of us would be under such bizarre circum-

stances: "There was elation in their faces, joy such as Michael had never seen in faces anywhere else. The years fell back from them, their eyes were lit again with vigour in their happiness . . ." The story ends with a rhetorical flourish that seems imposed upon the experience of a religious mystic for whom language itself would probably have been lost through desuetude:

> Their land would not again be tolled; he was not there for that . . . No choirs sang, there was no sudden splendour, only limbs racked by toil in a smoky hovel, a hand that blindly searched the air. Yet angels surely held the cobweb of this mercy, the gift of a son given again.

It's a deadpan-pious version of that cruellest of parent-son tales, W. W. Jacobs's "The Monkey's Paw."

But Trevor has other moods, fortunately for the reader. "Death of a Professor" introduces a refreshing bit of satire in an academic community in which a Professor Ormston has been the victim of a joke: his premature obituary has been released to the media, and everyone seems to know about it except Ormston. Stunned by the revelation, he wonders, "Why should he be a victim now? He is not arrogant that he's aware of, or aloof among his students; he does not seek to put them in their place. Lacking the ambition of his colleagues, he is a scholar as scholars used to be, learned in an old-fashioned sense . . . He is not a fool, of course he would have sensed unpopularity." Or would he? "Death of a Professor" shifts from satire to a story of marital intimacy as we begin to sense the title's deeper significance, in terms of the professor's childless, "surviving" wife.

Another deftly written, unexpectedly plotted story is "Against the Odds," which introduces an unlikely confidence-woman, sixty-year-old Mrs. Kincaid, who has sought naive victims, male, often widowers, in such wonderfully named places as Cushendun, Ballygalley, Portstewart, Ardglass, Bangor, Kilkeel: "Mrs. Kincaid had breathed the air in all of them." Mrs. Kincaid and the widower Blakely have their romantic, seemingly accidental meeting against a background of a temporary Declaration of Peace in northern Ireland; the relationship would seem to be ending with a resumption of violence in Belfast—except possibly it isn't ending, for "belief in the fragile peace persisted, too precious after so

long to abandon." "The Telephone Game" is the collection's most dramatic story, taking place on the eve of a wedding between the Englishman Tony and his German fiancée Liese who discovers, belatedly, a truth about Tony that should have sent her fleeing from him; except, "They had embraced, the warmth of their relief sensual as they clung to one another. And the shadow of truth that had come was lost in the euphoria." It's an epiphany worthy of the golden coins of James Joyce's *Dubliners,* carelessly opened in the palm of a hand: a revelation that will bring with it no wisdom, no application to life. *And how like life!*—the reader is inclined to say.

It has been said that all of modern Russian literature has come out of the pocket of Gogol's comic-grotesque masterpiece *The Overcoat* (1842); so too it might be said that much, though by no means all, of modern Irish short fiction has come out of the twilit echoing streets and exquisitely rendered boarding houses of Joyce's *Dubliners.* The Joycean short story is immediately recognizable as a sub-genre in which the directness of prose and the suggestive ellipses of poetry are blended; Joyce spoke of his style as one of "scrupulous meanness," and his subject the "paralysis" of his birthplace Dublin, yet the surpassing beauty of Joyce's language transmogrifies all that is merely mean or paralytic, rendering an art out of the most ordinary, seemingly vulgar of settings. In his gathering of linked stories, Joyce explored, experimented and brought to perfection a vision conjoining precise naturalistic detail with symbolic, even fabulous design; Joyce too wrote of urban "types," viewed through the sharp prismatic lens of his prose; defensively, or arrogantly, Joyce declared that as a writer he scorned action, and so the stories of *Dubliners,* like the myriad imbricated stories of *Ulysses,* are rather more anecdotal than plotted, evocative, nostalgic, atmospheric and often mysterious in resolution, trailing off instead of, to use the dread contemporary cliché, achieving "closure." Irish writers of generations succeeding the Joycean whirlwind could no more escape being influenced by Joyce than they might escape breathing the very air of Ireland, and in *The Hill Bachelors* William Trevor has written his most *Dubliners*-influenced stories.

For the most part, the influence is a positive one, though the focus upon "symbolic" details (meals, interiors of rooms) to the exclusion of dramatic exchanges and the understated trailing-away characteristic of the quintessential Joyce story can become frustrating at times, when we would wish for more vigor in Trevor's work, as he has displayed in previ-

ous stories. A wisp of a tale, "Low Sunday, 1950," is all atmosphere, indirection, and meal preparation; the more engaging "A Friend in the Trade" prepares us for a scene, or even a significant non-scene, between a wonderfully eccentric antiquarian book dealer and the married woman whom he allegedly loves, but after many pages setting the scene, Trevor simply skips it and ends with a tidy summing-up: "She does not know why the pity she feels is so intensely there, only that it is and that his empty love is not absurd." "Three People" is a more poetically wrought tale of Irish repression: a triangle of a kind, it's revealed, between an elderly father, a spinster virgin named Vera who apparently killed her invalided sister when they were girls, and the celibate handyman Sidney who perjured himself for the murderess, saving her from trial and public exposure. Without the elderly father's presence, "there would be no reason to play those parts; no reason to lose themselves in deception. The darkness of their secrets lit, the love that came for both of them through their pitying of each other: all that might fill the empty upstairs room, and every corner of the house." This so labored a resolution, interior to Vera, would surely have been more compellingly rendered in a dramatic form, like the disappointingly muffled conclusion of a tale of abrupt sexual mating, "*Le Visiteur*," which seems less understated in the classic Joycean mode than simply under-imagined and under-written: "In the cold bright moonlight [Guy] felt his solitude a comfort." But the reader neither knows nor cares enough of Guy to know or care for his comfort.

The strongest story in the collection is "The Hill Bachelors," which might well have been developed as a novella, or at least a longer story, to give ballast to this rather gossamer collection. Like "The Virgin's Gift," the title story brings a son, twenty-nine years old, back to his widowed mother's farmhouse in a remote part of Ireland known as the "bogs." It's observed that on the slopes of Coumpeebra, on Slievenacoush, on Knockrea, on Lurie, on Clydagh the farmer-bachelors find it increasingly difficult to attract wives to "the modest farms they've inherited." Where young Irishwomen would once have had little choice but to marry, and lead lives of soul-numbing hardship, now no one, even aging virgins, will consent; far rather would they work pumping gas or in fertilizer factories. Yet, to please his widowed mother and to accept his dread heritage, Paulie acquiesces, though he had not loved his father and will come to hate his life. How stark a contrast, Trevor's vision in this story with that

of the American novelist Douglas Unger, whose young male protagonist in the memorable, much-underrated *Leaving the Land* (1984), returned to his grandfather's desolate North Dakota farm in the 1970s, looks up from the back-breaking labor in which he's engaged to see an enormous tractor "the size of a house" moving on what had been a neighbor's land, since sold to a 40,000-acre corporate farm operated by a half-dozen employees:

> They seeded it in the fall . . . Maybe sent a tractor out like that one, once in a summer, to sweep the weeds off fallow land. Then just waited. That was all. Waited for the combine crews to harvest all the grain, working their way north all the way from Texas. Doing it that way, it was possible to take this one state and raise enough grain to feed the entire subcontinent of India with a bare minimum of human toil. And, like my father, I believed it was right that way. [The corporate] wheat farms were so much more efficient than what I was doing. The point was food, quantities of food . . . What matter if a whole style of life was gone? What matter if the earth no longer served a single family, a small parcel of immortality for the common man? . . . There was little beauty in it, in my mind. There was only sweat, and maybe a certain sense of unspeakable smallness in my soul in that of all the generations behind me, of all the lost tribes of my forefathers who had dug potatoes, milked cows, sown grain, picked fruit from primeval gardens, it had all come down to me in a knowledge I only wished to lose.

Spoken like a true American!—one thinks.

For the "hill bachelor"–Irish of William Trevor's valedictory collection, it's this knowledge of their forefathers they can't relinquish; they are of another era, another vision, another soil. Trevor resists a simplistic judgment: is Paulie heroic, a fool, or, simply, an obedient son? If he represents the Irish past, it's not very likely that he represents the Irish future, since bachelors leave no progeny. The vision is stark as an ancient ballad, and as unconsoling: "Enduring, unchanging, the hills had waited for him, claiming one of their own."

"Our Cheapened Dreams": E. L. Doctorow

City of God: A Novel
E. L. Doctorow

*Images are not arguments, rarely lead even to
proof, but the mind craves them . . .*
 Henry Adams, "A Law of Acceleration"

There is no fiction or non-fiction.
There is only narrative.
 E. L. Doctorow, "False Documents"

HENRY ADAMS IN "A LAW OF ACCELERA-
tion" nearly one hundred years ago eloquently brooded upon the in-
creasing split between the mind of science and the mind of the
historian-humanist. In this prescient essay, to become the penultimate
chapter of *The Education of Henry Adams* (privately printed 1907, pub-
lished 1918), Adams speaks without the defensive shield of his custom-
ary irony; there's an urgency to his prose, a sense of foreboding and an
air even of prophecy, as he contemplates the romantic concept of the
nineteenth century's "law of progress" (to Adams a "chasing of force
into hiding-places where nature herself had never known it") in terms of

the alarming acceleration in the increase of a certain kind of knowledge he has witnessed in his lifetime. Adam's conviction is that the civilization he has known is being transformed in ways that he and the (non-scientifically educated) class for whom he presumes to speak can't comprehend. As science doubles, or quadruples, its complexities every ten years, says Adams, even the astute student of history will soon be left behind. Scientific minds are in the process of reducing the universe to a series of mere relations:

> They had reduced themselves to Motion in a universe of Motions, with an acceleration . . . of vertiginous violence. With the correctness of . . . science, history had no right to meddle, since their science now lay in a plane where scarcely one or two hundred minds in the world could follow its mathematical processes . . . If any analogy whatever existed between the human mind, on one side, and the laws of motion, on the other, the mind had already entered a field of attraction so violent that it must immediately pass beyond, into new equilibrium, like the Comet of Newton, or suffer dissipation altogether, like meteoroids in the earth's atmosphere.

"A Law of Acceleration" is a feat of remarkable intellectual abstraction and bravura; it resonates with us at the start of the twenty-first century as the work of few other of Adams's contemporaries (excepting always William James) does. Where we have become accustomed, or resigned, to the abyss separating the knowledge of "hard" (mathematically based) science from the "soft" sciences and the humanities, Henry Adams despaired as one for whom the abyss, and the separation, were immediate, real, vital. If Adams had been able to peer into the twentieth century beyond his lifetime (he would die in 1918) into the chaos of human suffering initiated by scientific "progress," he would have recoiled in horror, yet without having been essentially surprised.

E. L. Doctorow's ebullient and knottily structured *City of God* would seem more temperamentally akin to Henry Adams's engaged agnosticism than to the Christian certainties of Augustine, whose fifth-century *City of God* defines history as the intersection between divine purpose and humankind, but whose presumption is that a narrowly defined Christianity controlled by Church doctrine is the one true philosophy. ("But *City of God*, that's a good title. I like the image, don't you?" Doc-

torow's writer-persona says.) Doctorow's contemporary city is New York City, at least the external, cinematically vivid city of the streets; this is a setting, we understand from previous works of his fiction, notably *The Waterworks* (1994), *Billy Bathgate* (1989), *World's Fair* (1985), and parts of dazzling *Ragtime* (1974), that has exerted a powerful spell upon the novelist, presenting itself as a dynamic riddle, a phenomenon of the "unnatural" world.

Doctorow's *City of God* unfolds as an urban cacophony/symphony of voices that take up, in their differing ways, those questions that so impassioned Henry Adams, locating them in the time of metaphysical anxiety our recent fin de siècle represented in some quarters. (The novel is set in autumn 1999; it's atypical of Doctorow to have been composing a work of fiction set, not in the past, but in what would have been for the author a future time.) Not so plangently as Adams but with a similar urgency, Doctorow's New Yorkers speculate, query, reminisce, expound, lament, grieve, excoriate, prophesy, and sermonize. They rant, they chant; they break out startlingly in free verse, memoralizing the Bronx ("in the early part of the century / when the streets were wide and new and the trees were / young in the parks"); they improvise extended riffs upon the "standards"—American popular song classics—in the guise of the aptly named Midrash Jazz Quartet. One of our American ventriloquist-virtuosos, Doctorow throws his voice into seemingly random New Yorkers, the first of whom, unidentified, broods upon the latest discoveries and theories of cosmology: what does it mean, this individual demands to know, that the universe has "expanded exponentially from a point, a singular space/time point, a moment/thing, some original particulate event . . ." What does it mean that "the universe did not blast into being through space but that space, itself a property of the universe, is what blasted out along with everything in it?" Above all, what can it mean that

> . . . the expanding [universe] expands futilely into itself, an infinitely convoluting dark matter of ghastly insensate endlessness, with no properties, no volume, no transformative elemental energies of light or force or pulsing quanta, all these being inventions of our own consciousness, lacking volume and physical quality in itself, a project as finally mindless, cold, and inhuman as the universe of our illusion.

We leap then to the heart of the paradox, for one who wishes to believe in God:

> In fact if God is involved in this matter, these elemental facts, these apparent concepts, He is so fearsome as to be beyond any human entreaty for our solace, or comfort, or the redemption that would come of our being brought into His secret.

One has to wonder, this interlocutor says, whether scientists possess the "moral gravity" to comprehend such knowledge; why, for instance, cosmologists and astronomers are given to "cute" names for their universe. We have the initial Big Bang, we may one day have the ultimate Big Crunch. If the universe continues to expand, there will come the Big Chill. The "inexplicable dark matter of the universe"?—WIMPS. The dark-mattered halos around the galaxies?—MACHOS. Through his disapproving narrator, Doctorow suggests that the scientific personality isn't just childlike in curiosity but childish: these people are "jerks."

(Since *City of God* is that rarity in American fiction, a novel of ideas, it might have been fruitful if one of these "jerks" had been allotted a voice. For it may be that cosmologists, astronomers, and astrophysicists speak in such metaphors so that laymen can understand, or almost understand, what they are saying, in grossly simplified terms. The sciences of the universe are disciplines whose primary language is mathematics, not conventional speech, and it's inaccessible to even the reasonably educated non-mathematician. If the metaphors have a childish, callow ring it may be out of a communal bemusement, or resentment, that metaphors must be used at all in the effort to communicate, or "popularize." When Albert Einstein, at the age of seventy-three, speaks in *City of God,* he is presented as a grandfatherly mensch quick to dispel notions of being a genius: he is the purveyor of a few "simple" physical laws, and nothing he has discovered is revolutionary "because I am seeing only what has always been as it is now and . . . will always be." Yet this too is misleading. Whatever Einstein's calculated public persona, the man of science was other, charged with revolutionary genius; his mode of expression was mathematics, not ordinary language, and it's quite possible that when genius addresses us in ordinary language, we are not in the presence of "genius" but of an ordinary person not much more qualified to speak of his or her achievements than anyone else. That Einstein can

be said to have believed in God—"the Old One"—is not very meaning-
ful when one understands that this metaphor is simply a way of speaking
of the principle of physical laws of the universe, which Einstein believed
was singular and immutable.)[1]

City of God is on firmer ground once we are introduced to its quest-
ing hero, the Reverend Thomas Pemberton, rector of St. Timothy's Epis-
copal Church in the East Village. Tom Pemberton, "Pem," is talky,
articulate, embattled; when we first meet him, he's stricken with a crisis
of faith, having difficulty believing his own "bullshit" (as he calls the
Episcopal theology he's supposed to spout to suffering members of his
congregation); he's painfully aware of the disparity between the cosmos
of the scientists and the fairy tale cosmos concoted by Christian theolo-
gians; and obsessed with the question, "Must faith be blind?" In a novel
whose plot will wed the seemingly unweddable, a middle-aged Episcopal
minister and a progressive young rabbi-widow, in a union reminiscent of
the movie-style wedding at the end of *Ragtime,* the most crucial ques-
tion Pemberton asks has gotten him into serious trouble with Episcopal
authorities:

> I merely asked the congregation what they thought the engineered
> slaughter of the Jews in Europe had done to Christianity. To our
> story of Christ Jesus. I mean, given the meager response of our guys,
> is the Holocaust a problem only for Jewish theologians?

I merely asked! This is Doctorow's abiding theme, memorably explored
in his early, brilliant *The Book of Daniel* (1971), in which cold war per-
secution and execution of alleged "atomic spies" becomes a metaphor
indicting historic Christian-American distrust of all that seems subver-
sive ("Jewish"). So too in *City of God,* Doctorow's Einstein recalls his
Munich boyhood among anti-Semites, noting "the pious brainwork of
Christian priests and kings that had demonized and radicalized the Jew-
ish people in Europe" and hypothesizing the inevitable implosion of
such beliefs into the Holocaust—"the accelerating disaster of human
history."

City of God is Doctorow's most disjointed, variegated, playful novel,
its episodes held together, to a degree, by an expeditious plot. It's part
mystery (unsolved), part situation-comedy: an eight-foot brass cross is
stolen from St. Timothy's Episcopal Church in lower Manhattan and left

on the roof of the Synagogue for Evolutionary Judaism on the Upper West Side with the terse anonymous phone message for the young married rabbis, "Your roof is burning." Is this message a "Jewish thing to say" as Rabbi Joshua speculates, or is it the work of a "raging anti-Semite"? Symbolically, the bulky, corroded Christian cross delivered to the progressive synagogue points toward Pemberton's revelation that God is "Something Evolving, as civilization has evolved" and—heresy of heresies!—"Judaism is Christianity without Christ." In plot-terms, this encounter of Episcopal minister and rabbis, of burnt-out Christians and energetic young Jews, sets into motion a lively narrative that involves numerous New York voices as well as those of Einstein and Ludwig Wittgenstein, and moves finally to a romantic ending in the union of Pemberton and Rabbi Joshua's widow, Sarah. As the omniscient narrator concludes, in the novel's final paragraph, "At this point we are introduced to the hero and heroine of the movie, a vitally religious couple who run a small progressive synagogue on the upper West Side."

LIKE JOHN Updike's *Toward the End of Time* (1997), a similarly millennium-minded fabulist work of fiction by a novelist of the American generation born in the early Depression (Doctorow was born in 1931, Updike in 1932), *City of God* is an inventive and sometimes confusing admixture of moral earnestness and postmodernist irony; conventional storytelling and characterizations, and sudden self-referential implosions of implausibility; agnosticism, cynicism, and traditional piety; the disarming contours of old-fashioned realism and the fantastic leaps and riffs of metafiction. Updike's novel is set in the near future, after a world catastrophe, a time not very different from the present; it exudes more the air of parable-fantasy than of admonitory science fiction. Doctorow's novel, though ostensibly future-minded, is emotionally rooted in the tragic European past of the Holocaust. (The most moving passages in *City of God* are recollections of Sarah Blumenthal's father of his boyhood as a Jew in Nazi Germany; it's eventually revealed that the narrator of *City of God,* an otherwise unidentified New York writer named Everett, "relied heavily" upon the Abraham Tory diary of the Kovno ghetto for the material.) The sixty-six-year-old retired protagonist of *Toward the End of Time* finds himself caught up in "counter-worlds" (by the grace of the principle of indeterminacy of quantum

theory), like a hapless Woody Allen figure spun about in a lunatic film; Doctorow's writer-protagonist morphs into a fictional Wittgenstein pondering upon the "multitudinous selves who are mere phantom presumptions of language [that] nevertheless contain all the experience of the world." Is this clear? Is it confusing? Purposefully, or not so purposefully? The uses of paradox in fiction are perhaps limited. Doctorow/Everett/Wittgenstein acknowledges the most appropriate image for this predicament: "the mirrors of a giant fun house from which there is no exit." Yet for both Doctorow and Updike there is an exit of sorts, or at the very least a way of bringing their metafictions to seemingly tender, domestic-scale conclusions: Updike's beleaguered couple of 2020 takes solace in their grandchildren and in the lyric turn of the seasons, Doctorow's ecumenical couple will devote themselves to a Judaic expression of the anthropic principle—"Whatever the universe is composed of seems to have made us possible."

Or is this a very minimal comfort, layered in irony?

VIRTUALLY ALL of Doctorow's novels utilize cinematic techniques and jazzlike improvisations and riffs, and *City of God* is no exception. Throughout, we are entertained by the Midrash Jazz Quartet's renditions of such old standards[2] as "Dancing in the Dark," "Good Night, Sweetheart," "The Song Is You." We are confronted with wildly inventive lunatic riffs:

We are instructed that whatever condition God provides, some sort of creature will invent itself to live in it. There is no fixed morphology for living things. No necessary condition for life. Thousands of unknown plant and animal beings are living in the deepest canyons of the black, cold water and they have their own movies . . . There is one fish, the hatchet, which skulks about in the deep darkness with protuberant eyes . . . and the ability to electrically light its anus to blind predators sneaking up behind it. The electric anus, however, is not an innate feature. It comes from a colony of luminescent bacteria that house themselves symbiotically in the fish's asshole. And there is a Purpose in this as well which we haven't yet ascertained. But if you believe in God's divine judgment and you countenance reincarnation, then it may be reasonably assumed that a certain bac-

terium living in the anus of a particularly ancient hatchet-fish . . . is the recycled and fully sentient soul of Adolf Hitler glimmering miserably through the cloacal muck in which he is periodically bathed and nourished.

A prevailing image of *City of God* is that it's a film on an enormous reel with frequent interruptions, flashbacks and flash-forwards, quick cuts, dissolves. Early on in *City of God* the mysterious Everett allows the reader to know that his character Tom Pemberton (surely a relative of the questing Martin Pemberton of *The Waterworks*) is based upon an actual man with whom Everett has lunch at the Knickerbocker Restaurant, but whom he has disguised; before beginning his novel, he'd drifted about Manhattan selecting locations, "like the art director of a movie," choosing to place St. Timothy's in the East Village off Second Avenue, and changing the name of the church. Metafictional mirrors reflecting mirrors! We're led to believe that somewhere beyond the tissue of words of *City of God* there is a palpable reality, for the purposes of fiction disguised.

"Do you turn the truths of your faith . . . into a kind of edifying poetry?" is a core question of *City of God*, and the implied answer might be, *Why not?* An aesthetic vision is simultaneously a moral vision. The development of civilizations, Doctorow suggests in "False Documents," a statement of the writer's first principles collected in *Jack London, Hemingway, and the Constitution: Selected Essays 1977–1992* (1993), is essentially a "progression of metaphors." Fiction and non-fiction are false categories: only narrative prevails, gripping the collective imagination. The modestly visionary ending of *City of God* with its marriage of Jew and Christian-converted-to-Jew recalls the hopeful end of Doctorow's preface to his essay collection: after the "social and cultural pathology" of the prior fifty years of cold war there is at last a sense that the era is over "and another, still to be defined, has begun."

Admirers of those exuberant Doctorow novels *Billy Bathgate, Loon Lake, Ragtime,* will miss the more energetic narrative voices, and the Dickensian portraits of larger-than-life mythic Americans that gave these novels their special resonance. But by degrees, out of the discontinuities of *City of God*, a richly ambivalent choral voice emerges and prevails. The City is not one we would have chosen, Doctorow suggests, but it has been given to us, it is ours.

Notes

1. For a radically different portrait of Einstein, see Alan Lightman's prose-poem novella *Einstein's Dreams* (1993). This enthralling little book, stylistically derived from Italo Calvino's *Invisible Cities,* obliquely represents the mind of Einstein as preoccupied with imaginative problems and paradoxes.

2. See Doctorow's essay on American popular music, "Standards," in *Jack London, Hemingway, and the Constitution.* These are to Doctorow the texts "of our cheapened dreams, our culture of popular song, the *standards,* as we call them, that sing in our heads generation after generation as a sort of un-text of the collective unconscious."

"Despair of Living": Anita Brookner

Undue Influence
Anita Brookner

ANITA BROOKNER IS THE VUILLARD OF despair. Our pleasure in her gracefully rendered romances of unrequited love and loss is almost thoroughly aesthetic. In her polished, monochromatic prose there may be discovered a bleakness not to be comforted by moral platitudes or even the "consolation of art"—of which Brookner, an art historian, has written skeptically—as unyielding as that of Beckett or Kafka; but Brookner is so resolutely British a writer, which is to say so resistant to Modernist strategies of matching vision to form and language, that her novellas are uniformly conventional, even predictable; rather more personal essays than prose fiction, in emulation of Benjamin Constant's *Adolphe* and the more obsessively analytic passages of Henry James and Proust. In Brookner's twilit, oppressive interiors and blurred avenues there is virtually no attempt to "dramatize"—to evoke in the reader an emotional response equivalent to what characters are said to be feeling; the most crucial events are assiduously summarized, at a distance, as if in a chamber in which there are haunting echoes, but no original, compelling sounds. "Not to let [one's skepticism] show is a

desideratum of civilized behavior," thinks the heroine of Brookner's new novel—but at what cost to spontaneity, vigor, life!

In *Undue Influence,* as in the preceding eighteen kindred novellas, a solitary individual of exceptional self-awareness and self-absorption approaches, but does not quite cross the threshold into what Henry James might have called, with a similar fascinated detachment, "life." For Brookner, as for James, Proust and Constant, the romance of embittered or doomed love is the imagination's subject exclusively. Thinks an abandoned wife, the desperately lonely Blanche Vernon of *The Misalliance* (U.S. 1986), "Love was the passing favor dispensed by the old, cynical, and unfair gods of antiquity; it was the passport to the landscape where the sun shone eternally . . ." Without this mysterious passport, the solitary individual hovers about the peripheries of others' lives, like twenty-nine-year-old Claire Pitt of *Undue Influence* a "mental stalker"—"a hunger artist whose hunger is rarely satisfied." In the absence of an active engagement with life there is the voyeur's ambiguous pleasure of observation; if one cannot know another person intimately, one can speculate endlessly about him or her, in a bloodless simulacrum of passion. Brookner's brooding characters may be hard on others, but they are hardest on themselves. In the recent novel *Visitors* (U.S. 1997), an aging woman, a widow, contemplates the "stoicism and distaste with which she endured herself"; in *Altered States* (U.S. 1996), a widower defines himself in terms of "inadequacy" and "dullness"; in *Undue Influence* the obsessively self-judging Claire Pitt is finally revulsed at her own failure to anticipate the course of a romance, the consequence of "a life spent watching rather than taking part."

Out of the despair of living, Anita Brookner once remarked, in a 1987 *Paris Review* interview, has emerged the act of writing, an act of self-expression and freedom. *Look at me!* is the writer's plea. The daughter of Polish Jews, Anita Brookner was inculcated from an impressionable age with a sense of permanent dislocation in England—"The English are *never* serious—they are flippant, complacent, ineffable, but never serious, which is sometimes maddening." Her abiding theme has been the painful contrast between "damaged people" and "those who are undamaged"; the writer identifies with the former, though disliking and pitying them, as rejected aspects of herself, while it is the latter who intrigue her. "If I were happy, married with six children, I wouldn't be writing"—a bold, unfashionable statement in our feminist age! (The woman with six

children, who might have wished to write, would take a very dim view of Brookner's romantic notions of the quotidian domestic life.) Given such a temperament, this younger coeval of the cheery Barbara Pym and the atrabilious Philip Larkin has become England's brave and indefatigable chronicler of diminished lives; those luckless individuals, in Brookner's world almost exclusively female, who, in a memorable phase of James Joyce's from his *Dubliners* story "A Painful Case," are "outcasts at life's feast."

And outcasts at life's feast they are, the protagonists of Brookner's nineteen novellas. In *Visitors,* she imagines a Hell of an English Heaven populated by such people, somewhere in Hyde Park, dull light, dull company, a vision of the 1950s where solitary individuals "would not fear introductions."

Given the limitations of her theme and technique, and her lack of a writerly interest in revision, as she claims in her wonderfully candid interview, it was perhaps inevitable that Anita Brookner should begin to repeat herself, and her novellas blur together, as the most elegant of patterned wallpapers may seem to blur together in the viewer's imagination, though surely distinctive in the creator's. Brookner's most compelling works were her earliest, when the author was in the process of discovering her unique voice and had only just begun to explore the small cast of characters that would populate her rarified fictional world; one feels that, in these slender, cautionary tales of the risks of love, the author was surprising herself with her material, while later novels contain virtually no surprises, and are but variants of a theme ever receding in immediacy and authenticity, like an artist's monotype struck too many times, its colors fading; though even in these near-static works, the reader is rewarded with subtly argued passages on aging, solitude, aloneness, the perils of risking involvement with others, and the tyranny of invalids.

By contrast, what plainspoken defiance in Brookner's third novella *Look At Me* (1983): "My name is Frances Hinton and I do not like to be called Fanny." The speaker is a young woman of uncommon intelligence, as *Look At Me* is a paradigm of Brookner's fictional universe, much of it set in the reference library of a medical institute "dedicated to the study of problems of human behavior." Brookner's narrator is, symbolically, in charge of a pictorial archive of illness and death; the institute is particularly interested in dreams and madness, "the incalculable

or the undiagnosed." Problems of human behavior still baffle, "but at least in the Library we have them properly filed." Frances muses:

> In old prints melancholy is usually portrayed as a woman, dishevelled, deranged, surrounded by broken pitchers, leaning casks, torn books. She may be sunk in unpeaceful sleep, heavy limbed, overpowered by her inability to take the world's measure . . . She is very frightening, but the person she frightens most is herself. She is her own disease.

Death, too, can be a woman, but death is "usually a skeleton one perceives as male."

Brookner's most popular novella, *Hotel du Lac,* awarded the Booker Prize in 1986, is her most immediately engaging, a sadly funny retelling of some themes of Henry James and Edith Wharton in a contemporary Swiss-hotel setting. In this dreamlike place all is "veal-colored"; Edith Hope, the heroine, a bestselling romance writer under a "more thrusting" name, is in exile after having fled her own wedding to a good, decent, dull man; Edith takes little pride in her commercial success in the debased romance genre, knowing herself a practitioner of "fantasy and obfuscation" in which, to her unrepentant shame, she actually believes. Her career has been concocted out of variants of the fable of the Tortoise and the Hare:

> People love [this fable], especially women . . . The tortoise wins every time. This is a lie, of course . . . In real life, it is the hare that wins. Every time. . . . Aesop was writing for the tortoise market . . . Hares have no time to read. They are too busy winning the game.

Is this Brookner's witty commentary upon her own career with its appeal to an upscale tortoise market—a segment of the British population that can be relied upon to buy books? There's a delicious irony in the fact that the chastely conventional *Hotel du Lac* should have won that year's Booker Prize; for all its charms, surely this is the slightest, least ambitious novella to have ever been awarded a major literary prize.

Even when Brookner's novellas are less inspired, their opening chapters are often brilliant; one has a sense of the writer's telegraphing a distillation of what's to come, as, so frequently, the opening credits of a film

will excite us in a way the film itself does not. The openings of both *The Misalliance* and *Altered States,* for instance, are exceptionally good, leading the reader to anticipate, wrongly as it turns out, that what will follow will be of equal merit.

Undue Influence is a Vuillard interior in faded, fading pastel tones; even its opening pages are dispirited. The old-young female narrator, appropriately named Claire Pitt, is in mourning for her mother, and haunted still by the ignoble figure of her invalided father, whom she disliked. Claire has a crushingly dull job in a Gower Street second-hand bookstore owned by elderly spinster sisters; in a cruel self-parody worthy of Beckett, Brookner confines Claire to the dusty basement of the bookstore where she spends her days, more or less happily, rummaging through mildewed papers and magazines of decades ago, and occasionally typing, employed in assembling a manuscript of the elderly spinsters' long-deceased father's stultifyingly banal literary effusions. Claire Pitt is herself something of a parody of a Brookner spinster, with a voice very familiar to us, and but one friend in the world, a similarly lonely woman; she inhabits the dowdy apartment she'd shared with her mother, filled with old furnishings; she hints at having attempted sexual relations with strangers, in Europe (this is hardly convincing, but at least a change for a Brookner heroine) out of the conviction that "Virginity is a rotten endowment." Claire is a sleepwalker yearning to be awakened, even as she knows, "There is no consolation for those who have missed their chance." Small, melancholy adventures bring Claire briefly out of her cocoon: she gamely pursues a nugatory romance with an older man, a widower, who has briefly befriended her; Claire can scarcely tolerate the man, but her aim is coldly calculating: "I longed to feature in another's plans, even if I had to maneuver my way into them." And: "Here was someone outside my experience, dull-witted and fine, who would never discern an ulterior motive, a man so sexless that he took me entirely at face value." To no one's surprise except poor Claire's—has she never read a novella by Anita Brookner?—the widower eludes her stratagems, and she is left not only isolated but humiliated in her own eyes: "It was the greatest failure of my life and no future success could ever obliterate it."

The abrupt end of *Undue Influence* replays the ending of Brookner's more appealing second novella, *Providence*: the triumph of an "undamaged" woman, healthy, fleshy, ordinary, unburdened by despair as by a

high intelligence, over the "damaged" female who is Brookner's spokes-woman. Obsessional themes need not result in repetitive fictions, if the writer can invest her characters with depth and subtlety, but Claire Pitt is a hopeless case, arousing in the reader pity rather than sympathy. "I lived in a millennial age; I had no need of faith." Where Barbara Pym might have created a bittersweet but moving tragi-comedy out of Claire, her eccentric employers and her remote, sexless man friend, and Philip Larkin might have dispatched them all in scathingly funny verse, Anita Brookner has written another of her novellas of obsessive self-awareness. In her *Paris Review* interview Brookner remarked, "What is interesting about self-analysis is that it leads nowhere—it is an art form in itself." But is it?

An Artist of
the Floating World:
Kazuo Ishiguro

When We Were Orphans
Kazuo Ishiguro

IN THIS, HIS FIFTH NOVEL, AS IN ITS PRE-
decessors, Kazuo Ishiguro distinguishes himself as one of our most elo-
quent poets of loss. His predominant subject is "remains": the remains
of passions once vital, living, and charged with significance; the remains
of childhood and youth; the remains of large-scale crises and cata-
clysms, now reduced to uncertain memories of "historic" events in aging
survivors. In his aptly titled tour de force *The Remains of the Day*
(1989), Ishiguro created one of the memorable fictional portraits of our
time in the butler of Darlington Hall, Stevens, who comes slowly to the
realization that he has served a tragically flawed employer, and even
more slowly to the revelation that he has missed the emotional core of
his life. "A butler's duty is to provide good service." In the hands of a less
gifted writer, Stevens would have been a stock figure of pathos or biting
satire; Ishiguro presents him as fully human in his blind devotion to a
fading authority, both deluded and noble. The belated recognition that
one has missed love—and consequently one's life—is a theme of Henry

James, and *The Remains of the Day* is Ishiguro's most finely calibrated Jamesian work.

Kazuo Ishiguro was born in Nagasaki, Japan, in 1954 and was brought to Britain to live in 1959. By his account in early interviews, the "Japan" of his fiction has been a region of the imagination, surely abetted by a close and sympathetic reading of the tantalizingly elusive, enigmatic work of the great Japanese writer Yasurnari Kawabata (1899–1972) who would seem to have been a powerful, beneficent influence on Ishiguro. In Ishiguro as in Kawabata, explicit statement is rare; the human mind is a region of ever-shifting mists; objects in the world are invested with a sort of shimmering, evocative significance we must interpret intuitively, and not attempt to decipher. Not symbol but haunting image is the core of such subtle watercolorist art. Kawabata remains mysterious and "foreign" to Western sensibilities; there have been excellent translations of his work, most recently by the young American translator Michael Emmerich, yet these tend to evoke rather more admiration than empathy.

Ishiguro conjoins the Kawabatan sensibility with a very different writerly vision. Though his novels are pervaded by memory, the reveries of individuals trying heroically to comprehend their place in the world, they are also informed by the ironies of history: how the heroism of one era, for instance, becomes shame and ignominy in the next. How, as in *When We Were Orphans,* a man's entire life can be shaped by "historic" events he has misinterpreted. Ishiguro's early novels, *A Pale View of Hills* (1982) and *An Artist of the Floating World* (1986), are explicitly concerned with Japanese themes: the first, set in rural England, is a first-person account by a Japanese woman who survived the devastation of Nagasaki, and whose older daughter has recently committed suicide; the second, and more ambitious, is a first-person account by a former "artist of the floating world," the middle-aged Japanese Ono who had made a name for himself as a "New Japan" propagandist painter in the 1930s, preceding Japan's invasion of China and the eruption of World War II. The now disgraced Ono, whom younger Japanese look upon with pity, exasperation, contempt and hostility, is simply struggling to comprehend: what went wrong? Like his British counterpart Stevens, he would seem to have devoted himself to a tragically flawed master; yet such wisdom is purely retrospective. At the time, youthful passions were galva-

nized by the prospect of Japan as an imperial, military world power; the vision of Japan as world conqueror seemed neither criminal nor mad. Ono's personal quest was to raise himself above the "mediocre." How is he to be fairly judged, and by whom? We are left with the possibility that the wisdom of the "floating world" (hedonistic, aesthetic, fleeting pleasure) is all that abides: "The best things . . . are put together of a night and vanish with the morning."

The Unconsoled (1995), Ishiguro's fourth novel, was a radical departure for the author, evoking Franz Kafka and Rex Warner (surely the most underrated of first-rate British writers of the twentieth century) rather more than Kawabata, and lacking the gravitas of a historic backstory and its related memory. The narrator is a disembodied "I" who possesses little identity; he might as readily be an artist, or a writer, as a musician; the "consolation" vainly sought might be a dispelling of the anxiety of childhood or adolescence, which would seem to be the novel's elusive subject. An awkward anomaly among the author's work, *The Unconsoled* provoked controversy, criticized in some quarters as vague and meandering, lauded in others as a "masterpiece" (often a sign of reviewer desperation). Fellow novelists may recognize its terrain with a shudder: the dissolving landscape of the imagination that hasn't yet located its subject, the fierce writerly impulse unattached to a coherent or even very intriguing plot, intermittently inspired stabs at "black comedy" amid a generally twilit and muted world, as if the boldly colored surrealist cityscapes of de Chirico had been rendered in dull half-tones and neutrals. The great model for such a nightmare-visionary journey is Kafka's *The Castle* (1925); the hero's tragi-comic, frustrating, ultimately quixotic quest is emblematic of all such quests, religious, political, ancestral, the individual's seeking for redemption he imagines must come from outside him. The theme is a noble one, but *The Unconsoled* is Kafka on Thorazine.

As *An Artist of the Floating World* is a precursor of *The Remains of the Day,* both novels narrated by "unreliable" protagonists who have served fascistic, military-minded masters in the years preceding World War II, so *The Unconsoled* would seem to be a groping precursor of the much superior *When We Were Orphans.* Like the musician-narrator of *The Unconsoled,* the detective-narrator of *When We Were Orphans* seems to inhabit a waking dream; he struggles to make sense of the simplest facts, and seems often to be making his way through a surrealist

landscape on the brink of dissolution. Here the Kafkaesque compulsion to question, to puzzle over, to analyze is given a dramatic urgency that makes psychological sense, for Christopher Banks is an orphan who as a schoolboy is fascinated by the "connectedness" that is taken for granted by his non-orphan classmates; through his life, which we track for about forty discontinuous years, ending in London in 1958, he thinks of himself in these stoic terms:

> . . . for those like us, our fate is to face the world as orphans, chasing through long years the shadows of vanished parents. There is nothing for it but to try to see through our missions to the end, as best we can, for until we do so, we will be permitted no calm.

Nominally beginning in London, in 1930, *When We Were Orphans* soon moves backward in time. Our earnest, intelligent, and punctilious narrator, Christopher Banks, a "celebrated" English detective, is preoccupied with childhood memories of the International Settlement in Shanghai, where he and his parents lived until their mysterious, separate disappearances in 1915, when Christopher was eight. His father was in the employ of the British trading company Butterfield and Swire; his mother, a highly moral, reform-minded woman of considerable beauty, was passionately involved in the campaign to abolish the opium trade in China. In this protracted flashback, the child Christopher comes to realize, by degrees, the irony and danger of his parents' position in Shanghai: "the British in general, and the company of Butterfield and Swire especially, by importing Indian opium into China . . . had brought untold misery and degradation to a whole nation." Christopher's mother is an outspoken critic of the very company that employs her husband and provides her with a large house and Chinese servants. How can this untenable situation be resolved?

Following the disappearances of his parents, who are presumed to have been kidnapped by agents involved in the opium trade, Christopher's lifelong mission will be to "combat evil." Already as an eight-year-old he plays the "father rescue game," a fantasy to be elevated into a distinguished professional career. Yet, since the elder Bankses have never been found, and the mystery of their "kidnapping" has never been solved, Christopher's life seems to him shallow and dissatisfying. Like the former artist of the floating world, the master detective is assailed by

self-doubt, uncertain even of the accuracy of his precious memories. He has become irremediably orphaned from his childhood self:

> . . . over this past year [1931], I have become increasingly preoccupied with my memories, a preoccupation encouraged by the discovery that these memories—of my childhood, my parents—have lately begun to blur. A number of times recently I have found myself struggling to recall something that only two or three years ago I believed was ingrained in my mind forever. I have been obliged to accept . . . that with each passing year, my life in Shanghai will grow less distinct, until one day all that will remain will be a few muddled images.

Banks's growing amnesia, which arouses panic in him, is symptomatic of a generalized cultural amnesia regarding British and European exploitation of China. Banks's mother has been a martyr to the anti-opium abolitionist cause, as the detective will eventually discover:

> . . . [the trading companies] not only liked the profits very much, they actually *wanted* the Chinese to be useless. They liked them to be in chaos, drug-addicted, unable to govern themselves properly. That way, the country could be run virtually like a colony, but with none of the usual obligations.

When We Were Orphans is intricately plotted as a conventional mystery novel, with an ending that's both unexpected and plausible. In such densely psychological works of fiction, "plot" is more significant in interior terms than exterior, and we are apt to feel more anxiety for the quixotic hero when he's pondering the labyrinth of his own mind than when, in an extended action scene near the end of the novel, he's making his way through a part of Shanghai in October 1937 during the shelling of the city by Japanese troops. Not that the brooding inner life ceases to exist in individuals during times of social crisis, but it comes to seem inescapably trivial; set beside wholesale destruction and slaughter, the puzzlements of a highly bred consciousness arouse impatience rather than sympathy.

As a detective, Christopher Banks is a romantic, mythic figure in the mode of that fantasy-concoction Sherlock Holmes. There is very little that is "real" about his procedure: he seems simply to brood upon crime scenes and through a process of ratiocination to which the reader isn't made privy,

he "solves" cases no one else can solve. He is never involved in crime inves-
tigations and seems utterly innocent of forensic science; he never seeks out
witnesses; this is the detective as mystic, not mortal man; he doesn't belong
to the same species as the police detectives of P. D. James, Ruth Rendell, and
Ed McBain. Ishiguro glosses over the details of Banks's work, in which he
clearly has no interest, by suggesting always that the detective is an allegor-
ical savior-figure whose true mission is to "combat evil" at its source. A vil-
lage police inspector, of all unlikely individuals, confides:

> If I was a greater man, then I tell you, sir, I'd hesitate no longer. I'd
> go to . . . the heart of the serpent . . . Why waste precious time
> wrestling with its many heads? I'd go this day to where the heart of
> the serpent lies and slay the thing once and for all . . .

As it happens, the heart of the serpent at this time happens to be in
China, where communist guerilla forces are fighting nationalist troops;
and where, in 1937, the imperial Japanese army has begun its invasion of
China, close by the very setting of Christopher Banks's parents' "kid-
napping" decades before.

When We Were Orphans takes enormous risks in boldly linking
the lone Christopher Banks with such global, impersonal events. It may
be that for some readers the strain of suspending disbelief will be too
much and the intricately devised house of cards will collapse into im-
probability. The more subtly modulated self-inflation of the artist Ono
of *Floating World* gives that novel an authenticity largely missing in
When We Were Orphans, for Ono's involvement in the "New Japan" was
never more than marginal, as he acknowledges. By contrast, Christopher
Banks is a public figure whose celebrity seems to be increasing, until, at
the novel's end, he's awakened from his deluded sense of mission. We last
see him in old age, retired to private life, accepting of his "ordinary"
status, very like the former artist of the floating world. "I do not wish to
appear smug; but drifting through my days here in London, I believe I
can own up to a certain contentment." Ishiguro's protagonists invariably
retreat, but with dignity, after having heroically struggled. If they don't
succeed in solving the mysteries that confront them, they solve other,
lesser mysteries. For all its ellipses and evasions, *When We Were Or-
phans* will linger in the mind as an often fascinating if enigmatic work
of fiction.

"City of Light": Robert Drewe's *The Shark Net*

The Shark Net: Memories and Murder
Robert Drewe

I'm only young, but this is how I'll feel forever.
Dazed, randy, mentally paralyzed and swept
along by events.

Robert Drewe, The Shark Net

But that horrid thing in the bush! . . . It must be
the spirit of the place.

D. H. Lawrence, Kangaroo

PERTH, IN WESTERN AUSTRALIA, THE
setting of this fascinating memoir by the Australian novelist and short
story writer Robert Drewe, is said to be the most isolated city in the
world. Facing the Indian Ocean, surrounded on three sides by sand and
bush and cut off from the far larger, more cosmopolitan cities of the
east, Sydney and Melbourne, by the vast Nullarbor Plain, Perth would
appear to be, to the traveler, a place of romance: the "City of Light" ac-
claimed by astronaut John Glenn who, orbiting the earth overhead in his

Mercury capsule in 1962, claimed to have seen "the tiny glow on the southwest tip of the great black southern continent" as its inhabitants left their lights on through the night in honor of Glenn and the United States space program. "I can see lights on the ground," Glenn reported. "I can see the lights of Perth on the coast. Thanks everyone for turning on the lights."

When D. H. Lawrence explored Perth and environs in 1922, preparatory to traveling to Sydney and the east coast where he would write, in five feverish weeks, the sporadically brilliant novel *Kangaroo* (1923), he found no "City of Light" but a malefic "spirit of place" that evoked metaphysical terror. Lawrence's protagonist, the Englishman Richard Somers, a thinly disguised portrait of the cranky, visionary writer, has decided that Europe is "done for, played out, finished," and emigrates to the "newest country, young Australia." At first, Somers's sense of his new environment is poetic-mystical, with an undercurrent of the romantically uncanny:

> . . . The vast, uninhabited land frightened him. It seemed so hoary and lost, so unapproachable. The sky was pure, crystal pure and blue, of a lovely pale blue color: the air was wonderful, new and un-breathed: and there were great distances. But the bush . . . the gray, charred bush. It scared him . . . It was so phantom-like, so ghostly, with its tall pale trees and many dead trees, like corpses, partly charred by bush fires: and then the foliage so dark, like gray-green iron. And then it was so deathly still . . .

Exploring the bush on foot, alone, Somers has a more alarming, visceral vision that stays with him through the remainder of his Australian adventure:

> Yet something. Something big and aware and hidden! He walked on, had walked a mile or so into the bush, and had just come to a clump of tall, nude, dead trees, shining almost phosphorescent with the moon, when the terror of the bush overcame him. He had looked so long at the vivid moon, without thinking . . . There was a presence. He looked at the weird, white dead trees, and into the hollow distances of the bush. Nothing! Nothing at all . . . It must be the spirit of the place. Something fully evoked tonight, perhaps provoked, by that unnatural West Australian moon. Provoked by the moon, the

roused spirit of the bush . . . It was biding its time with a terrible age-less watchfulness, waiting for a far-off end, watching the myriad intruding white men.

(These intruding white men represent an "Englishness all crumbled out into formlessness and chaos"; the civilization they've established in the new land is "a raw loose world" lacking all inner meaning and significance, sheerly animal, "swarming, teeming.")

Powerfully glaring, oversized Australian moons, whether full or otherwise, play a significant, symbolic role in *The Shark Net,* and Drewe's evocation of the Australian landscape, a native's, would seem to confirm that of the impressionable Lawrence. Drewe's Australia is a place of ocean and river shores where human life is oriented outward, toward water; in *The Shark Net* and in Drewe's collection of linked stories, *The Bodysurfers* (1983), virtually everyone swims and boats, bodysurfs and hikes along the beach; "we knew the tides and reefs, the hot easterlies and blustery westerlies of our coast." In the concluding story of *The Bodysurfers,* "Stingray," a spiritually exhausted man seeks rejuvenation in "the electric cleansing of the surf," only to receive an excruciatingly painful sting from a stingray or a yet more venomous butterfly cod ("a small brown fish that looks like a weed") and to think wryly:

> This country is world champion in the venomous creatures' department. The box jelly fish. Funnel-web spiders. Stonefish. The tiny blue-ringed octopus, carrying enough venom to paralyze ten grown men. The land and the sea abound with stingers. It suddenly occurs to him that he might be about to die . . . Venom is coursing through his body.

Another character in *The Bodysurfers,* exiled from his former life and living now by the shore, is haunted by sharks:

> I imagine they're everywhere. In every kelp patch, in the lip of every breaker, I sense a shark. Every shadow and submerged rock becomes one; the thin spume of spray in the edge of my vision is scant warning of its final lunge.

In *The Shark Net,* the young Robert Drewe is similarly obsessed by sharks, both as "archetypal" images and menacing reality; as a reporter

for a Perth newspaper, he follows a pack of tiger sharks along the coast, "searching for fins in the rise of each breaking wave, for those sinister, thrilling shadows in the swells . . ." His startling, sadistic fantasy is that he'll be the reporter to write of a bloody shark attack on a "noted victim." Though he has never seen a man-eating shark in its natural habitat, he's haunted by the possibility of being attacked and eaten every time he dives into the sea, which is every day; "it had to be that sharks were buried deep in my collective unconscious . . . This, I thought, was obviously the underlying anxiety of my life."

Unless the shark is a manifestation of a predator that can be seen, while less visible predators surround us, lacking faces and identities.

AS ITS subtitle suggests, *The Shark Net* has a double theme: it's an intimate account of Robert Drewe's coming-of-age in Western Australia in the 1950s and 1960s, during a period that overlapped with the reign of terror of one of Australia's most deranged and brutal serial killers; and an account of the killer himself, a man who turns out to have been friendly with Drewe as a boy, when he'd been employed by Drewe's father in his capacity as a manager of Dunlop Rubber. The memoir gains in power by this juxtaposition, for it's structured something like a mystery, and there's an ironic contrast throughout between the life of the body, a virtual religion in the Australia of Drewe's experience, and the fact of mortality.

The Shark Net is reminiscent of those unsettling paintings of Eric Fischl, mostly painted in the 1980s, in which a diminutive, brooding adolescent boy gazes without expression at adults who seem to take no notice of him, mysterious to him, and fascinating in their fleshly, self-absorbed sexuality. In both Fischl's mock-Hopperesque paintings and in Drewe's poetic prose the settings, frequently beach or pool scenes involving partially or wholly naked women and men, are so erotically charged as to seem tumescent. In both Fischl and Drewe the observer enters the scene by way of the boy, though the boy may be virtually invisible. In Fischl's often dark, congested surfaces there is a suggestion of impending violence, but only a suggestion, for the paintings are finally meant to appear bland and "illustrative"; in Drewe, darkening images of disorder and death intrude upon the Drewes' upper-middle-class suburban world, like the shadow of a shark beneath the surface of sunlit water, never

quite visible, but at the edge of one's vision. Drewe's idyllic boyhood ends; he falls in love, impregnates his girl friend and marries her, at the age of eighteen; his impetuous behavior outrages his mother, whose personality deteriorates; she dies abruptly, and Drewe is stricken with grief and guilt. ("You're probably wondering," the family physician says to Robert, "whether you killed her.") At the same time, the unknown killer commits a series of barbaric murders, of the ferocity and variety of those committed by the Los Angeles "Night Stalker" Richard Ramirez in the 1980s; after his arrest, Drewe attends his trial and interviews his wife, and leaves Perth shortly after the killer's execution.

As a landscape is seen in greater depth when it's viewed from numerous angles, so *The Shark Net* gains in depth by being read in tandem with *The Bodysurfers,* the only work of fiction of Drewe's that is currently available in the United States.[1] Episodes touched upon elliptically in the short stories are more fully developed in the memoir, and certain of the "historic" figures of the memoir are transformed into symbolic types in the stories. In both the memoir and the fiction there is the presence/absence of a mother who has died unexpectedly, her death signaling the breakup of a family, and there is an aggressive, assertive father who seems, in his eccentricities, potentially explosive. There are small, domestic mysteries of the kind never wholly explained within families. There are losses, griefs. There is a bittersweet contemplation of the "life of the body" and its ephemeral nature. There are beaches, sandhills, waterways, swimming and bodysurfing and lovemaking as sacred rites, in a brashly hedonistic, extraverted world in which, as D. H. Lawrence shrewdly perceived, there is little inner or spiritual meaning. And there are the haunting images of marauding sharks.

A shark net isn't a net in which sharks are caught, but a net stretched for miles along beaches in selected parts of Australia and Africa to prevent sharks attacking swimmers or waders. It seems like a quixotic attempt to combat a lethal predator, and yet if the nets are properly set and are moved frequently, to prevent packs of sharks from establishing territory, the method can be 100 percent effective. "I liked the idea of nets," Drewe says. So too the "net" of writing, the crafted manipulation of language, keeps at bay the chaos of a life merely lived, not mediated through art. But Drewe pushes the metaphor further, and finds it ambiguous: "If

our beaches were netted I knew I'd be a more confident person, happier and calmer. Then again, I might lose the shark-attack scoop of my life."

Drewe's memoir is also an affectionately satirical look at the paranoia of an isolated city. There is the Great Sparrow Panic ("The Government declared that Western Australia was the last place on earth apart from the North and South Poles where the sparrow hadn't gained a foothold") which involves the vigilance of the citizenry and special Government Sparrow Rangers licensed to shoot suspicious birds, with shotguns. These are brought to the Agriculture Protection Board:

> Shot birds were arriving curled up in shoeboxes and in preserve jars. There were heaps of gray whistlers, silvereyes, cuckoo-shrikes, thrushes, finches, flycatchers, shrike-tits, wrens, robins, mudlarks, willy-wagtails, fantails, and honeyeaters. But no sparrows.

There is also an obsessive fear of Argentine ants (which do invade Western Australia, and thrive), and strangers driving cars with "distinctive yellow Sydney license plates" that are noted by Perth police. In the not distant past, the Western Australian government sent Moral Agents to live among the Aborigines as models of Christian conduct.

Drewe deftly integrates the lurid saga of the serial killer (a seemingly affable workingman whom the reader would no more suspect than Drewe himself suspects him) with the saga of his own family's unraveling. A murderer of eight arbitrarily chosen individuals for whom he felt no emotion, neither positive nor negative, "Eric Edgar Cooke" is the father of seven young children and the husband of a cheerful woman who forgets to note the time of day when he's hanged. ("What with feeding the kids and getting them ready for school and all the rest of it, eight o'clock sort of went past without me noticing.") One of the murderer's sons tells Drewe that his father had warned them about the serial killer:

> At the time it was a very warm and secure experience, and maybe it expresses his sense of humor, but he said no one was safe and we had to lock our doors. All the boys used to sleep out in the sleeping porch, and it was a small house—well, it's got to be a small house, there were seven kids—and he put all the mattresses on the lounge-

room floor and we all slept in the lounge room together and he was there to stand over us.

Executed on October 26, 1964, Cooke is the last individual to be hanged in Western Australia and the second-to-last in Australia.

THE SHARK NET ends on a tentatively upbeat note: Drewe, his young wife and baby are leaving Perth for the east coast, where Drewe will be writing for *The Age,* a venerable Melbourne newspaper. He's only twenty-one. Feeling nostalgic about his boyhood, he revisits favorite places, swims in the ocean at Cottesloe Beach a final time: "It was an achingly familiar and sentimental tableau. But it was all used up."

All memoirs are finally about loss. We don't write of the past except when we've been ejected from it. The only way back is through memory, haphazard and unreliable as we know memory to be, and the only means by which memory is realized is through language. Robert Drewe has written a moving and unpretentious memoir of a precocious youth, a bittersweet tribute to youth's optimism that might "always be replenished by a good story, a glimpse of the sea and a particular angle of sunlight."

Notes

1. Drewe is the author of seven works of fiction, of which the novel *The Drowner* is best known in Australia. He is also a non-fiction writer, a playwright, and an editor.

L.A. Noir:
Michael Connelly

A Darkness More Than Night
Michael Connelly

LOS ANGELES HAS LONG BEEN CELE-
brated as the *noir* dream-factory of America. If, per capita, the city and
its environs may be less riddled with corruption and violence than
Youngstown, Ohio, or Camden, New Jersey, it possesses a redeeming
ironic glamor missing from such sublunary locales. This western edge of
our continent seems more truly to have "pandered in whispers to the last
and greatest of all human dreams" than the eastern island of which, in
the famous concluding passage of *The Great Gatsby,* F. Scott Fitzgerald
spoke with such melancholy lyricism. Southern California has been the
inspiration for a number of *noir* writers of distinction, from the most in-
fluential of "hard-boiled" detective novelists Raymond Chandler (*The
Big Sleep,* 1939; *Farewell, My Lovely,* 1940) and the more literary Ross
MacDonald (*The Moving Target,* 1949) to our contemporaries Joseph
Wambaugh, James Ellroy, and Michael Connelly.

Chandler and MacDonald wrote what are essentially romances,
about heroic private investigators involved in murder investigations. (In
real life, private investigators are virtually never involved in murder in-
vestigations.) Wambaugh, Ellroy, and Connelly write more realistic
crime novels of that popular sub-genre known as the police procedural,
which was virtually created in the 1950s by Ed McBain (pseudonym of

Evan Hunter) in his 87th Precinct series. In the classic police procedural, investigators are professional detectives, not private investigators or gifted, charming amateurs. The detailed procedure of a crime investigation, which constitutes the backbone of a typical Michael Connelly novel, can be assumed to be authentic, if not so minutely detailed as a forensics procedural by Patricia Cornwell, a former pathologist. In Connelly's novels we follow investigations from the often intimate perspective of a canny detective named Harry ("Hieronymus") Bosch, of the Hollywood division of the LAPD; Bosch's precinct is one Connelly came to know well during his thirteen years as a crime reporter for the *Los Angeles Times* in the late 1980s. (Connelly grew up in Fort Lauderdale, where he came of age during the South Florida high-profile cocaine-driven violence of the 1970s; as a young reporter for papers in Daytona Beach and Fort Lauderdale, he was assigned to police beats.) What is most appealing about Bosch is that, far from being a fantasy hero, he's a flawed, deeply troubled and isolated man; a professional police officer who has the grudging respect of most of his colleagues but has been suspended from duty at least twice (for shooting an unarmed suspect in a serial murder case, for an impulsive assault against one of his superiors), and who seems perpetually on the brink of burn-out or implosion. A colleague says of Bosch that he has "haunted eyes" and, in *A Darkness More Than Night,* he's even a suspect in a gruesomely elaborate murder.

Aptly named for Hieronymus Bosch, the fifteenth-century Dutch painter of nightmare moral allegories, whose Christian mysticism reveled in scenes of serio-comic sadism, Bosch too is an "avenging angel" with a powerful wish to see sinners punished. Bosch is far from being an idealist but, in his misanthrope way, he's an idealist who still believes in the possibility, if not the probability, of justice—through his own exertions. The background Connelly provides for Bosch is brief and instructive: Bosch's mother, a prostitute, was murdered when he was a child, and, during the Vietnam War, Bosch served in a special branch of the U.S. Army trained to enter the labyrinthine tunnel-networks dug by the Vietcong. Both experiences have left psychic damage, making Bosch into an obsessive who can't let go of a case. A colleague named McCaleb, a former F.B.I. profiler, perceives Bosch as a special breed of cop who sees his job not as a mere skill or craft but as a vocation; such cops take on the responsibility of speaking for the dead:

There was a sacred bond cast between victim and cop that formed at the crime scene and could not be severed. It was what ultimately pushed them into the chase and enabled them to overcome all obstacles in their path . . . It had been [McCaleb's] experience that these cop/angels were the best investigators he ever worked with. He also came to believe that they traveled closest to that unseen edge, beneath which lies the abyss.

Nietzsche's famous aphorism in *Beyond Good and Evil* might stand as an epigraph for Michael Connelly's fiction: "Whoever battles with monsters had better see that it does not turn him into a monster. And if you gaze too long into an abyss, the abyss will gaze into you."[1]

(It's interesting to note that Connelly modeled his fictitious detective on fellow *noir* novelist James Ellroy, whose mother was murdered in Los Angeles when Ellroy was ten, and whose subsequent career as a writer of crime fiction of Dostoyevskian passion and scope clearly springs from that childhood trauma.)[2]

Michael Connelly began his highly successful career with *The Black Echo* (1992), which introduced Harry Bosch, and quickly followed up with three Bosch novels, *The Black Ice, The Concrete Blonde,* and *The Last Coyote* (perhaps Connelly's strongest novel, in which Bosch, suspended from the LAPD, investigates the murder of his mother); Connelly then alternated Bosch novels (*Angels Flight, Trunk Music*) with densely plotted mystery-thrillers (*The Poet, Blood Work, Void Moon*) that continue the preoccupations of the Bosch novels, in particular the complicity between criminal and pursuer. Occasionally, as in *Trunk Music* and *Void Moon*, Connelly shifts his locale (to Las Vegas), but his base is Los Angeles in its infinite variety, and his subjects are timely as L.A. headlines: Hollywood murders, racism and race riots, drug-dealing, violence and corruption within the LAPD, sadistic sexual crimes, incest and child-rape and -murder, pedophilia on the Internet.

A Darkness More Than Night, Connelly's tenth novel, is something of an experiment: Connelly brings together Bosch with the less distinctive hero of *Blood Work*, F.B.I. profiler Terry McCaleb, now retired to a tenuous private life as a husband and father living on Catalina Island, and the even less distinctive journalist Jack McEvoy of *The Poet*. McEvoy has hardly more than a walk-on role here, as a journalist duped by a corrupt

source, but McCaleb is given equal billing with Bosch. In this *noir* landscape, McCaleb is an unlikely player: a reasonable, decent, fair-minded individual who's a devoted family man and who has recently had a heart transplant, disqualifying him from scenes of physical bravado and action. Where Bosch, an isolato, broods compulsively upon the past—his wife, appropriately named Eleanor Wish, whom he loves very much, has left their marriage under mysterious circumstances—McCaleb has found a new center to his life in his infant daughter, so tenderly noted in the novel that the reader fears for McCaleb's vulnerability: "He felt a kind of love he had never felt before."

But it remains Bosch, here as elsewhere, who propels the narrative and gives to *A Darkness More Than Night* its air of suspenseful urgency. Divided into two centers of moral consciousness—Bosch's and McCaleb's—the novel has a tricky double plot involving a high-profile murder trial in which Bosch is the primary prosecution witness (a Hollywood director is accused of having strangled a young actress and subsequently arranged her body to suggest a lurid auto-erotic accident), and a LAPD investigation into the murder of a low-level criminal (whose body has been arranged to suggest a re-enactment of a sadistic bondage scene out of Hieronymus Bosch's *A Garden of Earthly Delights*). By so dividing his novel Connelly allows Bosch and McCaleb to regard each other, like uneasy brothers. And when, after Bosch saves McCaleb's life, McCaleb calmly informs Bosch, "I'm not going to be your friend any more," the revelation is as startling as any in the novel and, for Bosch, more upsetting. For *A Darkness More Than Night* hasn't been so much about the pursuit of evil as the cultivation of conscience: how to live, amid evil, a decent life? How, policing violence, to avoid committing violence? In his rejection Bosch takes strength from a sense of kinship with Los Angeles: "A city of lost light. His city . . . The city of the second chance."

In the latter half of the American twentieth century, "crime" seemed to have acquired a mythopoetic status. In writing of crime, one is writing of American life *in extremis*. Crime detection, criminal trials, the enforcement or, more likely, the thwarting of justice—these have become crucial cultural issues, beyond mere entertainment; to anatomize a high-profile crime, in as much detail as possible, has become a way of decoding the American soul. This goes to the root of our childlike, or primitive, conviction that death can't ever be "natural"—always it must have an

agent, someone specific to blame and to punish. The fantasy exerts a powerful fascination for, if we can locate the agent of death, we can forestall death. The most talented of crime writers, like Michael Connelly, work with genre formulae as poets work with "fixed" yet malleable forms like sonnets and sestinas; they affix their signatures to the archetype. It's an art of scrupulous realism conjoined with the abiding fantasy of a resolution in which the terrifying mysteries of mankind's inhumanity to man, suffering, dying, death are explained and dispelled. As McCaleb, crossing by boat to Catalina Island at night, assures his worried wife: "I'll be all right. I can see in the dark."

Notes

1. Aphorism 146.

2. See Michael Connelly's interview in *Talking Murder: Interviews With 20 Mystery Writers* edited by Charles L. P. Silet (Ontario Review Press, 1999).

Ringworm
Belt

Cherry: A Memoir
Mary Karr

M Y MEMORY OF EIGHT SURREAL MONTHS in Beaumont, Texas, in 1961–62, overlapping minimally with the time span chronicled by Mary Karr in *The Liars' Club* (1995) and in her new sequel to that bestselling memoir, *Cherry,* is almost exclusively visceral. When the air is saturated with chemical smells—sickly sweet, acrid, like toxic-waste cherry syrup with a nasty undertone of sandpaper—you find it difficult to contemplate loftier subjects. Airborne pollution from oil refineries in this devastated East Texas landscape near the Louisiana border and north of the Gulf of Mexico, known without irony as the "Golden Triangle" (Beaumont, Port Arthur, Orange), must have been close to the edge of human endurance; yet the area's sense of itself was unfailingly upbeat, optimistic. These were "boom times" for Texas refineries. Luridly apocalyptic sunsets (flamey-orange, bruised-plum-tinged-with-acid-green) were admired as aesthetic bonuses—"Isn't the sky *gor-geous*?" Urban areas technically known as cities seemed to have been but recently, and hastily, hacked out of the Big Thicket (pinewood, scrub trees), lacking any architectural distinction, lacking even centers, on a grid of railroad tracks, their poorly paved roads susceptible to dangerous flash floods. There was no cultural life in the Golden Triangle, nor the acknowledgment of its absence, unless churchgoing (among

whites, predominantly Baptist) constituted culture. One of my Beaumont memories is waiting in an overheating car in long lines at train crossings as freight trains rattled past endlessly. This was hurricane territory, gale-force winds blowing up from the Gulf, but nearly every day there were torrential rains. There was a gasoline-oily glisten to surfaces. I remember a dead, bloated steer lying on its side in a road, forcing traffic to drive around it. Everywhere were snakes, often dead, of an amazing length, run over and mashed on the pavement. At Lamar State College, new, cheaply built classroom buildings were windowless, like cinder-block cubes, air-conditioned to a temperature that set one's teeth chattering. Here too, on campus sidewalks, dead snakes sometimes stretched. Everywhere were flying roaches of a species unknown in the north, large as hummingbirds, and aggressive. Beyond such visceral impressions, the Golden Triangle yet held little charm. This was a brutally segregated society in which "Ne-gras" were presumed to be subhuman and, if resistant to that label, uppity and troublesome, dangerous. Yet the de facto apartheid of the region guaranteed that communication between the races was very difficult, for regional blacks did seem to speak a foreign dialect, baffling to outsiders. Eight months can be a lifetime, and yet, for some, catatonic with amnesia, such a lifetime can yield little of worth.

And yet here is Mary Karr, whose triumphant first book of prose, *The Liars' Club*, ranks with the phenomenon of Frank McCourt's *Angela's Ashes* not only as one of the most artfully composed of recent American memoirs but as a book that has wholly deserved its success. Both *Liars' Club* and its sequel *Cherry* are macabre valentines of a sort to "Leechfield, Texas" (not located on my map, seemingly somewhere in the vicinity of Port Arthur), in the "Ringworm Belt," a town once voted by *Business Week* as "one of the ten ugliest . . . on the planet." Mary Karr is a daughter of that world, and of its particularities she has fashioned, with the loving precision of Proust for his wholly alien world, a region of the soul so vividly described it has the power of oneiric prose, entering our dreams as if it were our own:

> The sheer stink of my hometown woke me before dawn. The oil refineries and chemical plants gave the whole place a rotten-egg smell. The right wind could bring you a whiff of the Gulf, but that was rare. Plus the place was in a swamp, so whatever industrial poisons

got pumped into the sky just seemed to sink down and thicken in the heat. I later learned that Leechfield at that time was the manufacturing site for Agent Orange . . . In the fields of gator grass, you could see the ghostly outline of oil rigs bucking in slow motion . . . In the distance, giant towers rose from each refinery, with flames that turned every night's sky an odd, acid-green color . . . Then there were the white oil-storage tanks, miles of them, like the abandoned eggs of some terrible prehistoric insect.

(Mary Karr's father, Pete Karr, was a member of the Oil Chemical and Atomic Workers Union.)

In *Cherry*, Karr concedes, with characteristic irony:

The town tolerated affliction with more grace than most places I've lived. They had to, for we were, as populations go, teeming with chemical and genetic mutation. Toxic air, I suppose, cooked up part of the human stew. Plus there was inbreeding galore. People disapproved of marriage between first cousins, but it happened, and at least one boy I knew was rumored to have knocked up his sister. Three kids in my grade school contracted and later died from leukemia and bone cancer . . . Before we lined up at the elementary school for sugar cubes in paper cups, the polio bug ran through us, for there were stagnant ponds aplenty, and we worried little about wading in ditches to catch crawfish after a heavy rain, even times you could see the encephalitic mosquito eggs afloat on the surface.

And the only available cheese is Velveeta.

When, near the dramatic conclusion of *Cherry*, the sixteen-year-old Mary undergoes a nightmare acid trip, for all her stylistic virtuosity Karr is hard put to match, let alone outdo, the Texas-Bosch landscapes she has previously created.

IT HAS frequently been remarked that memoirs are flooding the publishing marketplace, and that the motive behind this fecundity is not a good one. The urge to confess in print, on TV talk shows, in person would seem to be a dominant characteristic of our time, a symptom of narcissism, exhibitionism; an acknowledgment of a failure of imagination. (As

if "imagining" the pattern of one's own life were an easy exercise; as if painting a self-portrait isn't the most challenging of tasks.) Yet it can be argued that the confessional mode is at the root of numberless great works of prose from Augustine's *Confessions* to James Baldwin's *Notes of a Native Son,* and that the most ambitious twentieth-century novels, Joyce's *Ulysses* and Proust's *Remembrance of Things Past,* are wholly memoirist, suffused with the obsessive wish to memorialize an individual's life and his experience of a highly particularized world. In poetry, from Sappho to Sexton, from Shakespeare's sonnets to *Berryman's Sonnets,* the perspective of the pronoun "I" is the rule, not the exception; poetry as disparate as that of William Wordsworth, D. H. Lawrence, and Sylvia Plath is forged from similar motives. Long regarded as a coolly Modernist work of collage, an amalgam of seemingly impersonal, disinterested voices springing from no evident emotional center, even Eliot's *Waste Land* is now seen as intensely personal. To relate a writer's work back to autobiographical sources need not diminish its significance, but may in fact enhance our awe at the ingenuity with which the merely personal is transformed into art.

Contemporary memoirs tend to divide informally into two types: the coming-of-age memoir that reads like an "authentic" version of the autobiographical novel, and the memoir of crisis. In the former, we follow an individual, usually a young person, through a portion of his or her life; the structure of such memoirs may seem episodic, but has its internal logic and rhythms: *how I came to be who I am.*[1] By contrast, the memoir of crisis focuses upon a single season or dramatic event in the memoirist's life; the technique may be synecdoche, the use of the symbolic part for the whole, or, as in a crisis-driven memoir like William Styron's radically distilled *Darkness Visible,* an account of the author's depression, the remainder of the life fades into the background, since the foreground is the entire subject.[2]

The coming-of-age memoir has the advantage of leisurely development; the memoir of crisis has the advantage of a concentrated focus. The one offers amplitude, the other a narrower, suspenseful concentration. Obviously, both types of memoirs share salient characteristics and both can be rewarding, or disappointing, depending upon that elusive factor we call "style"—"voice." A mediocre memoir may be easier to compose than a mediocre novel since, presumably, one need not invent much, but memoirs of distinction surely rank with novels of distinction,

for no literary genre is by definition inferior to any other. (Frank McCourt's *Angela's Ashes* and Mary Karr's *Liars' Club* might well be autobiographical first novels of distinction. In Limerick, Ireland, the impoverished setting for much of McCourt's childhood memoir, *Angela's Ashes* is in fact considered a work of fiction.) Though the memoir purports to be an account of actual events, a memoir isn't journalism or history, which genres had better supply us with verifiable, corroborative truth; a memoir is a literary text. This is to say that it consists of words artfully, and arbitrarily, arranged. Not ideas, not true-life adventures, not facts and not "profound" themes yield memorable works of art, for art by its nature is idiosyncratic and indefinable and aspires to uniqueness. Whatever we mean by "art" invariably involves "artifice."

This is not to defend memoirs like McCourt's or Karr's, or that most elegantly composed of twentieth-century memoirs, Vladimir Nabokov's *Speak, Memory,* utilizing as they do unlikely, even improbable recollections of long-ago dialogue, descriptive detail, and fleeting emotions and thoughts, but simply to explain that each memoir is *sui generis,* like any work of fiction; and that the very act of putting one's inchoate life into words, arranging it into chapter divisions, giving these divisions titles, deciding upon opening sentences and closing sentences, and so forth, is obviously an act of creation, or re-creation, largely an act of fiction-writing since it involves a purposefully chosen language and our lives are "alive"—not narrated. The memoir is to be distinguished from the diary, a presumably day-by-day chronicling of life *in medias res,* for the root of "memoir" is after all "memory," and its vision is retrospective. The memoir may be narrated in the historic present tense, to impart an air of breathlessness and suspense, but its ultimate perspective is past tense: the memoirist is gazing back, and may at any time dramatically bring us into his or her present tense which, in terms of the memoir, is future tense. (In *The Autobiography of Malcolm X,* for instance, a chapter concludes bluntly: "All praise is due to Allah that I went to Boston when I did. If I hadn't, I'd probably still be a brain-washed black Christian." Such starkly offered wisdom would be obtrusive in a work of fiction but would seem here to satisfy the reader's need to be assured that a recitation of biographical facts is more than a recitation of mere facts. *How I came to be who I am* is the continuous subtext.) In a yet more disarming gesture, retrospective vision in the memoir is aligned with the act of composition, and the reader is made to feel privileged by being taken

into the memoirist's confidence. (As at the conclusion to the harrowing opening chapter of Maxine Hong Kingston's *The Woman Warrior*: "In the twenty years since I heard this story I have not asked for details nor said my aunt's name; I do not know it . . . My aunt haunts me—her ghost drawn to me because now, after fifty years of neglect, I alone devote pages of paper to her . . .")

The Liars' Club is a luminous account of childhood amid unreadable, unpredictable adults: Mother, Father looming like demigods in a cracker-box house in Leechfield, Texas; and so it's akin to a *coup de theatre* to see them, and Leechfield, through the abruptly adult eyes of Mary Karr the writer, self-conscious in her task even as she's still in thrall to the emotional undercurrents of her childhood. Returning to tend to her dying father, Karr is shocked by the now financially devastated and depopulated Leechfield, for one quality of ugliness would seem to be durability; the memoirist confides in the reader:

> I set down in my journal the businesses we passed that night: nail-sculpting salon, knickknack shop, trophy store, aerobic-dance studio, K-9 dog-training school. There was a diet center that sported a plywood cutout of a pink pig . . . The bubble coming from this pig's mouth held this phrase: A New Way To Lose Weight Without Starving to Death . . . You could also get chemotherapy in a modern cinderblock building, which didn't surprise me since the town formed one of the blackest squares on the world cancer map. (It's still right up there with Bhopal and Chernobyl.)

A writer's journal! Can this account for the minuscule details of Karr's childhood? (Obviously not. This journal is mostly after-the-fact.) Though the primary focus of *Liars' Club* is Mary's childhood, and that of *Cherry* is adolescence, yet the powerful ending of *Liars' Club* takes us into a present when the narrator is an adult, while *Cherry*, to its disadvantage, ends somewhat abruptly in the past, with the seventeen-year-old Mary Karr, besotted by surfing and psychedilia, and with a yearning for sexual adventure, planning to leave home for Los Angeles with (male) druggie companions in a rattletrap truck. Ideally, *Cherry* should be read in tandem with *Liars' Club*, which yields a more expansive vision, though certainly it stands on its own as a fully achieved, lyrically rendered memoir of a bright young girl's coming-of-age in America in the 1970s.

. . .

IT WOULD have been presumed, when Mary Karr's *The Liars' Club* appeared in 1995 with much critical acclaim and commercial success, that the brash, mordantly funny memoir was the forty-one-year-old author's first book, but in fact Karr had published two books of poetry with New Directions, *Abacus* (1987) and *The Devil's Tour* (1993), and was writing the poems to appear in *Viper Rum* (1998). Much of Karr's tersely written, elegiac poetry is steeped in autobiography; without sentiment and without ornamentation; lacking, perhaps, the zestful energies and startling colloquialisms of the memoirs. Close-ups of aging, ailing parents, the long-ago demigods of childhood, provide the most moving subject matter, yet don't begin to suggest the distinctiveness of personality of Mother and Daddy of the memoirs. The once-beautiful, charismatic mother who could charm an eighty-year-old Texas judge into releasing her daughter, arrested on a drug charge, is now "gnarled as a tree root," ravaged by illness to a "meat hunk" that manages, still, outrageously, to smoke cigarettes. And Daddy, so compelling a presence in *Cherry*, is dead, cremated; evoked nostalgically in "The Patient" in which he directs his ten-year-old daughter to put him down one day when he's aged and decrepit. The father who drank himself to death haunts the poet: "Why can you not be / reborn all tall to me? If I raise my arms / here in the blind dark, why can you not / reach down now to hoist me up?"

Viper Rum concludes with an essay on poetics, "Against Decoration," which takes on, with commendable chutzpah, Neo-Formalism in contemporary American poetry ("obscurity of character," "foggy physical world," "overuse of meaningless references," "metaphors that obscure rather than illuminate," "linguistic excess for no good reason") and such mandarin poets as Amy Clampitt ("Clampitt's purple vocabulary sounds to me like a parody of the Victorian silk Pound sought to unravel") and James Merrill. ("Merrill . . . may well have been the first emperor of the new formalism. I contend that this emperor wore no clothes—or, to use a more accurate metaphor, that the ornamental robes existed, but the emperor himself was always missing.") Karr's passion for poetry is evident in her unfashionable willingness to speak polemically, charging that much of contemporary poetry is precious, vapid, and obscure; and stating that poetry should be, following Horace, *dulce et util,*

"sweet and useful." No poetry can be worthwhile, Karr argues, that lacks emotional content and clarity. Surely the same is true for prose?

If *Cherry* is less steeped in mystery and wonder, thus in suspense, than *Liars' Club,* it's because its protagonist is older, more canny, analytical, self-conscious. Mother and Father are beginning to lose their power and will become, by the memoir's end, "smaller somehow" than they once were. The first words of *Cherry* strike a chord of flight, freedom: "No road offers more mystery than that first one you mount from the town you were born to, the first time you mount it of your own volition, on a trip funded by your own coffee tin of wrinkled up dollars." The vision is thrilling, romantic: "Your young body is instantly a fresh-lit arrow notched and drawn back and about to be loosed." Yet the adolescent Mary who has imagined herself a rebel is rather hurt by her parents' willingness to let her go to Los Angeles with a gang of drug-taking friends and a mere one hundred dollars: ". . . Your mother's unbridled enthusiasm for this half-baked enterprise of yours sets a cold wind blowing through you." Yet, had Mary's parents tried to stop her, she would surely have left in any case, determined to plunge into the frenzied life of the drugged-out era: "When the blind seer in *The Odyssey* foretold the loss of all companions, that portent went unheeded."

But *Cherry* is the prelude to California, a pitiless examination of Leechfield, Texas, and a lyrically detailed preparation for the adolescent Mary's reckless plunge into the unknown. The memoir takes us through Mary's elementary school years ("our names ran together like beads on a string, JohnandBobbieClariceandCindyandLittleMary [as opposed to Big Mary, who was Mary Ferrell]") with a scrupulosity reminiscent of Margaret Atwood's *Cat's Eye,* a darker examination of the secret lives of prepubescent girls; through Mary's early infatuations with boys ("Time will never again stretch to the silky lengths it reaches that spring when you and Phil first sit entangled in his car, the odor of narcissus and jasmine and crab-apple blossoms blowing through the open windows on black wind. Nor will kisses ever again evolve into such baroque forms, delicate as origami in their folds and blendings") and her first sexual experiences, which leave her initially blissful, then abruptly disillusioned. ("Once you get to [Phil's] dorm room, you find the odor of old pizza unfathomably discouraging.") A rocky, rebellious adolescence is characterized by an increasing estrangement from adults ("Without math, you'll wind up being no more than a common prostitute," smugly predicts the

principal of Leechfield High) and involves a tentative suicide attempt by way of Anacin tablets washed down with orange juice ("Having cried yourself quiet, you now lie down . . . and cross hands over your chest and arrange the skirt so your underpants aren't gaping out at everybody. In this pose, you wait to die") that ends, fortunately, in vomiting.

Much of the latter part of *Cherry* concerns the young heroine's initiation into drugs at age fifteen: a friend's brother provides "valium by the packet and even birth control pills in round spaceship-like compacts . . . plus there are colored pills for any mood—methamphetamine (black mollies and white crosses), opiate derivatives like codeine, phenobarb in every dose level, nembutal (yellow jackets), seconal (red birds)." Plus pot, of course, and LSD. Lots of LSD. Smack, or heroin, holds little romance: "The one time you blammed heroin, you puked your way into nod-off, waking up astonished that guys would steal TVs for that stuff." Though *Cherry* ultimately makes a statement against drugs, noting their malevolent power to permanently alter personality for the worse, the reader is likely to be impressed, if not incredulous, that an individual who has so lavishly experimented with drugs can have survived to write even a coherent sentence, let alone draw conclusions from her experience: "With the aid of hallucinogens, you set off like some pilgrim whose head teems with marvels and vistas, baptismal rivers from which you plan to emerge purified. But what's longed for usually bears no resemblance to what you find." Funnily, Mary's most phantasmagoric acid trip yields her a platitude of stunning irony: "There's no place like home."

Most readers will consider Karr inordinately forgiving of her improvident, immature, hard-drinking parents. That she loves them both—and doesn't wish to judge them harshly—is clear. There is something chilling, however, about a father telling his ten-year-old daughter that she can do anything she's "big enough" to do; a father who "you'll hear . . . has a mistress much younger than he is, a waitress, whose husband . . . will put a bullet first through her skull, then his own." Mother, the red-haired siren of *Liars' Club* who has had seven marriages to six husbands (having married Daddy twice), continues her habit of disappearing from the household without warning or apology, arousing anxiety in both her daughters, who are forced to become her caregivers; she's an intelligent and perhaps even talented woman, but wholly unreliable; when Mary is arrested in a drug bust, she comes to fetch her home from jail, but registers not a scintilla of maternal concern: "Apparently, even getting thrown

in jail doesn't register a jag in your mother's heartbeat." In a reversal of one's expectation, given Mary Karr's youthful rebelliousness, it's Mother who insists upon her going on the pill (at age fourteen), while Mary protests she neither has nor wants a steady boy friend; unhearing, Mother reiterates, "If you want to have sex, so be it. Just don't get pregnant."

Like *Liars' Club, Cherry* ends on a resolute, upbeat note, with Mary's experience of a girl friend's kindness and in her realization that she possesses, for all her swings of mood and fortune, a "Same Self" that will endure. Yet the memoir's lingering tone is brooding, melancholy; beneath the sparkling prose surface there's a "repository of silence" we hear all too clearly. No child, however eloquent, should have to grow up so young.

Notes

1. Acknowledged by contemporary memoirists as primary influences in the genre are James Baldwin's *Notes of a Native Son* (1955), Frank Conroy's *Stop-time* (1967), and Tobias Wolff's *This Boy's Life* (1989).

2. Notable recent memoirs of this type are Mikal Gilmore's *Shot in the Heart* (1994), a younger brother's account of the family life of the executed Utah murderer Gary Gilmore; Kathryn Harrison's *The Kiss* (1997), a stylishly anorexic account of Harrison's protracted love affair with her father, which aroused outraged censure from conservative critics; Jane Bernstein's *Bereft: A Sister's Story* (2000), whose subject is the author's long obsession with her dead sister, murdered years ago while a college student; Elizabeth Kendall's *American Daughter: Discovering My Mother* (2000), a double memoir of the St. Louis–born author and her mother, who was killed in the accidental crash of a car driven by Kendall at the age of twenty-one; and Bill Henderson's quirkily lyrical, inspirational *Tower* (2000), which chronicles Henderson's one-man construction of a tower in rural Maine during a time of "middle-aged hypochondria and panic."

Evolutionary
Fever

Servants of the Map
Andrea Barrett

SERVANTS OF THE MAP IS AN INSPIRED
title for Andrea Barrett's painstakingly crafted book, a gathering of five
thematically interwoven stories and a novella linked by theme and char-
acters to her preceding *Ship Fever* (1996), itself a gathering of inter-
woven stories and a novella. Both collections deftly explore "the love of
science and the science of love—and the struggle to reconcile the two,"
as Barrett has said, and both contain vividly imagined historic situations
(in "Ship Fever," the typhus epidemic and Canadian quarantine of 1847,
following in the wake of the Irish potato famine; in "The Cure," the
novella that concludes *Servants of the Map* and continues the adventures
of an Irish survivor of "Ship Fever," the establishment of tuberculosis
"rest-cure homes" in the Adirondack Mountains in the early years of the
twentieth century).

In both collections, men and women behave with uncommon selfless-
ness and intelligence, as "servants" of one kind or another: naturalists,
explorer-mapmakers, chemists, biologists, ornithologists, geneticists,
geographical botanists, physicians, nurses, teachers. Barrett's favored era
is the mid-nineteenth century when virtually everyone, even young chil-
dren, is given to nature walking and collecting; it's a time of exploration
and discovery when, among the wealthy and acquisitive, "glass cases

filled with tropical creatures arranged by genus or poised in tableaux were wildly fashionable" (*Ship Fever*), and an ambitious young man could make a name for himself by striking out for the Amazon and paying the expenses of his trip by gathering birds, small mammals, land-shells, and "all the orders of insects." It's an exhilarating era when remote parts of the earth are being mapped, ever-new subspecies of animals, plants and insects are being discovered, and new sciences like genetics are being developed. Charles Darwin's *Origin of Species,* Asa Gray's *Lessons in Botany and Vegetable Physiology,* and Joseph Hooker's *Himalayan Journals* are being avidly read. Men and women write lengthy, elegantly composed letters to one another, sometimes in lieu of seeing one another for years. Lovers are steadfast in devotion, long-lost brothers and sisters are haunted by dreams of reunion. A Christian schoolmaster devotes his intellectual life striving to "reconcile the truths of Scripture with those of geology" (*Servants of the Map*). A young husband and father risks his life in the service of the British Trigonometrical Survey of India in the Himalayas, by degrees discarding his map-making vocation for the exotic pleasures of geographical botany ("Servants of the Map"); a young naturalist/collector explores such remote and dangerous places as the Amazon, Borneo, and Sumatra, in his hope of achieving renown like his friendly rival Alfred Wallace, but is fated to labor in Wallace's shadow ("Birds With No Feet," *Ship Fever*); a married couple, after early lives of privation, establishes the first Academy for the Deaf in the United States, in Ohio in the 1820s ("Two Rivers," *Servants of the Map*).

In an age of postmodern irony and distrust of science, there is an appealing young-adult earnestness in Andrea Barrett's nineteenth-century seekers that renders them both naive and heroic. Unlike A. S. Byatt, whose tour de force *Morpho Eugenia* (1992) combines the author's romantic interest in Victorian science and social mores with laser-eye irony,[1] and unlike Joanna Scott, whose Neo-Gothic tales of antiquarian science, medicine, and taxidermy[2] yield mordantly compelling psychopathological portraits, Andrea Barrett is straightforward in her presentation of exemplary men and women; she would seem to have no intention, for instance, in a story like "Servants of the Map," of indicting them as flunkies of the British Empire in its colonizing of the dark-skinned races of the globe for purely financial purposes. Barrett's seekers after truth are apolitical: Caleb, the fossil-hunter of "Two Rivers," looks

for fossils in a pre–Civil War America strangely untouched by the crucial issues of the day; Caleb's concerns aren't other-worldly so much as this-worldly in the most literal sense, the earth at his feet. The young man's vision is analogical and shaped by admiring wonder, like his father's:

> If we could fly, we would see from the clouds the clear waters of the Allegheny flowing down from the north, the muddy waters of the Monongahela flowing up from the south, two rivers merging into the Ohio at our house and forming a great Y. By that enormous letter we are meant to understand . . .

The passage breaks off, but the admonition is clear: human beings are meant to understand the world that surrounds them. For those intrepid servants of the map whose lives are shaped by their quests, there isn't the energy or imagination to perceive how their activities as individuals might be morally compromised by the conditions of their employment. Andrea Barrett portrays them as pioneers in the service of pure knowledge, risking their lives and personal happiness for the advancement of scientific knowledge.

In the fifty-page story that opens Barrett's new collection, the subtly realized "Servants of the Map," a young surveyor in the employ of the Crown's Grand Trigonometrical Survey of India writes to his wife back in England, in 1863:

> What draws me to [Hooker, Darwin, Gray] and their writings is not simply their ideas but the way they defend each other so vigorously and are so firmly bound. Hooker, standing up for Darwin at Oxford and defending his dear friend passionately. Gray, in America, championing Darwin in a series of public debates and converting the world of American science one resistant mind at a time. Our group here is very different. Although the work gets done—the work always gets done, the maps accumulate—I have found little but division and quarrels and bad behavior.
>
> You may find my handwriting difficult to decipher; I have suffered much from snow-blindness. And a kind of generalized mountain sickness as well. We are so high [21,000 feet], almost all the time; the smallest effort brings on fatigue and nausea and the most piercing of headaches. I sleep only with difficulty; it is cold at night, and damp.

Our fires will not stay lit. But every day brings new additions to our map, and new sketches of the topography: you will be proud of me, I am becoming quite the draughtsman.

Absent from his wife and young family for many months, Max Vigne begins to lose his emotional connection to them; when he receives his wife's letters, they strike him as addressed to a man who no longer exists, if he ever did. He fantasizes writing to his wife, "Who am I? Who am I meant to be? I imagine a different life for myself, but how can I know, how can anyone know, if this is a foolish dream, or a sensible goal? Have I any scientific talent at all?" Max's dream is to be a geographical botanist in the mode of Joseph Hooker who might "spend his life in the search for an answer—'Why do rhododendrons grow in Sikkim and not here?'" By the story's end, Max Vigne has decided not to return home with the others in his crew, but he can't yet tell his wife. "Servants of the Map" is a poignant story, brilliantly evoked in its high-altitude setting and in the paradoxes of experience *in extremis:*

> It's an odd thing, though, that there is not much pleasure in the actual recording. Although I am aware, distantly, that I often move through scenes of great beauty, I can't *feel* that as I climb; all is lost in giddiness and headache and the pain of moving my limbs and drawing breath. But a few days after I descend to a lower altitude, when my body has begun to repair itself—then I look at the notes I made during my hours of misery and find great pleasure in them. It is odd, isn't it? That all one's pleasures here are retrospective; in the moment itself, there is only the moment, and the pain.

Not until the concluding tale of *Servants of the Map,* "The Cure," do we learn that Max Vigne has become a world-explorer and collector who "attaches himself to expeditions . . . any kind of expedition you can imagine. There's always a need for someone who can collect and classify plants." Clara Vigne, the left-behind wife and mother, speaks of her absent husband with barely disguised impatience and hurt, but never accuses him of having abandoned her to raise their young daughters by herself. Far from feeling outrage on Clara's behalf, as a contemporary observer might, seeing that the woman's naive good nature has been exploited, an acquaintance admires her stoicism: "It's a kind

of courage. The way she waits, and takes care of his life for him. I admire that."

Clearly we are meant to admire Clara, too, and we are meant to admire the explorer-collector Max, for the impersonal quest for truth takes precedence over the merely personal, as the sacrifice of one's life in providing emergency medical help for victims of the typhus epidemic in "Ship Fever," for instance, is heroic. Nora Kynd, a typhus survivor who becomes a nurse and helps establish a rest-cure home in the Adirondacks is a woman for whom the description *plucky* might have been coined:

> "You'd live here," Elizabeth said. "With us. I'll manage the business end, and do the cooking, and hire whatever other help we need; and you'll supervise the health of the invalids."
>
> Nora's face lit up and her eyes glowed; she seized Elizabeth's hands in both of hers and said, "*Really?*" As if Elizabeth, in offering her hard work and a daily acquaintance with sickness and death, were giving her an enormous present. As if, Elizabeth thinks now, it hadn't been Nora who had given her everything. For seven years they worked together, building a reputation that extended far beyond the village. For seven years . . . they shared the care of the boarders, the surprises of their lives, and, occasionally, their deaths. When Nora finally sickened—"It is my *heart*," she said, with peculiar pleasure. "My *heart*, not tuberculosis"—she chose to spend her last days in her room at the house.

If there is a problem with such indomitably good characters it isn't that they are too good to be true but that, in prose fiction, "goodness" is as much a liability as extreme empathy would be in contact sports: we come to feel impatience with Barrett's characters who seem rather more representative or allegorical than real, like historic figures who have been lovingly crafted and costumed in a museum display. Their language, both spoken and written, has an air of the poetically self-conscious:

> "What makes you happy?" Mr. Wells asked. We were out in the garden again. This is a question no one has ever asked me . . .
>
> "To be out here at night," I told him. "On a clear cold night when the dew is heavy, to walk on the grass between the marigolds and the

Brussels sprouts and feel my skirts grow heavy with the moisture. Or to go further, into the hayfield, where the mist hangs above the ground, rising nearly to my waist . . ."

["Theories of Rain"]

Their stories have an air of stasis about them, often narrated in a breathless present tense in which every lived moment exudes mystery and wonder:

But here is her house. Here is her house. Not a duty, but her living self. It is as if, she thinks, as she moves toward Martin and Andrew and all the others up the walk and the clean brick steps, her hand reaching of its own accord for the polished brass knob in the four-paneled door, as if, in the order and precarious harmony of this house and those it shelters she might, for all that gets lost in this life, at last have found a cure.

["The Cure"]

Barrett's several contemporary stories, "The Marburg Sisters" in *Ship Fever* and "The Forest" and "The Mysteries of Ubiquitin" in *Servants of the Map,* which continue the adventures of the Marburg sisters, move much more swiftly and dramatically than her period fiction, though they deal in part with science, and the Marburg sisters are self-consciously brainy descendants of Max Vigne:

"You're in college?"

[Bianca] tossed her hair impatiently. "Not *now*. My sister and I were dreadful little prodigies—in college at sixteen, out at nineteen, right into graduate school. Rose already has her Ph.D . . ."

["The Forest"]

When we first encounter Bianca and Rose Marburg in *Ship Fever,* in a long, disjointed story that reads like an aborted but promising autobiographical novel, the sisters are adults still in mourning for their mother Suky who died when they were in grammar school, leaving them not fatherless exactly but emotionally rudderless—wild girls "in a place that seemed like wilderness" in upstate New York on Keuka Lake. Suky, in the mode of Nora Kynd, is one of those exemplary human beings who touch others magically, and whose deaths are felt as irrevocable losses.

As we might expect, the Marburgs are a scientifically minded family: Suky has dabbled in botany, her specialty mosses; Grandpa Leo, who has established a successful winery in Hammondsport, New York, is an amateur chemist, like the sisters' father. As a child of nine the precocious Rose had wanted to be an entomologist, having fallen in love with a charming family friend named Peter, a biologist who enlisted her in his nocturnal beetle-collecting. In flashback, the beetle-hunting scene is tenderly and romantically portrayed:

> "Fabre called the species of *Nicrophorus* native to France 'transcendent alchemists,'" Peter said. "For the way they convert death into life." He let Rose hold the beetles briefly before he placed them in his vial. "You always find them in couples—a male and a female, digging together to provide the family larder. They push away the dirt below their quarry until the corpse buries itself. And all the time they do that they secrete chemicals that preserve the body and keep other insects from eating it. Then they copulate—may I say that word in front of you?—and the female lays her eggs nearby. When the larvae hatch they have all the food they need. Aren't they pretty?" ["The Mysteries of Ubiquitin"]

Though the scene occurs in 1964, there's a Victorian courtliness to Peter's speech. Like the mythically empowered butterflies and ants of A. S. Byatt's *Morpho Eugenia*, Barrett's beetles exude a symbolic significance meant to suggest human actions.

The Marburg sisters, as young children, are keenly aware of their mother's reverence for her collector-grandfather Max Vigne, whose letters to her deceased mother Suky cherishes; the girls are made conscious at an early age of sharing a special destiny, though the destiny isn't clear, and after Suky's abrupt, accidental death, well into adulthood they seek her advice in alcohol- and drug-addled rituals instigated by Bianca. The less stable sister, Bianca drops out of graduate study in biochemistry to lead an unmoored hippie-style life in the 1970s while Rose, the elder and more competitive, immerses herself in molecular biology and becomes enormously successful at a young age:

> "I look at a protein called ubiquitin . . . It has that name because it's so abundant, and found in all kinds of cells—in people, beetles,

yeasts, everything. And it's almost identical in every species . . . What it does . . . in your cells, in any cell, proteins are continuously synthesized and then degraded back into their component amino acids. The degradation is just as important as the synthesis in regulating cellular metabolism. Ubiquitin molecules bind to other proteins and mark them for degradation. Without that marking and breaking down, nothing in the cell can work. I try to sort out the details of the protein-degradation process."

[*"The Mysteries of Ubiquitin"*]

As in a romance, Rose's first love Peter re-enters her life, much older, of course, in his fifties, while Rose is thirty-one—"the youngest Senior Fellow at the Institute." In a painful reversal of fortune, Peter has remained an old-fashioned "whole-animal" biologist while Rose has excelled in the hot new chemistry-based biology that brings not only prizes and recognition but large research budgets. Not meaning to be condescending, Rose asks Peter: "Is it still beetles with you?" Unluckily for Peter, it is. Their love affair is a sentimental gesture on Rose's part, but clearly doomed: "Each day seemed to increase the disparity in their professional situations, and neither could help knowing that Rose's star was rising fast while Peter was struggling just to stay in place." It's a brilliant choice for Barrett to bring the lover-biologists together at a time in the history of science when a new biology, disdainful of individual organisms, concentrating rather on the molecular, and cut-throat competitive as any capitalist enterprise, has swept all before it. The science of our era, Barrett suggests, is populated by careerists who take little pleasure in science any longer, as their starry-eyed nineteenth-century predecessors did.

Barrett's previously published fiction has been less ambitious than *Ship Fever* and *Servants of the Map,* and less mannered in style. Her third novel, *The Middle Kingdom* (1991), though artfully designed to jump backward in time, is characterized by fairly ordinary language in a familiar nascent-feminist mode. Visiting in China, an American woman named Grace feels a sudden sisterly rapport with a Chinese woman doctor, and begins complaining to the woman of her seemingly insufferable husband:

What was the harm in telling her? I thought about the way he wouldn't eat unless the food sat correctly on his plate—peas here, potatoes there; no drips, no drops, no smears. How he couldn't sleep

without the top sheet tucked in all around him; how he liked his women as neat as his mother. Smooth, groomed, no visible pores or swellings, no fat—my God, my fat! How he dressed after the manner of Einstein . . . And how uncomfortable he was here in China, how much he disliked the steamy, crowded buses, the old clothes, the crowded sidewalks . . . the smells, the dirt, the noise . . . I thought about that astigmatism of his, that twist which made him see the worst in anything, and about his ability to make others see the same way, as if he'd etched their corneas with acid rain.

The object of such scorn is an American academic, a lake ecologist, who has brought his wife with him to the 1986 Beijing International Conference on the Effects of Acid Rain, and will be stunned to learn, in his callow egotism, that he will be returning home without her. Grace, the complainant, is a virtual archetype—or stereotype—of pre-awakened Wife:

> I felt like a cross between a goddess and a whale—a goddess for my long, straight, pale-blond hair, which was streaming down my back in wild disorder, and a whale for my astonishing size. I'd gained thirty pounds in the past nine months and hadn't been so heavy since I was sixteen. My arms quivered when I moved, and in that room of short, slight men I felt as conspicuous as if I'd sprouted another head.

Those sections of *The Middle Kingdom* set in Beijing—the city with the worst acid rain in the world—are the most interesting, though Grace with her weight problem and nagging self-absorption is a distracting lens through which to view a foreign, complex, politically troubled culture. Barrett's abiding interest in science holds the disjointed novel together: "There are two laws of ecology. The first is that everything is related to everything else. The second is that these relationships are complicated as hell."

Like Alice Munro, Barrett writes stories so richly imbricated with detail, so intensely focused upon introspective characters moving back and forth through significant periods of time, the stories read like distilled novels rather than conventional short stories. In both writers pacing is extremely leisurely, sometimes to the degree to which the original narra-

tive momentum is in danger of being lost. Both writers combine fiction with an elastic, essay-like form that can accommodate large dollops of information, including sometimes passages from letters and other documents. Though described as a short story collection, *Servants of the Map* is perhaps more accurately seen as an eccentrically shaped novel in which virtually everyone is discovered to be related, however distantly, to everyone else, as in an immense tapestry of a genealogical chart. Perhaps Barrett's strongest writing is in the evocation of the visionary quest itself. Not "servants of the map" but the vast, mysterious map itself is of enduring interest: the culture of science, the communal expansion of human consciousness in the drama of what's called evolution. This is Barrett's subject, and it's a commendably ambitious one.

Notes

1. One of two novellas published as *Angels and Insects, Morpho Eugenia* (a species of exotic Amazon butterfly) is a virtuoso performance by Byatt. In it she explores "the blind violence of passion" in such social creatures as ants and Homo sapiens, in an ingeniously imagined ant-hill of a Victorian country estate.

2. *Various Antidotes: Stories* (1994) and *The Manikin* (1996). Like Byatt, Scott is a virtuoso writer in whose highly original imagination the materials of research are wholly transformed. The settings of *Various Antidotes* range from seventeenth-century Amsterdam and eighteenth-century Paris to upstate New York on the Mohawk River; *The Manikin* is an elaborately constructed Gothic tale set in an eccentric taxidermist's mansion. Scott's characters are both bizarre and quite ordinary-seeming, often addressing us, like the aged, hallucinating Dorothea Dix, in brilliantly sustained monologues.

"New Memoir":
Alice Sebold's
Lucky

Lucky
Alice Sebold

A LICE SEBOLD IS THE AUTHOR OF THE first novel *The Lovely Bones* (2002), one of those bestsellers described as "runaway" to distinguish them from more lethargic bestsellers that merely slog along selling copies in the six-figure range. Though deftly marketed as an adult novel with a special appeal to women, *The Lovely Bones* is in fact a young-adult novel of unusual charm, ambition, and originality. Its most obvious literary predecessor is Thornton Wilder's *Our Town,* in which the deceased Emily is granted omniscient knowledge of family, friends, and community after her death; a subtly orchestrated wish-fulfillment fantasy that allows audiences to weep, and at the same time feel good about weeping. Not the deep counterminings of tragic adult literature here, which suggests that death is not only painful but permanent, and that we are not likely to hover above our families as they mourn us, but a fantasy in which an event of surpassing horror (a fourteen-year-old girl raped, murdered, dismembered by a neighbor who is never apprehended for the crime) is sketchily narrated in the first chapter, to provide background for a story of mourning, healing, and re-

demption: "Heaven wasn't perfect. But I came to believe that if I watched closely, and desired, I might change the lives of those I loved on Earth." *The Lovely Bones* might be called "inspirational" fiction in its simulation of tragedy in the service of survival, since its goal is to confirm what we wish we could believe and not to unsettle us with harsh, intransigent truths about human cruelty. Written with the wry panache of contemporary young-adult fiction, its tone gamely "light" and chatty, *The Lovely Bones* is something of an anomoly: a "survivor" tale that is in fact narrated from Heaven. Following the terrorist attacks of 9/11 that left many Americans stunned and reeling, yearning to be assured of the possibility of Heaven and the immortality of the human soul, the extraordinary success of Alice Sebold's first novel is perhaps not so mysterious. Like Harper Lee's *To Kill a Mockingbird*, another young-adult novel skillfully marketed for an adult audience, *The Lovely Bones* tells a good story, and provides us with good, sympathetic characters with whom we can "identify."

For those to whom *The Lovely Bones* is simply too sugary a confection to swallow, Sebold's memoir *Lucky*, the author's first book (published in the United States in 1999), will be something of a revelation, if not a shock. For *Lucky* is an utterly realistic, unsparing, and distinctly unsugary account of violent rape and its aftermath in the author's life, based upon her experience as an eighteen-year-old freshman at Syracuse University in May 1981. Where the novel transports us immediately to a fantasy Heaven, the memoir transports us immediately to a very plausible Hell:

> In the tunnel where I was raped, a tunnel that was once an underground entry to an amphitheater . . . a girl had been murdered and dismembered. I was told this by the police. In comparison, they said, I was lucky.

Lucky is terse, ironic, controlled and graphic. It begins with a literally blow-by-blow account of the protracted beating and rape suffered by Sebold as a university freshman surprised in a park by an assailant who will turn out to be a resident of the city of Syracuse with a prior police record, a young black man so arrogantly self-assured that, when he and Sebold accidentally meet on a Syracuse street some months after the rape, he laughs at her terror: "Hey, girl. Don't I know you from some-

where?" After the ordeal of a preliminary hearing and a trial during which the rapist's defense attorney attacks Sebold's testimony with every weapon allowed in courtroom procedure, her rapist is found guilty of first-degree counts of rape and sodomy and is sentenced to eight to twenty-five years in prison—with time off for good behavior, the minimum eight years could be considerably reduced. Should anyone imagine that a jury verdict of "guilty" is a happy ending to any crime case, Sebold notes that the rape of her friend and roommate the following year in Syracuse is theorized by police to have been a "revenge" rape committed by friends of the convicted man, and includes a harrowing final chapter in which she speaks of years of drinking, drug addiction, and psychological unease that followed her rape: "I loved heroin . . . Ecstasy and mushrooms and acid trips? Who wanted to enhance a mood? My goal was to destroy it."

Ours is the age of what might be called the New Memoir: the memoir of sharply focused events, very often traumatic, in distinction to the traditional life-memoir. The New Memoir is frequently written by the young or relatively young, the traditional memoir is usually the province of the older. In this sub-genre, the motive isn't to write a memoir because one is an individual of stature or accomplishment, in whom presumably readers might be interested, but to set forth out of relative anonymity the terms of one's physical/psychological ordeal; in most cases, the ordeal is survived, so that the memoirist moves through trauma into coping and eventual recovery. Though the literary structure may sound formulaic, exemplary memoirs like *Lucky* break the formula with their originality of insight and expression. Like most good prose works, *Lucky* is far from unambiguous: the memoir can be read as an alarming and depressing document, and it can be read as genuinely "uplifting." The pivotal point in Sebold's recovery doesn't occur until years after the rape when, ironically, she comes upon her own case discussed in Dr. Judith Herman's *Trauma and Recovery* in terms of "post traumatic stress disorder":

[Individuals suffering from this disorder] do not have a normal "baseline" level of alert but relaxed attention. Instead, they have a baseline of arousal: their bodies are always on the alert for danger . . . Traumatic events appear to recondition the human nervous system.

The act of writing a memoir can be seen, ideally, as an act of reclaiming the victim's very nerves. Having been encouraged by her admirable writing instructors at Syracuse, Tess Gallagher and Tobias Wolff, to remember as much as she can and to write freely about it, Sebold will come in time to discover

> that memory could save, that it had power, that it [is] often the only recourse of the powerless, the oppressed, or the brutalized.

When Sebold was raped at the age of eighteen she was, unlike the majority of her classmates, a virgin, inexperienced in sexual matters. This fact would be many times reiterated in police and court documents as if, had the victim not been a virgin, the rapist's assault would not have been so heinous and the victim's claim of rape might have been undermined. The (suspicious, male) detective assigned to Sebold's case is finally more sympathetic because Sebold was a virgin than he would have been otherwise, though in his initial report, after having interrogated the injured, dazed, exhausted and sedated Sebold at length, in the middle of the night, the detective comes to the thoroughly unwarranted and arbitrary conclusion that Sebold was not being "completely factual" and that her case should be referred to the "inactive file." After Sebold's painfully vivid description of the assault and rape, the quoted police report is a masterpiece of banality, its flat, stereotypical language seemingly calculated to minimalize the horrific experience.

It will be upsetting for many readers, and certainly for women, to learn that the rape victim must "perform" convincingly, if she is to be believed. In giving police and courtroom testimony, it isn't enough to simply tell the truth ("If you just tell the truth, you lose"); one must play a prescribed victim-role, dress the part as deliberately as if one were appearing in a stage play, and above all appear innocent, humble, even repentant and apologetic in the face of others' suspicions ("Juror: Didn't you know that you are not supposed to go through the park after nine-thirty at night? Didn't you know that?"). Sebold endures the ordeal of the trial with a minimum of bitterness: "While still in court I thanked the jury. I drew on my resources: performing, placating, making my family smile. As I left that courtroom I felt I had put on the best show of my life." Sebold's experience helps to explain why, in the United States, it's believed that approximately 50 percent of rapes are never reported to po-

lice. For many women, the ordeal of rape's aftermath is simply not worth it.

Lucky is interlarded with astonishing remarks made to Sebold by well-intentioned but unthinking individuals, including Sebold's father: "How could he have raped you unless you let him?" Comparing Sebold with her allegedly more sensitive sister, Mr. Sebold says: "If it had to happen to one of you, I'm glad it was you and not your sister." Another classic line is delivered by a feminist psychiatrist: "Well, I guess this will make you less inhibited about sex now, huh?" After Sebold has managed to write a poem expressing hatred of her rapist, a fellow (male) poet protests not to understand: "You're a beautiful girl." Months after the rape when Sebold is trying gamely to lead a normal life, she assures a man in whom she is romantically interested that she has had sex three times since the rape, though in fact she has not had sex, and he says with approval: "That's a good amount. Just enough to know you're normal." The most devastating of remarks, however, is delivered by the rapist himself when he sees his victim naked: "You're the worst bitch I ever done this to."

Where *The Lovely Bones* ends with the greeting-card sentiment, "I wish you all a long and happy life," *Lucky* ends on a more ambivalent note: "It is later now, and I live in a world where the two truths coexist; where both hell and hope lie in the palm of my hand." That the victim-memoirist would one day make of her trauma the "runaway" *Lovely Bones* is a wonderfully ironic turnabout no one, surely not the victim, could have foreseen.

Property Of

Property
Valerie Martin

DEEP IN THE DARK XENOPHOBIC SOUL OF humankind there would seem to be a special terror of miscegenation: the "mixing"—"mongrelization"—of races. Where one race imagines itself as purer, closer to divinity than others, the terror may involve extreme acts of violence, even genocide. Knowing what we do today of the alleged biological imperative of the "selfish gene"—DNA blindly seeking to replicate itself with no regard, indeed no awareness of individuals—it seems self-evident that cultural, social, religious taboos are simply traditional ways of assigning a questionable objective value to primitive drives. For most of us, taboos lie too deep for introspection, let alone exorcism. We can analyze the biological underpinnings of taboos regarding incest, for instance, but we would probably not wish to attempt to violate them.

Valerie Martin's eighth novel *Property* begins with the cryptic and prescient remark: "It never ends." As in a film, we cut immediately to a cinematic scene, viewed through a spyglass by a narrator whose identity and sex we don't yet know; she will turn out to be the embittered, frustrated young wife, Manon, observing her husband acting out a crude, cruel sex game involving several young Negro boys who are his "property"—he's a slaveholder, a sugar planter in Ascension Parish, Louisiana, 1828. It is typical of Martin's technique in this tightly constructed, suspenseful monologue-novel to present actions visually, before

explaining them; we find ourselves in Manon's abject position, forced to observe, unable to intercede. The sex-scenario is humiliating to watch: "That's what the game is for. The boy tries to stay in the water, he hangs his head as he comes out, thinking every thought to make the tumescence subside. This is what proves they are brutes [the white man, Gaudet] says, and have not the power of reason." The scene makes of the reader a helpless voyeur of Manon's voyeurist experience of her husband's voyeurism, which quickly becomes violent, sadistic as he beats the Negro boys for their "raised members":

> Sometimes the offending boy cries out or runs away, but he's no match for the grown man with his stick. The servant's tumescence subsides as quickly as his master's rises, and the latter will last until he gets to the [slave quarter]. If he can find the boy's mother, and she's pretty, she will pay dearly for rearing an unnatural child . . .
>
> Often, as I look through the glass, I hear in my head an incredulous refrain: *This is my husband, this is my husband.*

Where there is taboo, there is continuous fascination. Where there is dread, there is desire. *Property* is a deftly sustained meditation upon such paradoxes, given a deeper resonance by its setting and by the unusual perspective of its narrator, a privileged white woman in the slaveholding South who is herself "property" of her husband, nearly as powerless as the slaves who serve her. Near the novel's end, after one of these slaves has fled the household in disguise as a white man, enjoying some months of freedom before she's caught, Manon observes that the Negro woman has tasted a freedom she and other white women will never know: "She has travelled about the country as a free white man."

TO BE a white man—even an ignorant, uneducated, failing planter like Gaudet—is of course to be "free": for sexual/racial taboos involve only one category of human beings, white women. Miscegenation is an unspeakable horror only if a white woman and a black man couple; that a white woman might give birth to a "mixed-race" baby is an obscenity from which not only custom but legal statutes protect us, while the reverse—white man, black woman, "mulatto" offspring—is common,

indeed integral to the society. Mulatto children are everywhere, light-skinned (female) "quadroons" are especially valued as sexual partners for white men. (In a mimicry of white debutantes' coming-out parties, "quadroons" are presented by their mothers at sumptuous Blue Ribbon Balls held in New Orleans, for the benefit of well-to-do white gentlemen who keep such practices secret from their wives and mothers.) Yet the white female of good family must play her prescribed role, secretly hoping, as Manon does, that her husband will be punished: "Although his ruin entails my own, I long for it."

> It was the lie at the center of everything, the great lie we all supported, tended, and worshiped as if our lives depended upon it, as if, should one person ever speak honestly, the world would crack open and send us all tumbling into a flaming pit. My future was dark and small . . . yet it was my duty to pretend I did not know it.

Manon is a vividly presented voice, poised, precociously cynical, mordantly amusing, despairing. We trust her as a truth-teller though we guess that we should not, for her fury at the bad luck of her life, masked as spiritual blankness and paralysis, distorts her vision. We would wish to think that Manon sees through the racist delusions of her society, but of course she does not; it would be a sentimental and unconvincing gesture for the author to isolate Manon in this way, despite the young woman's intelligence. Not unlike her husband, Manon too is obsessed with race. She is obsessed with the humiliation of having to live intimately with not only her husband's black mistress, Sarah, but in the same household with her husband's and Sarah's young deaf-mute son, Walter:

> So then we had the little bastard running up and down the dining room, putting his grubby fingers in the serving plates, eating from his father's hand like a dog. Sarah . . . watched, but she didn't appear to enjoy the sight much more than I did. The child is a mad creature, like a beautiful and vicious little wildcat . . . He has his father's curly red hair and green eyes, his mother's golden skin, her full pouting lips. He speaks a strange gibberish even Sarah doesn't understand. His father dotes on him for a few minutes now and then, but he soon tires of this and sends him away . . .

At times, Gaudet seems besotted by the retarded child, or by some distended image of himself in him; at other times, Gaudet slaps and beats him, making him howl and run in terror. Walter is the "wild" symbolic offspring of white slaveholder/rapist and black slave/female.

One of the inspired motifs of *Property* is Manon's obsession with Sarah. Long before Manon seems to realize it, we understand that Sarah is the only individual in Manon's life who means anything to her. Manon is bitterly jealous of Sarah, and yet Manon admires Sarah; Manon hates Sarah, thinking she would "sell" her if she could—but when Manon has the opportunity to sell Sarah for a very good price, after Gaudet's death, she refuses. From the first she has competed with her husband for Sarah's intimate attention. ("On the pretense that she is of some use to me, I had Sarah in my room all morning . . .") Wordless scenes between mistress and servant, tenderly and sensuously described by Manon, are surrogates for romantic, erotic experiences.

> I bade Sarah brush my hair . . . It relaxes me and gives her something to do . . . A fly buzzed around, landing on the mirror and crawling over our reflection. "Kill it," I said. She dropped my hair and took up a swatter. When she had smashed the thing, she wiped it away with a bit of rag. No sooner was this done than another came buzzing in at the window, skittering madly across the ceiling. "Finish my hair," I said, "and fill the trap." She took up my hair, which was already damp with perspiration, and began braiding it. I looked at her reflection, her face intent upon the task, a few drops of moisture on her forehead. She's an excellent hairdresser . . . When she was done, she pinned the braid up and my neck was cool for the first time all day.

The sickly languor of "slaveholding" is subtly communicated here; in her own less assertive way, Manon is as much a despot as her despised husband. Childless, she envies Sarah's fecundity (though younger than Manon, Sarah has two children) as she envies what she sees to be Sarah's "nerveless"—"inhuman"—state. As Sarah is trapped in the claustrophobic close quarters of slavery, so Manon her mistress is trapped in the claustrophobic close quarters of marriage, a witness to her husband's sexual exploitation of the servant girl:

The image of Sarah leaving my husband's room filled my head . . . Her hair was all undone, her eyes bright, she was wearing a loose dressing gown I'd never seen before and a dark mantle pulled over it. I had only the quickest look at her in the lamplight, but I'd seen a great deal . . . My head began to hammer. The room was so hot I was suffocating. I staggered to the dresser and poured out a glass of water, drank half of it, then poured the rest down the front of my shift. It was as if someone had slapped me . . . I gripped the table and hung my head forward, trembling from head to foot. A feeling of dread came over me and I realized that I was laughing.

Manon never loses an opportunity to denigrate her husband, however obliquely, in Sarah's hearing; she hopes to establish a bond between them based on their mutual hatred of Gaudet. Manon daringly encourages Sarah to believe that Gaudet suspects her of putting poison in his food, in this way hoping to give Sarah the idea of poisoning him. But Manon is surprised to discover that, unlike her, Sarah shrinks from looking through a spyglass.

Sarah backed away as if I'd asked her to pick up a roach. "No, missus," she said.

"And why not?" I asked.

"I don' like that glass."

"Have you ever looked through it?"

She looked down, shaking her head slowly . . .

"I'd look if I were you," I said. "You might see something you need to know."

For answer she took another step back.

"Or do you already know everything you need to know?" I said, turning back to the glass.

Manon doesn't quite realize that she is projecting her embittered, voyeuristic self upon Sarah, as, later in the narrative, she will come to believe that Sarah is involved in her husband's death during a violent slave insurrection.

Though Manon is vividly individualized, we understand that her experiences as daughter, naive young bride, despoiled and disillusioned

wife are representative of her social position. She marries a man she scarcely knows because her parents approve of Gaudet's background and money; Manon is a very pretty young woman, from a good family, but not rich. As a suitor, Gaudet appealed to her because he seemed mysterious: "I mistook his aloofness for sensitivity." A seemingly fastidious gentleman who required spotless, scented fresh linens, he impressed Manon by being unable to remain in the city because the sewer stench offended him. Yet this prissy Christian gentleman virtually rapes her on their wedding night:

> My invincible stupidity was revealed . . . [My husband] pushed the door shut with his boot. Mother's entire advice had been the word "submit," but I had no more idea of what I would be submitting to than I had of the workings of a steam engine. A likely metaphor! My husband roared over me like a locomotive. There were moments when it seemed to me his object was to pull my limbs from their joints. I glanced over his shoulder at the mantel clock, anxious to know how long the operation might take. My breasts . . . were so kneaded and sucked upon I feared they would be blackened by bruises. I wanted to shout to my mother, "Why did you not warn me?" . . . I looked into my husband's reddened face, at his eyes, which seemed to start from their sockets, at his lips swollen by his passion. Was there to be no trace of feeling for my helplessness, no tenderness in my marital bed?

It's a Sadean scene, and Manon's coolly clinical detachment in speaking of it has a distinctly literary sado-masochistic tone, belying the raw visceral experience being described. Sadean, too, is the unexpected and perhaps not altogether convincing response to Gaudet's crude copulations:

> I was not unhappy. There was the novelty of being greeted by friends who clearly thought I'd done well for myself. My husband had not yet begun his long descent into bankruptcy . . . The fury of my husband's nightly assaults did not abate, but they interested me, and I soon discovered I was strong enough to withstand him. I persisted in the delusion that the intensity of his abandonment was the direct result of some power I had over him . . . I went so far as to anticipate

his pleasure, I encouraged him, and found some pleasure in it. I entered the fray. Later, when I understood that my sense of having some particular value to him was a delusion, this willingness on my part became a source of deep humiliation.

In time, Manon learns to dose herself with tincture of opium before going to bed so that she can be "perfectly indifferent" to her husband's sexual rapacity: "I offered neither encouragement nor resistance; I was there and not there at the same time."

As Manon has demonized her husband, so she has idealized her deceased father, a small-scale slaveholder she wishes to see as "strict and fair" since he used the whip "sparingly" and had his driver administer the sentence: "He said it was wrong that any master be seen raising a whip himself; it demeaned him in the eyes of those who stood by." Manon's loathing for her husband partly derives from her father's self-righteous morality:

> . . . Father deplored the practice of some of his neighbors, who paraded about the town with their mulatto children in tow. That these men were often to be seen singing in church on Sunday morning was one more reason, Father maintained, to have nothing to do with religion. Religion was for the negroes, he said; it was their solace and consolation, as they were ours.

As they were ours! A remarkable statement from a white slaveholder, seeming to suggest as it does the extreme dependency of whites upon their Negro "property." While to Manon her father is a saint, to the reader he emerges as a priggish hypocrite-racist who has attempted to mollify his conscience by advancing notions of "virtuous" slaveholding. As Manon's aunt explains to her,

> "He became obsessed with the negroes. Your mother said it was because he'd not grown up with any. He wrote treatise after treatise on the management of the negro, and he tried to have them published . . . Of course he was always being disappointed when his own people ran away, or got drunk and sassed him, or pretended to be sick, or fought among themselves . . . He seemed to think some-

how he was going to make the negroes believe he was God and his farm was Eden, and they'd all be happy and grateful, which, you know, they never are."

After her mother's death, Manon discovers a diary kept by her father that reveals the man's hypocrisy: his "false cheer," the "charade of feelings he clearly didn't have." There are no startling revelations in the diary, only just entries of mind-numbing banality concerning cotton production, weather. What mordant poetry in the final entry, made only a few days before the man's death: "*Cold, damp, sowing oats, number wild geese, burning logs, three with pleurisy, misery in the cabins and the house, rain at dark.*" The only remarkable fact of Manon's father's life seems to be that he'd committed suicide and had not been murdered as his grieving widow had wished to believe. By the novel's end, Manon is bereft of her most cherished delusion: "[Father] was an impostor."

Drawing upon numerous slave narratives compiled by the Library of America, as well as books about the antebellum South like Herbert Aptheker's *American Negro Slave Revolts,* John Hope Franklin and Loren Schweninger's *Runaway Slaves,* Walter Johnson's *Soul by Soul: Life Inside the Antebellum Slave Market,* as well as the journals of two Louisiana plantation owners, Valerie Martin allows us to see in *Property* the exhausting burdens of slaveholding; the excruciating weight of its machinery. It's a world of ceaseless tension, anxiety; whites' obsessions with their intransigent and always unpredictable Negro "property"; runaway slaves hiding in swamps like rogue beasts bent upon revenge, impromptu uprisings and premeditated insurrections—

Five hundred slaves had simply gone mad and marched down the river road toward New Orleans, banging drums and waving flags. They killed Major Andry's son and wounded the major himself, set fire to mills and barns, raided the biggest houses. A stream of planters' families in wagons and carts, having taken flight in whatever vehicle they could quickly find, preceded the rebels into town.

It took almost ten days to route the negroes. The governor called out the militia and every patrol in fifty miles. It cost the state so much the treasury was bankrupted . . . The heads of the leaders were strung up in the trees all along the river from New Orleans to

Major Andry's plantation, and many a planter took his negroes out to see this display.

—astonishing to realize that it's only 1828 in this seemingly disintegrating society and there are decades to go before the Emancipation Proclamation of January 1, 1863. If the obscenity of slaveholding—the making of another into "property"—is dehumanizing, it's no less dehumanizing to the slaveholder than to the slave. Martin's white characters, including even Manon, are locked into stultifying roles of pseudo-privilege and deluded noblesse oblige even as their lives are unraveling. On her very deathbed, only a few minutes before she dies a hideous (and graphically described) death from cholera, Manon's self-absorbed mother berates her for not having been a good wife: how much better her home might be, if it included a "proper butler."

LIKE PREVIOUS works of fiction by Valerie Martin,[1] *Property* might be described as a novel of ideas in the guise of a darkly erotic romance. It isn't race or Negroes with whom Manon is obsessed, and her obsession is never theoretical like her father's: she is unwittingly in love with her servant Sarah, and most of her actions, even when she lashes out bitterly against Sarah, are guided by this thwarted passion. Significantly, there is only one erotic scene in *Property*, following Manon's mother's death, when Manon approaches Sarah as she nurses her baby, falls to her knees before her and without a word begins to nurse at Sarah's breast:

> . . . I guided the nipple to my lips and sucked gently. Nothing happened. I took it more deeply into my mouth and sucked from my cheeks. This is what [the infant] does, I thought. At once a sharp, warm jet hit my throat and I swallowed to keep from choking. How thin it was, how sweet! A sensation of utter strangeness came over me, and I tried not to swoon . . . I closed my eyes, swallowing greedily. I was aware of a sound, a sigh, but I was not sure if it came from me or from Sarah. How wonderful I felt, how entirely free. My headache disappeared, my chest seemed to expand, there was a complementary tingling in my own breasts . . . I opened my eyes and looked at Sarah's profile. . . . Her eyes were focused intently on the

arm of the settee. She's afraid to look at me, I thought. And she's right to be. If she looked at me, I would slap her.

It's a crucial, climactic scene in *Property,* the despairing (yet still despotic) white woman taking sustenance from her Negro "property" who dares not, in even this moment of astonishing intimacy, look at her.

After Sarah runs away, Manon becomes obsessed with finding her. Her passion, like her husband's, can only be expressed through physical possession, a self-righteous claiming of "property." She will not allow Sarah to be sold; she thwarts the possibility of Sarah marrying a freed Negro; she must have Sarah no matter the history between them. By the novel's end, a grotesque but utterly plausible new marriage has evolved: Manon with her scarred face and paralyzed arm, Sarah sullen and recalcitrant, the deaf-mute Walter their child. We can see what this menage will be, how Manon will bait Sarah and how Sarah will respond:

> "Does [Walter] remind you of someone?" I said, earning one of her thinly veiled looks of contempt. She took up the urn and leaned over me to fill my cup.
>
> "He's as much your responsibility as mine," I said. "God knows, I didn't ask for him, but here he is." . . .
>
> "It's useless to talk about responsibility to you people," I continued. "You have no sense of it. That's the gift we give you all. You just run away and we bring you back and you never have the slightest twinge of conscience . . ."
>
> "It's thanks to you that I'm a cripple," I said. "Look at the way I have to eat."

In the claustrophobic intimacy of their new household, Sarah boasts to Manon how, in the North, she'd been warmly treated by Abolitionists who had not only opened their homes to her, but asked her to sit at their table and drink tea with them. Manon is appropriately jealous, incredulous. "It struck me as perfectly ridiculous. What on earth did they think they were doing?"

A canny question, to be turned back upon the questioner in this subtly cadenced novel of racial and sexual transgressions.

Note

1. Martin is the author of seven previous novels and two collections of short stories, *Love* (1977) and *The Consolation of Nature* (1988). Her best-known work is *Mary Reilly* (1990), purportedly the diary of the naive, good-hearted young servant girl to Dr. Henry Jekyll and his demonic alter-ego Edward Hyde. More ambitious is *The Great Divorce* (1994), which juxtaposes contemporary and antebellum New Orleans in a narrative linking three women (one of them a nineteenth-century Creole heiress who crosses the color line in a desperate attempt to be rid of her despotic slaveholder husband). *Italian Fever* (1999), set in present-day Italy, blurs the lines between Gothic mystery, social/cultural comedy, and that reliable sub-genre "sexual awakening, American female abroad."

Programmed by Art: David Lodge

Thinks . . .
David Lodge

"SURELY A MAN MAY SPEAK TRUTH WITH A smiling countenance," Henry Fielding remarked in his comic masterpiece *Tom Jones* two and a half centuries ago. Such a claim usually carries with it an air of the defensive, for we tend to believe that tragedy is a more profound, if not an invariably more subtle or more realistic artform than comedy; we tend to reserve our highest accolades for those who insist upon the bleakest, most minimal and intransigent of human visions. Yet as individuals we tend to behave, domestically and socially, as if such bleakness isn't the case at all. *Homo sapiens* in the aggregate is incurably optimistic, teeming with ideas and schemes, inventions and gadgetry, rituals and romances and "narratives"—our contemporary term for good, old-fashioned stories.

David Lodge, novelist, playwright, critic, has long been the purveyor of this energetic, wryly antic vision, notably in his popular comedies of contemporary manners and morals, *Changing Places* (1975), *Small World* (1984), *Nice Work* (1988), *Paradise News* (1991), and *Therapy* (1995). In *Thinks . . .*, the eleventh and perhaps the most ambitious

novel of the author's sunny career, the very status of "stories" and the human-centered consciousness out of which they spring is challenged by the revolutionary new science of cognition—"the systematic study of the human mind . . . the last frontier of scientific inquiry." For suddenly in our time it isn't at all clear what a human being *is*; still more, what a "soul" is; how are mind and body connected if they are connected. Above all, are we anything more than areas of our brains "lighting up like a pinball machine, as different emotions and sensations are triggered"? Helen Reed, David Lodge's sympathetic but hapless heroine, a novelist so steeped in tradition that she appeals to Henry James and Andrew Marvell in times of crisis, is rather overwhelmed by these questions. She is made to feel that she's in a struggle for her very soul with a charismatic, sexually swashbuckling cognitive scientist aptly named Messenger: "Literally, because according to him, [my soul] doesn't exist . . . Self consciousness is a fiction, an epiphenomenon of surplus brain-supply."

So the stage is set for another of David Lodge's deftly witty, satirical yet humane and often very funny social comedies set in, or near, a university. Like a less morbidly frenetic Iris Murdoch, Lodge imagines his novels-of-ideas primarily in terms of Eros. Not for these hot-blooded Brits the abstruse, painstakingly cerebral novels-of-ideas of, for instance, our contemporaries Richard Powers (*The Gold-Bug Variations* et al.) and Bruce Duffy (*The World as I Found It*), let alone the master Thomas Mann (*The Magic Mountain, Dr. Faustus*). For Lodge as for Murdoch, sex is the saccharine coating on the bulky pill of intellectual engagement. In *Thinks . . .*, we have a sense of how things will turn out as Helen Reed struggles for her soul, and her would-be seducer Messenger struggles for her shapely body; Messenger, the local Don Juan fondly known as "Media Dong," is attracted to Helen as a bright, worthy critic of the new science as well as a desirable, and vulnerable woman.

Helen is a still grieving youngish widow who has come for a term to teach creative writing at the University of Gloucester—a mythical "greenfields" university refreshingly upscale from Lodge's more familiar, decidedly downscale red-brick University of Rummidge—where she immediately encounters Messenger, Director of the prestigious Centre for Cognitive Science. Messenger is indeed a winged messenger of the gods; an alpha male of a familiar species, the popularizer of a difficult, trendy new science "with a big handsome head: thick, grizzled hair combed

back from a broad brow, a hooked nose and a strong chin. In profile he [reminds Helen] of a Roman emperor on an old coin." In an earlier incarnation, this paragon of masculinity taught at MIT where he "looked more like a rock star than a scientist—he wore his hair long . . . , and dressed in flares and bright silk shirts . . . He talked like a man who had the future in his bones." Can Helen resist, with her ominous knowledge that sex is "ecstasy at one end and terror at the other"? But how can Helen resist, as a character in a comedy of Eros?

Thinks . . . is David Lodge's least inspired title, yet the novel is his most skillfully organized work of fiction. In alternating and sharply contrasting chapters Ralph Messenger and Helen Reed reveal themselves: the rapacious male egotist as he records his uncensored, rambling and repetitive stream-of-consciousness on tape and computer disk in the interest of "producing a specimen, that is to say a new data, on the basis of which one might begin to try to describe the structure of . . . thought"; the other, as she confides in her journal out of loneliness, grief, and curiosity about what is happening to her as she becomes emotionally involved with another woman's husband ("Yes, I was tempted—all the more because he wooed me with words, like a Renaissance poet to his coy mistress"). Messenger is the paragon of vanity who would tape a sexual encounter with a needy woman to play back for his private titillation years later; Helen Reed is the paragon of literary sensitivity who takes a schoolgirl delight in trudging about places like Ledbury, where Henry James fleetingly visited, Elizabeth Barrett was brought up, John Masefield was born, and John Langland is believed to have been born: "I loved all this . . . I loved to feel connected with the great, and not so great, writers of the past by walking the ground they walked and seeing the things they saw." Where Messenger's thoughts are banally sex-obsessed, and Helen Reed is but one woman among many of whom he thinks lasciviciously, Helen naively focuses upon Messenger as a romantic possibility. Her initial reluctance to sleep with him has to do with her moral conscience; she doesn't want to betray Messenger's wife, who has become a friend of hers, but most of all she doesn't want to betray her deceased husband, whom she recalls in inappropriately idealized terms: "I feel it would dishonour Martin's memory, or the memory of our marriage, if my first sexual experience after his death were to be an adulterous one. If that's irrational, even superstitious, so be it." Helen Reed is a novelist who plumbs the depths of her own most devastating emotional

experience in work that, to the speed-reading Messenger, is little more than "tedious" and "a woman's book" though—of course—as Messenger assures Helen, it's "beautifully written."

As *Thinks* . . . moves briskly through its clockwork plot its center of gravity gradually shifts, as in earlier novels of Lodge's in which the hand of the omnipotent, puppet-master novelist becomes increasingly evident. Lodge is a postmodernist writer in the affable guise of a reliable realist. By mid-novel in *Thinks* . . . we begin to see Helen and Messenger from a distance, not exclusively from their protective points of view. Observed as players in a larger saga, these protagonists shrink in significance; perhaps it's a plausible, not merely a provocative statement, as Messenger tells Helen, "You're a machine that's been programmed by culture not to recognize that it's a machine." Comedy turns upon coincidences, swift reversals of fortune, and happy, if ironic endings, and *Thinks* . . . is purely comic. The reader is reminded of the virtuoso ending of *Changing Places* in which the fact that the novel is ending is acknowledged, and prose narration is abandoned altogether in favor of a film script. Apposite lines from the conclusion of Jane Austen's *Northanger Abbey* are quoted: "Seeing in the tell-tale compression of the pages before them [readers will guess] that we are all hastening together to perfect felicity." Precisely the same might be said of *Thinks* . . .

Paraphrasing a comic plot tells us as little about the texture of the work as describing the outer rind of a melon tells us about the fruit of the melon, let alone its unique taste. So too no description of Lodge's ingeniously symmetrical plots, in which learned allusions abound (Austen in *Changing Places*; Charlotte Brontë, Dickens, and D. H. Lawrence in *Small World*; Descartes and Darwin in *Thinks* . . .) can give us an accurate sense of the warmth and intelligence of Lodge's prose. There is even room in the new novel, amid heady philosophical-neurological debate, for virtuoso flashes of parody, as in a writing exercise titled "What Is It Like To Be A Blind Bat?" that inspires one of Helen Reed's students to compose a piece by S*m**l B*ck**tt:

Where? When? Why? Squeak. I am in the dark. I am always in the dark. It was not always so. Once there were periods of light, or shades of darkness. Squeak . . . Now there are no more shapes, only touch, smells, sound. I have lost shapes forever. When? Why? How? Squeak.

One of the surprises of *Thinks . . .* is that Lodge finally resists carica-
ture. Even "Media Dong" Messenger emerges as rather more subtle, and
serious, than we think initially; under the pressure of personal and fam-
ily crises he becomes more thoughtful and engaging as the novel unfolds.
Often foolish, Messenger is yet no fool. He judges the three most signifi-
cant remarks in intellectual history to be Descartes's *I think, therefore I
am,* Nietzsche's *God is dead,* and Darwin's less well-known *Crying is a
puzzler.* (This gnomic remark will provide Helen Reed with the title of
her next novel.) Messenger's critique of humanism is certainly difficult
to refute:

> "Homo sapiens was the first and only living being in evolutionary
> history to discover he was mortal. So how does he respond? He
> makes up stories to explain how he got into this fix, and how he
> might get out of it. He invents religion, he develops burial customs,
> he makes up stories about the after-life, and the immortality of the
> soul. As time goes on, these stories become more and more elabo-
> rate . . . Not many intelligent people believe the religious story any
> more, but they still cling to some of its consoling concepts, like the
> soul, life after death, and so on."

For Messenger, all human beings including himself are "virtual ma-
chines in biological machines"; a machine is defined as anything that
"processes information."

Messenger is the bearer of a more plausible revelation, Lodge seems
to suggest, than his predecessor-guru Professor Morris Zapp of the State
University of Euphoria, the swashbuckling womanizer-deconstructionist
who made a career, in *Small World,* of giving keynote speeches at liter-
ary conferences worldwide cynically denying the possibility of knowing
truth ("Every decoding is another encoding") and confounding univer-
sity colleagues by insisting that the humanist tradition lacks any purpose
beyond providing jobs for people like himself who perform certain pub-
lic rituals "like any other group of workers in the realm of discourse."
On the contrary, Messenger is offended by deconstructionists who make
the claim that all is relative and there's no reality apart from human per-
ception. His attraction for Helen Reed, as for the reader, is that he's a
scientist who values science as the only way to the truth. (In his Ac-
knowledgements, David Lodge lists a considerable number of books and

articles on the subject of consciousness as well as the BBC 4 series *Brainspotting* and several international conferences on consciousness presumably similar to the gargantuan Conference on Consciousness organized by Messenger.)

If Messenger reminds us of the entrepreneurial Morris Zapp, the naively trusting Helen Reed reminds us of Zapp's antithesis, Professor Philip Swallow of the University of Rummidge, described in *Changing Places* as a man genuinely in love with literature in its diverse forms, "as happy with Beowulf as Virginia Woolf, with *Waiting for Godot* as with *Gammer Gurton's Needle.*" As Zapp challenges Swallow's assumptions and behavior, so too Messenger provokes Helen to self-doubt. A traditional novelist, she has taken for granted that the investigation of consciousness is the "province of the arts" to Messenger, such knowledge as the arts seem to provide of consciousness is merely fiction, lacking scientific value. Helen tries to counter by suggesting that novels are in fact "thought-experiments" in which fictitious characters are put in hypothetical situations, but privately she wonders at the worth of such effort:

> When you think of the billions of real people who have lived on this earth, each with their unique personal histories, that we shall never have time to know, it seems extraordinary, even perverse, that we should bother to invent all these additional pretend-lives. And it is a bother. So much that in reality is simply 'given' has to be decided when you're writing fiction. Facts have to be represented by pseudo-facts, laboriously invented and painstakingly described. The reader must register and memorize these facts in order to follow your story, but they are flushed away almost as soon as the book is finished, to make room for another story . . . It's frightening to think of how many novels I must have read in my lifetime, and how little I retain of the substance of most of them.

Helen may be temporarily disconcerted by Ralph Messenger, but she rallies by the end of the novel, and even manages to mount a spirited defense of literature to an audience of cognitive scientists, by analyzing Marvell's exquisite poem "The Garden" as proof of the uniqueness of the individual: "Marvell wrote 'The Garden' before the concept of copyright existed, but the fact remains that nobody else could have written it, and nobody else will ever write it again . . ." Released from mourning an

undeserving husband, Helen returns to London, leaving Messenger to his family and to a chastened, ostensibly monogamous middle-age. To her credit, she salvages her "greenlands" experience in a new novel judged by a reviewer as "so old-fashioned in form as to be almost experimental."

Ghosts:
Hilary Mantel

Eight Months on Ghazzah Street
Hilary Mantel

Giving Up the Ghost: A Memoir
Hilary Mantel

"PLAIN WORDS ON PLAIN PAPER. REMEMber what Orwell says, that good prose is like a windowpane." Hilary Mantel begins her dazzlingly written memoir by quoting Orwell, and then refuting him:

> Persiflage is my nom de guerre . . . I stray away from the beaten path of plain words into the meadow of extravagant simile: angels, ogres, doughnut-shaped holes. And as for transparency—windowpanes undressed are a sign of poverty, aren't they? How about some nice net curtains, so that I can see out but you can't see in? Besides, windowpane prose is no guarantee of truthfulness. Some deceptive sights are seen through glass, and the best liars tell lies in plain words.

Not "persiflage" so much as a virtuoso's love of language and its myriad shimmering associations would seem to best characterize Hilary Mantel's work. Among contemporary British writers she is a rarity: a

writer of subtlety and depth as engaged by the experimental possibilities of the novel as by its traditional "realist" concerns. As *Giving Up the Ghost* is a highly unorthodox account of what is essentially unsayable about the inward, uncharted life (". . . a complicated sentence that I am always trying to finish . . . and put behind me") (*Learning to Talk*), so Mantel's eight novels and story collection *Learning to Talk* (2003) are eloquent statements of intense spiritual apprehension and abrupt loss, and the mystery of such loss:

> There was a time when the air was packed with spirits, like flies on an August day. Now I find that the air is empty. There is only man and his concerns. [*Fludd*]

Or, as the eighteenth-century Irish Giant, O'Brien, ruminates:

> [We] are the sons and daughters of gods and kings. [We] are the inheritors of the silver tree amongst whose branches rest all the melodies of the world. And now without a pot to piss in.
> [*The Giant, O'Brien*]

In an early preface to *Giving Up the Ghost*, included in *Learning to Talk* but unfortunately excised from the formal memoir, Mantel speaks of her childhood as "haunted"; though, in time, she would marry, and travel far, and become a writer, yet the ghosts of childhood accompanied her, and, in time, were joined by others: "the wistful phantoms of her unborn children." Perhaps this helps to explain why Mantel's works of fiction differ so radically from one another, and why she has no single but rather singular styles, ranging from the visionary to the vernacular, the rhetoric of tragedy and the stammering speechlessness of diminished suburban lives.

Hilary Mantel was born in 1952 in the mill village of Hadfield, on the edge of Derbyshire moorland where "the wretched weather encouraged a dim view of life." The child of Roman Catholic parents, she was well educated in a convent school, studied law at the University of London, married young and lived with her geologist husband for five years in Botswana and for four years in Saudi Arabia before returning to England in 1987. Mantel has written of these very different places with a sharp yet sympathetic eye for regional essences and idiosyncracies: even in her

home territory, she sustains the vigilance of the perennial outsider, a cultural anthropologist of her own kind. Her experimentation with genre and language is never self-displaying or distracting but fully in the service of her material. She is the author of the emotionally wrenching "family" novel, *A Change of Climate* (1994), set alternately in upscale, semi-rural, contemporary Norfolk and in the desperately impoverished Africa of Cape Town and Botswana of thirty years before, and she is the author of the fabulist parable *The Giant, O'Brien* (1998), set in mythic eighteenth-century Ireland and Britain. Her most ambitious novel is the massive, magisterial *A Place of Greater Safety* (1992), a meticulously rendered fictional history of the French Revolution, near nine hundred pages in small print; her most curious novel is the magical, alchemical *Fludd* (1989), a tale of unexpected Christian grace and forgiveness set in the timeworn village of Fetherhoughton where, by tradition, "a multiplicity of devils" abides: "St. Hilary tells us that each devil had his particular bad smell."

Mantel's riskiest literary venture so far would seem to be a pair of demonically matched novels in the Muriel Spark/Iris Murdoch tradition of comic-grotesque satire, *Every Day Is Mother's Day* (1985) and *Vacant Possession* (1986), which cross and re-cross much of the same narrative territory from varying perspectives, but which finally fail to transcend the genre-limitations of fiction in which fundamentally silly, contemptible, or psychopathological characters are thrown together in a tizzy of a clockwork plot, accelerating to the point of impact; yet even here, Mantel spends more time convincing us of the human worth of her hapless characters than Muriel Spark and Iris Murdoch usually do, and the novels' predominant theme is timely: ". . . how the preoccupations of the sane reflect those of the insane. And vice versa, of course" (*Vacant Possession*).

Mantel's most conventional novel is *An Experiment in Love* (1995), a disingenuously narrated coming-of-age story of a bright, impoverished, self-absorbed girl from the provinces who studies law at the University of London, and who narrowly escapes death in a final, surreal conflagration. *An Experiment in Love* is so conventionally written, and for Mantel so relatively unimaginatively, one wonders at first if it might be a sly parody of genre-predecessors like Margaret Drabble's *Jerusalem the Golden*, but it would seem to be in fact an early, lightly sketched treatment of the more deftly executed autobiographical material of *Learning*

to *Talk* and the far more oblique, mysterious, and obsessive concerns of *Giving Up the Ghost*. Perhaps the most readable, compelling, and politically timely of Mantel's novels is *Eight Months on Ghazzah Street* (originally published in the U.K., 1988), a dramatic distillation of Mantel's ordeal in Saudi Arabia:

> My life in Saudi Arabia, for at least two years, was like life in jail. Simple force of will—or the force of simple will—could move the furniture and rip off the wardrobe doors. At times of stress, or on the brink of change, you can seem to act as a conduit for whatever disorganized, irrational forces are in the air. Shut in those dark rooms [in a company-provided flat in the city of Jeddah], life going on elsewhere, my body subject to strange mutations, I accumulated an anger that could rip a roof off. [*Giving Up the Ghost*]

Eight Months on Ghazzah Street reflects, in its subtly mounting tension and ironic illumination, the explosively repressed emotions of a Western, educated woman living in an alien culture in which the female is "revered" by being imprisoned in a nexus of religious/social constrictions; it's a cri de coeur that draws the reader into its protagonist's experience in a foreign culture as enigmatic, and as sinister, as the North African territories of Paul Bowles.

Though there are certainly common threads of concern—moral, political, metaphysical, aesthetic—that link these disparate works of fiction, yet the novels are so distinctive, and so intensely realized, one might be convinced that they have been written by a half-dozen writers. And when we learn in *Giving Up the Ghost* that Mantel was desperately ill for much of her adult life, suffering from a (misdiagnosed) case of endometriosis, her accomplishment seems all the more astonishing.

"I KNEW the facts . . . but I didn't know what it would feel like to live under them"—so it's belatedly realized by Frances Shore, the young, attractive, rather too inquisitive and independent-minded British-born woman who comes to live with her engineer husband in the Saudi Arabian city Jeddah, in 1984, in *Eight Months on Ghazzah Street*. Frances is trained as a cartographer: an appropriate analogue for the novelist's vo-

cation. Like Hilary Mantel before her, Shore suffers from an extreme case of culture shock in this unchartable place for which the only available map is outdated and useless. ("Cartography by Kafka," Frances writes on the map.) She is told matter-of-factly that, in the Muslim theocracy, as a woman "you're not a person any more"; it's a shock to her, as to the reader, to learn that, once she's in Saudi Arabia, she can't leave without an exit visa, and she can't acquire an exit visa from the Saudi government without the permission of her "sponsor," her husband. In this stifling environment in which the official year is 1405 it shouldn't be much of a surprise for Frances to discover that the front door to the Shores' flat had been bricked up by the previous tenant, a Muslim husband who didn't want his wife talking with her neighbors.

A sleekly contemporary re-imagining of the classic gothic tradition (see *The Turn of the Screw, Jane Eyre,* Daphne du Maurier's *Rebecca*), in which a naive but courageous young woman finds herself in a mysterious, threatening environment that must be continuously decoded, *Eight Months on Ghazzah Street* is also a very funny dark comedy of manners. One can imagine Hilary Mantel, upon whom nothing seems to be lost, unobtrusively taking notes on the well-intentioned advice of her sister-expatriate British wives:

> "You ought to get some kaftans really. Especially for the souk [market], you know, and for when you're out without your husband. The shop people won't serve you, if they don't think you're properly covered up." Mrs. Parsons looked her over. ". . . You've got that fairish hair, you see, fair hair's always an attraction to them."
>
> "I thought I'd be all right if I covered my arms."
>
> "Well, of course, there aren't any hard and fast rules." Mrs. Parsons passed a hand over her own bare forearm. "It isn't arms they mind, I understand, it's legs. Or if you want to just go out in your ordinary clothes, what you should do is get an *abaya*, you know, those black cloak things the Saudi ladies wear, and then you can just flip it over everything."

Frances is reassured by an "enlightened" Muslim woman neighbor who has lived in England that women condemned as adulteresses are not actually stoned to death: "Not nowadays. They just throw a few stones, as

a ritual, and then somebody shoots [them]." Nor are the amputation
punishments for lesser crimes so cruel as Westerners think, for an anes-
thetic is usually used:

> "When they do an amputation," Yasmin looked down at her own
> long hands, with their lacquered nails, "there is a doctor in atten-
> dance. It doesn't go poisoned, they make sure of that. Really,
> Frances, it isn't like you think."

It's remarked that the brutal rapes of two Australian women tourists
were only to be expected since the victims were wearing shorts.

Frances, who had previously lived in Botswana, in a far less stable so-
cial environment, is immediately in danger if she steps outside her heav-
ily fortified apartment building. Men cruise their cars past her calling
out such endearments as, "Madame, I love you . . . I want to fuck you";
they wave to her to cross the street, then try to run her down. Merely a
walk around the block leaves her exhausted, terrorized, and grateful to
lock herself back into her air-conditioned prison. As Frances's frustra-
tion, fear, and paranoia mount, she projects her dread onto the mystery
of an apparently empty flat above her own, in which she believes she
hears voices and sobbing; her suspicions are discounted by her husband,
Andrew, who seems to be withdrawing from her.

Andrew Shore, in his mid-thirties, is one of the numerous "expatriate
staff" of British and American engineers, architects, managers, and en-
trepreneurs drawn to Saudi Arabia at the time of the oil boom. There is
no idealism involved in the effort of these men to help develop a Third
World country, only a cynical wish to make as much money as possible:
"It's called the golden handcuffs." Andrew's salary is three times what he
would make in Britain, but in affluent Jeddah the cost of living is high;
well-to-do Saudis and expatriates are obsessed with material goods:

> The supermarkets are all well stocked, but there is always some elu-
> sive item; this breeds the desire to go to more supermarkets. Shop-
> ping is the highest good in Saudi life. Every need and every whim
> under one roof—Lebanese pastries, a Mont Blanc pen, a diamond
> snake with emerald eyes; a pound of pistachio nuts, two tickets to
> Bermuda, a nylon prayer rug with a built-in compass . . . The car
> parks consume acres, the facades glitter like knives . . .

Frances notes Muslim women, "trussed up in their modesty like funereal laundry, women with layers of black cloth where their faces should be. Only their hands reached out, sallow hands heavy with gold."

Eight Months on Ghazzah Street is a novel of steadily increasing tension, culminating in a sequence of violent acts that remain tantalizingly mysterious though we must guess, as Frances Shore does, that the British company for which her husband works is in some way complicit with Saudi police in the cover-up: the allegedly empty flat overhead, a probable site of torture and murder, is furnished in a way identical to her own. Frances realizes the politically pragmatic wisdom behind a remark by one of her husband's superiors: "There are things that might be true, but you can't afford to believe them."

SET BESIDE her precisely executed and shaped works of fiction, Hilary Mantel's *Giving Up the Ghost [a memoir]* will seem relatively disjointed and incomplete. Though always interesting, and frequently riveting, it has the somewhat improvised feel of several memoirist projects fitted together into a thematic yet not an emotional unity, undertaken after the death of the author's stepfather, Jack, whose role in the memoir turns out to be neither sympathetic nor major, and symbolically begun at the time of the author's fiftieth birthday:

> You come to this place, midlife. You don't know how you got here, but suddenly you're staring fifty in the face. When you turn and look back down the years, you glimpse the ghosts of other lives you might have led. All your houses are haunted by the person you might have been. The wraiths and phantoms creep under your carpets and between the warp and weft of your curtains . . . You think of the children you might have had but didn't . . . When you think you're pregnant, and you're not, what happens to that child that has already formed in your mind? You keep it filed in a drawer of your consciousness, like a short story that wouldn't work after the opening lines.

As this passage suggests, *Giving Up the Ghost* isn't about giving up ghosts so much as evoking them, giving shape to emotions too fleeting and enigmatic to be otherwise known.

The first and most unexpected of Mantel's ghosts is her own, lost child-self, a startlingly confident and rather bellicose girl known in the mill village of Hadfield as "Ilary." Though Ilary's Irish grandmother had become a mill worker at the age of twelve, and her mother was put into a mill at fourteen, and there were few adult models for the child to emulate apart from *King Arthur and the Knights of the Round Table,* Ilary takes it for granted that she is a very special little girl: one who will in fact become a boy. In an evocation of Mantel's technique of "extravagant simile" here is the six-year-old Ilary fantasizing herself a vengeful knight errant:

> I felt my man's spirit aroused, my ardor clenching inside my chest like a fist within a mailed glove. Saddle my charger: I'll canter up [the] street and decapitate him [the father of a friend, who has been beaten by him]. My sword arm twitched, and I pictured one lazy, scything stroke . . . then the head, bouncing over the cobbles.

Already as a child of three Ilary has reacted to a little girl neighbor, a Protestant, in a yet more exalted manner:

> Oh, is she [my friend]? I have some vague idea about the girl. I seem to think that before this we were carried like rival sultans to view each other, our retainers bearing us to the rendezvous in their arms; or bounced down Bankbottom in our big springing permambulators, to wave our woolly mittens at each other, and acknowledge each other with dips of our bonnets; like commanders from rival galleons bobbing on the sea.

This is very far from Orwell's "plain words"; perhaps, to some readers, too far. Mantel's sufflated language is best appreciated as the memorist's effort at evoking a mythic child-self that makes no concession to literal, but only symbolic credibility. This Ilary is so precocious as to have speculated, at the age of seven:

> The doctrine of transubstantiation caused me no headache. I was not surprised to find that a round wafer was the body of Jesus Christ. I'd been saying for years that things like this occurred, if people would only notice. Spaniel and cow fused their nature, so did

man and plant: look at Mr. Aldous, his milky stalks for arms. Girl could change to boy: though this had not happened to me, and I knew now it never would.

Yet, in this grim provincial landscape in which "theology and geography had got inextricably mixed," the child Ilary is studying for the priesthood, and fascinated by the possibilities of confession and absolution of sins.

Unsuited to being a child, Ilary is imbued by her memorist with remarkable fantasies of empowerment, perhaps to contrast with the more conventional memoirist-portraits of passive, victimized, muted girls about whom we have all read, and with whom we are made to commiserate. Taught by her grandfather to fight back when harassed at school, Ilary takes his advice to heart:

> Later, when I am a big girl, ten years old, a true bully arises in our own class. He is a short boy with shorn hair, and his name is Gary, which is a bully name if you ever heard one. He is broad, white, muscled, compact, and made of rubber. He takes my beret and throws it into the ditch. I declare I will make war on him. You can't bash Gary C.! the little girls say. I go after him, pale with fury, spitting with wrath. He stands his ground. I strike out. My fists sink into his torso and bounce back. The feeling is curiously soothing. I need have no conscience about him. He's made of some substance denser than flesh. I suppose he hits me back, but it doesn't hurt . . . Gary's like a creature the knight meets in a forest, you lop its head off, and it regrows.

Where in contemporary memoirs by women sexual abuse is "the usual horror," Mantel's claim of the horrific is more original: at the age of seven Ilary is visited by, not the Devil, nor even a devil, but an ineffable emanation of evil:

> I can sense a spiral, a lazy buzzing swirl, like flies; but it is not flies. There is nothing to see. There is nothing to smell. There is nothing to hear. But its motion, its insolent shift, makes my stomach heave. I can sense—at the periphery, the limit of all my senses—the dimensions of the creature. It is high as a child of two. Its depth is a foot,

fifteen inches. The air stirs around it, invisibly. I am cold, and ringed by nausea. I cannot move. I am shaking; as if pinned to the moment, I cannot wrench my gaze away. I am looking at a space occupied by nothing . . .

I pluck my eyes away. It is like plucking them out of my head. Grace runs away from me, runs out of my body like liquid from a corpse.

For Mantel this vision, or hallucination, signals both the end of childhood and the "beginning of shame."

Yet the memoir reverts to its previous tone of precocious self-sufficiency and sardonic observation, as Ilary takes note of her mother's live-in lover Jack, an exhibitionist body-builder and would-be writer (for *Health & Strength*) who seemingly overnight supplants her father in his own household: Jack is a bullying presence never explained to the reader, as perhaps he was never explained to Ilary though he becomes, in time, her "stepfather." (Strangely little is made of Ilary's father, Henry, who disappears from the family, and from the memoir. Only a wisp of a ghost remains, unoccluded by sentiment.) Ilary advances from her local, poorly staffed grammar school to an upscale, academically rigorous convent school in a nearby village where she is befriended by the "tiny, fierce, horribly feared" Top Nun, and soon becomes Top Girl: "I was entitled to a gown of scarlet with a gold stripe, which I wore with an air of sarcasm."

Giving Up the Ghost divides into two unequal parts, differing considerably in tone: "Ilary" is replaced by the adult, not so self-composed Hilary, whose arrival is signaled by these cryptic words:

By the time I was twenty I was living in a slum house in Sheffield. I had a husband and no money; those things I could explain. I had a pain, which I could not explain; it seemed to wander about my body, nibbling here, stabbing there, flitting every time I tried to put my finger on it.

This marks the onslaught of Mantel's long-misdiagnosed gynecological condition, endometriosis, which radically changes her life. Instead of receiving medical treatment, Mantel is prescribed a range of mood-altering medications from tranquillizers and anti-depressants to powerful anti-

psychotic drugs: "The more I said I had a physical illness, the more they said I had a mental illness." Most of the remainder of *Giving Up the Ghost* is a harrowing account to set beside such classics as Sylvia Plath's *The Bell Jar* and Charlotte Perkins Gilman's "The Yellow Wallpaper":

> If you didn't respond to the first wave of drugs—if they didn't fix you, or you wouldn't take them—the possibility arose that you were not simply neurotic, hypochondrical, and a bloody nuisance, but heading for a psychotic breakdown, for the badlands of schizophrenia, a career on the back ward. To head off this disaster, doctors would prescribe what were then called the major tranquillizers, a group of drugs intended to combat thought disorder and banish hallucinations and delusions.
>
> The next time I saw Dr. G. he forbade me to write: or, more precisely, he said, "I don't want you writing." He put more energy into this statement than any I had heard him make.

Mantel suffers attacks of akathisia (a side effect of antipsychotic medication that mimics madness, causing severe panic) and a morbid weight gain of more than 50 percent, a health threat in itself and deeply humiliating to an attractive young woman who had always taken her thinness for granted.

> I never was a size 16. I shot past it effortlessly . . . My skin turned gray, shading to slate blue as the autumn came on. My legs swelled and ached. Fluid puffed up my eyelids. Some mornings my head looked like a soccer ball. I was glad when my husband's job took us to Saudi Arabia, where women wear drapery instead of clothes.

By the time Mantel is properly diagnosed, her condition has become so extreme there is no remedy but a hysterectomy, which brings with it hospital infections. When she informs one of her string of incompetent doctors, his reply is: "There's one good thing, anyway. Now you won't have to worry about birth prevention."

Giving Up the Ghost ends with a lament for childlessness, made by a middle-aged woman who, when young, hadn't wanted children. In the background there is a husband whom Mantel marries while both are undergraduates at Sheffield University, later divorces, and still later remar-

ries; she lives with him in Botswana, Saudi Arabia, and in various houses in England; in this memoir of ghosts, he is the most ghostly. Mantel is reticent about her family, perhaps properly; yet it's something of a surprise to learn belatedly that she has an emotional attachment to her mother and brothers, and any feeling for her stepfather. The reader is provoked to wonder if the self-assured Ilary hasn't been a confabulation when Mantel remarks, near the end of the memoir, "I had always felt that I deserved very little, that I would probably not be happy in life, and that the safest thing was to lie down and die."

Memoirs are not lives, but texts alluding to lives. The technique of memoir resembles that of fiction: selection, distillation, dramatization. Inevitably, much is omitted. Inevitably, much is distorted. Memories are notoriously unreliable, particularly in individuals prone to myth-making and the settling of old scores, which may be all of us. Much in *Giving Up the Ghost* is memorable, but no passages are quite so convincing as those in which the memoirist speaks frankly and simply:

> Writing about your past is like blundering through your house with the lights fused, a hand flailing for points of reference. You locate the stolid wardrobe, and its door swings open at your touch, opening on the cavern of darkness within. Your hand touches glass, you think it is a mirror, but it is the window. There are obstacles to bump and trip you, but what is more disconcerting is a sudden empty space, where you can't find a handhold and you know that you are stranded in the dark.

An Endangered Species: Short Stories

Everything in This Country Must:
A Novella and Two Stories
Colum McCann

Scar Vegas
Tom Paine

Dressing Up for the Carnival
Carol Shields

In the Gloaming
Alice Elliott Dark

Pastoralia
George Saunders

The Toughest Indian in the World
Sherman Alexie

THE SHORT STORY IS A MINOR ART FORM that in the hands of a very few practitioners becomes major art. Its effect is rarely isolated or singular, but accumulative; a distinguished story col-

lection is one that is greater than the mere sum of its disparate parts. Such classics as Edgar Allan Poe's "The Tell-Tale Heart" (*Tales of the Grotesque and Arabesque,* 1840), Nathaniel Hawthorne's "Young Goodman Brown" (*Mosses From An Old Manse,* 1846), Ernest Hemingway's "Big Two-Hearted River" (*In Our Time,* 1925), Katherine Anne Porter's "Flowering Judas" (*Flowering Judas and Other Stories,* 1930), Eudora Welty's "Petrified Man" (*A Curtain of Green,* 1941) have acquired canonical distinction primarily because they were originally published in short story collections of exceptional merit, by writers of exceptional talent; in isolation, striking and original as the individual stories might be, it's likely they would have long since faded from literary memory, as a few scattered poems of Emily Dickinson, isolated from the poet's great body of work, would have long ago faded into oblivion.

Yet one might argue that collections of short fictions have been among the major literary accomplishments of the twentieth century. Surely the astonishing stories of Franz Kafka ("The Judgment," "The Metamorphosis," "In the Penal Colony," "A Country Doctor," "A Report to an Academy," "The Hunger Artist," among others) constitute a greater accomplishment than Kafka's uncompleted novels *The Trial, The Castle,* and *Amerika,* and Thomas Mann's shorter works, notably "Death in Venice," "Mario and the Magician," "Disorder and Early Sorrow," among others, constitute an achievement equivalent to that of the lengthy, ambitious, doggedly cerebral great novels.

In a very different vein, there are the brilliantly realized short stories of Katherine Mansfield, who never wrote a novel. There is Jorge Luis Borges, whose wonderfully original, idiosyncratic work consists almost entirely of enigmatic *ficciones,* some of them very brief. There is the African-American Jean Toomer, whose *Cane* (1923) is a "novel" of surpassing beauty in the form of interlocked poetry, prose poetry, and dramatic narration, whose influence upon contemporary African-American writers has been considerable. The short stories of Ernest Hemingway, including the entirety of his remarkable first book *In Our Time,* constitute a greater accomplishment than the novels *The Sun Also Rises, A Farewell to Arms,* and *For Whom the Bell Tolls,* that brought him wealth and celebrity; no novel by Katherine Anne Porter, Eudora Welty, Isaac Bashevis Singer, Bernard Malamud, Peter Taylor, Flannery O'Connor, John Cheever, Donald Barthelme, among others, is the equivalent of their short stories. J. D. Salinger's *Nine Stories* is at least the equivalent of the immensely popular

adolescent saga *Catcher in the Rye,* and of more abiding interest to adults. Philip Roth's first book, *Goodbye Columbus,* stories and novella, remains the sparkling equivalent of any of Roth's novels, and provokes the question of why so gifted a short story writer so quickly lost interest in the form. Admirers of John Updike are about equally divided between those who value the achievement of Updike's numerous short stories over his novels. And there is the shining example of Raymond Carver who wrote short stories and poetry exclusively, and who has ascended since his premature death in 1988 to near-mythic status as "the American Chekhov."[1]

The perennial question, "Is the short story an endangered species?" would seem to assume a perilous contemporary climate for the survival of this purely literary form. Despite the present-day profusion of literary magazines of varying degrees of excellence, and recent publications of outstanding short story collections by writers who have made the form their primary mode of expression, among these Tobias Wolff, Thom Jones, Lorrie Moore, the late Andre Dubus, and the veterans Grace Paley and Alice Munro, it's unlikely that the twenty-first century will be as hospitable to short story writers as the nineteenth and twentieth centuries were. Through much of the nineteenth century, writers of the caliber of Poe, Hawthorne, Herman Melville, and Henry James frequently published in such highly regarded and well-paying magazines as *The North American Review, Harper's Monthly, Atlantic Monthly, Scribner's Monthly* (later *The Century*), *The Dial,* and *Graham's Magazine* (briefly edited by Poe), and elsewhere; the extraordinary success of the new mass-market newspapers which appealed to both the educated and the relatively uneducated, and which syndicated features coast to coast, provided an outlet for more popular, vernacular writers like Samuel Clemens, who as "Mark Twain" became an unprecedented publishing phenomenon, North America's counterpart to Charles Dickens. A number of these magazines continued into the twentieth century and were joined by *The Little Review, The Transatlantic Review, Broom, transition, Story, The American Mercury, Cosmopolitan, Vanity Fair, Vogue, The New Yorker, Esquire, The Saturday Evening Post, Colliers,* and others of which very few have endured into the twenty-first century. Newspapers now rarely publish fiction per se, and never "literary" fiction. The audience for serious literature is static despite a booming economy and it's likely that in some quarters the perusal of reviews of

books has replaced an actual reading of books. In this radically diminished landscape, the generally reliable, heroically edited and accessible anthologies *The Best American Short Stories, Prize Stories: The O. Henry Awards,* and *The Pushcart Prize: The Best of the Small Presses* are invaluable.

NO MORE beautifully cadenced and moving collection of short fiction is likely to appear this year than Colum McCann's provatively titled *Everything in This Country Must,* a gathering of two stories and a novella. "This country" is Ireland, the time is the near-present, and the subject is the Troubles, pervasive as mist obscuring the green countryside. It's an era when political strife is unavoidable even by those who hope to define themselves as apolitical, and when no family, Catholic or Protestant, has been untouched.

Wounds are fresh, though rarely discussed; forgiveness, though reasonable and necessary, simply isn't possible for many who have suffered personal losses. The title story begins ominously, with that air of melancholy beauty and resignation that characterizes McCann's understated, luminous language:

> A summer flood came and our draft horse got caught in the river. The river smashed against stones and the sound of it to me was like the turning of locks. It was silage time and the water smelled of grass. The draft horse, Father's favorite, had stepped in the river for a sniff maybe and she was caught, couldn't move, her foreleg trapped between rocks.

The narrator is a young farm girl named Katie who may be somewhat slow; through her limited perspective we are brought into the lives of a Catholic family devastated by the loss of family members in an "accident" involving British soldiers:

> . . . I could hear in Father's voice more sadness than when he was over Mammy's and Fiachra's coffins, more sadness than the day after they were hit by the army truck down near the Glen, more sadness than the day when the judge said *Nobody is guilty, it's just a tragedy,* more sadness than even that day and all the days that follow.

McCann sustains a mood of dreamlike suspense and mounting anxiety through an adventure that involves young British soldiers helping to save the draft horse, and which ends in a gesture of anguish that's both unexpected and inevitable. "Oh what a small sky for so much rain."

Equally suspenseful, yet from a very different perspective, the second story, "Wood," depicts a Protestant family at a time when the father, a miller and carpenter, has had a stroke, and the mother must take on the responsibility of the household. Here too the perspective is that of a child, a boy who comes to a realization of his parents' precarious situation in a tensely politicized Northern Ireland; his father has distanced himself from local anti-Catholic activity ("Daddy says he's as good a Presbyterian as the next . . . but it's just meanness that celebrates other people dying"), while the boy's mother is more willing to cooperate, and to provide poles to carry banners in the annual Orangemen's march. The story builds to a dramatic pitch yet isn't finally dramatic, still less melodramatic; as in the Joycean model of poetically rendered, elliptical fiction, the conclusion is a poignant trailing off from overt confrontation:

> I looked at the oak trees behind the mill. They were going mad in the wind. The trunks were big and solid and fat, but the branches were slapping each other around like people.

The novella "Hunger Strike" is a more ambitious, and more painful, depiction of a young person's agitation at a time, presumably in the early 1980s, of intense political confrontation in Northern Ireland. A fourteen-year-old Belfast boy has been taken by his mother to live in Galway for the duration of a hunger strike by IRA prisoners in a Belfast prison; one of the prisoners is the boy's twenty-five-year-old uncle, his deceased father's younger brother whom the boy has never met, but whom he reveres. The novella takes us into the boy's most intimate experience in his involuntary exile; he's transfixed by the hunger strike, which lasts for over fifty days; with mounting terror and fury he thinks constantly of his uncle: "He was one of four prisoners on the strike—already, for each man dead another had replaced him and the boy found it strange that the living were stepping into the bodies of the gone. The dying, he thought, could go on forever." While the boy endures his uncle's martyrdom at a distance, he too is susceptible to frequent outbursts

of destructiveness and vandalism; his rage is barely contained. In Northern Ireland, too, violence erupts anew in response to British refusal to grant the striking prisoners political status:

> The riots back home were full-scale now. Some prison guards had been shot. Two joyriders had been gunned down in Twinbrook. A young girl, bringing home milk, had been hit in the head with a rubber bullet and she was in a coma. Somebody had slit the throats of a whole herd of cattle because they belonged to a Catholic farmer and the herd had been strung together to make the word NO in the field.

McCann's powerfully imagined elegy for the passing of youth's idealism suggests both the bittersweet, unsentimental lyricism of Edna O'Brien's early Irish stories and those novels by Bernard MacLaverty, *Cal* and *Grace Notes,* in which the tragic shadow of the political falls across the lives of sharply rendered, individualized men and women. At the end of "Hunger Strike," the bereft boy is forced to realize that ". . . The uncle he didn't know was all the uncle he'd ever know" and perhaps this is a way of speaking of the ambiguous relationship of a young generation of Irish writers, some of them expatriates (McCann, born in Northern Ireland, currently lives in New York City), to Ireland itself.

McCann is the author of several novels, and a previous collection of short stories, *Fishing the Sloe-Black River.* He's a writer of immense gifts, surely at the outset of a dazzling career.

THERE'S THIS frantic but good-hearted guy Johnny Loop, born loser, just released from two years in a Galveston prison and now "frying across the Texas panhandle" in July to arrive in Vegas where he meets up with Fruit Loop his stunted but busty and hippy and blond-as-bleach younger sister in her wedding dress who's about to be married to built-like-a-bull semipro football player Breezy Bonaventure of the Sarasota Panthers, except there are complications involving considerable violence when a pervert in a nearby hotel conspicuously leers at Fruit Loop and Breezy and the entire Panther team are obliged to seek vengeance, and Johnny Loop is left to ponder his existential dilemma, while downing numerous cans of beer—

I do not like to gamble and done Vegas too many times. I am not lucky. Some people are lucky. The big finger in the sky is pointed at them. The big finger in the sky never so much as took the time to poke me in the eye.

—and in a casino bar Johnny Loop is approached by a beautiful woman who is ten times better looking than any woman who ever looked at him twice in his life, a schoolteacher from Iowa dressed all in shiny spangles, and she smiles at him, and next thing Johnny Loop knows it's hours later, he's waking from a nightmare, his sister Fruit Loop and Breezy Bonaventure are married and gone on their honeymoon and it's being explained to Johnny Loop by a doctor how lucky he is to be alive because . . . But to continue would be to cheat the reader of the opportunity to discover precisely how Tom Paine works out this wild, wacky and finally poignant title story of his virtuoso story collection *Scar Vegas*.

There are ten remarkable stories here, singular idiosyncratic voices, an impressive range of thoughtfully evoked domestic and foreign settings, characters *in extremis* as Johnny Loop, and a passionate political vision underlying the inspired chaos of the plots. In short, *Scar Vegas* is a bold and original debut rendered for the most part at break-neck speed. In the opening story, "Will You Say Something, Monsieur Eliot?" a young American male of the privileged Caucasian class ("The world loves me") suffers an accident on a single-handed sailing trip out of the Bahamas and bound for St. Barts, endures hardship in the killing sun, and begins to hallucinate:

> The third day the sea was glass, and then the wind whispered at noon and feathered the glass in running swaths. For hours, Eliot watched the swaths dapple in the sun . . . When he awoke, his throat was on fire, and he wanted to drink from the sea and he swallowed, and the salt burned like acid down his throat . . . He closed his eyes and saw the boom over the fieldstone fireplace in the pastel living room of his house in Locust Valley and saw himself standing under it telling the story of his shipwreck. There were many people in the room listening, and they were all strangers.

In this cruel parable of First and Third World experience, Eliot Swan is joined at sea and his life saved by desperate Haitians who have fled their

country seeking asylum in the United States, their battered wreck of a boat having been drifting for twenty days. The story would seem to be gearing up for a fairy-tale happy ending, but when American rescue workers arrive in a helicopter to save the privileged Mr. Eliot, will he insist that they save the Haitians, too?

Among Paine's dramatic stories of winners and losers, the privileged and the victimized, the companion piece to "Will You Say Something, Monsieur Eliot?" is a surrealist horror story, "A Predictable Nightmare on the Eve of the Stock Market First Breaking 6,000," tracing the physical and mental degradation of a female stock market broker (her Cheeveresque name, Melanie Applebee) who has been fired by her superiors after having discovered that a colleague was trading illegally on inside information. Melanie Applebee has been a highly productive employee of a wealthy capitalist organization:

> [She] had been praised by Hart's management for her plan for a restructuring. The plan closed down marginal stores, bought a chain of cut-rate drugstores, slashed the pension program, reduced employee stock options, severely limited the health plan, and cut wages. [An associate] she went on a blind date with at the time told her everything she and he were doing was probably pure evil.

As in a medieval allegory in which "evil" is suitably punished, beautiful blond Melanie with her MBA winds up as a piece of merchandise herself, sold to an Arab sheik to be transported "to Mexico City, then to Oman. Or Dubai. Where the market wills." Clearly, these savagely politicized stories by Tom Paine are not in the fastidiously crafted, psychologically subtle mode of the mainstream modern short story that has descended through the decades from Anton Chekhov, James Joyce, and Henry James; these are tales that play boldly with caricatures, stereotypes, and large moral issues that in the hands of a less gifted writer would make for painful reading.

In "Unapproved Minutes of the Carthage, Vermont, Zoning Board of Adjustment," a Vermont town is revealed to be endangered by carcinogenic radio waves carelessly transmitted by a local station allied with a national conglomerate, and arrogantly unrepentant; in "General Markman's Last Stand," a Marine hero revealed as a cross-dresser prepares for

public humiliation on his last day of service; in "The Battle of Khafji" a "clean-cut Burlington [Vermont] boy" joins the marines and is shipped to fight in Operation Desert Storm, with tragic consequences (". . . It was like a party: *We were finally going to get some trigger time*"); in the zestful monologue "The Spoon Children," a sixteen-year-old contemporary Huck Finn in the guise of a druggie skateboard artist narrates a tale of attending the '96 Portland Anarchist's Convention, surviving an encounter with riot police, and falling improbably in love. As this summary suggests, these are emboldened tall tales that thrive upon excess, and if the gifted Paine has any weakness it's his very energy, which can become wearing; paragraphs dense with detail fly by us like a conveyer belt whose speed is ever accelerating, and the precarious humanity of Paine's characters is overshadowed by the very ambitions of his prose. But *Scar Vegas* introduces a writer of genuine talent and vision.

DESPITE ITS fatuous cover—the torso of a chunky ballerina in green chiffon, with a cutely blank Magritte-mirror for a head—Carol Shields's third collection of stories, *Dressing Up for the Carnival,* is an intelligent, warmly provocative and entertaining gathering of variegated prose pieces, both conventional and unconventional. Of the twenty-two stories a few are admittedly slight, and overly whimsical; several of the more promising fade disappointingly, as if the author had lost interest in maintaining her own fictions; but the majority are deftly, even sunnily written, and bristling with ideas, reminding us that fiction need not be emotionally devastating or "profound" to be worthwhile.

The quicksilver opening story, a sort of musical overture, "Dressing Up for the Carnival," glides rapidly about an unspecified Canadian city (Shields, an American, lives in Winnipeg, Ontario) with Woolfian bravura: "All over town people are putting on their costumes." In thumbnail sketches we glimpse women and men in private moments as they reinvent themselves by way of eye-catching clothing or ornamentation, or impulsive, exotic purchases (a mango, for instance, or a big bouquet of daffodils), or running an unusual errand for one's boss, or sporting a "smart chignon." Shields both celebrates and gently mocks the human need to mythologize the self, in however trifling and evanescent ways. Thinks a middle-aged man who sometimes, in secret, waltzes about in

his wife's nightgown, "We cannot live without our illusions." The "shriveled fate" these anonymous citizens perceive for themselves can be postponed, it's believed, by such hopeful acts.

Shields suggests that "dressing up" is what we are all doing, and certainly what writers must do, in the service of creating and sustaining the illusion of art. Several of her most winning stories are about thoroughly unromantic, self-doubting women writers; like the middle-aged female protagonist of "The Scarf," they have come to the writing life not by way of passion and vision but indirectly, having first been editors and scholars. The author of *My Thyme Is Up* is puzzled by her novel's "sparky sales" and has been made to feel guilty in the light of the lack of success of a more gifted, but less "accessible" woman writer-friend; she is awarded the Offenden Prize, given annually to a novel of literary quality that has "a beginning, a middle, and an ending," which confirms the book's minor status. (Shields won a Pulitzer Prize for her novel *The Stone Diaries* in 1995.) The author of *My Thyme Is Up* can make no great claims for herself as a novelist, though she feels a glimmer of resentment on behalf of her sex: "Imagine writing something called *Death of a Saleswoman.* What a joke." "The Scarf" is a story of a comic-melancholy misunderstanding that nonetheless turns out well, with the strengthening, if only through error, of an old friendship between women.

In a companion story, the mildly satiric "The Next Best Kiss," two academic writers meet, and begin a love affair, at a conference on the *fin-de-siècle* crisis: the male professor gives a paper titled "End of the Self" ("Todd confided to Sandy that the text . . . might eventually find its way into the *New York Review of Books,* although the editors were asking for substantial changes"); the female professor presents a seminar titled, "Diatribe and Discourse in the Twenty-first Century" which is "loaded with allusive arrows" to Lacan. The love affair, such as it is, would seem to have been concocted out of sheer verbiage, as well as groveling need on both sides; it ends abruptly, when the woman utters an unintended truth the man isn't prepared to accept, for all his pose of unflinching honesty. In any case, what is happiness, in contemporary times?

> . . . Those twin demons, happiness and sadness, had lost their relevance. Happiness was a crock; no one . . . really had it for more than a minute at a time. And sadness had shrunk, become miniaturized and narrowly defined, a syndrome, a pathology—whereas once, in

another time, in a more exuberant century, in a more innocent age, there existed great gusts of oxygen inside the sadness of ordinary people . . . Sadness was dignified; it was referred to as melancholy . . . It was a real affliction, like color blindness.

In "Death of an Artist," another elderly writer, a man, leaves behind at his death a set of "undiaries" of his "choleric, odd, furiously unproductive, and thoroughly unsatisfying life" which are to be read in the reverse order in which they were written; that is, from the final entry backward through the decades, to childhood and infancy and beyond: "I am utterly alone" is written in red on top of the final page. Shields seems to be suggesting, in this rather sketchy story, that the writer is as mysterious to him- or herself as to others; or, conversely, that there is no more mystery in the artist than in anyone else. In any case, we are living in an age of diminishments:

Everyone is coming out these days for the pleasures of ordinary existence. Sunsets. Dandelions. Fencing in the backyard and staying home. "The quotidian is where it's at . . ."

The ordinary has become extraordinary. All at once—it seems to have happened in the last hour, the last ten minutes—there is no stone, shrub, chair, or door that does not offer arrows of implicit meaning or promises of epiphany.

The weakest prose pieces in *Dressing Up for the Carnival* read as if they've been spun of sheer whimsy, to be hurriedly typed out even as whimsy fades: what if the National Association of Meteorologists were to go on strike, and we had no weather for weeks; what if the Queen vanishes, and the "progression of seasons" ceases; what if a harp falls through the air, and strikes a bystander; what if a Window Tax were introduced, and people began to board up their windows to save money; what if the ruins of a Roman arena were discovered in Manitoba, and the entire economy of the region transformed by tourism?—and so on. Shields is amusing, but not very interested in pursuing where whimsy might lead, so that these pieces tend to trail off into irresolution; prompting the reader to wonder why they've been included among stronger, more thoughtfully developed stories like the concluding "Dressing Down," a chill counterpoint to the opening story of dressing

up: a young boy's grandparents become permanently estranged over the issue of a summer nudist camp in southern Ontario, to which the grandfather is devoted; encouraged by the grandfather to spend time with him at the camp, the ten-year-old boy is shocked and sickened by what he sees, not liberated as his grandfather had hoped:

> People with their limbs and creases and folds were more alike than I thought. Skin tones, hairy patches—that was all they had. Take off your clothes and you were left with your dull suit of invisibility.
>
> What I witnessed led me into a distress I couldn't account for or explain but which involved a feverish disowning of my own naked body and a frantic plummeting into willed blindness. I was launched into the long business of shame, accumulating the mingled secrets of disgust and longing . . .

In a final defiant gesture, the boy's grandmother leaves instructions that after her death her naked body be placed in a coffin to be kept open at her wake; of course, the family refuses to obey.

The author of nine well-regarded novels, Carol Shields would seem to have focussed her imaginative energies on longer, not shorter forms of fiction. Even the stronger stories in this collection have a sketchy, provisional air when set beside the more substantial achievement of many of Shield's contemporaries for whom the art of the short story has been a serious professional commitment. Shield's attentiveness to literary theory gives to her stories an inevitable glibness, as if theory might in any way explain, or explain away, the power of genuine art.

> A narrative isn't something you pull along like a toy train, a perpetually thrusting indicative. It's this little subjunctive cottage by the side of the road. All you have to do is open the door and walk in. Sometimes you might arrive and find the door ajar. That's always nice. Other times you crawl in through a window. You look around, pick yourself a chair, sit down, relax. You're there. Chrysalis collapses into cognition.

WHERE CAROL Shields is light, swift, effervescent and idea-driven, Alice Elliott Dark is thoughtful, introspective, brooding; willing to risk a

kind of Jamesian stasis in the hope of deepening our engagement with her characters. Unlike Shields's women and men who bounce about the page like balloons, Dark's women, men, and children are defined by and often burdened by their histories; they are individuals not to be glibly defined in terms of class or types, though they might seem, from a distance, to be of a singular species: educated, upper-middle-class Caucasian suburbanites for whom financial security, social status and politics are not issues. They don't reside in Locust Valley, like Tom Paine's privileged ugly-American Eliot Swan, nor are they near neighbors of the alcohol- and lust-driven inhabitants of John Cheever's Shady Hill. The citizens of Dark's suburban village Wynnemoor (an inspired name) are unexceptionally intelligent, decent, good-hearted and hopeful; even the adulterous are desperately eager to do the "right" thing, and no action is performed that isn't mulled over, conscientiously. Dark's characters are husbands and wives, fathers and mothers, daughters and sons, almost exclusively family-defined; quite a few are middle-aged or older; it's rare that one can say of himself: "I was a bachelor unto myself and complete. I'd never married or even fallen in love" ("The Tower"). One of the collection's most moving stories, "Home," takes us into the experience of an elderly woman whose invalid husband has just been admitted to a nursing home, on the day she's informed by her married daughter that her husband and family are selling the home she'd believed was hers, and making arrangements for her to live with her invalid husband in the nursing home; when she objects, she's informed that she has no choice, for she has no property or income of her own. This subtly rendered story becomes by swift degrees a horror story, the more terrifying for its domestic setting. The good dutiful wife of sixty years, Lil, is informed by her daughter:

You should have stood up to Dad years ago . . . I hate the thought of you losing this house. You're like one of those Indian women being thrown alive onto her husband's funeral pyre. A suttee.

In the Gloaming is a collection of ten skillfully composed, quietly narrated short stories reminiscent of the stories of love and loss of the late Alice Adams. Each story exudes the gravitas of a radically distilled novel; though, in well-crafted short story fashion, we begin near the story's climax, we are brought through flashbacks into the protagonists'

lives, and come to assess them in ways they aren't able to assess themselves. The title story is a love story of a special kind: the emotional experience of a woman who discovers that her gay son who is dying of AIDS is "the love of her life," and not her husband who has been largely absent from his family, made into a "benign image" concocted by the wife herself, a "character of her own invention, with a whole range of postulated emotions." This elegiac but toughly unsentimental story is utterly convincing in its depiction of the dying son's last days, and the urgency both mother and son feel about exploring their new, rather romantic discovery of each other: "You're where I come from," the son, Laird, says. "I need to know about you." This unsentimental story is utterly frank, candid:

> "I'm asking about your love life," she said. "Did you love, and were you loved in return?"
>
> "Yes."
>
> "I'm glad."
>
> "That was easy," he said.
>
> "Oh, I've gotten very easy, in my old age."
>
> "Does Dad know about this?" His eyes were twinkling wickedly.
>
> "Don't be fresh," she said.

So subtle is the presentation of the mother's mental state, the reader comes to share in her delusion that the afflicted Laird will somehow not die, and that their journey of discovery will continue indefinitely; as if the bond between mother and son weren't predicated entirely upon Laird's fatal illness. If Laird were well, the last place he'd be would be in Wynnemoor, in his parents' home. Yet the mother can console herself, in the gloaming (Scottish for "twilight") of their life together,

> How many mothers spend so much time with their thirty-three-year-old sons? She had as much of him now as she'd had when he was an infant—more, because she had the memory of the intervening years as well, to round out her thoughts about him.

F. Scott Fitzgerald once remarked that if a writer begins with an individual, he may end up with a type; if he begins with a type, he will end

up with nothing. Dark would seem to refute this theory by presenting us with characters who, at first glance, appear to be familiar types: the suspected "other woman" ("The Secret Spot") who turns out to be quite different from her image; the callow young husband/adulterer ("Close") who makes a pilgrimage to his boyhood home, quixotically seeking a sign to help him with his life; the boastful bachelor ("The Tower") who falls deeply in love, for the first time, with a young woman who is the daughter of a former mistress, and who might, or might not, be his own daughter. In the volume's concluding story, "Watch the Animals," a suburban stereotype named Diana Frick, (one of Wynnemoor's "moneyed blue bloods, descendant of a signer"), dying of cancer, and needing to find homes for her numerous rescued animals, is confronted by stereotypical gossipy neighbors, who ponder the older woman's behavior, which differs so markedly from their own:

> [Diana's animals] were not purebreds, or even respectable mutts. She collected creatures others had thrown away, the beasts left on the side of the highway or confiscated from horrific existences by her contacts at the ASPCA; the maimed sprung from labs, the exhausted retired from dog tracks; the unlucky blamed for the sins of the household and made to pay with their bodies . . . Immigrants from hell, she called them . . .
>
> She took these animals that otherwise would have ended up euthanized at best, and she trained them and groomed them and nursed them and fed them home-cooked foods until—we had to admit—they bore a resemblance to the more fortunate of their species. They behaved, as far as we could tell. But from a practical standpoint, could they ever be considered truly trustworthy? Who knew what might set them off?

Yet these clucking old biddies reveal themselves, finally, as fully human too, in an unexpected reversal of fortune. "Watch the Animals" is a perfect ending for the elegiac stories of *In the Gloaming,* bringing together Dark's commingled themes of impending loss and unreasonable hope. The Wynnemoor community embraces Diana Frick only when she signals them that she is as vulnerable as they, and as mortal. The "gloaming" is our human condition.

. . .

IF GEORGE Saunders's hyperkinetic dark-fantasist-satirist prose in the mode of Pynchon, Coover, Barthelme, and DeLillo is an acquired taste, it's a taste quickly acquired. This master of low-mimetic lunacy can make you laugh aloud even as you wince at his deadpan excess and the manic-compulsive syntax that mimics, as in a ghastly echolalia, those thoughts we might consider our own, and "normal." There's an admirable boldness, too, in the way in which Saunders recycles motifs (America-as-theme-park, for instance) from story to story. The six talky bizarre tales of his new collection, *Pastoralia,* are very like the seven talky bizarre tales of his first collection, *CivilWarLand in Bad Decline* (1996); like the entrepreneurial zealots whom he satirizes, Saunders exploits his material with slight variants, improvising upon a formula of stream-of-consciousness black humor that sometimes, but not often, spills over into sheer comic-book silliness but occasionally, as in the new collection, engages our sympathies unexpectedly. Saunders's brain-damaged and frequently physically handicapped characters will perhaps be more amusing to readers not personally acquainted with mental retardation, autism, senile dementia and physical disabilities, but it should be kept in mind that satirists from Aristophanes to Rabelais to Jonathan Swift to Louis-Ferdinand Céline and Lenny Bruce have been outrageously cruel, and our current "politically incorrect" humor especially so:

> The first great act of love I ever witnessed was Split Lip bathing his handicapped daughter. We were young, innocent of mercy, and called her Boneless or Balled-Up Gumby for the way her limbs were twisted and useless . . . She was scared of the tub, so to bathe her Split Lip covered [her] couch with a tarp and caught the runoff in a bucket.
> ["Isabelle," *CivilWarLand in Bad Decline*]

From *Pastoralia,* the final minutes of a child named Cody who's afflicted with a mysterious nosehole:

> The boy on the bike flew by the chink's house, and the squatty-body's house, and the house in which the dead guy had rotted for five days, remembering that the chink had once called him nasty, the squatty-body had once called the cops when he'd hit her cat with a

lug nut on a string, the chick in the dead guy's house had once asked if he, Cody, ever brushed his teeth. Someday when he'd completed the invention of his special miniaturizing ray he would shrink their houses and flush them down the shitter while in tiny voices all three begged for some sophisticated mercy, but he would only say, Sophisticated? When were you ever sophisticated to me?

. . . but then oh crap he was going too fast and missed it [running over a neighbor's hose], and the announcers in the booth above the willow gasped in pleasure at his sudden decisive decision to swerve across the newly sodded lawn of the squatty-body's house. His bike made a trough in the sod and went *humpf* over the curb, and as the white car struck him the boy and the bike flew together in a high comic arc across the street and struck the oak on the opposite side with such violence that the bike wrapped around the tree and the boy flew back into the street.

["The End of FIRPO in the World"]

The America of Saunders's deadpan prose has become a virtual-reality America of theme parks, amusement enterprises, and private habitations like Sea Oak ("no sea and no oak, just a hundred subsidized apartments and a rear view of FedEx") where characters watch TV programs like *How My Child Died Violently* and *The Worst That Can Happen*. They work at places like Joysticks, a male stripper's joint. They live with physically impaired relatives, whom they are obliged to care for, with limited resources. And try to earn a decent living! The hapless narrator of the title story plays a prehistoric cave dweller in a theme park, but business is falling off; his mate keeps forgetting her scripted role, jeopardizing both their jobs by speaking English ("No freaking goat?" "What a bunch of shit".) and behaving like a contemporary miserable middle-aged TV sitcom Mom with a drug addict-thief-loser son. Nor is romance a likely possibility for the cave-couple:

She's in there washing her armpits with a washcloth. The room smells like her, only more so. I add the trash from her wicker basket to my big white bag. I add her bag of used feminine items to my big white bag. I take three bags labeled Caution Human Refuse from the corner and add them to my big pink bag labeled Caution Human Refuse . . .

She's fifty and has large feet and sloping shoulders and a pinched little face and chews with her mouth open. Sometimes she puts on big ugly glasses in the cave and does a crossword: very verboten.

And there are increasingly cryptic memos from a supervisor:

> Please know that each one of you is very special to us, and are never forgotten about. Please know that if each one of you could be kept, you would be, if that would benefit everyone . . . But as we meld into our sleeker new organization, what an excellent opportunity to adjust our Staff Mix.

As if aping primitive cognition, "Pastoralia" is excruciatingly long, and slow, as a centipede is slow, moving its legs in deliberate sections, unhurried. Here is a purposefully clumsy prose that presents a considerable obstacle to the reader, yet the effort is worth it, as with the effort required to get through the companion stories "Winky," "The Barber's Unhappiness," and "The Falls." In these, unattractive, seemingly moronic protagonists work themselves up to decisive acts, or almost. "Winky" is the funniest, its opening scene a parody of an EST-like self-help seminar held in a Hyatt, under the direction of Tom Rodgers himself, founder of the Seminars.

> "Now, if someone came up and crapped in your nice warm oatmeal, what would you say? Would you say: 'Wow, super, thanks, please continue crapping in my oatmeal'? Am I being silly? I'm being a little silly. But guess what, in real life people come up and crap in your oatmeal all the time—friends, co-workers, loved ones, even your kids, especially your kids!—and that's exactly what you do. You say, 'Thanks so much!' You say, 'Crap away!' You say, and here my metaphor breaks down a bit, 'Is there some way I can help you crap in my oatmeal?'"

All the protagonist Neil-Neil wants is the courage to tell his mentally retarded sister Winky to move out of the apartment they've been sharing for too long, but when he's put to the test Neil-Neil fails. Of course: "He wasn't powerful, he wasn't great, he was just the same as everybody else."

In their original settings in the columns of *The New Yorker*, amid

glossy advertisements for high-priced merchandise, George Saunders's goofy riffs on the travails of freaks and losers who sometimes manage to rise, only just barely, to the level of the human, suggest the voyeuristic fascination/revulsion of those eighteenth-century European aristocrats who visited asylums to be entertained by the spectacle of lunatics. Yet *Pastoralia* is less stridently dystopian than *CivilWarLand in Bad Decline,* and the author's vision, if that's an appropriate term, is less cruel. At the end of the final story, "The Falls," a man is drawn to attempt the rescue of two girls in a sinking canoe, as if David Lynch and Norman Rockwell were suddenly conflated: ". . . making a low sound of despair in his throat he kicked off his loafers and threw his long ugly body out across the water."

WHAT IS an Indian? runs through Sherman Alexie's second collection of short stories *The Toughest Indian in the World* like a demented, demanding mantra. In these nine stories, irony is sounded like the tribal drums of the ghost-musicians of the story "Saint Junior" that haunt the Spokane Indian Reservation. ("Irony, a hallmark of the contemporary indigenous American.") Alexie, best known for his novels *Reservation Blues* and *Indian Killer,* is a Spokane/Coeur d'Alene Indian educated at Gonzaga University and Washington State University, a funny, irreverent, sardonic-but-sentimental, rebellious voice set beside his elder and conspicuously more writerly and "spiritual" Native American contemporaries N. Scott Momaday, Leslie Silko, and Louise Erdrich. Sherman Alexie is the bad boy among them, mocking, self-mocking, unpredictable, unassimilable, reminding us of the young Philip Roth whose controversial works of fiction "The Conversion of the Jews" and *Portnoy's Complaint* outraged an older generation for whom anything Jewish had to be sacrosanct, revered. For weren't the Jews victims of the Holocaust, and martyrs? And aren't Native Americans victims of Caucasian exploitation and genocide, and martyrs? Shouldn't one's tone in writing of "victims" be solemn, or at least serious?

Unfortunately, Sherman Alexie's ironic narrators know too much of Indian history: "It was Indian scouts who had helped white people kill Sitting Bull, Geronimo, and every other Indian warrior in the world." Their nostalgia for "the rez" is tempered by the memory of unsentimental parental advice: "Son, if you're going to marry a white woman, then marry a rich one, because those white trash women are just Indians with

bad haircuts." And "the rez" itself is "spiritual and magic" mostly in the imaginations of white tourists, who know nothing of its "wet monotony." As Low Man Smith, a successful writer of mysteries, reminisces of the Coeur d'Alene Reservation he has left behind:

> The tourists didn't know, and would never have guessed, that the reservation's monotony might last for months, sometimes years, before one man would eventually pull a pistol from a secret place and shoot another man in the face, or before a group of women would drag another woman out of her house and beat her left eye clean out of her skull. After that first act of violence, rival families would issue calls for revenge and organize the retaliatory beatings. Afterwards, three or four people would wash the blood from their hands and hide in the hills, causing white men to write editorials . . .
>
> ["Indian Country"]

Through most of the stories of *The Toughest Indian in the World* a singular voice of ironic intelligence and self-deprecatory humor prevails, that of a youngish male, reservation-born, who has been educated in white schools and has left the reservation for work (journalism, law); sometimes he has married an Indian woman, and sometimes he has married a white woman, as in the story "Class" ("Blonde, maybe thirty-five, and taller than me, [Susan] was the tenth most attractive white woman in the room . . . I didn't have enough looks, charm, intelligence, or money to approach anybody more attractive than that"; obsessively this young man broods upon "the rez" and what he has lost, and what he has gained, by moving out into the white world. Does he appear successful, in that world? Does he appear "assimilated"? Even so, "I know enough to cover my heart in any crowd of white people." He thinks, like the lonely narrator of the title story, a journalist with a Spokane Indian background, of his father's warning:

> "They'll kill you if they get the chance . . . Love you or hate you, white people will shoot you in the heart. Even after all these years, they'll still smell the salmon on you, the dead salmon, and that will make white people dangerous."

All of us, Indian and white, are haunted by salmon.

This man has learned, he tells us, to be silent in the presence of white people: "The silence is not about hate or pain or fear. Indians just like to believe that white people will vanish, perhaps explode into smoke, if they are ignored enough times." But when the journalist-narrator of "The Toughest Indian in the World" is confronted with the personification of the salmon, a "beautiful and scarred" Lummi Indian hitch-hiker to whom he has given a ride, he sends the man away after a single awkward attempt at lovemaking, as if he lacks the courage to accept his own deepest nature: "I watched him rise from earth to sky and become a new constellation."

For Alexie, racial identity and self-identity would appear to be tangled inextricably with sex. In the opening story, "Assimilation," a Coeur d'Alene woman married to a white man whom she loves, but with whom she has been having sexual problems, decides impulsively that she wants to have sex with "a white man, a stranger, only because he was white"; she finds the man, very pale, fat, predictably repulsive: "Hate, hate, hate, she thought, and then let her hate go." In "Class," the young Indian lawyer who'd married the tenth most attractive white woman in the room has marital problems too, and confesses to having slept with seventeen prostitutes, "all of them blond and blue-eyed"; when he hires a call girl advertised as Tawny Feather, she too turns out to be white, with a black wig over her short blond hair; the story takes a sudden violent turn when, in a rough Indian bar, he approaches an Indian woman ("she was a woman who had once been pretty but had grown up in a place where pretty was punished"), and is savagely beaten.

> "I wanted to be with my people," I said.
> "Your people?" asked [the woman]. "Your people? We're not your people."
> "We're Indians."
> "Yeah, we're Indians. You, me, Junior. But we live in this world and you live in your world."
> "I don't like my world."
> "You pathetic bastard . . . You sorry, sorry piece of shit."

What is an Indian? asks a professor at Washington State University, infuriating the young Indian protagonist of "One Good Man" with his

absurd boastfulness of being an Indian himself ("a Cherokee-Choctaw-Seminole-Irish-Russian"). For even as the educated, assimilated Indian is repudiated by Indians of a lower social class who perceive themselves, and are perceived, as authentic Indians, so too the full-blooded Indian is contemptuous of individuals of mixed ancestry who boast of their Indian blood while looking nothing like Indians: "[The professor] was a small man, barely over five feet tall, with gray eyes and grayer hair." Indians beware Indians! A Mohawk Indian woman from Manhattan has lived so long on the Spokane Reservation with her Spokane husband, she realizes she's become more Spokane than Mohawk: "She'd always understood that an Indian could be assimilated and disappear into white culture, but she'd discovered that an Indian of one tribe could be swallowed whole by another tribe." For Grace Atwater, however, love for her failed basketball-player husband is more important than tribal identity.

The Toughest Indian in the World is an uneven collection. Though Alexie is clearly a gifted writer, and a writer with a mission, he gives the impression here of performing well beneath his powers. The weaker stories swerve into self-conscious comedy, as in "Dear John Wayne," an interview in which a cultural anthropologist—"the Owens Lecturer in Applied Indigenous Studies at Harvard University"—pompously interviews a 118-year-old Spokane Indian woman who reminisces of her not very convincing love affair with the actor John Wayne, or into fantasy, as in the long, awkwardly composed "The Sin Eaters," in which Indians are terrorized and humiliated by the United States government, in a saga out of the *X-Files*. The last story in the collection, "One Good Man," is perhaps the strongest story, describing the last days of a sixty-five-year-old Spokane Indian diabetic whose feet have been amputated, and whose son, a character very like Alexie's other young-male Indians who have returned to the reservation, fulfills his father's final wish and brings him to the Mexican border. The question *What is an Indian?* is asked repeatedly, and Alexie's final reply is, "You tell me." The story, and the collection, end on a defiant, rhapsodic note: "I lifted my father and carried him across every border."

Notes

1. The romance of Raymond Carver's posthumous career is a literary phenomenon of our time, akin to the papal sanctification of a martyr. Carver was no romantic himself, however, and explains candidly in his essay "Fires" his reasons for concentrating on short forms:

> During [the] ferocious years of parenting, I usually didn't have the time, or the heart, to think about working on anything very lengthy. The circumstances of my life, the "grip and slog" of it, in D. H. Lawrence's phrase, did not permit it. The circumstances of my life with these children dictated something else. . . . If I wanted to write anything, and finish it, and if ever I wanted to take satisfaction out of finished work, I was going to have to stick to stories and poems. The short things I could sit down and, with any luck, write quickly and have done with.

> In his twenties, Carver "always worked some crap job or other," sawmill jobs, janitor jobs, delivery man jobs, service station jobs, stockroom boy jobs, even tulip-picking in Arcata, California. His desperation to find time to write was conjoined with an equal desperation to make enough money to support his young family.

> There were good time back there, of course; certain grown-up pleasures and satisfactions that only parents have access to. But I'd take poison before I'd go through that time again.
>
> [from *Fires: Essays Poems Stories,* 1983]

News from Everywhere: Short Stories

OUR PREEMINENT MID-TWENTIETH-CEN-
tury American short story writers seem to us now brilliantly inspired re-
gionalists, though it would have been difficult to see them as such at the
time. The America of Katherine Anne Porter, Eudora Welty, Peter Taylor,
Jean Stafford, Flannery O'Connor, John Cheever, and the young and rap-
idly ascendant John Updike was exclusively Caucasian, predominantly
Protestant, likely to be middle-class conservative if not genteel. (Flannery
O'Connor, a fiercely partisan Roman Catholic, cast her merciless satiric

eye upon the Protestant South, in which her broadly caricatured poor whites and poorer blacks crowd against the property lines of uneasy middle-class whites. Katherine Anne Porter, born to hardscrabble poverty in a log cabin in West Texas, was inspired in time to invent for herself a pseudo-Southern aristocratic background and to establish her own adamant property lines.[1]) Though there were notable exceptions—certain of Welty's more dreamlike, myth-inspired stories, such dark fantasies by Cheever as "The Enormous Radio" and "Torch Song," and Updike's extravagantly Joycean *The Centaur*—these writers were unflagging realists with little interest in literary experimentation; their acclaimed fictions are not so much mirrors moving along roadways, in the mode of Stendhal, as mirrors held up to reflect domestic places, times, and manners; mirrors reflecting the private lives of authors' ever fascinating and worthy kind.

In the twenty-first century, the landscape of American literary fiction is radically altered. There is no longer any "mainstream" but rather numerous tributaries, highly charged, churning with energy and invention. The anarchic experimentation of the 1960s and 1970s has been assimilated into even popular, commercial fiction and has become, for most practitioners, simply another mode of writing as traditional in its way as realism. If these four new collections of short stories—except for Brady's *Curled in the Bed of Love*, all first books—are a reliable indication, there is as much writerly concern for form and precision of language as there was fifty years ago, but subjects are not likely to be defined by the regional; characters are nearly always from somewhere else, and their "roots" are not an issue. In contemporary fiction it's more likely to be locale that matters, not a region with a specific history. Not where one has come from but where one is going is the issue.

HAS THERE been, in recent memory, a first story collection, American or otherwise, as ambitious, varied, and compelling as John Murray's *A Few Short Notes on Tropical Butterflies*? These eight thematically linked stories are so richly diverse in their characters' ethnic and family backgrounds, so provocative in their ideas, and so generously fitted out with scientific, medical, and historical information that to say that Murray (trained as a doctor, with experience as an emergency medical worker in Third World countries suffering the ravages of cholera, dysentery, and massacre) is a prodigious talent is something of an understatement.

Where most first story collections are hardly more bulky than books of poetry, likely to repeat character-types and settings from story to story, *A Few Short Notes on Tropical Butterflies* contains enough material for several very different novels, family sagas set on several continents and involving such vocations as microbiology and emergency medicine in Bombay ("The Hill Station"), lobster fishing in Maine and nursing in Africa for the UN ("All the Rivers in the World"), neurosurgery and butterfly collecting ("A Few Short Notes on Tropical Butterflies"), paleontology in Iowa City, Iowa, and emergency medical work, again in Bombay ("White Flour"), missionary and medical work in the civil war–torn Congo ("Watson and the Shark"), carpentry and oil painting ("The Carpenter Who Looked Like a Boxer"), mountain climbing in the Himalayas ("Blue"), surgery and amateur coleoptery, or beetle collecting, in Iowa City ("Acts of Memory, Wisdom of Man"). As this (incomplete) catalogue suggests, Murray is not a minimalist but one for whom "Nothing is too small to escape his attention" as it's remarked admiringly of one of his physician visionaries.

A Few Short Notes on Tropical Butterflies is a gallery of striking portraits to which narratives, most of them protracted in space and time, are sometimes awkwardly joined. In actual life, we are far more than the sum of our actions: it may even be that our actions are inadequate to suggest our complexity, or contradictory. Murray means to suggest such complexity by way of lengthy background summaries, descriptions and analyses of his characters. The author is perhaps not unlike one of his insect collectors, an Indian-born surgeon of whom it's said, "He was obsessed with the systematic classification of his [2000] specimens, and he could talk about beetle phenetics and phylogeny for hours."

Obviously the author is most at home with the scientifically-minded, but his zealous protagonists are as likely to be foreign-born as they are likely to be Caucasian Americans, and the professional and domestic lives of women are as likely to be explored as those of men. It's remarked in "White Flour" that "Every family has at least one lunatic"; each story in this collection has at least one lunatic, if by "lunatic" we mean an individual possessed by the unattainable ideal, like saving lives in Third World countries in which deplorable social conditions prevail or bringing back a whole specimen of *Omithoptera alexandrae* (Queen Alexandria's birdwing, the largest butterfly in the world). Murray's women are more likely to be frustrated in their careers than his men, emotionally

volatile and ill-suited for domestic life. "The only romance you have is with disease," it's charged against a devoted woman microbiologist whose lovers are for her "a series of sensations" ["The Hill Station"]. The Indian-born wife in the title story, daughter of a physicist and trained as a neurosurgeon for whom "the world is nothing but a mass of electrons, neutrons, and quarks, each with clearly defined rules of action and interaction," nonetheless yearns for a baby, and is an enigma to her American-born Caucasian husband:

> [Maya] grew up in Washington, D.C., cut her teeth to the sounds of Elvis Presley and learned to drive during the last days of the Johnson Administration. She understood the first law of thermodynamics before her first kiss. Maya is a mass of cross-cultural contradictions— Levi's and sari's; Twinkies and dhal; David Bowie and Mahatma Gandhi; the Kama Sutra and *Casablanca*.

In "White Flour," another dissatisfied Indian-born wife, trained as a paleontologist, provokes her more conventional, rather dull American physician-husband to flee their ruin of marriage, taking refuge in, ironically, volunteer medical work in Bombay, and leaving her and their young son behind in Iowa City. Aging, the runaway husband remains "full of optimism and plans for the future" while his estranged wife is ever more embittered and baffled by her fate:

> She was never able to get a university appointment in paleontology although it was the only subject that had ever interested her. She did not understand . . . She could upset people, [her son] knew that, could push people away when she thought she was drawing them in . . . Everything was clouded by her ambition. She did not have the capacity to see herself at fault . . . Every rejection made her harder and more unforgiving. Joseph's father had left her with no money. She could not ask for help. All she had was her independence. I would rather live the life of a pauper, she said, than do a job that is beneath me.

In the sixty-three-page story that concludes the collection, "Acts of Memory, Wisdom of Man," an Indian-born couple flee political strife in India at the time of partition to settle in Iowa City, where the man, a specialist in gall bladder surgery, is embraced by the hospital community:

I realized when I was young that it was my father's Englishness that was admired and made him acceptable: his manners and accent; his refinement and clothes; his stories of picnics at Oxford with friends from Christ Church . . . We grew up without Bible or Koran.

This marriage, too, flounders, as the wife becomes increasingly Americanized, and then, by 1968, radicalized, and the political division in the United States between pro- and anti-Vietnam War sentiment is paralleled in the household. Murray is considerably challenged by this overly familiar material, and the slowness of his narrative, recounted by a now middle-aged, ophthalmologist son long after the family's breakup, allows the reader to predict the double, melodramatic ending; but the portraits of the Indian couple are precisely drawn and memorable.

The most extreme, least sympathetic and least credible of Murray's independent-minded female characters is the wife of the carpenter Danny Dalton of "The Carpenter Who Looked Like a Boxer," a resident in psychiatry who, in the intimacy of her marriage with a very physical, crude-mannered but naive man, revels in sado-masochistic sex:

> It had all seemed very strange to [Danny Dalton] a revelation when she brought out a suitcase full of steel handcuffs, a leather hood, and a stock whip of the type he'd seen used to round up sheep. He didn't understand her need to be tied up and beaten, but she was excited by it in a way he had never seen before—it was almost like a compulsion—and she was turned on by the violence.

It may be that, in life, sado-masochists can be estimable individuals, to be taken seriously, but in fiction such characters invariably appear silly, as in a Woody Allen film; and Danny Dalton's uninflected, unironic consciousness does nothing to convince the reader otherwise. The weakest, most curious story in the collection, "The Carpenter Who Looked Like a Boxer," is both over-determined (there is a barely realized sub-plot involving Dalton's allegedly famous artist-father) and under-determined (lacking crucial dramatic scenes to make the carpenter's marriage credible), revealing the limitations of the author's methodical writerly technique which mimics scientific research, the accumulation, classification, and "theorizing" of data.

It's no surprise that the strongest story in this collection is a first-person account of the horrific experiences of a multi-national team of medical workers in a Congo refugee camp in the late 1990s. Though composed with Murray's customary descriptive thoroughness, "Watson and the Shark" is less tangled in background exposition and family history than the other stories, and moves with suspenseful fluidity:

> . . . I could see that every eye was fixed upon me and I felt that sense of power and control that I needed then—this was why I was a trauma surgeon—and I wanted life-or-death, all-or-nothing situations. Life or death. That was why I was there in the jungle, and I honestly had a tremendous feeling of being in the right place and of being filled with a certain glorious energy.

Contrasted with the narrator is a Catholic missionary whose humility and stubborn faith in the midst of catastrophe would seem to doom him to a tragic-heroic fate, as in a Graham Greene novel of sacrifice in the face of acknowledged futility; and the Russian helicopter pilots hired by the U.S. government to fly emergency supplies into the countryside, as they'd done previously in Somalia for very good wages.

> "Really, this is like an escape for us," [the Russian pilot] told us. "It is good for us to get out of Russia. To be frank, we are running away . . . Like all the people who are coming in to help are running away from something . . . You don't come into these places out of goodness of heart. No."

The story takes its title from the eighteenth-century painting by John Singleton Copley *Watson and the Shark,* painted in homage to an actual event that occurred in Havana Harbor, Cuba, in 1749. This famous painting in the heroic mode—"a moment of rescue and salvation"—confirms for the narrator the necessity of his risk-taking in the Congo. Another trauma surgeon speaks with the stoic wisdom of a harassed Robert Stone character:

> ". . . What you need is a philosophy. This is what you need. A way of making sense of the world. You cannot rely on what you see—because it will always be chaos, without rules. Wars are ridiculous. By

definition, there is never any *common sense* . . . Many people will die in quite awful ways and we will never stop that . . . And of course you will go mad. I have a philosophy of disaster, you understand . . . That if you save just one life, then you have saved many. This is what I believe . . . Every day in the operating theater, I am affirming my humanity . . . I cannot change the war, but I can affirm that every life has value."

By the story's violent end, the idealistic medical workers, to save themselves from being massacred, must bribe marauding "rebel soldiers" with everything they have, including clothes, shoes, and razor blades, and the helpless, unarmed refugees under their care. There is a bloody, protracted slaughter in a church, after which the medical workers are rescued by a team of Belgian UN soldiers.

In Paris, I had the sensation that I was weightless. Barely visible to the people around me. Perhaps you have to become nobody to understand who you are. I realized that I could not go home to the things that are comfortable to me. This was a strange kind of realization and it has come silently and imperceptibly, like a layer of frost gathering overnight on a piece of cold glass.

John Murray has clearly been influenced by the example of Andrea Barrett, whose meticulously researched long stories in *Ship Fever* and *Servants of the Map* deal similarly with obsessed scientists and naturalists, doctors, explorers, and even coleopterists; both Barrett and Murray write of heroically misguided individuals who squander their energies in field research intended to refute Darwin's theory of evolution. ("When there is only one [butterfly] of its kind," writes the grandfather of the surgeon-narrator of the long title story, "with no clear survival advantage to being of such magnitude and color, then it must surely have been placed here by a divine hand.")

IN OUTLINE, David Marshall Chan's *Goblin Fruit* would seem wholly in the mode of a conventional "debut" story collection by a young university-educated (Yale, UCLA) writer now "living in New York City." The nine stories focus upon childhood, family background, coming-of-

age in Los Angeles in the waning, media-saturated years of the twentieth century. A virtually unchanging narrative voice persists from story to story and there are linked references and implicit assumptions that suggest that the stories are really fragments of a novel or memoir. Two of the stories are raggedly composed, so rambling and repetitive in structure as to suggest earlier work sliced in among more accomplished stories. Yet, from the opening sentence of the first, powerful story "Lost Years" through the final "Open Circles," David Marshall Chan's voice is haunting and original.

Goblin Fruit confounds our expectations of "American-ethnic" fiction. Not much is made of the clash of races or cultures here. Little is made of the clash of generations. The disaffected young Chinese-American protagonist feels so little emotional identification with his so-called ethnic roots that he observes his own brother's funeral with an impersonal pity:

> Now I realize that despite the show and pomp, the Chinese spectacle, all of it was probably very cheap. It was the way of the Chinese here in America. In the living and in the dying, there was the inevitable sweat, the inescapable poverty; the penny counting. The rusted trombones and frayed marching costumes passed down and reused, never new; the rice wine poured in shot cups for ghosts at the graveyard eventually poured back into the bottle . . .

There is something chilling, though surely illuminating, about a boy for whom the natural way of describing his background is to note that his high school had been used in the filming of *Rebel Without a Cause* and that two of the Manson murders had taken place in a house in his neighborhood:

> . . . a simple home, someone's dream house. The grass was neatly trimmed, there was the ubiquitous armed response security sign that every home on the block had, and a picket fence circled the yard, an arc of pure whiteness. The image was perfect.
>
> ["Open Circles"]

Coincidentally, the first story in *Goblin Fruit* begins with butterflies: "Out there, on the road, we didn't have much to do, so when the orange

butterflies first appeared to us they were a welcome distraction." Two young Chinese boys have been abducted by their father from their mother, put alone on a plane in Chicago and sent to Los Angeles to live with their father's parents. Little is explained to the boys and they ask few questions. Months later, they have been uprooted again, packed into their grandfather's car and driven in the direction of Vancouver, British Columbia, where in that city's large Chinatown their grandparents believe they might "lose" themselves. The long, monotonous drive is punctuated by swarms of Monarch butterflies migrating along the coast from Canada to Mexico: "Sometimes their number seemed endless, flying together like a blanket in front of the windshield, blocking our grandfather's view." Butterflies are not images of fleeting beauty here, but of an appalling blind mass-instinct. The boys learn to expect nothing from their elders. The journey to Vancouver is meandering, desultory: "Some cities we drove through like ghosts: we appeared and then we disappeared." The story ends with the abducted boys in their grandfather's car, approximately two hours from the Canadian border and listening for (imagined) sirens. "And that was the beginning, the start of the lost years."

In "Goblin Fruit," a young man impersonates his (deceased) brother, who'd been a notable Asian child actor killed in a helicopter accident while making a film. The narrator, formerly "D," is now "M." His career is sporadic, disappointing: he can only get work as an Asian-American actor, on such projects as a *Star Trek* rip-off called *Z-Star II*. He is working on a screenplay, heavily derivative of other films, called *Goblin Men.* To support himself he develops electromicroscopic photographs at a medical center:

> . . . the AIDS and cancer patients would be surprised by the beauty of their illnesses, shocked to discover we keep a gallery of their cells most attractive and exquisite mutations, our exhibit of faces and crosses and half-moons on the wall.

He waits for his brother's ghost to come to him, in vain. He tries to feel his brother's loss, in vain. He studies *A Course in Miracles* in the hope of feeling "more positive" about himself. He regrets he didn't study kickboxing instead of attending Yale.

In "Falling," the young Chinese-American narrator broods over the loss of a high school friend named Jon who seems simply to have disap-

peared: possibly Jon has died (of a drug overdose? a car accident?). Like the lost brother, Jon acquires a mythic but debilitating significance, as if he were a lost portion of the narrator himself. In the end, the narrator prefers not to know whether Jon is dead or still living, in another part of the country; he takes solace not in the personal but in impersonal, clearly ludicrous images of "transformations, the hope of possibilities."

> Every year, within a few days of Christmas, you can be sure that a miracle will transpire; on the evening news Tricia Toyota or Laura Diaz will announce that a struggling L.A. family has received a sign from above . . . These revelations take many forms—a shadow in the shape of a cross appearing for days across a sidewalk, an image of the crucifixion seen through a dirty bathroom mirror, the face of Jesus Christ in a burnt tortilla.

Chan's Los Angeles is a sequence of highly charged yet static images, a curious admixture of the vaguely threatening and the banal, as in a de Chirico painting. On Mulholland Drive the narrator is struck by an enormous estate where life-sized statues have been carved in black stone to resemble groundsmen working in front of the house:

> . . . two stoneboys bent down at the base of a large tree, another pair working in a patch of flowers, a couple raking leaves together, and the two closest to the road, who stood with their backs turned and their heads tilted towards one another as if in conversation.
>
> ["Falling"]

In the night, an enormous neon pie revolves above the Palace of Pies Coffeehouse attracting great swarms of insects that, when the light is switched off, remain for a moment hovering in the air, confused: then "in an act of faith and with great purpose they quickly reorient themselves and fly, blindly and crazily, toward the nearest light." In the parking lot of a Thrifty's a homeless man in a wheelchair lives like a feral creature, lacking arms, legs, and a face. On a freeway, the narrator notes a Don Kott auto dealership electronic billboard: MEMORY IS MORE INDELIBLE THAN INK. Other homeless individuals are in the business of selling "bugs"—ladybugs—door to door, in a well-intentioned civic philanthropic project:

When it rained, these homeless bug vendors wandered the streets wearing shiny, metallic-looking smocks . . . , guarding their precious eggs from the wetness beneath this makeshift silver rainwear. Their shiny outfits dragged along the ground so that they seemed to float as they drifted slowly down the wet streets, looking like ghosts from some distant, unnamed future: an era of silver clothes and silver eggs and constant rain. ["Brilliant Disguise"]

Wistfully the narrator recalls when he'd been a boy "who still believed in Santa Claus and in [my] parents" and had been mesmerized by a gargantuan figure with the muscled body of a man and the head of a chicken looming over downtown L.A. from a restaurant roof: "He was a bizarre and incredible hero for the city—he was the Chicken Boy."

In "Brilliant Disguise" the narrator, now in his twenties, recalls when he'd been a boy living with his parents in "a section of Los Angeles that had no name" but was close by a prime real estate area named Silver Lake where more affluent Asians lived. His father supported his family by professional wrestling, of which he was too ashamed to speak, playing villainous roles as Mr. Moto ("Even though we're Chinese") and the masked Yellow Angel, doomed in the choreography of pro wrestling always to lose crucial matches against blue-eyed American wrestlers like Fabulous Frank Fortune.

In the black and white world of the wrestling stage, with its pantheon of heroes and villains, my father always played the heavy. He was the inscrutable one, the devious Oriental who will do anything to win and who can never win fairly . . . He plays the threatening jap, the one who's booed, who's told to go back to where he came from.

"Brilliant Disguise" is an entertaining though cryptic account of the evolution of wrestling after the end of the cold war: overnight the villainous Russians disappear, replaced by such crowd-infuriating characters as Rockin' Ricardo Romano, the Cuban immigrant who yells, "I don't want just a stinking crumb of the American pie . . . I want the whole thing!" and the Cherokee Hunter Goingsnake who enters the ring "for the dignity and ghosts of his ancestors." The most alarming feature of the pro wrestling world is the audience:

[Frank Fortune's fans] appear for a moment like well-behaved boys out enjoying the theater, until my father or some other despised villain appears, and then they shout their obscenities, saliva flying, their face twisted monstrously to resemble Hallowe'en masks.

A predominant theme in *Goblin Fruit* is the desperate mythologizing of fantasy "heroic" figures, whether grotesquely costumed wrestlers, comic book starship explorers, or boy sleuths solving such cases as *The Secret of the Chinese Boat*. If there is a time-specific feature of our twenty-first-century literature very likely it will mirror Chan's preoccupations with pop-culture images that transcend, or obliterate, ethnic and family identity. Passion is replaced by wistful yearning as in a perpetually suspended adolescence. By the end of *Goblin Fruit*, the young narrator has made a journey of sorts, but to what purpose? He is one who yearns to believe in miracles, yet lacks faith. He's a pilgrim without a pilgrimage who observes: "When you live in Los Angeles, there is nowhere to run away to." *Goblin Fruit* is an uneven collection yet a fascinating cri de coeur that introduces a young writer of promise and substance. Perhaps most admirably, it resists an upbeat "mythic" ending as the narrator recalls cutting high school to ride a bus through Chinatown and seeing a seemingly endless freight train:

> The names of long-bankrupt companies appeared on the cargo box sides in worn paint, passing before me like a parade of apocrypha. The boxcars spoke of better, simpler days, a time when rails stretched across the entire nation. Now, most of the vessels held nothing, the few full ones carrying animals going to slaughter, cattle with swishing tails who stared vacantly back at me through the slat boards with blinking eyes.

WHERE JOHN Murray and David Marshall Chan incline toward longer, less defining forms like the novel and the memoir, Ann Cummins is a natural short story writer. Judging from the verve and vivacity of the more accomplished of the twelve stories of *Red Ant House*, Cummins is a natural storyteller as well: one for whom "story" means an oral, idiomatic telling in the mode of Eudora Welty, Grace Paley, Bobbie Ann Mason. When we read writers for whom the rhythms of the spo-

ken voice are preeminent we can have the mistaken impression that such stories spring into language with little effort on the writer's part, since there is so little effort in the reading. Yet such "artlessness" is supreme art. To say that storytellers are not concerned with ideas in the highly explicit way of, for instance, John Murray, isn't to say that there are not ideas implicit in their work but rather that the storyteller hopes to evoke in her reader an emotional experience that can translate into an intellectual experience, as similar experiences in our lives, deeply felt but unarticulated, can move us to think, and to think profoundly. The lyric short story, in contrast with the more self-consciously composed, meditated story, is akin in its aesthetic effect to the art of watercolor, which must be quickly and unerringly executed and in which thinly layered washes and bare, untouched spaces are as crucial to the composition as its ostensible subject.

Red Ant House is set primarily in Colorado (Leadville, Durango) and New Mexico (on or near a Navajo reservation in the vicinity of the small city of Farmington). The earliest stories are told from the quirkily imaginative perspective of a young girl whose father works for a uranium mining company, many of whose less skilled laborers are Navajos; all but three of the stories focus on the adventures of girls and women. It's difficult to suggest the fey, funny, quicksilver rush of Cummins's prose except by quoting it at length:

> The first time I saw this girl she was standing at the bottom of the coal pile. I thought she was a little wrinkled dwarf woman, with her sucked-in cheeks and pointed chin. She had narrow legs and yellow eyes. They had just moved into the old Perino house on West 2nd. This was the red ant house. ["Red Ant House"]

> [Purple] crossed her arms like some kind of prizefighter, and there was this gleam in her eye, and I knew what she was thinking. She was thinking *Yes, I do dare to punch a hole through this scared little white girl in her corduroy overalls and saddle shoes and pin-curled hair. Yes, I'd be pleased to roll this little puff of kitten fur in the dust.* I believe she was the first Navajo to really notice me, and I guess the only one to go really deep—from the rim of my belly button to the mole on my spine. ["Trapeze"]

I wouldn't mind a fat man. A fat man would be somebody you could wrap yourself around and never meet yourself coming or going. If I married a fat man, I'd draw stars on his back every night. I'd say, How many points does this star have? Now pay attention, termite, I'd say. How many points does this star have?

["Where I Work"]

Dr. War is a voice on the phone, he says, "Come on, baby, let's fight."
I say, "I don't mind."
He says, "What's your address?" Then I go out on the curb to wait. ["Dr. War Is a Voice on the Phone"]

The precocious little girl of "Red Ant House" who torments her only friend Bean (the "little wrinkled dwarf" girl) is one of six children in a harassed Catholic household. Beyond her deadpan narration of surreal neighborhood events and family mishaps is a desperately sick mother who endures repeated pregnancies and miscarriages:

My mother was down sick all that summer. The doctor had prescribed complete bed rest so the baby would stay in. For the last three years, she had gone to bed again and again with babies that didn't take.

In a grisly scene chattily recounted by the precocious daughter, one of the mother's miscarriages is discovered by her children as a "little blue baby on a bloody sheet." The mother refuses to summon help, and nearly bleeds to death in the living room of their house for her husband to discover when he returns home from work. In the companion story "Trapeze," the family has been moved to New Mexico where they have quarters on a Navajo reservation near the uranium mill. Here the girl Karen is herself bullied by a Navajo girl named Purple, so called because she always wears the same oversized, frayed purple sweater. Karen is both intimidated by Purple and drawn to her, as to a more vibrant, reckless self: "Each day, Purple cooked up some new torture for me. She was smart in that way. It's like she walked into my head and poked around and found my secret-desire room." Yet Karen does not tell her parents or school authorities as if, in a way, she is protective of the Navajo girl; at

the story's end, Purple is revealed as the more vulnerable of the two girls, pregnant in junior high school:

> [Purple] looks odd without her sweater, like some little girl playing at acrobatics. But she has this round ball of a belly . . . She's tossing herself every which way, and suddenly I want to scream at her: YOU DID THIS TO YOURSELF! In my head I'm screaming it.
>
> She's just throwing herself all over that bare sticky floor, like she's trying to shake that baby out of there.

In the most powerful stories of *Red Ant House* girls and young women confront physical threats: from the gritty, gruelling high desert landscape of the Southwest, and from men. In "Headhunter," a young woman driving alone to visit her dying father in a desolate mountainous area is stalked by a Mexican man who tailgates her, passes her, slows down, brakes to a stop and blocks the road in front of her. Panicked, she reacts impulsively:

> . . . she threw the gearshift into first, rammed him hard. His car leaped and the door snapped on him. He fell back in, and she rammed him, saw him sit up in the seat . . . rammed him again, then jammed her foot on the brake, put her hand over the mouth, and watched the [other car] slip over the edge of the mountain.

In a similarly gripping story, "The Shiprock Fair," a fourteen-year-old Navajo girl struggles with her drunken father, who nearly drowns in a muddy river; humiliated, she has to walk along a roadside with him leaning on her, the two of them covered in mud, in full view of gaping witnesses: "White people in some cars, and Indians, none she knew—where did they all come from? Indians packed in their pickups, laughing at them—her father's body still trembled. Her father's little body. He was like a little boy, so bony and tough, and hot, hot with fever." In "Bitterwater," a young white girl, daughter of a uranium mill manager, falls in love with a Navajo boy named Manny whose self-displaying machismo is irresistible when she's young, but threatening after their marriage when Manny begins to drink heavily and his personality deteriorates.

I went into the kitchen to make coffee. In the kitchen I found a puddle on the floor. It was urine . . . He was a goddamn drunk, and I was a goddamn drunk's wife and it was just piss on the floor.

Yet "Bitterwater" ends with a scene of possible reconciliation: the connection between wife and husband, white woman and Navajo man, runs too deep to be easily broken.

The weakest stories of *Red Ant House* are told from the perspective of boys or men. In "Blue Fly," not very convincingly set in 1903 in the wilds of Durango, Colorado, an orphaned brother and sister live with their older brother and his nineteen-year-old, seductive wife in a "soddy"— the dug-out foundation for a house that hasn't yet been built. Why these oddly assorted characters? Why their overly specified, yet largely unexplored relationships? Why 1903? In another random-seeming story, "Crazy Yellow," a fatherless young boy awaits his mother's return from having hospital tests, in the company of a quirky, garrulous neighbor. "The Hypnotist's Trailer" is a story of promise that quickly diffuses its energies among several cartoonish characters. "Billy by the Bay," a very short story that ends with its loser protagonist leaping into San Francisco Bay—"right smack into the middle of one sweet moment"—is relatively slight, a disappointing final story for the collection.

Though one comes away with the sense that *Red Ant House* has been, for all the dazzle of its strongest stories, somewhat prematurely assembled, yet the collection is a conspicuous debut for a young writer of obvious gifts.

CURLED IN THE BED OF LOVE, co-winner of the 2003 Flannery O'Connor Award for Short Fiction and Catherine Brady's second collection of short stories, is the most traditional of the collections reviewed here. These eleven carefully crafted stories, primarily about women past the first bloom of youth and uneasy in the choices that young middle age has forced upon them, might have been written fifty years ago. Which isn't to suggest that Brady's stories are dated but rather that the mode of fiction to which they belong, which has been called "psychological realism," the core of the perennial appeal of mainstream prose fiction, is timeless.

Ironic that Brady's name should be linked with that of Flannery

O'Connor, since no two writers could be more temperamentally un-
alike. Where O'Connor's imagination is fundamentally allegorical,
and her characters tend toward a comical cartoon simplicity even as
they are smote down by the Eternal, Brady's characters are painstak-
ingly particularized, emotionally complex, of their time and place:
northern California in the late decades of the twentieth century. Where
O'Connor is harshly punitive and unforgiving of the most innocent of
sinners, as "sin" might be defined by a fundamentalist Christian, Brady
is sympathetic and unjudging: her stories celebrate the ordinary hu-
manity of small sins as of small triumphs, flawed but well-intentioned
characters, imperfection. (Brady's women even forgive and befriend
the men who've betrayed them.) Where O'Connor's stories are self-
consciously crafted as rituals, in the post-Conradian mode of explicit
literary symbolism that verges at times upon the surreal, Brady's stories
call no attention to themselves as artifacts; nor does Brady's post-
1960s California of mostly Caucasian, mostly college-educated middle-
class individuals contain any extreme or improbable acts. And where
the Catholic O'Connor scorned sexual love as a carnal weakness, Brady
writes of quite ordinary sexual, marital love with laudable precision and
tenderness:

> Here is the thing about loving a man who stumbles when it comes to
> words. Jay has an astonishing facility at speaking through his body,
> through his eloquent hands. When I curl up against him after we
> make love, he strokes my back, and my nerves tingle under his fin-
> gers, emit pulses that chase his hand as he repeats a delicate trace-
> work on my skin, the echo of the satisfaction of our lovemaking.
> Jay's dyslexia might be what makes him so good at what he does for
> a living, just as it makes him so good with me. As a programmer he
> translates words and functions into binary operations, simple yes/no
> questions that branch out to the next, neat yes/no. As a lover he uses
> his careful hands to perform a similar feat, to elicit responses that
> trigger a chain reaction of yes.
>
> Nothing's so nice as our sleepy postcoital talk about the kids, the
> thriving product of our love. We trade stories of their day the way
> that other lovers might trade bites of some delicacy to romance one
> another. ["Nothing to Hide"]

In "Comfort," a male character happens to be reading stories by Flannery O'Connor which he dislikes for their punitive nature:

> I suspect the brutal way she goes about her business stems from that Irish last name of hers . . . She makes fun of her characters the whole way through the story, and then she pounds them with something terrible . . . I'd love a chance to ask old Flannery why she took it so to heart, the mean idea that salvation should cost too much, the eye of the needle and all that.

Where O'Connor's world is suffused with the unsparing light of the supernatural as in an El Greco landscape, Brady's is a world of familiar, wholly secular domestic scenes. In the opening story of the collection, "The Loss of Green," a poet named Claire who has fled a chaotic life of alcohol, partying, promiscuous and punishing sex, lives quietly now with her husband at Point Reyes Station, a two-hour drive from San Francisco along the coast:

> . . . [their] house was built on the San Andreas Fault, the rift zone that records the efforts of the Pacific plate to move northwest and tug free of the North of California, working for millions of years to take the coast of California, including the headlands to the west of them, with it. Geology is more metaphor than fact to Claire, and the secret strain in the earth beneath them makes her delight all the more in her solid house and lush garden.

Yet Claire invites a former lover, something of a reckless character, to spend time with her and her husband: Sam is her San Andreas Fault, to whom she's still dangerously drawn, as if to test the solidity of her new life. "The Loss of Green" is notable for the clarity of its prose, the author's wonderfully sharp poet's eye: pelicans are seen paddling in water "with timid fuss, like ungainly, plain girls invited to the ball after all—there's something so pleased and modest about their tucked heads." Where the former lover Sam once forced Claire to watch a snake devour a living frog, Claire's husband Russell has taught her that "the world was a shell whose hinged mouth could be pried open to reveal a secret, smaller morsel of joy." In such adroit ways what might be called an

apocalyptic symbolism is demystified, given an intimate and comforting significance.

In "Nothing to Hide," a wife who is a recovered alcoholic risks the happiness of her domestic life to give consolation to a "fellow drunk" she has befriended at her AA meeting; he is her alter ego, her nemesis, her San Andreas Fault of a temptation:

> Walter looks like everything that made me afraid to sign up for AA. His dirty hair is pulled back from his face in a careless ponytail, his shirttail hangs out, his face has *wreckage* written all over it. . . . Just about everyone but Walter seems to be trying to lead a nice middle-class life.

It's Walter's very hopelessness that draws Maizie to him, a craving as strong as that for alcohol: "It cycles inside me like a poison, this want that has no object." Like Alice Adams, who wrote with a similar, spare sensuousness of middle-aged love and its aftermath, setting many of her stories in the San Francisco area, Catherine Brady understands that erotic passion is far more complicated and more mysterious than merely sexual passion.

"Curled in the Bed of Love," the almost too determinedly upbeat title of a story about a gay man and his HIV-positive lover, seems less original than others in the collection: "cliché" and "soap opera" are acknowledged by the story's characters, who strain to transcend them. "Light, Air, Water" is a more subtle tracking of the hurt of diminished love: a woman who has had a child with a man remains on friendly terms with him, but finds herself exploited anew when he requires her help in dealing with a much younger lover who has clumsily tried to kill herself. Perversely, she feels a kind of happiness at being needed in even this sordid situation: "I can't tell if this pleasure is vindictive or born of some sympathy I can't help . . ." It's rare for a writer to explore with such subtlety and respect the curious symbiosis of the needy and the needed as Brady does; and rarer still for a woman writer to write with such knowledge and sympathy of the promiscuous male who drifts from woman to woman, energized by desire as by an insatiable appetite, as Brady writes in "Roam the Wilderness" of a young man mourning the death of his brother by seeking out sexual liaisons with several very different women in very different California settings. This deftly orchestrated story ends

on the perfect, abrupt note: "Oh God, he doesn't want to be trapped here."

Though Brady's stories are unsparing and unsentimental as a mirror confronted in the starkest light, they yet yield, as such thoughtful writing invariably does, a kind of comfort.

Notes

1. Porter's self-mythologizing was a way of establishing personal identity: "Perhaps I am among the last few persons of my class and kind who were brought up in the house with two former slaves . . . of the original thirty-nine in Kentucky" (quoted in *Katherine Anne Porter: A Life* by Joan Givner, p. 452); and of establishing boundaries to link her and her writing with a "pure" American type as contrasted with a rising, ever more vociferous and threatening "impure" type: "This [a photograph of Leslie Fiedler] is what the Jews used to call a Kike—I don't know what that means but this nasty smug conceited smirk is the front for the most indecent mind and pickiest envy of talent I know and it is pure Jewish . . ." (Givner, p. 414).

Mythmaking Realist: Pat Barker

Double Vision
Pat Barker

T HE SOMBER EPIGRAPH FOR PAT BARKER'S tenth novel, taken from Francisco Goya, is applicable to all of Barker's fiction:

> *No se puede mirar*. One cannot look at this.
> *Yo lo vi*. I saw it. *Esto es lo verdadero*. This is the truth.

Pat Barker, best known for *The Regeneration Trilogy* (*Regeneration*, 1991; *The Eye in the Door*, 1993; *The Ghost Road*, 1995 Booker Prize winner), belongs to that small but distinguished company of post-War British writers who have taken as their subjects the brooding presence of the past; the ironic contrast between the mythopoetic and history. Though very different from the German-born W. G. Sebald, for instance, whose enigmatic and elusive fictions in the shadow of the Holocaust exude an unnerving memoirist power, and A. S. Byatt, whose elaborately structured experimental fictions examine "archetypes" from Victorian and Modernist perspectives, Pat Barker is, like them, both myth-maker

and realist; whether her subject is working-class, poorly educated, and politically disenfranchised women, as in *Union Street* (1982) and *Blow Your House Down* (1984), the infirm and ghost-haunted elderly in a rapidly changing urbanized England, as in *Liza's England* (1986) and *Another World* (1998), or the elite British officers and the psychologists who treat the "shell-shocked" of World War I, as in *The Regeneration Trilogy,* Barker's unadorned prose is distinguished by an intensely rendered sympathy for her characters and by a vision of humanity and social justice that is austere, unflinching, and yet cautiously optimistic. Out of the muddle of human history, Barker seems to suggest, there are not only moments of individual communication and enlightenment but rituals of atonement to sustain them.

Like its immediate predecessor, *Border Crossing* (2001), with which it shares so many thematic preoccupations as to constitute a kind of mirror-novel, *Double Vision* begins with an unexpected emergency which will lead to life-transforming consequences for its principal characters. In *Border Crossing,* a disturbed young man plunges into a river in what turns out to be a staged suicide attempt; in *Double Vision,* a woman loses control of her car on a stretch of black ice, crashes, and is injured, and while semi-conscious becomes aware of the presence of another:

> . . . a figure appeared at the [car] window. A headless figure was all she could see, since he didn't bend to look in. She tried to speak, but only a croak came out. He didn't move, didn't open the door, didn't check to see how she was, didn't ring or go for help. Just stood there, breathing.

In time, Kate Frobisher will learn the identity of this mysterious figure: a disturbed young man who insinuates himself into her life.

These paired novels, written in the aftermath, in a sense, of the magisterial *Regeneration* trilogy, represent for Barker a return to contemporary realism. Instead of "historic" figures like Siegfried Sassoon, Robert Graves, Wilfred Owen and the distinguished psychologist William Rivers of Craiglockhart War Hospital who treated soldiers suffering wartime traumas, Barker's characters in *Border Crossing* and *Double Vision* are wholly fictitious and belong to that category of individual we might identify as urban, and urbane, well-educated and well-intentioned liber-

als who are journalists, war correspondents and photographers, social workers, psychologists, lawyers, and artists. In both novels individuals with whom we are meant to identify (in *Border Crossing* a social-services psychologist, in *Double Vision* a talented and driven woman sculptor) are confronted by highly attractive, charismatic young men who are revealed to have committed brutal murders as children. In both novels, a good deal is made of the need to protect the young men who have served their prison sentences and are considered now rehabilitated; wisely, Barker never presents the charming sociopaths except by way of others' responses to them:

> [Danny Miller] . . . borrowed other people's lives. He . . . it was almost as if he had no shape of his own, so he wrapped himself round other people. And what you got was a . . . a sort of composite person. He observed other people, he knew a lot about them, and at the same time he didn't know anything because he was always looking at this mirror image. And of course everybody let him down, because you couldn't *not* let Danny down. Being a separate person was a betrayal. And then you got absolute rage.
>
> [*Border Crossing*]

In *Double Vision,* the sinister Peter Wingrave is perceived as "a cold bright star circling in chaos."

> [The vicar] felt Peter shadowing him down the corridor to the living room, almost treading on his heels. So much power this man had, and yet he seemed to have no identity, clingfilming himself round other people in order to acquire a shape.

In the novel's most chilling scene, Wingrave dresses himself in the sculptor Kate Frobisher's clothes and mimics her behavior in her studio as if attempting to take on her identity. In seeing her young assistant's "utterly deranged" actions, Kate is forced to see herself and to question her own motives in having allowed him into her life:

> She felt a spasm of revulsion, not from him but from herself, as if he had indeed succeeded in stealing her identity. It was easy to believe that what she'd seen in the studio, through the crack in the door, was

a deranged double, a creature that in its insanity and incompetence revealed the truth about her.

Of the paired novels, *Border Crossing* is the starker and less ambitious, as if it were a preliminary study for *Double Vision,* as the somewhat stereotypical psychopath Danny Miller is a preliminary study for Peter Wingrave who, perhaps unsurprisingly, turns out to be a writer. ("There was nothing 'neutral' about the behavior in his stories. Torture. Mental and physical. Murder.") In *Border Crossing* the reader is allowed to know from the start that Danny Miller has killed an elderly woman in an unprovoked rage, at the age of ten, and that he is intent upon insinuating himself into the private life of the psychologist who testified against him at his trial; in *Double Vision,* the reader is kept as uninformed as Kate Frobisher who has unwittingly hired Wingrave as her assistant at the urging of a vicar who acts as the young parolee's protector and advocate. Barker is not a satirist though her well-intentioned liberals, like the vicar, behave at times with exasperating naïveté putting themselves and others at risk in their efforts to extend sympathy to those who perhaps don't deserve it.

Is there a symbiotic relationship between morality and its polar opposite? Is sympathy with violence a kind of complicity with violence? How can one justify a professional fascination with evil? Is giving solace to the seemingly reformed psychopath-murderer a betrayal of his victim, and a stimulus to further crimes? Both Barker's novels expose their protagonists to humiliation as well as physical danger, and *Border Crossing* forces what might be called a ritualistic ending with Danny Miller's former psychologist at last acknowledging the bond between him and Danny, and paying homage to the long-dead, all-but-forgotten victim of Danny's senseless crime:

> There, under the lilacs, with nobody to care or know, he stood for a moment in silence, remembering Lizzie Parks.

As its title suggests, *Double Vision* is a portrait of doubles, in fact of matched, or ill-matched, pairs. There are two principal characters with whom we are meant to identify: Kate Frobisher, the sculptor, widow of a renowned war-correspondent photographer who has died recently in post-9/11 Afghanistan, and Stephen Sharkey, Ben Frobisher's colleague

and closest friend, a journalist who quits his job and returns home to England, disillusioned with the exploitative nature of his profession and having discovered, not coincidentally, that his wife is involved with another man. Kate Frobisher is a grieving widow not unlike other grieving women in Pat Barker's fiction who have lost their men to wartime violence:

> She would never, never, never be able to accept his death, and she didn't try. This wasn't an illness she would recover from; it was an amputation she had to learn to live with. There was a great and surprising peace in acknowledging this.

Kate has, at least, the solace of her work: symbolically, a commission for a large sculpture of Jesus Christ, an iconic image in which she doesn't believe.

Her husband's collaborator Stephen Sharkey is yet more broken, suffering from the kind of insomnia that accompanies shell-shock; he sees himself as a "pink, peeled prawn of a man." His malaise is both emotional and intellectual for he has lost faith in the worth, even the veracity of war correspondence. He must rewrite passages in his newspaper articles at the bidding of editors, he must falsify what he knows to have been true even as the photographic images for which his colleague Ben Frobisher sacrificed his life can be exploited to suggest events that have never occurred:

> He kept telling himself it didn't matter, but all the time he knew it did. Images before words every single time. And yet the images never explain anything and often, even unintentionally, mislead.

Stephen is haunted specifically by the image of a young girl he and Ben discovered in a ruin of a house in Sarajevo, a dead rape victim with "splayed thighs enclosing a blackness of blood and pain" whose photograph Ben took. Stephen's revulsion is both visceral and cerebral:

> No way of telling whether this was a casual crime . . . or a sectarian killing linked to the civil war. Increasingly crime and war shade into each other, Stephen thought. No difference to their victims, certainly . . . Patriot, soldier, revolutionary, freedom fighter, terrorist,

murderer—cross-section their brains at the moment of killing and the differences might prove rather hard to find.

Stephen's disillusionment we might recognize as postmodernist, symptomatic of the Media Age in which wars appear on TV screens "as a kind of *son et lumière* display" and human suffering becomes a branch of entertainment: "What happens to public opinion in democracies—traditionally reluctant to wage war—when the human cost of battle is invisible?" Barker suggests that what was new about war in Baghdad and Belgrade was a combination of media censorship and "massive, one-sided aerial bombardment so that allied casualties were minimal or non-existent and 'collateral damage' couldn't be shown." Stephen's return to England from a war-ravaged foreign country is measured ironically against tragic/sentimental images of a tradition of war-mythologizing:

> A man gets off a train, looks at the sky and the surrounding fields, then shoulders his kitbag and sets off from the station, trudging up half-known roads, unloading hell behind him, step by step.
>
> It's part of English mythology, that image of the soldier returning, but it depends for its power upon the existence of an unchanged countryside . . . Certainly Stephen had returned to find a countryside in crisis. Boarded-up shops and cafés, empty fields, strips of yellow tape that nobody had bothered to remove even after the paths reopened, just as nobody had bothered to remove the disinfectant mats that now lay at the entrance to every tourist attraction, bleached and baking in the sun.

It's an inspired coup for Barker to bring Stephen back to an English countryside devastated by government hysteria over the recent outbreak of mad cow disease.

The characters of a typical Barker novel inhabit what might be called islands of privileged consciousness within a larger, despoiled or chaotic environment, usually urban. *Double Vision* provides a combination of the pastoral and the urban: characters may be living in the country, but are urban-oriented in their professions and preoccupations. Complaining of the terrible stench of burnt slaughtered animals in the countryside near his home, Stephen's brother Robert acknowledges his and his family's privileged position in the area:

"It started two miles down the road. We got the first blast. They closed the roads—sent in the army. You could smell the carcasses for miles. I used to smell them on my skin at work . . . I say 'we' but of course it isn't 'we.' We're not part of it. Country life, I mean. We just float on the surface like scum . . . Buy up the houses. Commute into work. We don't give anything back . . ."

More typically in a Barker novel it's a despoiled and threatening urban setting inside which her highly sensitive, articulate characters bear witness to what D. H. Lawrence called the "disintegrated lifelessness of soul" resulting from the rapacious industrialization of the Midlands in the early decades of the twentieth century. Lawrence would seem to be Barker's great influence, not so much in language as in vision; the prevailing stench of smoldering animal carcasses in the English countryside, like the prevailing stench of the chicken slaughtering house in Barker's painfully observed saga of prostitutes *Blow Your House Down,* is a Lawrentian touch, both symbolic and "historic." If Barker expresses little of Lawrence's impassioned rage, it may be because such passion, such rage, such overwrought prose of the kind we call Lawrentian, is no longer fashionable, though the emotions such language expresses are no less relevant now than they were in Lawrence's time. In *Border Crossing,* set in Newcastle, the empty-souled Danny Miller stages his suicide attempt amid a "mist like a sweat" at the edge of "what had once been a thriving area of docks, quays, and warehouses now derelict and awaiting demolition"; to haul Danny from the river, the psychologist Tom Seymour must plunge into "thick, black, oily, stinking mud, not the inert stuff you encounter in country lanes and scrape off your boots at the end of the day, but a sucking quagmire." Once-thriving Newcastle has become an urban shell in which, one is meant to think, child-psychopaths like Danny Miller at the age of ten are a natural spawn:

> Every house left vacant here was stripped of fireplaces, bathroom fittings, pipes, roof tiles, and set on fire, either for fun or because the owners, despairing of selling or letting the property, paid children to do it. At the corner of the street there was a skip full of burning rubbish. A knot of children, on the other side of it, shimmered in the heat, like reflections in water.

In *Double Vision,* the former war correspondent Stephen Sharkey looks with appalled fascination upon adolescent children running wild at a fair in an unidentified city near the moors:

> They seemed to wade through noise, lean into it. Young girls, faces blank in the yellow, green, and purple lights, shouted and screamed, while gangs of youths stared after them, their bristly scalps slick with sweat. In the male guffawing, which both acknowledged and discounted the girls' presence, there was a yelp of pain. The clammy night, the syrupy music oozing like sweat from every pore, the smell of beer on belched breath as another group of youths walked past, combined to produce a sexual tension that hung over everything palpable as heat.

Yet more palpably, in Newcastle:

> . . . starlings were beginning to gather, huge folds and swaths of them coiling, spiralling, circling, and everywhere their clicks and chatterings, as insistent as cicadas. Beneath this frenzy, another frenzy of people rushing home from work, shopping; young people setting off for a night out; girls, half naked, standing in shop doorways; young men in short sleeves, muscular arms wreathed in blue, green, red and purple, dragons and serpents coiled round veined biceps. He passed a gaggle of girls, the pink felt penises on top of their heads bobbing about in the wind . . . Perhaps [Stephen] gaped too obviously, for one of them turned round and stuck two fingers in the air.

The subtly rendered "double vision" of the novel is provided by alternating and overlapping chapters presenting Kate's and Stephen's perspectives. The two are united in their grief for the newly deceased Ben Frobisher, but they don't become lovers, fortunately. Kate's mysterious young assistant Peter Wingrave is revealed to have been the first lover of Stephen's twenty-year-old girlfriend, Justine, which links Kate and Stephen in another, seemingly more sinister way, but by the end of the novel Wingrave has become almost irrelevant, as if Barker lost interest in the Doppelgänger motif. After much effort, Kate manages to complete her heroic sculpted Christ; Stephen realizes that he is seriously in love

with Justine after a house-breaking episode in which she is brutally assaulted by local thugs. Abruptly and rather awkwardly, Barker drops Kate Frobisher from the novel, and the final chapters belong solely to Stephen who takes a trip with Justine to the windswept Farnes Islands that has the effect of exorcising the trauma he experienced in Sarajevo: "Last night had been extraordinary—the sex passionate and yet interspersed with tender, almost sexless kisses. He had been so afraid of hurting her."

If the ending of Barker's provocative and timely novel is something less than inspired, like the "upbeat" endings of other of her novels, it's a measure of this ambitious author's effort not simply to bear witness to the terrible truths of our era—to tell us, with Goya, *This is the truth*—but to bring such truths home, so to speak, to the despoiled English landscape.

Crazy
for Love

A Ship Made of Paper
Scott Spencer

History in one corner and love in the other?
Fine. Ring the bell. Let the fight begin. Love, *he*
thinks, will bring history to its knees.

Idealism, hubris, hypomania in about
equal measure characterize the thirty-six-year-old protagonist of Scott
Spencer's new novel, Daniel Emerson, who embarks upon a reckless love
affair with a young wife and mother who happens also to be, unless in
David's eyes this is the primary feature of her attractiveness to him,
African-American. By "history," Daniel means the rift between the races
that is a consequence of slavery in America; by "love" he means the
fevered intensity of the passion he feels for Iris Davenport, no matter
what the consequences for others.

A Ship Made of Paper is an ideal title for Spencer's eighth novel, a
tragicomic middle-aged re-imagining of the adolescent obsessions of
Spencer's bestselling *Endless Love* (1979). We are meant to think perhaps
of a Ship of Fools, in this case a landlocked ship, the fictitious Hudson
Valley town of Leyden, New York: a small, not very prosperous commu-
nity of mostly foolish men and women whose lives are altered, in two
cases physically impaired, by Eros. As if the erotic dreams of a midsum-
mer's night have spilled out like plague, over a period of weeks and

months infecting innocent individuals whose connections with the Eros-besotted principals are merely tangential: children and stepchildren, betrayed spouses, blood kin, in-laws, neighbors and old hometown friends. This Ship of Fools is further complicated by the race issue: "Blacks and whites don't get along," is the mantra of one wounded observer. "Too much has happened. It's ruined. If something doesn't begin well, how can it end well?"

The funny-romantic boast of the bluesy "Just to Be with You" ("On a ship that's made of paper / I would sail the seven seas") is the unspoken mantra of mock-heroic Daniel Emerson, whose romantic yearnings precipitate a Grand Guignol of serio-comic and grotesque happenings in Leyden. (Recall the Chicago teenager David Axelrod of *Endless Love* who ends up burning down the house of his teenaged beloved and provoking the death of her father.) Daniel is a richly drawn character, alternately exasperating and appealing, a good-natured, tirelessly smiling and affable adult with the emotional needs of a child; his transcendental yearnings are of the scale of Ralph Waldo Emerson's, if his intellectual capacities are not. Daniel will remind some readers of those hapless characters in Iris Murdoch's novels who fall in love blissfully, brainlessly, and with little concern for the consequences of their behavior, with strikingly emblematic individuals whom they scarcely know. In Daniel's case, the object of his infatuation is a newcomer to Leyden, one of very few African-Americans in the area, a part-time graduate student in American studies who brings her four-year-old son to the same day care center to which Daniel brings his four-year-old stepdaughter. Innocent in his yearning for Iris, at least initially, Daniel, who has "all his life . . . been in love with black women—Dinah Washington, Billie Holiday, Irma Thomas, Ivie Anderson, Ella Fitzgerald, Ma Rainey, Bessie Smith," very quickly seduces Iris, who feels under-appreciated in her marriage to an ambitious Wall Street investment banker and who has doubts about her own intelligence and worth: "If there's no one around," [Iris] says, "I just say what I'm thinking . . . 'I'm in love. I'm in love with a man who thinks I'm smart and beautiful.' "

The borders of Scott Spencer's expertly drawn Leyden, New York (the author lives in Rhinebeck), are contiguous with Cheever country to the south and Updike country to the northeast. Like John Cheever, Spencer has imagined for his suburban dreamers and infatuated lovers melodramatic crises that verge upon the surreal; like John Updike, Spencer is a

poet-celebrant of Eros, tirelessly and lyrically precise in his detailed descriptions of lovers' fantasies, lovers' lovemaking, lovers' bodies. Spencer is neither so playfully sadistic with his characters nor so magical in his prose as Cheever, and his writerly skills are perhaps less dazzling than Updike's, but his narrative voice is zestful and distinctive, unpredictable. *A Ship Made of Paper* is a wild ride that lurches, careens, swerves, and is even for a while airborne (as in a tenderly silly dream sequence that allows Daniel, at this late point in the novel in physical distress and blind in one eye, to hover fifty feet above Leyden "beaming down his prayers of love and happiness to all who are sleeping, and to all whom sleep eludes"). There is an inspired three-page threnody that begins "It was snowing and it was snowing and it was going to snow some more," a concatenation of weather-related mishaps that might have been illustrated by Edward Gorey. There is a grotesquely protracted interlude in a dense woods in which, thrown together as a pair in a quixotic search for a runaway blind girl, Daniel Emerson and Iris Davenport's cuckolded husband Hampton wander about lost, and discover how much they dislike each other ("Daniel?" "What?" "Can I make a suggestion?" "Sure. What?" "Go fuck yourself") prior to a catastrophic accident caused by Daniel's carelessness that will make of Hampton a permanent invalid. And there are, scattered through the novel, outbursts of slightly deranged rapture from Daniel's perspective:

> What can the world do to you with its beauty? Can it lift you up on its shoulders, as if you were a hero, can it whoopsie-daisy you up into its arms as if you were a child? Can it goad your timid heart, urge you on to finally seize what you most shamefully desire? Yes, yes, all that and more. The world can crush you with its beauty.

And, in these (fortunately unspoken) words addressed to the woman with whom Daniel lives and whom he has betrayed:

> Have you ever made love for six hours barely stopping? Have you ever had nine orgasms in a night? Have you ever seen me weep from the sight of your beauty? When was the last time we slept in each other's arms? Have you ever seen my savage side? Have you ever known me to be absolutely helpless with passion? Has anyone ever stuck their tongue up your ass? Have you risked disgrace for me?

Have you made a double life and been willing to hurt another person for the love of me?

Daniel's fever state is matched by the novel's antic plot, that never ceases rolling forward, backward, in lateral directions. We learn that Daniel's frenzied need for love is very probably the result of his having been the only child of a husband-and-wife team of chiropractors who had him in middle age and seemed never to have especially wanted him—a "creaky couple" who surprise Daniel early in *A Ship Made of Paper* by announcing that they have changed their will and are no longer leaving their estate to him but to a county Raptor Center. ("This is in no way meant to indicate what our feelings are for you, Dan. You're our son.") We learn that Daniel had to abruptly flee Manhattan, and give up his lucrative law practice there, after he lost a pro bono case defending a black drug dealer, whose associates unreasonably blamed Daniel for the defeat, beat him and threatened to kill him. We learn that Daniel's fatal weakness for falling in love—that phenomenon of emotional life described with clinical chill by Sigmund Freud as the "over-estimation of the individual"—began in his lonely, fevered adolescence:

> Around and around he'd gone, and now it seemed to be coming to this: that phantom female, that ghostly girl, Darlin', Baby, all those creatures of his longing, all those spirits of love and desire whom he thought he had exorcised with the power of plain old common sense, put in their place at the back of the class by irony, experience, and practicality, they had survived after all, they had not been cast out, they had merely shrunk back, they had hibernated, and they have fused into a single woman.

Because race is the issue in contemporary society that tends to dwarf and eclipse all other issues, so *A Ship Made of Paper*, an intimate, psychologically astute exploration of obsessive love, will probably be discussed primarily in terms of race. Is the liaison between (Caucasian) Daniel Emerson and (African-American) Iris Davenport a classic *folie à deux*, in which incomplete, lonely individuals project onto the Other their childlike need for love; or is theirs a mature passion that will evolve, in time, into a stable relationship? Kate Ellis, the acerbic-tongued writer from whom Daniel is estranged, sums up Daniel's preoccupation with

Iris Davenport: "You always wanted to be black, and now you've figured out a way to be black by proxy." (Kate is a frustrated novelist who herself has become morbidly obsessed with the O. J. Simpson case, which is being tried at this time; in her overwrought southern-female imagination she is haunted by the "narcissistic, sexually preening, and ultimately predatory black man who prowls, sulks, and rages.") Iris Davenport confesses to Daniel, shortly before they become lovers:

> All my [thesis] topics have been African-American, and I think that's why I haven't been able to stick with them . . . I'm really getting *tired* of being African-American. I always thought of myself as just me . . . I'm just exhausted by it, it's so much *work* being black. And no days off, either. And the pay stinks.

Of her light-skinned patrician husband, Hampton, Iris says:

> He really and truly wishes I was lighter, and I think he feels the same way about Nelson. And the really strange part of it is Hampton is obsessed with being black, he's black twenty-four hours a day, it's all he thinks about. He sort of dislikes white people, but at the same time he's like most of us: He really wants white people to like *him*. And that, by the way is the dirty little secret of the Africans in America. We really want y'all to like us.

Daniel's response to this is the impulsively uttered, non-retractable "I love you."

Since the angry responses of black intellectuals and critics to William Styron's *The Confessions of Nat Turner* (1967), making of the Pulitzer Prize–winning novel an object of extra-literary controversy and its author a pariah in some quarters, few Caucasian American writers have wished to wade into the dangerous waters in which racial/sexual issues are frankly, let alone idiosyncratically, discussed. Where it is not only safest but easiest to write about one's own, sequestered world, the temptation to back off from interracial subjects is strong. In the past several years the African-American writers Andrea Lee (*Interesting Women*) and Stephen L. Carter (*The Emperor of Ocean Park*) have zestfully skewered clichéd racial ideas and pretentious individuals bearing every degree and nuance of skin pigmentation; Stanley Crouch (*Don't the*

Moon Look Lonesome) has reversed Styron, in his portrayal of a white woman involved in an inter-racial love affair of long standing with a black jazz musician. Most Caucasian writers, by contrast, have been fastidiously "politically correct": they have simply avoided the issue of race altogether.

A Ship Made of Paper is not restrained by such fastidiousness. The novel's omniscient ease of narration allows us to move without effort from individual to individual, residing in no one exclusively, and so we observe the Ship of Fools from above, like Daniel Emerson floating fifty feet above Leyden. Where everyone is foolish to some degree, it's unsurprising that African-Americans are foolish, too. The most relentlessly satirized is Iris's husband, Hampton, the preppy snob who condescends to his darker-skinned wife, yet is furious when Caucasians condescend to him. He baits Daniel Emerson, whom he intimidates physically. He keeps pump-and-squirt bottles of antibacterial soap next to every sink in his house, in his paranoia about germs, yet practices clinical sex with prostitutes in the city, as a means of proving to himself that "physical intimacy is a matter of relatively small importance." Unlike Iris, who emerges as a flawed but fully realized and sympathetic character, Hampton is rather more a caricature, punished by fate in the form of the clumsy Daniel Emerson. It's an added irony that poor Hampton will be an invalid for life, dependent upon Iris and, indirectly, her adulterous white lover who feels obliged to help with him. As Daniel observes to Iris: "There's no turning back."

Amateurs

The Amateur Marriage
Anne Tyler

If THE TERM HAD NOT BEEN COINED TO define an essentially surrealist/exotic mode of twentieth-century fiction, "magical realism" would most accurately describe the considerable emotional power that can be generated by a sudden illumination of meaning in the ordinary, routine, and largely unobserved in our daily lives. Realism is a mimicry of life in the quotidian, not the heroic or cataclysmic; at its core, the greatest of all dramas can be simply the passage of time. Where the essential strategy of poetry is distillation, the strategy of the realistic novel is accumulation, which is why novels as diverse as Flaubert's *Madame Bovary,* Bennett's *The Old Wives' Tale,* James T. Farrell's *Studs Lonigan* trilogy depend for their effect upon a painstaking if not obsessive recording of minutiae. When the realistic novel works its magic, you won't simply have read about the experiences of fictitious characters, you will have seemed to have lived them; your knowledge of their lives transcends their own, for they can only live in chronological time. The experience of reading such fiction when it's carefully composed can be breathtaking, like being given the magical power of reliving passages of our own lives, indecipherable at the time of being lived.

Through sixteen novels of poetic realism set predominantly in Baltimore in the middle decades of the twentieth century and encoded with this unnerving "magic" in the minutiae of daily life, Anne Tyler has

created a gallery of American originals. Tyler's people seem to be members of a single extended clan, lovingly observed eccentrics inhabiting a mythic Baltimore located somewhere between the elevated folksiness of Thornton Wilder's *Our Town* and the flat-out grotesqueries of Sherwood Anderson's *Winesburg, Ohio*; her slightly seedy, quaintly run-down neighborhoods are contiguous with the small Mississippi towns and villages of Eudora Welty, Tyler's most obvious influence, and the North Carolina settings of Reynolds Price, with whom Tyler studied as an undergraduate at Duke University. Ostensibly mid-to-late-twentieth century, Tyler's Baltimore is quintessential 1950s, predating the adulterous/alcoholic suburbias of John Cheever and John Updike and bearing no relationship at all to the contemporary cityscapes, ravaged by irony as in a harsh fluorescent glare, of Thomas Pynchon and Don DeLillo. Though African-Americans play walk-on roles in some of Tyler's fiction—there is a "darky," Eustace, who assists in a grocery store in *The Amateur Marriage*—Tyler's Baltimore shares no borders with the cityscapes of Toni Morrison, Gloria Naylor, John Edgar Wideman or Walter Mosley. As Tyler's themes are exclusively domestic and family-centered, so her settings seem to exist in a historic void: it's significant that, in *The Amateur Marriage,* men who serve in the armed forces in World War II, and the women who wait for them at home, never express a single political thought about the war, its origins, its consequences, its unmitigated Holocaust horrors. Evil as a force, individual or collective, simply doesn't exist in Tyler's universe; she has never created a character capable of violence or deliberate cruelty, let alone evil. Such tragic vistas are precluded by Tyler's comic-melancholy tenderness toward her characters. Where her older contemporary Diane Arbus famously remarked, "You see someone on the street, and essentially what you notice about them is the flaw," Anne Tyler has said:

People have always seemed funny and strange to me, and touching in unexpected ways. I can't shake off a sort of mist of irony that hangs over whatever I see . . .

Tyler recalls having read, as a high school student who'd hoped to be an artist, a book of short stories by Eudora Welty in which a character named Edna Earle appeared:

. . . so slow-witted she could sit all day just pondering how the tail of the C got through the loop of the L on the Coca-Cola sign. Why, I knew Edna Earle. You mean you could *write* about such people?

(from "Still Just Writing")*

Tyler's favored characters are not slow-witted so much as quietly subversive, refusing to behave as others wish them to behave. They tend to seem, or to be, sexless, with the defiance of overgrown children. They are likely to be pathologically reclusive, like the hapless thirty-eight-year-old child-man Jeremy of *Celestial Navigation* (1974) of whom family members love to despair:

[Jeremy] is, and always has been, pale and doughy and overweight, pear-shaped, wide-hipped. He toes out when he walks. His hair is curly and silvery-gold, thin on top. His eyes are nearly colorless . . . There is no telling where he manages to find his clothes: baggy slacks that start just below his armpits; mole-colored cardigan strained across his stomach and buttoning only in the middle, exposing a yellowed fishnet undershirt top and bottom, and tiny round-toed saddle oxfords. Saddle oxfords? For a man?

If not reclusive, they are likely to be obsessive in their interest in others' lives, as a way of shoring up the emptiness of their own lives, like the wily shape-changer/confidence-man Morgan of *Morgan's Passing* (1980) who intrudes in the lives of a young married couple:

He was a lank, tall, bearded man in a shaggy brown suit that might have been cut from blankets, and on his head he wore a red ski cap— the pointy kind, with a pom-pom at the tip. Masses of black curls burst out from under it. His beard was so wild and black and bushy that it was hard to tell how old he was. Maybe forty? Forty-five?

You could say he was a man who had gone to pieces, or maybe he'd always been in pieces; maybe he'd arrived unassembled. Various parts of him seemed poorly joined together. His lean, hairy limbs were

*Anne Tyler, "Still Just Writing," in *The Writer on Her Work*, edited by Janet Sternberg, 1980.

connected by exaggerated knobs of bone; his black-bearded jaw was as clumsily hinged as a nutcracker. Parts of his life, too, lay separate from other parts. His wife knew almost none of his friends. His children had never seen where he worked . . . Last month's hobby—the restringing of a damaged pawnshop banjo, with an eye to becoming suddenly musical at the age of forty-two, bore no resemblance to this month's hobby, which was the writing of a science-fiction novel . . .

He thought of clothes—all clothes—as costumes.

A typical Tyler eccentric is the widowed Mrs. Emerson of *The Clock Winder* (1972) who inhabits a falling-down old Victorian house literally filled with antique clocks that must be wound at different times to achieve a synchronized time: "What was the meaning of these endless rooms of clocks, efficiently going about their business while she twisted her hands in front of them?" In so gothic a setting, who will come to Mrs. Emerson's rescue? Another Tyler recluse awaiting a catalyst to propel him from the stasis of his life is the "accidental tourist" Macon of Tyler's bestselling romantic comedy *The Accidental Tourist* (1985), who becomes an obsessive-compulsive after his wife leaves him:

> . . . he dressed in tomorrow's underwear so he wouldn't have to launder any pajamas . . . He had developed a system that enabled him to sleep in clean sheets every night without the trouble of bed changing . . . What he did was strip the mattress of all linens, replacing them with a giant sort of envelope made from one of the seven sheets he had folded and stitched together . . . He thought of this invention as the Macon Leary Body Bag.

Ezra Tull, of Tyler's most engaging novel *Dinner at the Homesick Restaurant* (1982), is another feckless, good-hearted bachelor who has come to seem to himself unreal: "His large, floppy clothes covered a large, floppy frame that seemed oddly two-dimensional. Wide in front and wide in back, he was flat as paper when viewed from the side." Ezra has no sexuality, no life apart from being his mother's son and the proprietor of the Homesick Restaurant where "home-cooked" meals are served to customers yearning for the comforts of nostalgia: "Try our gizzard soup . . .

It's really hot and garlicky and it's made with love." The appealing fantasy of a restaurant where strangers come as if to family meals is rebuked by Ezra's own difficult family, who continually upset the meals he so painstakingly tries to arrange, and constitutes an apt metaphor for the fiction of Anne Tyler that manages to be both comforting and gently rebuking. Ezra's brother disrupts even the meal following their mother's funeral:

> "You think we're a family . . . You think we're a jolly, situation-comedy family when we're in particles, torn apart, torn all over the place, and our mother was a witch."

In novels artfully composed as *Dinner at the Homesick Restaurant, Searching for Caleb* (1976), *Saint Maybe* (1991), and *The Amateur Marriage,* which move at times as if plotless in the meandering drift of actual life, it is time itself that constitutes "plot": meaning is revealed through a doubling-back upon time in flashes of accumulated memory, those heightened moments which James Joyce aptly called epiphanies. The minutiae of family life can yield a startling significance seen from the right perspective, as Tyler shows us. Even her relatively light, formulaic works of fiction—*Breathing Lessons* (1988), *Ladder of Years* (1995), *A Patchwork Planet* (1998), *Back When We Were Grown-Ups* (2001)—are laced with such moments in the way that certain minerals, dull in daylight, yield a startling phosphorescence in semi-darkness.

It was famously said that Henry James had a mind "too fine to be violated by an idea" but, in fact, James was supremely a writer of ideas; his works of fiction are highly conceptualized, like formal works of music. Anne Tyler is much more the kind of writer to whom ideas have very little appeal, as ideas have little appeal to her characters. Tyler writes as if the team of Gass/Gaddis/Barth/Barthelme/Coover had never existed, let alone the maestro Nabokov. Her novels are narrated by near-identical voices, sympathetic but detached. Like the soft-focus cover art of Tyler's hardcover novels, domestic images and scenes perceived through a scrim of nostalgia and varying minimally from book to book, Tyler's voice is unfailingly reassuring. It's a voice in which authorial omniscience is qualified by human kindness of the sort we all might wish to narrate the stories of our muddled lives.

They were such a perfect couple. They were taking their very first steps on the amazing journey of marriage, and wonderful adventures were about to unfold in front of them.

The Amateur Marriage begins with cinematic zest in 1941 in a Polish grocery in the "poky" East Baltimore neighborhood St. Cassian. Virtually at once the ill-advised romance of the naive twenty-year-old virgins Michael Anton (the family name has been changed from Antonczyk) and Pauline Barclay becomes community property: "Anyone in the neighborhood could tell you how Michael and Pauline first met." In romantic Hollywood films it used to be called "meeting cute": a pretty girl, bleeding from a superficial forehead wound, is given first aid by an attractive young man who seems to fall in love with her in the space of a few dazed seconds: "Her voice was low and husky . . . Her eyes were the purple-blue color of pansies. Michael swallowed." It's a scene that might have been enacted by Debbie Reynolds and Eddie Fisher early in their careers, the ravages of marital unhappiness yet to come.

Michael is caught up in the excitement following Pearl Harbor, and the excitement of first love: he enlists in the U.S. Army, is discharged after a training "accident" (he's shot in the buttocks by a fellow trainee, is discharged back to Baltimore with a permanent limp to acquire, in time, the mythic designation "war wound") and marries Pauline. Though the two are ill-suited from the start, virtual strangers to each other, a kind of legend-making process seems to buoy them along:

> Long, long afterward, reminiscing together about how oddly exhilarating those hard, sad war years had been, more than one of the [St. Cassian] women privately summoned the picture of Michael Anton and his mother hugging on the sidewalk while Pauline watched, smiling, tipping slightly backward against the weight of his bag.

In a structure that replicates that of *Dinner at the Homesick Restaurant, The Amateur Marriage* is divided into ten chapters shaped like independent stories. These move swiftly through the years, dramatizing the saga of the "amateurs" from alternating and contrasting points of view. As in *Dinner at the Homesick Restaurant,* it's the children who provide the most insight, especially as the novel moves into its final, elegiac chapters bringing us into the twenty-first century. For decades the

Antons endure as a couple trapped together in a TV situation comedy, or a comic strip like "Blondie"; their exchanges are mostly superficial bickering, with now and then a moment of ominous insight: "Pauline believed that marriage was an interweaving of souls, while Michael viewed it as two people traveling side by side by separately." Pauline takes it amiss when Michael gives her a family-sized canning kettle for her twenty-third birthday, Michael is miffed at her reaction: "Was it possible to dislike your own wife?" Belatedly we learn that Pauline had written a letter to Michael in training camp, breaking off their engagement, but, when he'd been "wounded," she had torn up the letter and gone through with the marriage.

Tyler moves the Antons through a familiar sequence of marital strains. Briefly, Pauline is attracted to a neighbor whose wife has left him, an individual hardly more promising than Michael as an object of romance, but nothing comes of their flirtation; she is stuck with Michael who so lacks imagination and verve, he's afraid to telephone the police when their seventeen-year-old daughter, Lindy, is missing overnight, insisting upon waiting twenty-four hours. Pauline's disillusion with her marriage trails somewhat behind the reader's:

> When he didn't get her jokes, when he sacrificed her feelings to his mother's feelings, when he showed a lack of imagination, when he criticized one of her friends, she gave a kind of mental blink and persevered in her original version of him: he was the romance she had been waiting for all her life.

In turn, Michael sees Pauline as a "frantic, impossible woman, so unstable, even in good moods, with her exultant voice and glittery eyes, her dangerous excitement." Pauline would seem to be bipolar by present-day psychiatric standards, while Michael's problems are rather more imbued in his deeply conservative, unimaginative character which takes its cues from other people, so far as Michael can decode them:

> Sometimes he felt they were more like brother and sister than husband and wife. This constant elbowing and competing, jockeying for position . . . Did other couples behave that way? They didn't seem to, at least from outside.
>
> He believed that all of them, all those young marrieds of the war

years, had started out in equal ignorance. He pictured them march-
ing down a city street . . . Then two by two they fell away, having
grown seasoned and comfortable in their roles, until only he and
Pauline remained, as inexperienced as ever—the last couple left in
the amateurs' parade.

It's a poignant image, to set beside the more sexually experienced cou-
ples of John Updike's marriage stories who, like the Antons, make their
way toward separation and divorce. Unfettered by exaggerated romantic
expectations, Updike's couples break up more readily, and remarry; only
after thirty embattled years do the Antons decide to separate. The meta-
phor for the death of their marriage provides the chapter title "Killing
the Frog by Degrees," a singularly ugly image:

> [Michael says], "Seems if you put a frog in a kettle of cold water and
> light a slow flame beneath, the water heats up one degree at a time
> and the frog doesn't feel it happening. Finally it dies; never felt a
> thing."

Though Anne Tyler writes compellingly about the Antons, especially
post-marriage, Michael and Pauline are not among her more interesting
or original creations. Their quarrels are generic, the issues between them
trivial. In Hollywood terms, there's no "chemistry" in their relationship,
only just childish contentiousness. Far more than Ezra Tull who comes
to think of himself as two-dimensional, the Antons resemble comic strip
characters. Still, we feel a pang of sympathy for Pauline when, after years
of telling her husband to leave if he's so unhappy, Michael moves out and
suddenly she's alone:

> She had a slippery, off-balance feeling, the feeling a person might get
> if she were sitting on a stopped train and the train next to hers
> started gliding away and she wasn't sure, for a second, whether it
> was her train or the other one that was moving.

The most substantial chapters of *The Amateur Husband* are those in-
volving the Antons' rebellious daughter Lindy, "a jagged dark knife of a
person" who runs away from home to San Francisco, has a baby whom
she abandons when he's three years old, disappears and, like the wayward

father in *Dinner at the Homesick Restaurant,* unexpectedly reappears many years later. Initially, Lindy's character is a compendium of clichés:

> This was a skinny, bony girl (deliberately skinny, calorie-obsessed— a girl who weighed all her clothes before deciding what to wear to the doctor's office), but somehow she managed to loom . . . She spat out words like "middle class" and "domestic" as if they were curses. She quoted a line from a poem called "Howl" that got her banished to her room. She urged books upon her parents—her beloved Jack Kerook and someone named Albert Caymus . . .

Lindy's abandoned son, Pagan, mildly autistic, is brought home to be raised by the Antons, who devote themselves to their traumatized grand-son even as their marriage deteriorates. Like the Learys of *The Acciden-tal Tourist,* whose son is killed, the Antons become further estranged in the aftermath of family tragedy. Many years later when Lindy returns as a middle-aged woman, a veteran of the San Francisco drug scene whose brain has been "zonked"—"zapped"—"fried"—"hopped up"— "wigged out"—"blown away by drugs," she turns out to be an individual of no special distinction in wool knee socks and felt clogs, colorless and shabby, wanly "witchlike." Yet Lindy has been to the Antons what the long-missing Caleb Peck is to his left-behind family: "the central mys-tery of their lives, the break at the heart of the family." (Caleb Peck, who makes a belated appearance in the Eudora Welty–inspired *Searching for Caleb,* is a far more engaging and convincing character than the sketchily drawn Lindy.) In an offhand remark to her brother, Lindy provides some insight into her behavior:

> ". . . those eternal family excursions! 'Just us,' Mom would say, 'just the five of us,' like that was something to be desired, and I'll never forget how claustrophobic that made me feel. Just the five of us in this wretched, tangled knot, inward-turned, stunted, like a trapped fox chewing its own leg off."

Yet "those eternal family excursions" are Anne Tyler's inspired sub-ject, as the abiding myth of the family as both nurturing and devouring its captive young remains one of the great subjects of our literature. As Anne Tyler has moved steadily away from the richly idiomatic,

character-driven materials of her more overtly southern literary background, in the direction of popular commercial fiction of a more generic sort, her novels have lost some, though hardly all, of their magic. Still, in the carefully orchestrated closing chapters of *The Amateur Marriage* Tyler allows us to feel, not simply to observe, the ravages of time and loss in the Antons' lives. The novel's poignant ending brings us, with a now elderly Michael Anton, to the twilit edge of senility where, to his astonishment and ours, he imagines the long-dead Pauline as his vibrant young wife again, awaiting his return home: "He began to walk faster, hurrying toward the bend."

Memoirs of Crisis

Truth & Beauty
Ann Patchett

Ours is a memoir-obsessed literary culture. With the waning of confessional poetry, what we might call the "memoir of crisis" has blossomed in recent decades: such memoirs need not be written by individuals of distinction but by little-known or unknown individuals who have achieved distinction of another kind, through suffering. In theory, the advantage of the memoir is that the reader is allowed immediate entry into "real" life and spared the metaphorical strategies and impediments of imaginative literature. The strongest memoirs may be beautifully composed but beauty is hardly the point of memoir. As Robert Lowell famously remarked, "Yet why not say what happened?"

Lucy Grealy's *Autobiography of a Face,* published in 1994 when the author was thirty-one, has become a classic of this sub-genre. Here indeed is a beautifully composed work of literature, a sequence of thirteen interlocked essays, each exploring a facet of the author's experience as a survivor of a disfiguring face cancer, that makes of pathology a mirror of the human condition. *Autobiography of a Face* is also a moving meditation upon "ugliness" and "beauty" of particular significance in a culture obsessed with the outward self. Stricken with an Ewing's sarcoma at the age of nine, Lucy Grealy endured years of radiation and chemother-

apy followed by a succession of reconstructive operations, most of them unsuccessful. (The chance of survival of such cancer is 5 percent.) Yet it was the anguish of being perceived as ugly, and of feeling ugly, that Lucy Grealy experienced as the tragedy of her life: "I *was* my face, I *was* ugliness.*"* Viciously teased and tormented through school and even as an adult gawked at and occasionally insulted on the street, Lucy Grealy came to feel that her experience as a cancer patient had been minor in comparison.

In all, Lucy Grealy would endure thirty-eight operations until, exhausted and demoralized and increasingly dependent upon drugs, she died of an apparent heroin overdose in December 2002, aged thirty-nine. She had attempted suicide several times and had more or less abandoned her once promising literary career. (After the media-generated success of *Autobiography of a Face,* Grealy's more loosely structured memoirist essay collection *As Seen on TV: Provocations,* published in 2000, though containing much that is brilliant and wise, was ignored.) As Lucy Grealy's friend Ann Patchett observes in her memoir of their seventeen-year friendship: "[Lucy] had a nearly romantic relationship with Death. She had beaten it out so many times that she was convinced she could go and kiss it all she wanted and still come out on the other side . . . She believed that the most basic rules of life did not apply to her."

Truth & Beauty is a harrowing document, composed in a spare, forthright style very different from the elegant artifice of Ann Patchett's best-known novels *The Magician's Assistant* (1997) and *Bel Canto* (2001). It begins in 1985 when Ann Patchett and Lucy Grealy, both newly graduated from Sarah Lawrence, enroll in the University of Iowa Writers' Workshop and room together in an effort to economize. At Sarah Lawrence, Lucy Grealy had been famous for being the smartest student in all her classes as well as for the heroic drama of her face; by her own modest account, Ann Patchett was less known. From the start, in Iowa, Ann perceives herself and Lucy as radically different types:

> We were a pairing out of an Aesop's fable, the grasshopper and the ant, the tortoise and the hare. And sure, maybe the ant was warmer in the winter and the tortoise won the race, but everyone knows that the grasshopper and the hare were infinitely more appealing animals . . .

Ann is the diligent ant, Lucy the insouciant grasshopper. At their initial meeting in Iowa, though they scarcely know each other, Lucy runs to "pitch herself" into Ann's startled arms:

> When I turned around to say hello, she shot through the door with a howl. In a second she was in my arms, leaping up onto me, her arms locked around my neck, her legs wrapped around my waist, ninety-five pounds that felt no more than thirty . . . It was not a greeting so much as it was a claim: she was staking this spot on my chest as her own and I was to hold her as long as she wanted to stay.

So through the turbulent years of their friendship, Lucy Grealy will pitch herself into Ann Patchett's protective arms and Ann will hold Lucy as long as she is able.

It can be no surprise that the memoir of a friendship that ends in the premature death of a gifted writer does not make for cheerful reading. And yet there is much in *Truth & Beauty* that is uplifting, a testament to the perennial idealism and optimism of young writers: "[Lucy] was absolutely committed to the idea that writing would be her salvation and that she would pull herself out of all her present miseries with the sheer strength of her will and talent." The powerful solace of art to the lonely and dissatisfied is wonderfully rendered here:

> [Lucy and I] had come to realize that no one was going to save our lives, and if we wanted to save them ourselves, we had only one skill that afforded us any hope at all. Writing is a job, a talent, but it's also the place to go in your head. It is the imaginary friend . . .

Showcased inside Ann's plain-style prose, Lucy's letters (mostly sent to Ann from Aberdeen, Scotland, where Lucy had gone for protracted reconstructive surgery in 1989) glow with the energy of a quirkily original voice:

> Dearest anvil, dearest deposed president of some now defunct but lovingly remembered country, dearest to me, I can find no suitable words of affection for you, words that will contain the whole of your wonderfulness to me. You will have to make due with being my

favorite bagel, my favorite blue awning above some great little cafe where the coffee is strong but milky and had real texture to it.

The juxtaposing of these very different voices makes of the memoir an inspired duet: the reader sees Lucy through Ann's eyes, yet hears Lucy directly in her own voice.

The astute, eloquent, self-scrutinizing Lucy Grealy of *Autobiography of a Face* and *As Seen on TV* doesn't quite prepare the reader for the Lucy Grealy who emerges from these pages. Here is an antic, fey, restless, demanding and exasperating child-woman whose frequent queries to her friend are "Do you love me?"—"Do you love me best?"—"Why doesn't anybody love me?". Like a Carson McCullers character, part waif, part vampire, Lucy demands constant attention:

> As much as Lucy liked my friends, it was important for her to know at every moment that she was my uncontested favorite. There was nothing subtle in her methodology. When we had lunch with Elizabeth [McCracken], Lucy would inevitably leave her chair at some point during the meal and come and sit in my lap.
>
> "What are you doing in my lap, pet?" I asked her.
>
> Lucy would lean her head against my chest and turn her eyes up to me. "Do you love me?" she said.
>
> "Of course I love you."
>
> "Best?"
>
> "Yes, best, but you are crushing my thigh."
>
> Lucy sighed, contented now, and continued her conversation with Elizabeth from the comfortable vantage point of my lap, eating what she could off my plate.

Though *Truth & Beauty* is a memoir in which love is omnipresent, it may remind some readers of Ted Hughes's controversial *Birthday Letters* (poems to Hughes's deceased wife Sylvia Plath), in its way of relentlessly exposing what might be described as flaws in its subject's character. For here is a wholly self-absorbed Lucy Grealy who borrows money she has no intention of returning, including money for non-facial surgery (". . . when [Lucy] decided that breasts would be the best accessory to go with her new skirts and heels, she simply took out another government loan"), shoplifts books at poetry readings, accepts a large advance from a pub-

lisher to write a novel she never gets around to writing. Unpaid bills and student loans, back federal taxes accumulate in Lucy's wake like the careless litter of her living quarters in which even cherished Prada dresses wind up "all knotted together on the floor of her closet." When Lucy is "too depressed" to open her long-accumulated mail, Ann heroically undertakes to deal with it, "forging [Lucy's] name" when necessary. Ann pays bills for Lucy, Ann helps clean Lucy's apartment, Ann is wakened by a call from Lucy at 5:30 A.M. and sent out to search Manhattan for "apricot nectar." Lucy is something of a sexual adventuress, so needy for love from men that she will have sex with virtual strangers; she is continually asking Ann, "Will I ever have sex again?" even on days when, as Ann points out, she has already had sex: "But I want to know if I'm going to have it *again*." In a display of selflessness worthy of one of the martyred saints of Ann Patchett's Roman Catholic girlhood, Ann even offers to write the novel for which Lucy has been contracted: "We wouldn't have to tell anyone. I could write it and you could rewrite it so it sounded like you."

As Lucy's physical and mental health deteriorates, their friendship takes on an aura of symbiotic romance. Ann helps nurse Lucy in appallingly understaffed hospitals and when Lucy is discharged, carries Lucy publicly in her arms:

> Lucy was never happier than in the moments she was held and despite everything she had been through, she was incredibly happy to be out on the street in my arms . . . There wasn't any trick to it. She was a sparrow, a match. The trick would have been to figure out a way to do it all the time so that she could have always been happy.

Ann appeals to Lucy to live with her in Nashville: "I wanted to keep [Lucy] as much for myself as for her."

The brief flurry of "fame" in the wake of *Autobiography of a Face* brings some happiness into Lucy Grealy's life, but by the late 1990s, after continued surgeries, post-op depressions, and romantic disappointments, Lucy has become addicted to OxyContin and finally, lethally, to heroin: "Lucy was having the great love affair she had always dreamed of. It was dangerous and rocky, violently depleting, but in the few minutes that it was sweet it made her feel the all encompassing heat of love." By this time Ann, disapproving of her friend's drug use, is no longer in constant

communication with her and Lucy dies alone on December 18, 2002, in New York City, leaving Ann to ponder the second half of her life—"the half that would be lived without Lucy."

Our wish to memorialize the dead who haunt us is a powerful and ambivalent wish, as Ann Patchett's riveting *Truth & Beauty* will attest.

III.

Homages

Emily Brontë's *Wuthering Heights*

OF CLASSIC ENGLISH NOVELS, WUTHER-*ing Heights* is our great romance of adolescent passion, as Emily Brontë (1818–1848) is one of the elusive, haunting figures of our literature. Like her near-contemporary in America, Emily Dickinson, whose reclusive personal life and enigmatic visionary poetry suggest a spiritual kinship with Brontë, this gifted but isolated writer has had primarily a posthumous reputation, and has been the excited focus of myths, legends and interpretative portraits. Has there ever been a more astonishing "first novel" than *Wuthering Heights*? Granted, every work of literary genius is *sui generis,* still *Wuthering Heights* strikes us as unique. Reading it more than a century and a half after its initial, under-acclaimed publication in 1847 (under the androgynous pen name "Ellis Bell") we are struck by the novel's masterful amalgam of voices as well as the breadth and imagination of its vision. The "worlds of Heaven and Hell"—to quote one of Emily Brontë poems—are "centered" here, in a passionately human experience: the transformation of Heathcliff as vengeful lover to one who forgives his enemies and is capable of "magnanimity" in allowing them the freedom to love which he himself was denied.

Like her doomed heroine Catherine, Emily Brontë died young; unlike her elder sister Charlotte who embarked upon a career and established a relationship with the English literary world, Emily Brontë has always remained a mystery, having published only this single work of genius and a small gathering of poems of uneven though undeniable quality that cele-

brate the power of the imagination in the individual soul. ("No coward soul is mine / No trembler in the world's storm-troubled sphere.") Where *Jane Eyre* (1847) presents a highly observant, analytical, self-reflective young woman narrator with whom a reader can identify, *Wuthering Heights* more ambitiously diffuses its consciousness among several contrasting perspectives; its structure is not so complicated as it initially appears, but chronology is fractured, not linear, and certain of its most powerful images (the early, gothic-ghostly appearance of Cathy in Lockwood's nightmare, for instance) require a second reading to be fully comprehended. What is mystery becomes irony; what is opaque becomes translucent poetry. There are numerous flash-forwards, as well; and a mirroring of characters across generations (the elder Catherine and her daughter, also named Catherine; Heathcliff and Hareton). *Wuthering Heights* is both a fascinating saga and a feat of poetry-in-prose, a precursor of such very different novels as Thomas Hardy's *Tess of the D'Urbervilles* and D. H. Lawrence's *The Rainbow* and *Women in Love*.

How does a work of such genius come to be written by a young and inexperienced woman living in a rural parsonage in Yorkshire, suffering from chronic ill health and emotionally exhausted by family tragedies?—how, in fact, does a work of such genius come to be written at all? We know—biography can supply no real answers. A summary of historic facts can deepen obscurity. Yet it must have been crucial for Emily Brontë's original conception of Heathcliff (as dark-skinned "gypsy" orphan brought from Liverpool by the master into the Earnshaw household) that her great-great-grandfather Hugh Brunty had adopted a black-haired foundling from Liverpool (who in turn adopted their own grandfather, the younger Hugh). It would have been crucial that the young author was familiar since childhood with fairy tales, Aesop's fables, romantic and gothic adventures, and such classics as the works of Shakespeare, Milton, Keats and Lord Byron and Sir Walter Scott. Certainly, Emily Brontë's physical environment was crucial to her vivid creation of the mythopoetic world of "Wuthering Heights" (in contrast with the genteel "Thrushcross Grange"): the wild, remote, wind-haunted moors and cliffs of Haworth, Yorkshire (in contrast with the bustling, burgeoning cities of mid-nineteenth-century England where a very different sort of "women's novel" was being written and eagerly consumed). No one stands as a more opposed, antithetical figure to Emily Brontë than the quintessential English novelist, Jane Austen; even

within the Brontë household, if we compare the more conventional novels of her sisters Charlotte and Anne to *Wuthering Heights,* Emily Brontë is *other.* As Charlotte Brontë said of Emily after her death, in *A Biographical Notice of Ellis and Acton Bell,* "Stronger than a man, simpler than a child, her nature stood alone."

GREAT LITERATURE springs from great, often thwarted or lost love. Where there is no yearning, there can be no fantasy; where no fantasy, no imaginative transformation of the "real" into art. The romantic vision has become somewhat debased in our time, but it might be argued that all works of art whether "romantic" or "realistic" are in fact the products of an intense, interior romance: that of the artist for his or her subject. Memorialization of the subject, and nearly always its precisely rendered setting, land- or city- or seascape, is the fuel that drives imaginative creation; it may be that much of writing springs from a hope of assuaging homesickness. Every biographical note about Emily Brontë remarks upon the young woman's extreme identification with her Haworth background, and her homesickness when she was away from it. In her heroine Catherine's words:

> ". . . Supposing at twelve years old, I had been wrenched from the Heights, and every early association, and my all in all, as Heathcliff was at that time, and had been converted at a stroke into Mrs. Linton, the lady of Thrushcross Grange, and the wife of a stranger; an exile, and outcast, thenceforth, from what had been my world. You may fancy a glimpse of the abyss in which I grovelled! . . . Oh, I'm burning! I wish I were out of doors—I wish I were a girl again, half savage, and hardy, and free; and laughing at injuries, not maddening under them! Why am I so changed? Why does my blood rush into a hell of tumult at a few words? I'm sure I should be myself were I once among the heather on those hills. Open the window again wide, fasten it open!" [Chapter 12]

"Why am I so changed?" Catherine asks—as if the very fact of time's passing, her maturing out of childhood and into adulthood, were incomprehensible, and morally outrageous.

Emily Brontë was the fifth of six children born to Patrick Brontë, a

clergyman with literary aspirations, and his wife Maria Branwell, who, worn out from her numerous pregnancies and general ill health, died shortly after the birth of her last child, Anne. Motherless, the Brontë children were looked after by a stern, not very loving aunt; their emotional focus was upon their spirited father, and perhaps more significantly, and intensely, upon one another. When Mr. Brontë brought home a box of twelve wooden soldiers, for instance, these toys quickly acquired life and identities in the children's imaginations; before long, the children were writing serial stories in minute italic handwriting meant to resemble print, in miniature "books" of their own creation. One can imagine them reading or reciting these stories to one another, as well as dramatizing "bed plays" (secretly written at bedtime). In 1826, Emily began writing, with her younger sister Anne, a collaborative fantasy set in a mythical land called "Gondal"; Charlotte and their brother Branwell began a fantasy set in "Angria." These sagas absorbed the Brontë children for an extraordinary fifteen years and clearly informed, in spirit if not in actual content, the writing of the famous Brontë novels. *Wuthering Heights* with its celebration of fierce storms and fiercer passions would seem to have been particularly inspired. Have the shadowy worlds of fairy tale, legend, gothic horror and romantic adventure ever been so triumphantly transfigured into art?

Yet *Wuthering Heights* is a fully mature work of the imagination. Like most fairy tales, in fact, it doesn't celebrate rebellion, but, surprisingly, given its romantic temperament, presents the "dissolving" of youthful passion into something approaching a transcendental harmony. It is Shakespeare's *Romeo and Juliet* re-imagined, not as tragedy, but as a novel in which the dialectic of warring opposites is at last quieted; we are meant to take Nelly Dean's words seriously when she says, in Chapter 34, after Heathcliff's rather mystical death, that "the lawful master [Hareton] and the ancient stock [the Earnshaws] were restored to their rights." The tangled, quasi-incestuous histories of the Earnshaws and the Lintons evolve with the inevitable passage of time into an equilibrium, with the unexpected (yet dramatically ideal) liaison of the young Catherine and the abused Hareton. At the same time, the novel explains why Hareton, the sole living Earnshaw heir, will leave the Heights to live with his cousin-bride at Thrushcross Grange. It's as if, despite the violent, rhapsodic love of the elder Catherine and the foundling Heathcliff, forged in a childhood of deprivation, their primitive energies must give

way to the refinements and compromises of adulthood; as if, perhaps unconsciously, Emily Brontë were transcribing a symbolic history of civilization itself.

Wuthering Heights, like the great novels of Hardy and D. H. Lawrence, is a work of intense, precise, often lyric observation. Its story springs from its setting, and Emily Brontë makes a brilliant decision to begin the novel with the narration of the outsider Lockwood, in 1801, years after the primary events of the novel have occurred. In this way, the reader is introduced to the Heights—and to the "erect and handsome"— and "rather morose" figure of Heathcliff, as if we, too, were visitors, uncertain of our bearings. For all his callowness, Lockwood is a wonderfully attentive observer. He sees, hears, smells, absorbs. He notices the smallest details, architectural oddities and facts; he appreciates the rugged charm of Wuthering Heights as none of its current inhabitants could:

"Wuthering" being a significant provincial adjective, descriptive of the atmospheric tumult to which its station is exposed in stormy weather. Pure, bracing ventilation they must have up there . . . one may guess the power of the north wind, blowing over the edge, by the excessive slant of a few stunted firs at the end of the house; and by a range of gaunt thorns all stretching their limbs one way, as if craving alms of the sun. Happily, the architect had foresight to build it strong: the narrow windows are deeply set in the wall, and the corners defended with large jutting stones.

Before passing the threshold, I paused to admire a quantity of grotesque carving lashed over the front . . . above which among a wilderness of crumbling griffins and shameless little boys I detected the date "1500" and the name "Hareton Earnshaw."

[Chapter 1]

Compare the gauzy imprecision of more conventional gothic sensibilities: the floridly wrought rhetoric of Mary Shelley's *Frankenstein; or, The Modern Prometheus* (1818); Edgar Allan Poe's "The Fall of the House of Usher" (1839); Robert Louis Stevenson's "Dr. Jekyll and Mr. Hyde" (1886). *Wuthering Heights* is among other things a paean to the beauty and mystery of the *real world*.

And this lovingly detailed world isn't just that of the wild moors and cliffs that so define Catherine and Heathcliff as children but the interior, domestic world presided over by Nelly Dean as well. Like *Jane Eyre, Wuthering Heights* is enriched by a Vermeer-like respect for ordinary life:

> Under these circumstances I remained solitary. I smelt the rich scent of the heating spices; and admired the shining kitchen utensils, the polished clock, decked in holly, the silver mugs ranged on a tray ready to be filled with mulled ale for supper; and, above all, the spotless purity of my particular care—the scoured and well-swept floor.
>
> I gave due inward applause to every object . . . [Chapter 7]

This "inward applause" radiates through the whole of Emily Brontë's novel, illuminating its darkest, most gnarled and obscure reaches. The startling flash-forward at the end of Chapter 16, for instance, describes Catherine Earnshaw Linton's final resting place, in Nelly Dean's calm voice:

> The place of Catherine's interment, to the surprise of the villagers, was neither in the chapel, under the carved monument of the Lintons, nor yet by the tombs of her own relations, outside. It was dug on a green slope, in a corner of the kirkyard, where the wall is so low that heath and bilberry plants have climbed up over it from the moor; and peat mould almost buries it. Her husband lies in the same spot, now; and they each have a simple headstone above, and a plain grey block at their feet, to mark the graves. [Chapter 16]

For the reader caught up in the doomed love of Catherine and Heathcliff, these lines are inexpressibly beautiful, and sad. And what a contrast these words are with Heathcliff's shocking revelation, much later in the novel, that he has violated this very grave, eighteen years after Catherine's death. At the time of Linton's death, he'd asked the sexton to unearth and open Catherine's coffin so that he could look at her face once again. Nelly asks indignantly what Heathcliff would have dreamt of, if Catherine had been "dissolved into earth," and Heathcliff replies,

> "Of dissolving with her, and being more happy still! . . . Do you suppose I dread any change of that sort? I expected such a transfor-

mation on raising the lid, but I'm better pleased that it should not commence until I share it. . . . You know, I was wild after she died, and eternally, from dawn to dawn, praying for her to return to me—her spirit. I have a strong faith in ghosts; I have a conviction that they can, and do exist, among us." [Chapter 29]

Wuthering Heights is remarkable for its synthesis of the "real" and the "romantic/gothic"; the dissolution of barriers between the living and the dead. There would appear to be no transcendental God in this universe, only powerful, oceanic human passions that transcend what we call "death."

(We should recall how the Brontë household in Haworth was saturated with death: by the time Emily was a young adolescent, she had lost not only her mother, whom she'd scarcely known, but her beloved older sisters Maria and Elizabeth. Emily herself was never in strong health, and the deterioration of her brother Branwell, an alcoholic and opium addict, over a period of years, left her so exhausted at the time of his death in September 1848 that she herself died three months later in December.)

What we most recall from *Wuthering Heights* are, of course, its moments of high, operatic drama. These almost exclusively involve Catherine Earnshaw and Heathcliff. There is a Shakespearean grandeur to the star-crossed lovers' fate, which makes of them martyrs for passion, of a strangely chaste sort. (Victorian convention would have forbidden any depiction of physical, sensual feeling between the very physical, very sensual young people, but it's unlikely that Emily Brontë imagined them as "sexual.") Where Jane Eyre and her husband-to-be Rochester are clearly opposites, and, as opposites, romantically attracted to each other, Cathy and Heathcliff are soul-mates. Their feeling for each other is narcissism of the most intense kind. Cathy tells Nelly Dean, "I *am* Heathcliff—he's always, always in my mind." Heathcliff is the very personification of the moors and cliffs of Yorkshire that so suffused Emily Brontë's soul. Set beside this landscape, "Heaven" is an empty abstraction. Cathy has had a dream of ascending to Heaven, shortly before her marriage to Linton, and realizes that Heaven isn't her home:

. . . And I broke my heart with weeping to come back to earth; and the angels were so angry that they flung me out, into the middle of

the heath on the top of Wuthering Heights; where I woke sobbing for joy. . . . I've no more business to marry Edgar Linton than I have to be in heaven; and if [Hindley] hadn't brought Heathcliff so low, I shouldn't have thought of it. It would degrade me to marry Heathcliff now; so he shall never know how I love him; and that, not because he's handsome, Nelly, but because he's more myself than I am. Whatever our souls are made of, his and mine are the same.

[Chapter 9]

The love of Cathy and Heathcliff has been forged in a childhood in which they'd been allowed to grow up "rude as savages" and to run away to the moors for entire days; no attractions of adulthood can quite compete. Heathcliff entirely shares Cathy's sentiment, in a language even more passionate, uttered after Cathy's death (in childbirth):

"May she wake in torment!" he cried, with frightful vehemence, stamping his foot, and groaning in a sudden paroxysm of ungovernable passion. . . . "Where is she? Not *there*—not in heaven—not perished—where? Oh! you said you cared nothing for my sufferings! And I pray one prayer—I repeat it till my tongue stiffens—Catherine Earnshaw, may you not rest, as long as I am living! You said I killed you—you haunt me, then! The murdered *do* haunt their murderers, I believe. I know that ghosts *have* wandered on earth. Be with me always—take any form—drive me mad! only *do* not leave me in this abyss, where I cannot find you! Oh, God! it is unutterable! I *cannot* live without my life! I *cannot* live without my soul!"

[Chapter 16]

By the time of Lockwood's arrival in 1801–02, the doomed-love story of the 1770s has not yet run its course, and Heathcliff's drift into a kind of madness is made both poetic and convincing. He becomes a tragic figure of paranoia, self-loathing, perpetual and helpless mourning for a lost "love"—a lost time. Heathcliff's true bride is Death. To be in love obsessively with the past and with one's own youth is to be in love with Death. This shading of a one-time vigorous love into pathology is finely rendered by Emily Brontë, who was surely giving voice, through the Byronic Heathcliff, to her own mourning for her lost loved ones. Yet the genius of *Wuthering Heights* is to transfigure this morbid, reticular, self-referential

obsession into its opposite: the daylit, sunlit, less passionate but equally companionable, and tender, love of the young Catherine for the near-orphaned Hareton.[1] The evolution of primitive Nature into an accommodating Society; the transformation of inchoate, undifferentiated, uncompromising passion into adult love and marriage. So transformed are the young Catherine and her fiancé Hareton, Lockwood enviously observes that they look as if, together, "they would brave Satan and all his legions." The lovers of the second generation will be living, not in Wuthering Heights, but in the more gracious Thrushcross Grange, opening, both symbolically and literally, onto the rest of the world and into a new era. The "old" will remain, preserved through the decades as fairy tales and local legends remain, though relegated to darkness and storm-tossed nights on the moors when it's believed that Heathcliff and Catherine walk together. But the novel's final image belongs to sunlight when we return another time to the kirkyard, where there are three headstones:

> The middle one, grey, and half buried in heath—Edgar Linton's only harmonized by the turf, and moss creeping up its foot—Heathcliff's still bare.
>
> I lingered round them, under that benign sky; watched the moths fluttering among the heath and hare-bells; listened to the soft wind breathing through the grass, and wondered how any one could ever imagine unquiet slumbers for the sleepers in that quiet earth.
>
> [Chapter 34]

So romantic love consumes itself, even as the "gothic" romance yields to "realism" in the novel's concluding chapters. Heathcliff, who has cruelly assured his young victim-bride Isabella that he's no hero of romance, but rather a man of base, vindictive motives ("The more the worms writhe, the more I yearn to crush out their entrails! . . . And I grind with greater energy, in proportion to the increase of pain") is suddenly, unexpectedly, redeemed after his exhuming of Catherine's corpse. His villainous "diabolical brow," "basilisk eyes," and "cannibal teeth" yield to the impairments of time; he finds himself making peace with his old enemies. Seeing Hareton as an embodiment of his own, lost youth and the young Catherine as an embodiment of her dead mother, Heathcliff feels his hatreds fade; by raising the dead, in a sense, he re-experiences his tragic love as a "spectre of hope" and not mere continued

grief. Or, if Heathcliff's love *is* grief, he has acquired a new perspective on it:

> . . . What is not connected with her to me? and what does not recall her? I cannot look down to this floor, but her features are shaped on the flags! In every cloud, in every tree—filling the air at night, and caught by glimpses in every object by day, I am surrounded with her image! The most ordinary faces of men and women—my own features—mock me with a resemblance. The entire world is a dreadful collection of memoranda that she did exist, and that I have lost her.
>
> [Chapter 33]

After this insight, Heathcliff accepts his own "dissolving"—into the mysterious primal elements from which, the gypsy-foundling from Liverpool, he'd sprung. To Heathcliff, the approach of death itself is little more than an ecstatic communion with Catherine: "My soul's bliss kills my body, but does not satisfy itself." Nelly Dean, the perennial witness, considers whether the master of Wuthering Heights is a ghoul or a vampire: "Where did he come from, the little dark thing harboured by a good man to his bane?" But Nelly can offer no answers, and can't truly believe that an individual she has known since his infancy can be a "hideous, incarnate demon." When he dies, Heathcliff will be commemorated on his gravestone with no date of birth and no surname except the stark, iconic HEATHCLIFF.

One generation passes, another generation takes its place.

Like *Jane Eyre,* that more conventionally imagined romance in which a plain, plucky young virgin-governess marries her dark-browed lover, now physically impaired and partly blind, *Wuthering Heights* ascends through melodrama and emotional excess to austerity and accommodation; from turbulence to peace. Rarely has a happy ending seemed so natural, so inevitable, as if in mimicry of the very cycle of seasons. Yet the subtle tonal shift from the gothic sensibility to the realistic has been prepared from the novel's opening, through the detached perspective of Lockwood; at the novel's end, in 1802, we return to this perspective. And how different is Lockwood's approach to the Heights than it was only the previous year, for mystery and dread had been dispelled by Heathcliff's self-willed death and the lifting of the curse on the Earnshaws.

All that remained of the day was a beamless, amber light along the west; but I could see every pebble on the path, and every blade of grass by that splendid moon.

Notes

1. The classic film *Wuthering Heights,* released in 1939, with powerful performances by Laurence Olivier as Heathcliff, Merle Oberon as Cathy, and David Niven as Edgar Linton, is a much truncated, bowdlerized version of the novel. The "second-generation" doesn't get born at all; the movie ends abruptly on the morning after Lockwood's initial arrival at the Heights, with a vision of Heathcliff (in the flesh?) and his beloved Cathy (a wraith?) walking off into the moors. More importantly, the novel's dark vision is lightened: Heathcliff isn't portrayed as a genuinely brutal, dangerous individual but a far simpler man, a heartsick lover. The starkness of Emily Brontë's vision dissolves into mere romance.

"Tragic Mulatta"

Clotel; or, The President's Daughter
William Wells Brown
with an introduction by Hilton Als

"You Americans! Still obsessed with guilt over slavery!"

This remark, derisively tossed off by a British writer at an otherwise convivial gathering in Princeton, was met with initial stunned silence. (And then, of course with much verbal opposition, particularly from American historians who happened to be present.) It's an absurd charge and yet there's something about it that rankles: the possibility that, to some foreign observers, our appalled fascination with Southern slavery is little more than an expression of personal eccentricity, a kind of arcane hobby; more than a possibility, a likelihood, that after decades of scholarship, historical research, and imaginative literature in the service of the illumination of the darkest, most feculent corner of our American democracy, there are those individuals, presumably Caucasian, to whom the enterprise meets with the sort of bemused indifference of which Frederick Douglass spoke in his great autobiographical work *Narrative of the Life of Frederick Douglass, An American Slave, Written by Himself* (1845):

So profoundly ignorant of the nature of slavery are many persons, that they are stubbornly incredulous whenever they read or listen to any recital of the cruelties which are daily inflicted upon its victims.

They do not deny that slaves are held as property; but that terrible fact seems to convey to their minds no idea of injustice, exposure to outrage, or savage barbarity. Tell them of cruel scourgings, of mutilations and brandings, of scenes of pollution and blood, of the banishment of all light and knowledge, they affect to be greatly indignant at such enormous exaggerations, such wholesale misstatements, such abominable libels on the character of the southern planters!

[Preface]

This ignorance, which made a kind of sick sense in 1845, when slavery was flourishing in the American South and its excesses weren't universally known, is surely unconscionable in the twenty-first century.

Contrary to the British writer's assumption, it isn't possible for Americans to know too much about the "peculiar institution" of our native slavery and the yet more peculiar history of those Americans known as "African Americans" since 1619, when the first twenty Africans were brought to Jamestown, Virginia, on a Dutch man-of-war whose captain exchanged them for food. (These were indentured servants, not "slaves.") The classic slave narratives by Frederick Douglass, Harriet Jacobs, and William Wells Brown need to be read and reread. Not because slavery per se is likely to come again but because certain of the assumptions that made slavery palatable still prevail. Capitalist slaveholders to whom an entire class of individuals is less than human, brutal white overseers who enforce the will of the slaveholders, auction sales, the breakup of families, the degradation of young female slaves by white males with money: these are still with us in transmogrified, euphemistic forms. That "race" is even a valid intellectual category might be questioned.

Of African Americans who have written on such subjects from the perspective of having been born slaves, lived as slaves, suffered as slaves and at last escaped from slavery, no one has written more movingly and more persuasively than William Wells Brown (1816–1884), an abolitionist and reformer whose last book, *My Southern Home; or, The South and Its People* (1880), is a forerunner of W. E. B. Du Bois's magisterial *The Souls of Black Folk* (1903). Less acclaimed than Du Bois and Frederick Douglass, less a rallying iconic figure than Sojourner Truth, Brown would seem to have been a remarkable individual. Though he came relatively late to the cultivation of what the nineteenth century called *belles*

lettres, after an activist involvement in the Underground Railroad and the Western New York Anti-Slavery Society, Brown is credited with having written the first African-American novel, *Clotel; or, The President's Daughter* (1853); the first African-American travel book, *Three Years in Europe* (1852); the first African-American drama, *The Escape; or, A Leap for Freedom* (1858); one of the first African-American autobiographies, *Narrative of William W. Brown, A Fugitive Slave,* which went through numerous American and British editions before 1850 and made its author internationally famous; two volumes of history, *The Black Man: His Antecedents, His Genius, and His Achievements* (1863); and the first military history of African Americans in the United States, *The Negro in the American Rebellion* (1867). Brown's most comprehensive African-American history is *The Rising Son; or, The Antecedents and Advancements of the Colored Race* (1874), containing biographical sketches of more than 110 prominent African Americans. Yet Brown remains relatively unknown to contemporary readers. His listing in the encyclopedic *Black Saga: The African American Experience* by Charles M. Christian (1995) is minimal, and he isn't included at all in Gerald Early's massive two-volume *Speech and Power* (1992–93).

Like *Clotel,* Brown's bravura mix of reportorial history and romantic fairy tale, Brown's life-story would seem to have been partly invented along mythic lines. The tradition of "authenticating" one's authority to speak of, and against, slavery obligated the former slave to narrate his or her life in convincing detail; to make one's experience seem representative, archetypal, dramatic was the goal. To this end Brown provides several versions of his parentage and early life and in successive versions his story became more emblematic. In the first edition of the *Narrative,* Brown is born of slave parents in 1814 on a plantation near Lexington, Kentucky; in the second edition, Brown is stolen as an infant by a slave trader; in the second revised edition, Brown is born of a slave mother and a white slaveholding father, and his "mulatto" mother's father was "the noted Daniel Boon." In this way, Brown as abolitionist-author-visionary is aligned with a mythic-historic figure of white America, like his romantic heroine Clotel whose alleged father (Thomas Jefferson) is even more elevated.

This claim not merely of white blood, but of aristocratic white blood, is another means of authenticating one's right to speak intimately of race, with a suggestion too that the figure of mixed-blood ancestry

"knows" more than ordinary African Americans and Caucasians. The most self-aware and idealistic characters in *Clotel* are "mulatto"; while ordinary black slaves speak a sort of sage, comic dialect (". . . I don't like to see dis malgemation of blacks and mulattos, no how"), Clotel, her sister Althesa, and her daughter Mary speak a dialect-less, self-consciously literary English reminiscent of the elevated speech of the heroines of bestselling romances by Mrs. E.D.E.N. Southworth and Susan Warner ("If the mutual love we have for each other, and the dictates of your own conscience do not cause you to remain my husband, and your affections fall from me, I would not, if I could, hold you by a single fetter," Clotel tells her lover, who is also her master). Moreover, Brown's aristocratic mulattos are abolitionists by nature (i.e., by "blood"):

> The infusion of Anglo-Saxon with African blood has created an insurrectionary feeling among the slaves of America hitherto unknown. Aware of their blood connection with their owners, these mulattoes labour under the sense of their personal and social injuries, and tolerate, if they do not encourage in themselves, low and vindictive passions.

Yet "low and vindictive passions" are missing from Brown's mixed-blood characters, who are too genteel (too "white," too literary) to rise against their oppressors. By contrast, Brown speaks in passing, with obvious admiration, of the martyred insurrectionist Nat Turner ("a full-blooded negro"), and another escaped slave of legend, named Picquilo, who has reverted to African custom in his exile in the Dismal Swamps of Virginia ("a large, tall, full-blooded negro, with a stern and savage countenance; the marks on his face showed that he was from one of the barbarous tribes of Africa, and claimed that country as his native land").

These bold, black Negroes may be heroic; but they are not the heroes of William Wells Brown's terrain.

For the "tragic mulatta" the erotic attractions of a light skin and Caucasian features don't confer power but constitute a fairy-tale curse of the sort suffered by Cinderella and Snow White:

> Every married woman in the far South looks upon her husband as unfaithful, and regards every quadroon servant as a rival . . . However painful it was to [Clotel], she was soon seen with her hair cut

short as any of the full-blooded negroes in [her master's house in Vicksburg, Mississippi].

In a surprising alliance, the jealous and vindictive white woman joins forces with her black-skinned female servant to punish Clotel's daughter Mary by forcing her to work bare-headed in the sun and, when the child collapses, allowing her to lie there and "broil." White mistress and black servant gleefully conspire as in a cruel melodrama:

> "[Mary] is lying in the sun, seasoning; she will work better by and by," replied the mistress. "Dees white niggers always tink dey sef good as white folks," continued the cook. "Yes, but we will teach them better, won't we, Dinah?" "Yes, missus, I don't like dees mular- ter niggers, no how; dey always want to set dey sef up for some- thing big."

The only violence of which the refined Clotel is capable is finally against herself: fleeing would-be white captors, she throws herself off a bridge into the Potomac, within view of the President's house; her death is bit- terly ironic, emblematic of the betrayal of white patriarchs of their un- acknowledged children. *Clotel* is an American fairy tale in which the royal-blooded Cinderella isn't claimed by her royal destiny but "de- posited" into a beggar's grave.

CLOTEL WAS revised in 1867 by Brown, given a new title, *Clotelle; or, The Colored Heroine,* and in this more upbeat, post–Civil War version Clotel escapes from slavery, survives and becomes free, and heads a school for freedmen and -women at the end of the war. It's the earlier, 1853 edition which has been reprinted by the Modern Library, with footnotes and commentary and an introduction by the black memoirist Hilton Als notable for its prickly antagonism to his subject. Far from inflating the worth of his assigned text, like most commentators in his position, Als doesn't disguise his scorn for this "first novel by an African American"; he dismisses it as trashy, clichéd, and "porno- graphic" as the 1992 TV miniseries *Queen,* which was based upon an uncompleted biographical story by Alex Haley. (Much of Als's intro- duction is about the long-forgotten *Queen.*) While allowing that

Brown's *Narrative* is meritorious, Als sees in *Clotel* "a kind of auto-erotic writing in which Brown projects his nobility of purpose, his 'blacking' of [Harriet Beecher] Stowe." It's a "pornography of self, informed by the props of a most brutal history, both worthy of TV . . . Clotel is Brown's guilty pleasure." In reference to *Clotel*'s deficiencies, Als quotes a passage from James Baldwin's 1948 essay, "Everybody's Favorite Protest Novel":

> *Uncle Tom's Cabin* is a very bad novel, having, in its self-righteous, virtuous sentimentality, much in common with *Little Women*. Sentimentality . . . is the mark of dishonesty, the inability to feel; the wet eyes of the sentimentalist betray his aversion to experience, his fear of life, his arid heart; and it is always, therefore, the signal of a secret and violent inhumanity, the mask of cruelty. *Uncle Tom's Cabin*—like its multitudinous, hard-boiled descendents—is a catalogue of violence.

Baldwin's harsh judgment of Harriet Beecher Stowe's great populist novel is in itself a species of violence. Baldwin is always a powerful and persuasive rhetorician, even when he's totally mistaken, as he is here. Even Baldwin's pronouns are wide of the mark: not *his* but *her* is the point. The enormously bestselling sentimental romances and melodramas of the nineteenth century, of which *Uncle Tom's Cabin* is a premier specimen, were primarily a female phenomenon. In these chaste Christian fantasies, women of all classes and backgrounds, deprived by law and custom of intellectual, political, social, financial and even, or especially, biological independence could project their wishes onto admirably pure, refined, well-spoken female characters, many of them orphan girls and widows, mothers made single and impoverished by disaster, daughters nursing elderly parents and maidens pining for true love; or, like Clotel, sacrificing their lives for their children's sakes. The nineteenth-century sentimental novel made sacrifice a sacrament, for women. (Clotel is of this sisterhood: safe in the North, she dresses as a foreign-born Caucasian male and ventures back into slaveholding Virginia to rescue her daughter Mary, with fatal results.) No one familiar with the domestic lives of nineteenth-century wives, mothers, and daughters could wish to accuse them of a "fear" of life unless it was a well-founded fear of dying in childbirth, as many did. "Sentimental"-

minded women do indeed feel, and are indeed human, though in ways that may seem quaint or contemptible to male observers.

Though it's refreshing to encounter an introduction so clearly at odds with its text, in fact Als's commentary on *Clotel* is misleading. There is nothing remotely "pornographic" about Brown's cobbled-together novel; the mild description of the heroine quoted by Als is all there is of Eros in *Clotel,* and Brown's prose is no more "autoerotic" than Als's prose. The flaws of *Clotel* are those of nineteenth-century romances generally, read in the clinical, critical light of our time in which, as in a photograph negative, the womanly virtues of one era (chastity, piety, self-abnegation, quivering emotion, subordination to males and elders and family, unflagging idealism in the face of tragedy, sympathy and forgiveness for all) are held up, if at all, only to scorn; while the "bad" womanly traits (pride, self-assertion, sexual autonomy, independence of family, skepticism in the face of received wisdom and custom, etc.) have become virtues. Who could have predicted such a cataclysm, in 1853? So too the elevated rhetoric of nineteenth-century "good" characters has become unreadable; if readable, unpalatable. Yet a contemporary reader might find fascinating those lengthy passages in *Clotel* in which modestly educated women deliver speeches of the sort William Wells Brown probably delivered to white abolitionist audiences in the North and abroad.

Yet more fascinating, and far more vividly narrated, are the scenes in *Clotel* that have nothing to do with romance or rhetoric, but with quotidian life in the slaveholding South. Here, Brown's prose is more supple, and urgent: there's an ugly, compelling brief chapter titled "The Negro Chase," which is about the pursuit of two fugitive slaves by specially trained "negro dogs," and ends with a laconic account of a lynching in a Natchez newspaper:

> . . . The torches were lighted, and placed in the pile, which soon ignited. [The negro] watched unmoved the curling flame that grew, until it began to entwine itself around and feed upon his body; then he sent forth cries of agony painful to the ear, begging some one to blow his brains out, until the staple with which the chain was fastened to the tree . . . drew out, and he leaped from the burning pile. At that moment the sharp ringing of several rifles was heard: the body of the negro fell a corpse on the ground. He was picked up by

some two or three, and again thrown into the fire, and consumed, not a vestige remaining to show that such a being ever existed.

Worthy of Mark Twain at his most bitterly funny is a scene from the chapter "Life and Escape" in which William Wells Brown, writing of himself in the third person, describes the trickery of slave traders before an auction:

> [William] had to shave off the old men's whiskers, and to pluck out the grey hairs where they were not too numerous; where they were, he colored them with a preparation of blacking with a blacking brush. After having gone through the blacking process, the [slaves] looked ten or fifteen years younger.

Twain in the most inspired satirical pages of *Huckleberry Finn* couldn't have outdone this "specimen of poetical genius" by a Mississippi parson, which begins:

My Little Nig.

> I have a little nigger, the blackest thing alive,
> He'll be just four years old if he lives till forty-five . . .
> His lips bulge from his countenance—his little ivories shine—
> His nose is what they call a pug, but fashioned very fine:
> Although not quite a fairy, he is comely to behold,
> And I wouldn't sell him, 'pon my word, for a hundred all in gold.

Nor could Edgar Allan Poe in one of his grimly jokey tales have imagined anything more gruesome than this ad from the Mississippi *Free Trader*:

> To Planters and Others.—*Wanted fifty negroes*. Any person having *sick negroes*, considered incurable by their respective physicians . . . and wishing to dispose of them, Dr. Stillman will pay cash for negroes affected with scrofula or king's evil, confirmed hypochondriacism, apoplexy, or diseases of the brain, kidneys, spleen, stomach and intestines, bladder and its appendages, diarrhoea, dysentery, etc. *The highest cash price will be paid as above.*

The advertiser is a medical school instructor looking for specimens to dissect: "They keep them on hand, and when they need one they bleed him to death."

HOWEVER OFFENSIVE to those sensible individuals for whom mere lightness of skin and Caucasian features don't signify a special destiny, whether blessed or doomed, the "tragic" mulatta/mulatto has been irresistible as symbol; the archetype most closely resembles the childlike thinking of fairy tale and myth than the common-sense subtleties of realistic literature. (We know we're in the land of myth when heroines are the "fairest" in the land and there are no plain, unspectacular protagonists.) Though far more realistic than William Wells Brown's *Clotel*, Nella Larsen's *Passing* (1929) also ends with the falling-death of its mulatta figure, the blond, white-skinned and spectacularly beautiful Clare Kendry. Where Clotel is a romantic figure, however, Clare Kendry is a complex, convincing woman capable of "passing" in the white, moneyed world (she's married to a white racist, in fact) yet at ease only in the Negro world she has left behind. It's Clare's loneliness for this world that will destroy her: "You can't know how in this pale life of mine I am all the time seeing the bright pictures of that other I once thought I was glad to be free of . . ." *Passing* is a meticulously composed work in which a self-revealing narrator (herself light-skinned enough to "pass" but remaining in the Negro world) obsesses upon Clare Kendry's "incredibly beautiful face," her "ivory" complexion, and "softly chiselled features"; her "pale gold hair" and "magnificent dark, sometimes absolutely black, always luminous" eyes and the "absolute loveliness" of her being. Yet Clare is more than these superficial attributes, and will die an ambiguous death: a mulatta-sacrifice, but not a self-sacrifice. *Passing* is a shrewdly conceived and flawlessly executed novella that raises questions not only of racial identity in a realistically rendered middle- and upper-middle-class Negro society (in Harlem and Chicago, 1927) but of the murderous rage one woman might feel for another who has "passed" beyond her.

The most notable of "tragic mulatto" figures of twentieth-century American literature is Faulkner's Joe Christmas of the dithyrambic *Light in August* (1932) with his heavily symbolic name and ominous

"parchment-colored skin." Unlike Clotel and Clare Kendry, constrained by their sex, Joe Christmas is a man driven by "the courage of flagged and spurred despair" to commit an irrevocable act of violence. Of "mixed" parentage, Joe Christmas is obsessed with defining himself in terms of race. Living with a woman who resembles an "ebony carving," he wills himself to become black:

> He would do it deliberately, feeling, even watching, his white chest arch deeper and deeper within his ribcage, trying to breathe into himself the dark odor, the dark and inscrutable thinking and being of Negroes, with each suspiration trying to expel from himself the white blood and the white thinking and being. And all the while his nostrils at the odor which he was trying to make his own would whiten and tauten, his whole being writhe and strain with physical outrage and spiritual denial.

In time, Joe Christmas enacts an obscene ritual of denial: the virtual decapitation of his lover, the spinster Johanna Burden, a daughter of northern abolitionists. (Joe Christmas's sexual appropriation of Miss Burden, and his murder of her, might be read as a demonic parody of the desire of the American South to take revenge upon northern reformers by way of the very beneficiaries of this reform, the disenfranchised southern Negro.) At the novel's orgiastic conclusion, Joe Christmas is hunted down by a posse headed by the rabid white racist Percy Grimm, who castrates him ("Now you'll let white women alone, even in hell"). The confused nature of Joe Christmas's identity is presented as crude allegory by Faulkner's spokesman Gavin Stevens:

> . . . The black blood drove [Christmas] first to the Negro cabin. And then the white blood drove him out of there, as it was the black blood which snatched up the pistol and the white blood which would not let him fire it. And it was the white blood which sent him to the minister . . . Then I believe that the white blood deserted him for the moment. Just a second, a flicker, allowing the black to rise in its final moment and make him turn upon that on which he had postulated his hope of salvation. It was the black blood which swept him by his own desire beyond the aid of any man . . . And then the black blood failed him again, as it must have in crises all his life.

This certainly makes for painful reading, a doggedly literal Faulknerian prose indistinguishable from self-parody. Perhaps the very attempt to speak in such metaphorical terms of "blood"—"race"—is doomed, no matter the writer's genius and the ferocity of his vision. Only through the thoughtful depiction of characters in recognizably "real" worlds, with a respect for the myriad possibilities of the individual (in contrast to the allegorical), can the novelist hope to express anything like the complexities and ambiguities, ever-shifting and rarely predictable, of what we presume to call "life" but which is, in fact, a socially determined phenomenon. And when we attempt to enter the nineteenth century, we must learn to decode its language to discern what truths, bitter or enlightening, may be hidden within it.

Ernest Hemingway

I always try to write on the principle of the iceberg. There is seven-eighths of it under water for every part that shows.

—*Ernest Hemingway*

Of the great twentieth-century Modernist writers, a distinguished though heterogeneous group including James Joyce, Virginia Woolf, D. H. Lawrence and William Faulkner, only Ernest Hemingway achieved an early and sustained popular success in addition to widespread critical acclaim; and only Hemingway achieved an international celebrity (verging at times upon notoriety) at considerable odds with his private writerly self. Though as devoted to the craft of fiction as his predecessors Gustave Flaubert and Joseph Conrad and his contemporaries Joyce and Woolf, Hemingway exploited and was exploited by the media to an extraordinary degree from the late 1940s until his premature death in 1961, at the age of sixty-two, of self-inflicted gunshot wounds. The cult of "Papa" Hemingway has tended to overshadow Hemingway's accomplishment, as his suicide after years of alcoholic depression and decline has tended to overshadow the remarkable energy and imagination of his life-in-art. If, along with D. H. Lawrence, Hemingway has become a highly controversial figure among the Modernists, his reputation having declined since the 1960s, it must be acknowledged that Hemingway created a masterly, much-imitated prose style that combines the sharpness of poetic observation with the

seemingly relaxed, colloquial rhythms of natural speech. In his language as well as in his characteristic subject matter, Hemingway is a descendant of Mark Twain, Stephen Crane, Jack London, and Sherwood Anderson. Yet his is the "art that conceals art," an assiduously cultivated prose ideally suited to his great themes: what is courage? what is honor? what is morality? what does it mean to be a "man"? what, if anything, does the individual owe to society? and what is the mysterious and elusive conjunction of the natural, external world of fact and the subjective, internal world of human emotion and desire? In Hemingway's essentially frontier cosmology, man is both "nature" and above nature; morality is not socially generated but arises from the relationship of the individual to his fate.

This is the quintessential "masculine" perspective: an aggressively non-domestic, self-determined identity that admits of no allegiance beyond the immediate and existential. In Lieutenant Frederick Henry's famous words,

> I was always embarrassed by the words sacred, glorious, and sacrifice and the expression in vain. We had heard them, sometimes standing in the rain almost out of earshot, so that only the shouted words came through, and had read them, on proclamations that were slapped up by billposters over other proclamations, now for a long time, and I had seen nothing sacred, and the things that were glorious had no glory and the sacrifices were like the stockyards at Chicago if nothing was done with the meat except to bury it. There were many words that you could not stand to hear and finally only the names of places had dignity . . . Abstract words such as glory, honor, courage, or hallow were obscene beside the concrete names of villages, the numbers of roads, the names of rivers . . .
>
> [*A Farewell to Arms*]

Henry is an American volunteer in the Italian army in 1915, a young officer soon to negotiate a "separate" peace by retreating in disgust from the chaos and purposelessness of the war. Like most of Hemingway's protagonists, Lieutenant Henry reacts instinctively, not intellectually: "I never think and yet when I begin to talk I say the things I have found out in my mind without thinking." There is a directness and a

simplicity in such a perspective that aligns the Hemingway hero with the world not of men but of nature; a primary, primitive, and often harshly beautiful objective world. The young Nick Adams of Hemingway's first book of fiction, the thematically linked tales of *In Our Time* (1925), is such a protagonist, a version of the older, more experienced, and yet idealistic Robert Jordan of *For Whom the Bell Tolls,* who will sacrifice his life for the cause of the peasants in the Spanish Civil War out of a passionate love for Spain. (Though Jordan has no illusions, like his creator, about the integrity of the Communists who supported the peasant cause for their own political purposes.) Differing considerably from these youthful Americans, at least superficially, the elderly Cuban fisherman Santiago is revealed as a spiritual kinsman, a more purified form of the Hemingway hero; in unsophisticated, childlike speech he addresses the power and beauty of *la mar* even as he acknowledges its danger:

> He looked across the sea and knew how alone he was now. But he could see the prisms in the deep dark water and the line stretching ahead and the strange undulation of the calm. The clouds were building up now for the trade wind and he looked ahead and saw a flight of wild ducks etching themselves against the sky over the water, then blurring, then etching again and he knew no man was ever alone on the sea. [*The Old Man and the Sea*]

In this late, beautifully spare parable, Hemingway brings together the predominant themes of his fiction: the old man is clearly an archetypal being, a vision of Hemingway himself in isolated old age, devoted to his craft and willing to be defeated in pursuit of it, yet not inwardly destroyed. Through his intimate relationship with *la mar,* Santiago is ennobled even as he physically suffers. Here as elsewhere in his fiction Hemingway suggests the mutual (unless merely anthropomorphic) respect between hunter and hunted, fisherman and fish. Santiago is contemptuous of the ugly scavenger-sharks that devour his catch but rapt with an almost mystical awe for the fifteen-hundred-pound marlin whose eye "looked as detached as the mirrors in a periscope or as a saint in a procession." *The Old Man and the Sea* fuses the mythic and the "natural" in the very poetry of realism.

Awarded the Nobel Prize for Literature in 1954, at the age of fifty-five, Ernest Hemingway remains the most popular literary writer in English of the twentieth century.

BORN IN 1899, in the middle-class suburban town of Oak Park, Illinois, Hemingway would come of age with the new, turbulent, uncharted century. Ezra Pound's famous adage "Make it new!" might have been Hemingway's. Unlike James Joyce, whose obsession was to memorialize his hometown Dublin in increasingly ambitious works of prose fiction, and unlike William Faulkner, who remained in his hometown Oxford, Mississippi, for most of his life with the intention of cultivating his small "postage stamp" of the earth in the saga of Yoknapatawpha County, Ernest Hemingway was determined at an early age not only to leave his comfortable home in Middle America but to re-invent himself as a heroic man of action, an expatriated American with no allegiance to Victorian values. Of his many books only his first, *In Our Time,* published when Hemingway was only twenty-six, is set primarily in the United States, in northern Michigan (where the Hemingway family spent summers); the others are set in vividly observed foreign places: France, Spain, Italy, Africa. The very titles of Hemingway's works of fiction suggest exotic and poetic locales: *Green Hills of Africa, Death in the Afternoon,* "The Snows of Kilimanjaro," "Hills Like White Elephants," *Islands in the Stream, Fifth Column and Four Stories of the Spanish Civil War,* "On the Quai at Smyrna," "An Alpine Idyll," *Garden of Eden, Across the River and into the Trees.* Apart from the mythic Santiago, Hemingway's heroes are American travelers, but never tourists; like the rootless and expatriated Americans of the fiction of Hemingway's younger contemporary Paul Bowles, they belong to a disillusioned, alcohol-prone post–World War I generation to whom Gertrude Stein allegedly alluded in her famous remark, "You are all a lost generation." (Hemingway seriously considered calling his first novel *The Lost Generation.*) Nowhere in his fiction does Hemingway dwell upon family relationships of the kind that constitute the subject matter of many, even most novels. His self-invention of an essentially solitary individual would be modified to some extent in his efforts, in the 1930s, to make an impression on Communist and left-wing commentators, but fiction slanted to this end like *To Have and Have Not* (in which the

smuggler-murderer-"hero" Harry Morgan mutters, dying, "A man alone ain't got no bloody fucking chance") is not among Hemingway's most convincing or memorable.

Hemingway was one of six children born to a physician who enjoyed hunting and fishing and a strong-willed, active woman from whom he would become estranged in young adulthood and whom he would blame, with increasing bitterness, for his father's death by suicide when Hemingway was twenty-nine. (According to his biographer Kenneth S. Lynn, as an adolescent Hemingway boasted to a friend of how, watching his father working outdoors, he would sit with a loaded shotgun beside him and occasionally draw a bead on his father's head. When Dr. Hemingway killed himself with a Civil War revolver inherited from his own father, Hemingway asked his mother for the revolver—and his mother sent it to him. Decades later, Hemingway would kill himself with a gun; in 1982, his brother Leicester would kill himself with a gun. The macho-mystique of firearms has its roots, one must surmise, in unconscious wishes for self-destruction, self-punishment.) Allusions to the strong, pseudo-masculine and consequently "castrating" female abound in Hemingway's fiction, springing from his seemingly pathological hatred of his mother; in *For Whom the Bell Tolls,* we learn little of the hero Robert Jordan's background except that he's from Montana, and that his father had killed himself with his grandfather's pistol, which Robert threw into a mountain lake. (In this beautifully written memory-passage, a friend says to Robert Jordan, "I know why you did that with the old gun," and Robert replies, "Well, then we don't have to talk about it.") Jordan thinks: "He understood his father and he forgave him everything and he pitied him but he was ashamed of him."

Tension in the Hemingway household may have precipitated Hemingway's desire to leave home after high school as well as to re-invent himself as a man very different from his seemingly conventional parents. Not yet twenty, Hemingway took a reporting job on the *Kansas City Star* and, in 1917, joined the war effort as an ambulance driver. Within a few weeks he was wounded with shrapnel, and during his six-month hospitalization in Milan he fell in love with an American nurse whom he wanted to marry, and whom he would memorialize in the terse, cynical two-page "A Very Short Story"—an early example of the emotionally powerful minimalist prose that would become Hemingway's signature and an excellent example of what Hemingway meant when he spoke of

"writing on the principle of the iceberg." In 1920, at the young age of twenty-one Hemingway married and went with his wife Hadley, several years his senior, to live in Paris and to devote himself to writing. There, as Hemingway would write in his controversial memoir *A Moveable Feast* (posthumously published, 1964), he came to know a wide and varied circle of literary figures including his countrymen Sherwood Anderson, Ezra Pound, Gertrude Stein, and F. Scott Fitzgerald who would figure in Hemingway's life as a brother/rival for decades. ("Ernest speaks with the authority of success," Fitzgerald would say, matter-of-factly. "I speak with the authority of failure.") With the publication of *In Our Time* in the United States in 1925, Hemingway acquired a reputation as an important, gifted younger writer with a mordant post-War vision; with the publication of *The Sun Also Rises* in 1926, he became famous virtually overnight and would long be associated with a gathering of expatriated Americans for whom he felt a good deal of contempt. *The Sun Also Rises,* narrated by the laconic, ironic Jake Barnes (whose war wound has made him sexually impotent), was both a bestseller and something of a cult novel taken up by younger, disaffected Americans in the way that Paul Bowles's yet more mordant and nihilistic *The Sheltering Sky* was greeted at the time of its publication in 1949.

The Sun Also Rises is quintessential Hemingway: minimalist prose, elliptical dialogue, an ironic and detached tone. Though Hemingway would express dissatisfaction with the novel that made him a literary sensation ("I tried to give the destruction of character in the woman Brett—that was the main story and I failed to do it—I wouldn't have published it except that was the only way I could get it behind me") the novel met with widespread and generally positive critical attention. Considered more than seven decades later, *The Sun Also Rises* seems less original than it did in 1926; the disillusioned coming-of-age of young people who have rejected their parents' lives to live abroad, prone to alcoholism and sexual promiscuity and a ceaseless search for "sensation," is a variant of the genre to which F. Scott Fitzgerald's equally successful first novel *This Side of Paradise* (1920) belongs. At the novel's sentimental core is the quasi-love affair between Jake (the impotent male) and Lady Brett (the nymphomaniac female). Hemingway contrasts the shallowness of the American and British expatriates with the lives of Spanish peasants, extolling the more "primitive" over the sophisticated and decadent. The pure man of action is the young bullfighter Romero who

kills his bull with ritualistic precision. Romero is one of Brett's sexual conquests, but in a rare act of decency she decides to give him up. She confesses to Jake that she's thirty-four; Romero is only nineteen. "You know it makes one feel rather good deciding not to be a bitch . . . It's sort of what we have instead of God." The novel ends with Brett and Jake in a taxi, and in the background a cinematic, phallic flourish:

> "Oh, Jake," Brett said, "we could have had such a damned good time together."
> Ahead was a mounted policeman in khaki directing traffic. He raised his baton. The car slowed suddenly pressing Brett against me.
> "Yes," I said. "Isn't it pretty to think so?"

Hemingway's second novel, the more accomplished and considerably more moving *A Farewell to Arms* (1929), is set in Italy during World War I and is the tragic love story of Frederick Henry and the British nurse Catherine Barkley. Catherine is a beautiful, extremely feminine and self-abnegating woman, the very antithesis of the promiscuous Brett; she has been traumatized by the loss of a fiancé, yet falls quickly in love with Henry and tells him repeatedly that there is "no me, only you" and that her fantasy is to cut her long hair short so that she would resemble her lover:

> ". . . Then we'd be both alike. Oh, darling, I want you so much I want to be you too."
> "You are. We're the same one."
> "I know it. At night we are."
> "The nights are grand."
> "I want us to be all mixed up. I don't want you to go away . . . Why, darling, I don't live at all when I'm not with you."

Catherine's beauty is described in vague, generic terms; we fail to "see" her as a woman independent of male fantasy, and for this reason Hemingway has been severely criticized by feminists. It is true that Catherine, like the even childlike and self-abnegating Maria of *For Whom the Bell Tolls*, is not a very convincing character set beside male characters like Henry, Rinaldi, and Count Greffi, but Catherine's extreme insecurity may be attributed to her earlier loss of a fiancé. The fantasy of male-

female "twins" was lodged deep in Hemingway's imagination. According to biographer Kenneth S. Lynn, Hemingway's mother had often expressed a curious wish to have had twins, and dressed Hemingway as a small child in girl's clothing, so that he was a "twin" of his sister Marcelline. Ernest was Mrs. Hemingway's "summer girl." So obsessive was this fantasy on Mrs. Hemingway's part, she held Marcelline back from school so that sister and brother could enter together. Catherine Barkley's wish to be a twin of her lover's is in fact her lover's wish to be a twin of hers, but of course Hemingway wouldn't have characterized the very masculine, heroic Lieutenant Henry in such a way, just as Hemingway would not have wished to qualify his protagonist's independence by having him become a father and marry Catherine. *A Farewell to Arms,* as its title suggests, cannot end happily for the woman bearing Henry's baby. The most powerful sections of *A Farewell to Arms* depict the natural world, and these contain passages of surpassing beauty and understated drama; among these are the suspenseful chapter in which Henry and Catherine flee (by rowboat) across a northern lake into Switzerland, and neutral territory; and scenes of war and army movements like the novel's famous, much-quoted opening:

> In the late summer of that year we lived in a house in a village that looked across the river and the plain to the mountains. In the bed of the river there were pebbles and boulders, dry and white in the sun, and the water was clear and swiftly moving and blue in the channels. Troops went by the house and down the road and the dust they raised powdered the leaves of the trees. The trunks of the trees too were dusty and the leaves fell early that year and we saw the troops marching along the road and the dust rising and leaves, stirred by the breeze, falling and the soldiers marching and afterward the road bare and white except for the leaves.

Much-quoted, too, are Henry's reflections upon the mysterious world-order (society? parents? God?) that threatens individuals in love as Henry and Catherine are:

> If people bring so much courage to this world the world has to kill them to break them, so of course it kills them. The world breaks every one and afterward many are strong at the broken places. But

those that will not break it kills. It kills the very good and the very gentle and the very brave impartially. If you are none of these you can be sure it will kill you too but there will be no special hurry.

Such maudlin but heartfelt sentiments have much to do with Hemingway's commercial success and enduring popularity.

TO HAVE AND HAVE NOT (1937) is a curiosity amid Hemingway's generally well-crafted fiction, though it continues, in a caricatured way, his obsession with masculinity and manhood. Described as a novel by Hemingway's publisher Scribner's, it actually consists of three independently written short stories somewhat arbitrarily and awkwardly fused together. The first and most engaging (originally titled "One Trip Across") is about Harry Morgan, a Havana fishing guide who becomes desperate to support his family and must resort to running contraband between Key West and Cuba in the 1930s. Harry Morgan is a simple character as Hemingway presents him, lacking the subtlety and psychological interest of other Hemingway heroes. He is, in a sense, a caricature of Hemingway's masculine ideal: physically commanding, near-inarticulate, casually racist and capable of murder with his bare hands ("I got [the Chink] forward onto his knees and had both thumbs well in behind his talk-box, and I bent the whole thing back until she cracked. Don't think you can't hear it crack, either"). Morgan is so without conscience, remorse or even memory, he seems literally to have forgotten he has committed murder. (Or is it Hemingway who has forgotten?) Morgan's terse, understated narration is a liability here for he comes quickly to seem merely brainless. Allegedly written with the hope of establishing Hemingway's credentials with the Left, *To Have and Have Not* contains satiric portraits of bewildering crudeness and ill will (Dos Passos, of whom Hemingway was intensely jealous, is reputedly the model for "Gordon"); it was intended as a drama of the victimization of *have-nots* (like Harry Morgan) by *haves* (contemptible rich tourists and government agents). Though generally conceded to be Hemingway's weakest novel, yet its opening pages contain superb descriptions of seafaring and marlin fishing, foreshadowing the more controlled and mythic narrative of *The Old Man and the Sea*.

More substantial in conception and execution is *For Whom the Bell*

Tolls (1940), an adventure-love story set in rural Spain at the time of the Civil War. This lengthy, carefully crafted novel moves forward with cinematic swiftness; if the heroic protagonist Robert Jordan doesn't strike us as a very convincing professor of Spanish from a Montana college (yet an expert on blowing up bridges!), he is nonetheless one of Hemingway's more complex characters, so different from hapless Harry Morgan as to belong to another species. Robert Jordan, like his predecessor Frederick Henry, is a volunteer in a foreign army; he has aligned himself with Spanish guerillas in rebellion against the Fascist dictator Franco. Like Lieutenant Henry, Robert Jordan falls in love with a beautiful and extraordinarily compliant girl, here named Maria, who has been raped and humiliated by Fascists, and whose shorn hair endears her to Robert Jordan. The American fantasizes with Maria in his arms:

> ". . . We could go together to the coiffeur's [in Madrid] and they could cut [your hair] neatly on the sides and in the back as they cut mine and that way it would look better in the town while it is growing out."
> "I would look like thee," she said and held him close to her. "And then I never would want to change it."

Another time, the erotic fantasy of "twins"—"doubling." It isn't clear that Robert Jordan really loves Maria until the novel's end when he speaks of wanting to marry her; and acknowledges that they may die in a Fascist attack instead. He thinks, "Maybe I have had all my life in three days."

For Whom the Bell Tolls is Hemingway's most humane and subtly rendered novel. Its portrait of the self-effacing Maria is complemented by the powerful character of Pilar, a female guerilla easily the match of her male comrades, stronger and more outspoken than her weakling husband Pablo. Virtually alone among Hemingway's numerous female characters Pilar defies the female stereotype: she's physically unattractive, yet admirable; she dares to question male authority; she teases and annoys Robert Jordan with her "ugly" talk, yet retains his respect and a modicum of affection. Pilar is the peasant-shrewd, protective, courageous mother wholly lacking the guile and hypocrisy Hemingway attached to middle-class women like his own. She tells her husband "Here I command" in front of witnesses, and the man capitulates. The novel is

stylistically varied to a degree rare in Hemingway, and contains, in addition to numerous descriptive passages in the signature Hemingway style, those clear, forthright, declarative sentences that roll along like artillery, passages rendered in sinuous, complex language ideally suited to suggest psychological ambiguity, as in this scene in which Robert Jordan feels himself threatened by some of his guerilla-peasant comrades, prepared to reach for his gun to protect himself:

> Robert Jordan watching Pablo and as he watched, letting his right hand hang lower and lower, ready if it should be necessary, half hoping it would be (feeling perhaps that were the simplest and easiest yet not wishing to spoil what had gone so well, knowing how quickly all of a family, all of a clan, all of a band, can turn against a stranger in a quarrel, yet thinking what could be done with the hand were the simplest and best and surgically the most sound now that this had happened) saw also the wife of Pablo standing there and watched her blush proudly and soundly and healthily as the allegiances were given.

Derided as sentimental and overblown by Hemingway's detractors, the prose Hemingway employs to render Jordan's and Maria's lovemaking is perhaps more questionable. Here, the writer is at least attempting a richer and vulnerable prose, perhaps in imitation of the rhapsodic erotic flights of D. H. Lawrence in *The Rainbow* and *Lady Chatterley's Lover*. A stark, minimalist prose would simply be inadequate to suggest the emotions of desperate, doomed lovers:

> Then there was the smell of heather crushed and the roughness of the bent stalks under her head and the sun bright on her closed eyes and all his life he would remember the curve of her throat with her head pushed back into the heather roots and her lips that moved smally and by themselves and the fluttering of the lashes on the eyes tight closed against the sun and against everything . . . For him it was a dark passage that led to nowhere, then to nowhere, then again to nowhere . . . always and forever to nowhere, heavy on the elbows in the earth to nowhere, dark, never any end to nowhere, hung on all time always to unknowing nowhere, this time and again for always to nowhere . . . now beyond all bearing up, up, up and into nowhere,

suddenly, scaldingly, holdingly all nowhere gone and time absolutely still and they were both there, time having stopped and he felt the earth move out and away from beneath them.

For Whom the Bell Tolls would become the biggest bestseller in American fiction since *Gone With the Wind,* selling, as Hemingway boasted to an ex-wife, "like frozen Daiquiris in hell." In 1943–44, the Paramount film version starring Gary Cooper and Ingrid Bergman was a box-office "smash."

Through the 1940s and 1950s, however, Hemingway's highly publicized "masculine" life, in particular his continuous drinking and his propensity for accidents, steadily eroded his strength and psychological well-being; he became increasingly depressed and suicidal. The late, elegiac novella *The Old Man and the Sea* (1952) beautifully compresses Hemingway's lifelong themes of individual courage in the confrontation with nature (or death) in a language of poetic directness and simplicity. Santiago, like Harry Morgan, is one of the *have-nots* of the world; yet, unlike Harry Morgan, Santiago is a noble human being. "He was an old man who fished alone in a skiff in the Gulf Stream and he had gone eighty-four days without taking a fish"—so the parable-like tale begins. By the tale's end, Santiago has caught an enormous marlin, only to lose it to sharks; he comes close to extinction, yet prevails; his ordeal exemplifies the human condition—"He tried not to think but only to endure." Hemingway's style is perfectly suited for Santiago:

> You are killing me, fish, the old man thought. But you have a right to. Never have I seen a greater, or more beautiful, or a calmer or more noble thing than you, brother. Come on and kill me. I do not care who.

The Old Man and the Sea is a parable to set beside Herman Melville's similarly late, elegiac *Billy Budd.* Each represents an aging writer's attempt to express his vision of loss and tragic acceptance, and each occupies a significant position in its creator's career as in American literary history.

The Old Man and the Sea, originally printed in *Life* magazine, was widely acclaimed, and awarded the Pulitzer Prize in 1953; the following year, Ernest Hemingway was awarded the Nobel Prize.

Hemingway's death by suicide in 1961, in a beautiful and isolated Ketchum, Idaho, would seem to have brought him full circle: back to the America he had repudiated as a young man, and to the method of suicide his father had chosen, a gun. To know the circumstances of the last years of Hemingway's life, however, his physical and mental suffering, is to wonder that the beleaguered man endured as long as he did. His legacy to literature, apart from the distinct works of art attached to his name, is a pristine and immediately recognizable prose style and a vision of mankind in which life and art are affirmed despite all odds.

"You Are the
We of Me"

Illumination and Night Glare:
The Unfinished Autobiography of
Carson McCullers
Edited and with an introduction by
Carlos L. Dews

The wedding was like a dream outside her
power, or like a show unmanaged by her in
which she was to have no part.
—*Carson McCullers,*
The Member of the Wedding

How to account for the vagaries of literary reputation? In the 1940s and early 1950s, such disparate, talented young writers as Carson McCullers, Truman Capote, and Flannery O'Connor were perceived as kindred; there was a highly publicized vogue of American Southern Gothic writing, abetted by photographs of the campily effeminate Truman Capote reclining on a chaise lounge like a delicious dream of old Oscar Wilde's, and by lurid tales of the erratic, often inebriated behavior of Carson McCullers, a literary prodigy to set beside F. Scott Fitzgerald of an earlier generation. (McCullers, married to a bisexual man, was frequently enamoured of women who some-times, but more often did not, welcomed her effusive advances.) Of the

trio, Flannery O'Connor, who published her first novel *Wise Blood* in 1952, and her first collection of short stories *A Good Man Is Hard to Find* in 1955, to more restrained publicity and book sales, was the most reclusive, preferring to spend her writing life on her family's farm in Milledgeville, Georgia; O'Connor, like McCullers, suffered from chronic poor health and was physically handicapped, but, unlike the adventurous McCullers, O'Connor hoarded her strength and concentrated exclusively on her craft.

During their lifetimes, Carson McCullers and Truman Capote were far more acclaimed and commercially successful than Flannery O'Connor. McCullers's novels were usually bestsellers, including even the last, poorly reviewed novel *Clock Without Hands* (1960), and her stage adaptation of the autobiographical *The Member of the Wedding* (1946) was a critical and commercial success in the 1950s. Capote's first novel *Other Voices, Other Rooms* (1948) and *Breakfast at Tiffany's* (1958) were bestsellers; Capote wrote successfully for Broadway and Hollywood and published, in 1965, his non-fiction crime novel *In Cold Blood,* which brought him commingled praise and notoriety for its seeming exploitation of violent murders in Kansas and of the murderers themselves, whose executions he wrote of. Capote would die an alcoholic, drug-ravaged death at the age of sixty, in 1984, his talent long since exhausted; McCullers died much earlier, at fifty, in 1967, after fifteen years of severe ill health; O'Connor died most prematurely at the age of thirty-nine, of a rare, incurable disease, lupus, in 1964, leaving behind a small but distinguished body of books. O'Connor, a writer's writer, had no single bestseller, but her starkly ironic, parable-like stories were perennial favorites in the influential *Best American Short Stories* and *O. Henry Awards* yearly anthologies.

If American Southern Gothic survives as a literary mode, it's only as parody. The reputations of Carson McCullers and Truman Capote have severely diminished even as the reputation of Flannery O'Connor has steadily risen. McCullers may be perceived in some quarters as a writer of young adult classics whose work has not transcended its era; Capote is little read except for his atypical *In Cold Blood,* which was the inspiration for more complex and ambitious non-fiction novels by Norman Mailer (*The Executioner's Song*) and Don DeLillo (*Libra*). In the massive, magisterial *The Best American Short Stories of the Twentieth Century* edited by John Updike, Flannery O'Connor is included with one of

her much-anthologized stories, "Greenleaf," while McCullers and Capote are not only absent, but their absences have gone unremarked by reviewers. Fifty years ago, such a state of affairs would have been greeted in literary circles with astonished disbelief.

YET CARSON McCullers is the author of a number of works of fiction that compare favorably with the best stories of Flannery O'Connor, and her finest novel, *The Member of the Wedding,* is an exquisitely rendered, genuinely haunting work of art that surpasses, in its humanity and poetry of language, anything O'Connor has written. McCullers's portraits of lonely, eccentric, sexually ambiguous men and women achieve a mythopoetic power largely lacking in the two-dimensional portraits of "grotesque" Southerners who populate O'Connor's backwoods Georgia fiction; McCullers's gift was to evoke, through an accumulation of images and musically repeated phrases, the singularity of experience, not to pass judgment upon it. Where Flannery O'Connor's characters are actors in an ideologically charged theological drama (O'Connor was a fiercely polemical Roman Catholic), tending toward allegory (or caricature), McCullers's characters are like us: human, hapless, hopeful, "real."

In *Illumination and Night Glare,* McCullers's posthumously published "autobiography," dictated to a secretary in the final months of the author's tragically foreshortened life, McCullers's intention is stated:

> I think it is important for future generations . . . to know why I did certain things, but it is also important for myself. I became an established literary figure overnight, and I was much too young to understand what happened to me or the responsibility it entailed. I was a bit of a holy terror. That, combined with all my illnesses, nearly destroyed me. Perhaps if I trace and preserve for future generations the effect this success had on me it will prepare future artists to accept it better. [Introduction]

With the 1940 publication of the much-acclaimed *The Heart Is a Lonely Hunter,* McCullers was indeed an overnight literary figure who was not only young, but looked much younger: at age twenty-three, she bore a distinct resemblance to the novel's epicene Mick Kelly, a "gangling, towheaded youngster, a girl of about twelve." Yet McCullers was even more

of a prodigy than most people knew, for she'd published her first story, appropriately titled "Wunderkind," written when she was seventeen, in the distinguished American literary magazine *Story* (December 1936). ("Wunderkind" is a subtle, sensitively imagined story of a "wunderkind" girl pianist who comes to the realization, painful both to her and her piano teacher, and to the reader as well, that her early genius for the piano is fading in adolescence. The story bears a peripheral resemblance to Katherine Mansfield's more poetically, deftly rendered "The Wind Blows," but it's an excellent story in its own right, the more remarkable for having been written by a seventeen-year-old. *Story* also bought another early work of McCullers's, "Like That," but had second thoughts about publishing it because it dealt, however obliquely and tastefully, with a young girl's first menstruation and her first sexual experience, subjects that *Story*'s male editor thought were too extreme for his readers in the late 1930s.)

The Heart Is a Lonely Hunter begins with a mature storytelling ease that suggests parable: "In the town there were two mutes, and they were always together." The deaf-mute whom we come to know is named John Singer, a jeweler's assistant who possesses a mysterious, indefinable charisma; in Singer's "eternal silence" others find comfort as they tell him their stories, eliciting from Singer an always sympathetic if minimal response, sometimes in writing. (Singer can read lips.) Only the reader understands that Singer has a secret of his own: he's hopelessly, one might say quixotically in love with his companion deaf-mute, Antonapoulos, an obese, seemingly retarded man with few redeeming virtues. When Antonapoulos dies of Bright's disease, Singer is bereft and commits suicide, to the astonishment of the five townspeople, among them the troubled adolescent Mick Kelly, who have idolized him as a superior, Christ-like human being. This debut novel is perhaps uneven in execution, and the character of Mick Kelly is an early, sketchier version of Frankie Addams (of *The Member of the Wedding*), but it remains a powerful and original work of fiction, especially daring in its graphic depiction of white racist cruelty against Negroes, and in its portrait of a Negro doctor who urges his fellows to "throw off the yoke of submission and slothfulness" and assert their rights as human beings. In rural Georgia, in the late 1930s? It's no wonder that McCullers's fellow Georgians, among them the Ku Klux Klan, didn't take kindly to the young woman author's iconoclastic vision.

"Even as a grown woman I was haunted always by homesickness," McCullers says in *Illumination and Night Glare,* and it's clear in *The Heart Is a Lonely Hunter* that the young author was entranced as much by place, and the ineffable "soul" of place, as by her characters. If the entrancement had been simple nostalgia, the results would have been sentimental; in fact, McCullers was as much revulsed by her Southern hometown, Columbus, Georgia, as she was enthralled by it. For the artist, commingled love-hate is the true generative impulse.

McCullers's second novel, *Reflections in a Golden Eye* (1941), was, unsurprisingly, less enthusiastically received than her first. Indeed, *Reflections* is a less accomplished novel, in a quite different tone, more clearly a tall tale of the grotesque, or the frankly freakish. Inspired by an anecdote McCullers had heard of a voyeur at a local Army post, *Reflections* scandalized Georgians and incurred the wrath of the Ku Klux Klan, those American watchguards of morality; McCullers was given police protection after having received a threatening telephone call: "[We] are the Ku Klux Klan and we don't like nigger lovers or fairies. Tonight will be your night." [*Illumination.*] Considering the violent, racist atmosphere of the American South well into the 1960s, when lynchings of Negroes were not uncommon and virtually never punished, it's remarkable that McCullers and her family escaped physical injury. (Even with much of the world watching by way of the media, the young black civil rights demonstrator Medger Evers was shot in the back in Jackson, Mississippi, in the spring of 1963, and his killer, though probably known to local authorities, was never named.)

McCullers would suffer her first stroke at the young age of twenty-nine. Though she would continue to write, and sometimes to write very well after this, the zenith of her career was the years 1942–1946, when she wrote the *The Ballad of the Sad Café* (1943) and *The Member of the Wedding* (1946). These works of fiction, set in Georgia, confirmed her early promise and established McCullers as perhaps the premier writer of her generation. (*Clock Without Hands,* labored on intermittently, often in a sickbed, for twenty years, wasn't published until 1960.)

McCullers admired the Gothic tales of Isak Dinesen, whom she would eventually meet, and the imperial, somewhat arch style of Dinesen seems to have been an influence on *The Ballad of the Sad Café.* This parable-novella is an acquired taste, defiantly risky and weird; the story of a love triangle composed of the cross-eyed, Amazonian Miss Amelia,

the well-to-do proprietress of a café in a small Georgia mill town, and the hunchback dwarf Lymon whom Miss Amelia uncritically adores, and Miss Amelia's ex-husband, a violent ex-convict named Marvin Macy who is adored by Lymon. To paraphase the novella without making it sound like a parody of Southern Gothic is a challenge, but there are luminous passages that transcend the melodramatic plot:

> . . . Love is a joint experience between the two persons—but the fact that it is a joint experience does not mean that it is a similar experience to the two people involved. There are the lover and the beloved, but these two come from different countries. Often the beloved is only a stimulus for all the stored-up love which has lain quiet within the lover for a long time hitherto. And somehow every lover knows this. He feels in his soul that his love is a solitary thing.

The once proud Miss Amelia comes to a sorry end, publicly humiliated by her beloved Lymon and her cast-off husband Marvin Marcy; the "sad café" is shut down forever. Love, McCullers seems to be suggesting, is a hurtful, freakish experience, in mythic-rural Georgia at least.

By contrast, *The Member of the Wedding* is a wholly realistic work, beautifully composed and nuanced; as original and haunting as any work by Eudora Welty, Katherine Anne Porter, Virginia Woolf. According to McCullers's biographer Virginia Spencer Carr, McCullers wrote no less than seven drafts of *The Member of the Wedding*. Yet there is nothing artificial or over-polished about its fluid, poetic style or its brilliantly compressed drama. This heartrending tale of adolescent isolation—of twelve-year-old Frankie Addams's infatuation with, and inevitable expulsion from, her brother's wedding is that rare work of the imagination, the rendering of experience so convincing that we may come to think it has been our own. Sometimes we inhabit Frankie, in her head that's teeming with thoughts and impressions; often we float above Frankie, amused by her and alarmed in turn, and understanding the disillusion to come.

> . . . She hastened after [the married couple] with her own suitcase. The rest was like some nightmare show in which a wild girl in the audience breaks onto the stage to take upon herself an unplanned part that was never written or meant to be. You are the we of me,

her heart was saying, but she could only say aloud, "Take me!" And they pleaded and begged her, but she was already in the car. At last she clung to the steering wheel until her father and somebody else had hauled and dragged her from the car, and even then she could only cry in the dust of the empty road: "Take me! Take me!" But there was only the wedding company to hear, for the bride and her brother had driven away.

Small in scope, intense as Frankie Addams's fevered imagination, *The Member of the Wedding* is magical in effect, a true American classic. Its mixture of comedy, pathos, and tragedy (for there is a shock of an ending, beyond Frankie's personal humiliation) is rendered with such seeming effortlessness, one might be inclined to call it "artless." Perhaps, in art, there is no higher praise.

ILLUMINATION AND NIGHT GLARE was a 128-page typescript found among McCullers's papers at the University of Texas at Austin, never before published. Though described as an "autobiography" it is rather more of an informal, truly artless memoir organized by the principle of association of ideas, not by chronology or theme; it's touching, conversational, inevitably disjointed. For some time before McCullers's death in September 1967, the stroke-debilitated author had been dictating random memories to a secretary, and the present book, compiled by Carlos L. Dews of the University of West Florida, is all that she completed before a massive brain hemorrhage left her comatose for forty-seven days. The sketchy memoir comes to not quite eighty printed pages and has been filled out, to use a neutral expression, by material of dubious worth: dozens of letters from McCullers's husband Reeves to McCullers and a detailed outline of "The Mute" (the working title of *The Heart Is a Lonely Hunter* which had been submitted by the twenty-two-year-old McCullers to a publisher). Though the "autobiography" recapitulates, in radically distilled, censored form, the events of McCullers's life traced in pitiless detail by Virginia Spencer Carr in *The Lonely Hunter: A Biography of Carson McCullers* (1975), there are frequent passages of interest, and one can see why an editor would want to present the attenuated manuscript for publication, for it is all that remains of the not very prolific McCullers's unpublished work.

▼

Carson McCullers was born Lula Carson Smith in Columbus, Georgia, in 1917; she would marry at the age of nineteen, divorce, and some turbulent years later remarry, the charming, handsome, emotionally unstable, and fatally alcoholic bisexual Reeves McCullers, who was to commit suicide in 1953, having failed to coerce McCullers into committing suicide with him. According to her biographer Carr, though it's scarcely mentioned in *Illumination,* Carson McCullers was herself a chronic alcoholic from her early twenties onward; even after her strokes, she continued to drink heavily and to chain-smoke, so that her "premature" death was certainly self-hastened. McCullers speaks circumspectly of her attachments to other women, which Carr elaborates upon in sometimes serio-comic detail (McCullers pursued the attractive, then-famous Katherine Anne Porter so obsessively that Porter was once forced to step over McCullers's supine body in a doorway, at the writers' colony in Yaddo, New York); she says very little about her complicity in her disastrous marriage, while Carr traces the couple's unhappy history in excruciating detail.

The self-portrait of *Illumination* is fuzzy and vague as if a light were being shown, not on the subject's face, but into the viewer's eyes; the portrait of McCullers in the biography is both appealing and unflattering. This is Frankie Addams as a psychic vampire, a perennial waif who exploited the kindness of friends and admirers until in some cases she bled them dry. What a steely, self-absorbed will in Carson McCullers, even when she was so severely debilitated by strokes she was confined to a wheelchair. Yet as both the Carr biography and *Illumination* record, McCullers enjoyed a diverse assortment of friends and admirers over the course of her turbulent lifetime, among them her most all-forgiving friend Tennessee Williams, a fellow Southerner, "lonely hunter," and drinker; W. H. Auden, Edith Sitwell, Henry Miller, Janet Flanner; Richard Wright, who praised McCullers for her complex, realistic portraits of Negroes; the American composer David Diamond who had a triangular love affair with McCullers and Reeves that ended unhappily for all; the distinguished film director John Huston, who directed the film version of *Reflections in a Golden Eye;* and the younger playwright Edward Albee who adapted, with limited success, *The Ballad of the Sad Café* for the stage.

"Illumination" is McCullers's term for epiphany, inspiration, insight; "night glare" her term for her illnesses, bad luck, and the loss of inspira-

tion: "the soul is flattened out, and one does not even dare to hope. At times like this I've tried praying but even prayers do not seem to help me . . . I want to be able to write whether in sickness or in health, for indeed, my health depends almost completely upon my writing." One feels that McCullers is telling the truth in such passages, as she saw it; yet how to reconcile her devotion to her art with her reckless disregard for her health? As F. Scott Fitzgerald said of himself, McCullers would seem to have been a "poor custodian" of her own talent. To friends, lovers, admirers and strangers such self-destructive individuals present the very face of mystery: how can genius so rare so squander itself?

The fragmentary and only intermittently inspired *Illumination and Night Glare* doesn't consider such questions, for its vision of Carson McCullers is nostalgic, highly subjective, and uncritical; and indeed it would be unfair to expect a more rigorous self-examination by a woman so severely afflicted. But if this memoir leads a new generation of readers back to McCullers's outstanding work, it will have more than justified its publication.

Remembering
Robert Lowell

For many of us, and surely among
these many women, Robert Lowell figured somewhat less profoundly in
our imaginative lives than his younger contemporaries Anne Sexton and
Sylvia Plath. I don't need to enumerate the obvious reasons for this pref-
erence, though none of us could quite have anticipated how tri-
umphantly Plath continues to soar, in a sense, her once-fragile
wind-buffeted kite now risen very high indeed, while Anne Sexton would
seem to have retreated, to a degree, and Robert Lowell, like his poet-
friend John Berryman, is most revered by middle-aged and older readers
of poetry, and relatively ignored by younger poets.

There are socio-political reasons for this, of course. Reputations wax
and wane, and what may be lost in one decade may be excitedly found in
the next. Rarely do these fluctuations in literary reputation have much to
do with aesthetic values.

Through the years of Robert Lowell's often astonishing productivity, I
was an avid reader of his work. I had not seen how Allen Ginsberg's
"Howl" might have anticipated the more formally restrained "Life Stud-
ies"; I was not an early admirer of Ginsberg, nor am I much of an ad-
mirer of the Beats, as they are called, at the present time. Lowell had
found a way of writing of oneself as if—almost!—one were a specimen,
an isolated being. (But perhaps you had to be a Lowell, and of that tra-
dition, to feel entitled to such solemnity regarding the self.)

It was T. S. Eliot's public conviction that art is a retreat from overt

emotion, and that the personality is dissolved in art; not the personal but the impersonal is art's goal. Lowell would seem to have rejected this straitjacket in the cultivation of a frank, seemingly unfettered voice— "Yet why not say what happened?"

For most virtually all prose writers, especially those who have created a substantial body of work, simply "what happened" is not enough. We must devise ways to attach ourselves emotionally to characters, stories, settings that are not autobiographical; we must seek metaphors, perhaps not entirely consciously, for our lives, which in Lowell's words are "poor passing facts" hardly adequate to stand alone. In Lowell's "Epilogue" (*Day by Day*, 1977), to which I've been alluding here, the poet echoes Yeats in his initial frustration—

> Those blessèd structures, plot and rhyme—
> why are they no help to me now
> I want to make
> something imagined, not recalled?
> I hear the noise of my own voice:
> The painter's vision is not a lens,
> it trembles to caress the light.

Lowell prays for the "grace" of accuracy, alluding to Vermeer. One does think of "grace" in Vermeer, as in much of Lowell, but we have no way of knowing what Vermeer was actually seeing, "painting from," in his renowned interiors. We know what Vermeer has painted, and we know what Robert Lowell has written, but we have no way of knowing what the originals were, or even that they *were*.

So-called confessional poetry, like the most formally constrained poetry, is a matter of language artfully arranged. "What really happened" is never in the poem, only the poet's recollection and calculated rendering of what happened. If Robert Lowell's poetry continues to engage us, it isn't because he revealed himself, and others around him, with such startling intimacy, but because there is the abiding grace of art in his language.

I saw Robert Lowell only once, and may have shaken his hand, at a crowded New York awards ceremony, long ago in the 1970s. I recall that Lowell was tall, attractive, rather feverish-faced, and that he carried himself with an air of ironic dignity. Among the "famous"—the "celebrated"—you will often find this ironic manner, which is perhaps a kind of grace in itself.

"About Whom
Nothing Is Known":
Balthus*

I N 1965, UPON THE OCCASION OF A RET-
rospective of his work at the Tate Gallery in London, Balthus sent a tele-
gram to the art critic John Russell who had requested biographical
information: "Begin this way: Balthus is a painter about whom nothing
is known. Now we may look at his paintings."

Such injunctions have a way of inciting, not dampening, the curiosity
of others, as Balthus would discover. The more withdrawn and inacces-
sible an artist declares himself, the more the world clamors to know
him—"know" in the most intrusive and vulgar of ways; when the artist
is one of the great originals of twentieth-century European painting like
Balthus, this clamoring can spill over into rudeness and exploitation. In
preparing *Balthus* (1996), the artist's son Stanislas Klossowski remarked
that Balthus was disappointed with "virtually everything written about
him, which is all too often characterized by a combination of misunder-
standing and sheer nonsense." In this memoir, Balthus makes the plea
repeatedly that art should be recognized as autonomous, and not bio-
graphically linked: painting is a spiritual act, a kind of prayer ("To paint
is not to represent, but to penetrate, to go to the heart of the secret"); in

*Introduction to *Vanished Splendors: A Memoir by Balthus* (2002).

words very like T. S. Eliot's in "Tradition and the Individual Talent," in which Eliot memorably argued that art isn't an expression of personality but an escape from it, Balthus claims:

> My memory of the century I have lived through and the people I've met remains intact, but it isn't chronological. Rather, it is analogical, with one event and anecdote linked to another, weaving my life's canvas. I've often thought that the best value and finest virtue was in keeping quiet and creating silence. I never interpreted my paintings or sought to understand what they might mean. Anyway, must they necessarily mean something? That's why I so rarely discuss my life, finding it useless to describe it.
>
> Rather than expressing myself, I've busied myself expressing the world through painting. Besides, the moments of my life are drowned in memories of wartime; so many things almost killed me that there is something derisory and aleatory about chronicling one's life in a well-designed way.

There is no reason, in theory, why an artist's work must inevitably be linked to the "private life" that brought it into being. Still less is there any reason to link it with the social and political history of its time. For the artist, the instinct to create art predates the content of his art: the instinct is likely to begin in early childhood, in the sheer playful discharge of energy, devoid of significant content and certainly of "ideas." In time, the artist acquires content, perhaps even "obsession": but these are the raw material of art, shaped, like a sculptor's clay, to the forms of his imagination. That Balthus would seem to have fantasized "Balthus" into being[1] suggests the need of the artist to construct an artist-self by way of which his art comes to be produced. But the biographical, the anecdotal, the literal are only distracting when introduced into art or literary criticism, for the temptation is to trace works of the imagination back to their presumed "origins" in the artist's private life. Does it matter that there were "real" models for Balthus's young girls, and does it matter that Balthus may have had, or had, sexual relations with them? Responding to the sentimental excesses of the Romantic tradition, and the "public ecstasies" accruing to the Brontë sisters, Henry James remarked impatiently: "Literature is an objective, a projected result; it is life that is the unconscious, the agitated, the struggling, floundering cause."

James also remarked, "The artist's life is his work, and that is the place to find him."

THESE ARE propositions that might have been uttered by Balthus himself. For decades, through his long life and increasingly distinguished career, Balthus had the reputation of being the most reclusive and secretive of artists; except for a period in the 1960s when, at the bequest of his friend André Malraux, then French Minister of Culture, Balthus undertook a complete restoration of the Villa Medici, seat of the French Academy in Rome, Balthus preferred to live and work in isolation in remote areas of France and the Swiss Alps. He worked very slowly on his paintings, sometimes taking as long as twelve years to complete a canvas; he refused all requests for interviews, photographs, visits. This memoir dates from Balthus's last years, in Montecalvello, a meticulously restored eighteenth-century chalet near the village of Rossinière, Switzerland, where he lived with his second wife, the Japanese-born artist Setsuko, and their daughter Harumi. (The most remarkable of Balthus's late paintings are the bizarrely surrealist *Grande composition au corbeau*, 1983–86; *Nu couché*, 1983–86; and the intricately structured *Le chat au miroir II*, 1986–89, and *Le chat au miroir III*, 1989–94. *Katia lisant* was painted over a period of eight years, from 1968–76, and the lesser-known, atypical *Japonaise à la table rouge* and *Japonaise au miroir noir* were painted over a period of nine years, from 1967–76.) In this place of beauty and seclusion in the Alps, Balthus immersed himself in his art as a mystic immerses himself in God:

> I always begin a painting with a prayer, a ritual act that gives me a means to get across, to transcend myself. I firmly believe that painting is a way of prayer, a means of access to God.

In this entranced region, the artist enters into a communion of sorts with his great predecessors of the classic past, both European and Far Eastern; certain of Balthus's most haunting canvases look as if they've been unearthed from a lost civilization. Avoiding the specifics of memory in this memoir, which would yield a very different sort of document, Balthus alludes only in passing and in a curious aesthetic context to distressing wartime memories: "I think of the yellow mustard gas that

killed so many men in the trenches during the First World War, and the blue gas that annihilated Jews in the camps." And only intermittently does Balthus respond, with indignation, to the apparently frequent charge against his work that it's obsessively erotic, "pornographic"; that in his recurring fascination with prepubescent, often nude girls, the artist is revealing a private pathology:

> My painting was described as "glaucous" [*glauque*]. What could they have meant by that? . . . Was the word used in its moral meaning, namely perverse, dubious, and steeped in a shady world? Of course, that's the way the adjective was used. Nevertheless, this nonsense about my painting made me smile. I secretly noticed that it wasn't entirely disagreeable to be thought of in this way. The young girls I've sketched and portrayed, including the willfully scandalous "Guitar Lesson," can be seen as revealing compulsively erotomanical behavior. I've always refuted this, seeing them as angelic, heavenly images . . . The adolescent agitation of my young girls' bodies reflects an ambiguous nocturnal light along with a light from heaven.

Which leaves the issue as it should be, *ambiguous*.

A FORMALIST in art, as he was aristocratic and conservative in life, Balthus revered such Italian masters as Masaccio and Piero della Francesca, whom he saw as artists of scrupulous modesty and precision. Nothing seems to have more offended Balthus than the self-conscious, highly engineered (and publicized) art of the Surrealists under the tutelage of André Breton.

> The humility of the early Italian painters constantly compels me to imitate them. Personality cults by contemporary painters infuriate me. One must seek the opposite, fade away more every day, find exactness only in the act of painting, and always forget oneself. Instead, one sees everywhere nothing but self-exhibitionism, personal confessions, intimate avowals, auto-voyeurism, and egoistic declarations. I often say that one mustn't try to explain or express oneself, but rather the world and its darkness and mystery . . . Real modernity is in the reinvention of the past.

In his late seventies, as a result of failing eyesight and health, which made lengthy workdays in his studio more difficult, Balthus began at last to concede to interviews, including even television documentaries; he allowed his photograph to be taken, notably by his friend Henri Cartier-Bresson at Le Grand Chalet in Switzerland; so began the artist's acknowledgment of his place in twentieth-century European art as "Balthus." Two years before his death (in 2001) Balthus began a memoirist project "as told to" his friend Alain Vircondelet, which was published in France in 2001 as *Memoires de Balthus*.

The memoir is purposefully unstructured and impressionistic, a sequence of reveries that are nostalgic and brooding by turns, idealistic, argumentative, mystical. There is no gossip here, and virtually no confessional material. Balthus's first wife and his children are scarcely mentioned. Yet the memoir is laced with autobiographical asides that rivet the attention (how many young artists begin their careers at the age of twelve with the publication of a book of cat drawings—*Mitsou*, 1922—with an introduction by Rainer Maria Rilke, who happened to be Balthus's mother's lover at the time?); it evokes a vanished Europe reminiscent of the pre-Revolutionary Russia eulogized by Nabokov in *Speak, Memory*. Unlike Nabokov, however, Balthus presents himself as appealingly modest: "I have no real life to write about, only scraps of memory which when connected create a woven version of myself. The man and his painting are one, and my only real statement is through painting." And, "Perhaps there really is nothing to say, and all that matters is observing . . . I look at [my paintings] and enter into their mystery."

Like the gentle riddlesome admonitions of a Zen master such statements recur through the memoir yet are misleading, for Balthus does provide us with a sense, however abbreviated, of what it was to have been born (in 1908) into an educated, cosmopolitan Parisian society in the early years of the twentieth century, the son of a Polish-born art historian who counted among his friends such neo-Impressionist painters as Bonnard and the intellectuals Maurice Denis and André Gide. (Unfortunately the Klossowski family lost everything in 1914, as a result of Balthus's father's investing all his savings in Russian railway stock.) As a young man Balthus moved in circles that brought him into contact with Picasso, Derain, Giacometti, Artaud, and Camus; though he died in 1926, when Balthus was only sixteen, Rilke exerted a strong influence on Balthus through his life. (It was Rilke who provided Balthus with a pre-

dominant metaphor for his art: the "crack" in reality that is the way in to mystery, magic; the disorienting sense, in a typical canvas of Balthus, that "anything might happen.")

The memoir is a key to understanding the interior logic of Balthus's enigmatic paintings, symbolically if not literally. (Though Balthus does describe *Le cerisier,* 1940, which depicts an adolescent girl climbing a ladder into a strangely shaped cherry tree, as an emotional, nostalgic re-action to the war—for this reason, perhaps, not one of Balthus's memorable paintings.) We are drawn to see beyond the arresting, dreamlike images of the familiar *La rue* (1929), *La montagne* (1935–37), *André Derain* (1936), *Le salon* (1942) and numerous other studies of adolescent girls in moods of reverie what Balthus presents as an obsessive spiritual interiority given an aesthetic shape through obsessive painterly crafts-manship:

> No one thinks about what painting really is, a skill like that of a la-borer or farmer. It's like making a hole in the ground. A certain physical effort is needed in relation to the goal one sets for oneself. It is a discernment of secrets and illegible, deep, and distant paths that are timeless.

Balthus is vehement in rejecting "ideas" in art, yet there emerges in the memoir a distinctly Balthusian iconography of the idealized (female, prepubescent) human form always depicted in states of freizelike immo-bility, as if captured in the artist's dreaming mind. (See the unsettling *André Derain,* in which the painter's hooded eyes and massive figure in a dressing gown loom in the foreground while, in the background, a child-like, partly unclothed, and seemingly insensible model is seated in a chair. The viewer is led to think that the model has been used, or mis-used, in ways other than for art.)

> During my youth, there was a misunderstanding between critics and those who "made" paintings . . . In the middle of abstract euphoria, I was accused of being a figurative painter because no one could imagine that my painting could have any other purpose than repre-sentation. But I learned this early on by paying attention to ancient art. The great masters of sacred and religious painting in the West are not only figurative . . . They provide a vision beyond, as their

painting displaces the eye, which turns inward, meditating and join-
ing the great spiritual questions.

Balthus's "day-dreaming angels" often gaze into mirrors, he instructs us,
not out of vanity, but in quest of spiritual knowledge; Balthus's strangely
stylized cats, with humanoid/demonic features, prevail in numerous
paintings as expressions of the inhuman and ineffable, not unlike gar-
goyles on cathedrals.

Through the memoir, the elderly Balthus reiterates the prayerlike na-
ture of his painting. He describes himself as an "ardent Catholic"—a
"strict Catholic"—who has hung saints' images on the walls of his
room, including an icon of Our Lady of Czestochowa given to him by a
Polish cardinal; surprisingly, Balthus wasn't born Catholic (he identifies
his father as Protestant, and says nothing of his mother's background)
but converted as a young man, in order to inherit a piece of property
from a well-to-do Catholic relative. Medieval and early Renaissance
Catholic iconography has certainly had an influence on Balthus's paint-
ings, of his "angels" in particular. Yet there is no sense of Roman
Catholicism otherwise in Balthus's art; no suggestion of the Church's
patriarchal hierarchy, its sacraments and church rituals.

Of his young girls, Balthus declares:

> Some have claimed that my undressed young girls are erotic. I never
> painted them with that intent, which would have made them anec-
> dotal mere objects of gossips. I aimed at precisely the opposite, to
> surround them with a halo of silence and depth, as if creating ver-
> tigo around them. That's why I think of them as angels, beings from
> elsewhere, whether heaven, or another ideal place that suddenly
> opened and passed through time, leaving traces of wonderment, en-
> chantment, or just an icon.

In this way we are invited to see Balthus's famously disturbing paint-
ings as the very obverse of the iconoclastic, as we might have imagined
them; however boldly original Balthus's art strikes the eye, Balthus seems
not to have intended it as radical or discontinuous with the painterly—
"sacred"—tradition. Whether his day-dreaming young girls are so
wholly un-erotized as Balthus recalls them will continue to be a matter
of dispute, for like all great artists Balthus leaves the viewer shaken and

disoriented, not reassured. As his memoir is something of a mythopoetic creation, an effort of self-defining and self-invention, so his paintings are riddles to which we can supply no answers; they are immensely beautiful and seductive dream-worlds of arrested time, as if European civilization fell into a trance in the early decades of the twentieth century, and never woke. (As Balthus remarked in 1995, at the age of eighty-seven, his art represents the effort of a man seeking to escape the "chaos governing the end of the twentieth century.") His most powerful work is of domestic scenes charged with mystery and strangeness, like the air before an electric storm, and where the painterly treatment is "primitive" and frescolike, in contrast to more realistic and polished, his art exerts its great appeal to the unconscious. (Compare the two very different treatments of an identical subject: the detailed *La patience* of 1943 with the stylized *La patience* of 1954–55.)

What is perhaps most valuable in this memoir is Balthus's depiction of his art as a process, not a product. The paintings are rituals requiring countless hours, days, weeks and frequently years of rapt concentration; a slow, groping, intuitive process by which the art-work emerges out of a mysterious conjoining of the artist's highly informed conscious mind, steeped in the history of his predecessors, and the artist's imagination. We are most charmed by the memoir's ease of expression, as if Balthus were confiding in us, as individuals. We are brought into a startling intimacy with genius.

> Although I've reached the point where I am given much praise, I feel without false modesty that most of my paintings are total failures . . . It's because I find so many things still lacking in them, unattainable yet foreshadowed. One day or another, they must be abandoned.

Notes

1. There is no gossip in Balthus's memoir, but much gossip has been generated by Balthus's highly secretive and highly irregular private life. See "The Strange Case of the Count de Rola" by the zestful gossip James Lord in *Some Further Remarkable Men* (1996). That Balthus seems to have invented for himself a noble title, and that his aristocratic pretensions were a matter of hilarity and outrage among his acquaintances, is of passing interest, but has nothing to do with the quality of Balthus's art.

In the Ring
and Out

*Unforgivable Blackness: The Rise and Fall of
Jack Johnson*
Geoffrey C. Ward

**God, it would be good to be a fake somebody
than a real nobody.**
—Mike Tyson, New York Times, *May 2002*

It was a scandalous and historic
American spectacle yet it took place in Sydney, Australia. It had the elements of a folk ballad set to an accelerated Scott Joplin tempo. It might have been a silent film comedy or a Chaplinesque farce for its principal actors were a wily black Trickster and a blustering white racist Hero: heavyweight contender Jack Johnson versus heavyweight champion Tommy Burns for the world title in December 1908. Though the arena in which the boxers fought reverberated with cries of "coon"—"flash nigger"—"the hatred of twenty thousand whites for all the negroes in the world," as the *Sydney Bulletin* reported, yet the match would prove to be a dazzling display of the "scientific" boxing skills of the thirty-year-old Johnson, as agile on his feet and as rapid with his gloves as any lightweight. The setting for this historic encounter was Australia and not North America for the long-shunned Negro contender had had to literally pursue the white champion to the ends of the earth—to England, Ireland, France, and at last Australia—in order to shame him into de-

fending his title. The bloody outcome of the fight, Johnson's victory over Burns in the fourteenth round, the first time in history that a Negro defeated a white man for the heavyweight title, was an astonishment in sports circles and seems to have provoked racial hysteria on several continents. Immediately, it was interpreted in apocalyptic terms:

> Is the Caucasian played out? Are the races we have been calling inferior about to demand to us that we must draw the color line in everything if we are to avoid being whipped individually and collectively?
> [*Detroit Free Press*, January 1, 1909]

If as John L. Sullivan famously declared, the heavyweight champion is "the man who can lick any son of a bitch in the world," what did the ascendency of the handsome and stylish "flash nigger" Jack Johnson portend for the white race? Jack London, at that time the most celebrated of American novelists and an ostensibly passionate socialist, covered the fight for the *New York Herald* in the most sensational race-baiting terms, as Geoffrey C. Ward notes in this compelling new biography of Johnson, transforming a sporting event into a "one-sided racial drubbing that cried out for revenge":

> It had not been a boxing match but an "Armenian massacre" . . . a "hopeless slaughter" in which a playful "giant Ethiopian" had toyed with Burns as if he'd been a "naughty child." It had matched "thunderbolt blows against butterfly flutterings." London was disturbed not so much by the new champion's victory—"All hail to Johnson," he wrote; he had undeniably been "best man"—as by the evident glee with which he had imposed his will upon the hapless white man: "A golden smile tells the story, and that golden smile was Johnson's."

Summing up the collective anxiety of his race, the poet Henry Lawson gloomily prophesied:

> It was not Burns that was beaten—for a nigger has smacked your face.
> Take heed—I am tired of writing—but O my people take heed.
> For the time may be near for the mating of the Black and the White to Breed.

As if to fan the flames of Caucasian sexual anxiety, the new Negro heavyweight champion returned in triumph from Australia with a white woman as his companion, whom he introduced to reporters as his wife. (She wasn't.) Through his high-profile career Johnson would flagrantly consort with white women ranging from prostitutes to comfortably well-off married women; in all, he would marry three. The first, Etta Duryea, who may have left her husband for Johnson, became so socially ostracized that she attempted suicide repeatedly and finally succeeded in killing herself with a revolver. Johnson's other liaisons were equally publicized and turbulent. In the prime of his career as the greatest heavyweight boxer of his time Johnson had the distinction of being denounced by the righteous Negro educator Booker T. Washington for "misrepresenting the colored people of this country" even as he was denounced at a National Governors' Conference by, among vehement others, the North Carolina governor who pleaded for the champion to be lynched: "There is but one punishment, and that must be speedy, when the negro lays his hand upon the person of a white woman." (Since 1900, nearly seven hundred Negroes had been lynched in the United States, for allegedly "sexual" reasons.) In 1913, Johnson had the further distinction of being the catalyst for the introduction of statutes forbidding miscegenation in the legislatures of numerous states; at this time, interracial marriage was officially outlawed in thirty of the forty-six states. (None of the proposed statutes of 1913 passed into law and fifty-four years later, the U.S. Supreme Court declared all such laws unconstitutional.) It would seem that Jack Johnson was simultaneously the most famous and the most notorious Negro of his time, whose negative example shaped the low-profile public careers of his Negro successors through nearly five decades.[1] Only in the 1960s, with the emergence of the yet more intimidating Sonny Liston and the brash, idiosyncratic Cassius Clay/Muhammad Ali, was Johnson vindicated. The massive Liston, hulking and scowling and resistant to all white liberal efforts to appropriate him, was Jack Johnson revived and reconstituted as a blackness ten times black. Ali, as viciously reviled in the 1960s as he is piously revered today, was a youthful admirer of Johnson: " 'I grew to love the Jack Johnson image. I wanted to be rough, tough, arrogant, the nigger white folks didn't like' " [*King of the World*, David Remnick, p 224].

Ali had the distinct advantage of being born in 1942, not 1878. He had the advantage of a sports career in the second half of the twentieth

century, not the first. And, by instinct or by principle, he seems to have avoided white women entirely.[2]

OF GREAT American heavyweight champions, Jack Johnson (1878–1946) remains sui generis. Though his dazzling and always controversial career reached its zenith in 1910, with Johnson's spectacular defense of his title against the Great White Hope former champion Jim Jeffries, Johnson's poised ring style, his counterpunching speed, precision, and the lethal economy of his punches, seem to us closer in time than the more earnest and forthright styles of Joe Louis, Rocky Marciano, Larry Holmes, Gerry Cooney, et al. That inspired simile "float like a butterfly, sting like a bee," coined to describe the young Cassius Clay/Muhammad Ali in his early dazzling fights, is an apt description of Jack Johnson's cruelly playful dissection of white opponents like Tommy Burns.[3] Ali, a virtuoso of what was called in Johnson's time "mouth-fighting," a continuous barrage of taunts and insults intended to undermine an opponent psychologically, and the inventor of his own, insolently baiting "Ali shuffle," can be seen as a vengeful and victorious avatar of Jack Johnson who perfected the precarious art of playing with and to a hostile audience, like a bullfighter who seduces his clumsy opponent (including the collective "opponent" of the audience) into participating in, in fact heightening, the opponent's own defeat. To step into the ring with a Trickster is to risk not only losing your fight but your dignity.[4]

What was outrageous and "unforgivable" in Johnson's boxing wasn't simply that he so decisively beat his white opponents but that he publicly humiliated them, as a way of demonstrating his smiling, seemingly cordial, contempt for their white constituents. Like Ali, except more astonishing than Ali since Johnson had no predecessors,[5] Johnson transformed formerly capable, formidable opponents into stumbling yokels. Like Ali, Johnson believed in allowing his opponents to wear themselves out in the effort of throwing useless punches. And, like Ali, Johnson understood that boxing is theater. Geoffrey Ward describes the 1909 (mis)match between Johnson and the white middleweight champion Stanley Ketchel in Colma, California:

> For eleven rounds the bout went more or less the way the Burns fight had gone. Johnson towered over his opponent, picking off his punches,

smiling and chatting with ringsiders, landing just often and just hard enough to cause Ketchel's mouth and nose to bleed but to do no more serious damage. Several times Johnson simply lifted the smaller man into the air, feet dangling like an oversized doll, and put him down just where he liked. One ringsider called it a "struggle between a demon and a gritty little dwarf."

After a reckless attempt to knock Johnson out, the fight ended brutally for Ketchel with four of his teeth strewn across the ring, or, in variants of the account, embedded in Johnson's glove, and the hostile crowd silent. After Johnson's equally decisive defeat of the former heavyweight champion Jim Jeffries in 1910, Jeffries was unexpectedly generous in conceding to a reporter, "I could never have whipped Johnson at my best. I couldn't have reached him in a thousand years." More often, white reactions to Johnson's victories were bitter, vicious, hysterical. After Jeffries's defeat, as word of Jack Johnson's victory spread, riots began to break out across the United States. "No event since emancipation forty-five years earlier had meant so much to Negro America as Johnson's victory," Geoffrey Ward notes, "and no event yielded such widespread racial violence until the assassination of Dr. Martin Luther King, Jr., fifty-eight years later." In all, as many as twenty-six people were killed and hundreds more hurt in the rioting, most of them black. In the jubilant wake of this new victory of Jack Johnson's, there would be countless casualties.

Unforgivable Blackness: The Rise and Fall of Jack Johnson is as much a portrait of the boxer's turbulent time as it is of Johnson him-self, in the way of such exemplary recent boxing biographies as David Remnick's *King of the World* (1998), which deals with the early, ascending years of Cassius Clay/Muhammad Ali, Roger Kahn's *A Flame of Pure Fire: Jack Dempsey and the Roaring '20s* (1999), and *The Devil and Sonny Liston* (2000) by Nick Tosches, a brilliantly sustained blues piece in prose perfectly matched with its intransigent subject. (Of heavyweight champions, Liston remains the "taboo" figure: the doomed black man unassimilable by any racial, cultural, or religious collective. Even the nature of Liston's death by heroin overdose—suicide? murder?—remains a mystery.) Ward, author of numerous historical studies includ-

ing *A First Class Temperament: The Emergence of Franklin Roosevelt* (1989) and a frequent collaborator with the documentary filmmaker Ken Burns on such American subjects as the Civil War, baseball, jazz, Mark Twain, Elizabeth Cady Stanton, and Susan B. Anthony, among others, is both lucky in his biographical subject (Jack Johnson's life even outside the ring reads like a picaresque dime novel) and judicious in his presentation (Johnson's recollections of his life, like those of countless observers, are to be taken with more than a grain of salt). Quite reasonably, Ward focuses upon the phenomenon of Jack Johnson primarily in terms of race, though it might be argued, from a purist boxing standpoint, that Johnson's racial background had no more to do with the elegance and precision of his ring style than any other biographical fact about him.

"Unforgivable blackness" is in reference to a quote from W.E.B. DuBois in his publication *The Crisis* (1914) with which Ward begins his biography:

> Boxing has fallen into disfavor . . . The reason is clear: Jack Johnson . . . has out-sparred an Irishman. He did it with little brutality, the utmost fairness and great good nature. He did not "knock" his opponent senseless . . . Neither he nor his race invented prize fighting or particularly like it. Why then this thrill of national disgust? Because Johnson is black. Of course some pretend to object to Johnson's character. But we have yet to hear, in the case of White America, that marital troubles have disqualified prize fighters or ball players or even statesmen. It comes down, then, after all to this unforgivable blackness. [p. viii]

(It isn't clear to which fight Du Bois is alluding since Johnson's major fights in 1913–14 took place in Paris and Buenos Aires and it's unlikely that Du Bois saw these fights or even, judging by the broad terms with which he described Johnson's fighting style, that Du Bois ever saw Johnson fight.) Geoffrey Ward notes that, researching the biography, he had no Jack Johnson "papers" to consult apart from such self-mythologizing autobiographies as Johnson's *In the Ring and Out,* and that much of his book is based upon contemporaneous newspaper accounts heavily saturated with "racist contempt." In order to "recapture something of the atmosphere of the world in which [Johnson] always insisted on remaining

his own man," Ward resists the "anachronistic term 'African American' "
in favor of the one that whites of Johnson's generation used grudgingly
and blacks most hoped to see in print: "Negro."

Arthur John Johnson was born in Galveston, Texas, on March 31,
1878, both his parents former slaves. Of the Johnsons' nine children,
only four would live to maturity. The third child and first son, Jack was
the immediate focus of his family's attention even as, in time, he would
seem to have been the focus of attention in virtually every situation,
every setting, every gathering in which he was to find himself through
most of his life: as naturally charismatic, physically striking and insou-
ciant as Cassius Clay/Muhammad Ali decades later. Like Ali, Jack John-
son was a "cheerful fabulist"—an "inexhaustible tender of his own
legend, a teller of tall tales in the frontier tradition of his native state" —
as well as a gifted athlete who seems to have seized upon boxing as much
as an opportunity to draw attention to himself as a means of making
seemingly "easy" money. Unlike Ali, whose I.Q. was once registered as
an astonishing 78, and who is said to have been able to read but a small
fraction of the voluminous praise and censure heaped on him over the
years, Johnson seems to have been an unusually intelligent, articulate,
and, to a degree, cultured individual whose emergence out of the Jim
Crow South of his era is nothing short of extraordinary.[6] It was John-
son's claim that having been born in the bustling port city of Galveston
with its "more relaxed view of racial separation" than that of inland
towns and cities of the South accounted for his sense of himself as an in-
dividual, and not a member of a racial minority. Long before he became
the first Negro heavyweight champion, Jack Johnson knew himself
heroic and would have heartily endorsed his biographer's claim that he
"embodied American individualism in its purest form; nothing—no law
or custom, no person white or black, male or female—could keep him
for long from whatever he wanted."

Yet everywhere in the United States, in the North no less than the
South, opportunities for Negro athletes were in fact shrinking. The
modest advances that had been made in the late 1800s were being taken
back by the passage of Jim Crow laws that allowed white professional
baseball players, for instance, to force their black competitors off the
field and white jockeys to void licenses held by black jockeys. Even the
League of American Wheelmen, Ward wryly notes, banned black bicy-
clists from their ranks. Boxing remained open to Negroes, but only if

they fought other Negroes and didn't aspire to title fights (and the larger purses that came with title fights). In 1895, the prominent newspaperman Charles A. Dana, editor of the *New York Sun*, warned readers: "We are in the midst of a growing menace. The black man is rapidly forging to the front ranks in athletics, especially in the field of fisticuffs. We are in the midst of a black rise against white supremacy."

Yet Jack Johnson began successfully fighting white boxers in San Francisco in the early 1900s and seems to have been from the first a strikingly original, elegant, and elusive counterpuncher given to shrewd theorizing: "By gradually wearing down a fighter, by letting him tire himself out, by hitting him with my left as he came to quarters with me, then by clinching or executing my uppercut, I found that I lasted longer and would not carry any marks out of the ring." Except for carrying a few marks out of the ring, this is a variant of the famous "rope-a-dope" strategy with which Muhammad Ali rewon his heavyweight title from George Foreman in Zaire in October 1974, one of the most astonishing title fights in ring history. It isn't surprising that Jack Johnson's early hero was the counterpuncher Jim Corbett whose ring style appeared "scientific" in contrast to the stiffly upright, crudely aggressive heavyweights of his time, all forward-lunging offense and no defense, lumbering strongmen looking for a place to land roundhouse punches. (As in 1926, in the first of their celebrated title fights, Gene Tunney would confound the brawling aggressor Jack Dempsey with a similar "scientific" strategy, landing blows even as he retreated, gliding "like a great skater on ice" to win every round of the ten-round fight on points and take Dempsey's title from him.)[7] In the first film footage showing Jack Johnson in the ring, a scratchy fragment from the silent film of Johnson's title fight with Tommy Burns in 1908, we see a tall, unexpectedly graceful heavyweight with a chiseled upper body, slender waist and legs; Johnson's head is smooth-shaved and his features might be described as "sensitive." In the most widely published photographs of Johnson he as much resembles a dancer as a heavyweight boxer. (At six feet, weighing a little more than two hundred pounds, Johnson would be a "small heavyweight" by contemporary standards. Physical size and strength increased dramatically in the division after 1962, when super-sized Sonny Liston won the title from the much smaller Floyd Patterson in arguably the most excruciatingly one-sided title

fight in heavyweight boxing history.) Two years later in his title defense against the much larger ex-champion Jim Jeffries, Johnson would perform with equal skill (despite the distracting presence of his old hero "Gentleman" Jim Corbett striding about at ringside screaming racist insults at him). Only in the last major fight of his career, against the six-feet-six, two-hundred-thirty-pound White Hope giant Jess Willard in Havana, Cuba, in 1915, did Johnson's counterpunching style fail him: in the famous, or infamous photograph of Jack Johnson lying on his back, Johnson has lifted a gloved hand to shield his eyes from the blinding Caribbean sun, and would afterward claim that he'd thrown the fight.[8]

As heavyweight champion Johnson enjoyed a degree of celebrity unknown to any Negro in previous American history, basking in media attention that kept his handsome, smiling image continuously before the public. Like Muhammad Ali, whose handsome, smiling image would be recognized in parts of the world in which the image of the President of the United States wasn't recognized, Johnson became an icon of his race: "the greatest colored man that ever lived."[9] When not training for an upcoming fight (in gyms and training camps to which the admiring public was invited) he embarked upon theatrical tours across the country. He shadow-boxed, he sparred, he performed in vaudeville and burlesque routines. Here was the very archetype of the "sport"—the dread "flash nigger" made flesh—in ankle-length fur coats, expensive racing cars painted bright colors, tailor-made suits, with rubies, emeralds, diamonds displayed on his elegant person, and the dazzling gold-capped smile for which he was known. (Naturally, Johnson's women were decked in jewels as well. Some of these jewels, Johnson only lent to women for an evening on the town; others were given as gifts to his wives. Etta, the suicidal first wife, was ensconced in a luxury hotel in London during one of Johnson's tours of English provincial music halls and provided with a chauffeur-driven $18,000 royal blue limousine with $2,500 worth of interior fittings, which seemed only to increase the unhappy woman's wish to kill herself.) It was common practice for Johnson to invite (male) journalists to observe him bathing nude and to allow them to touch his muscled body; his training camps were virtual open houses for the boxer's self-display, which seemed never to flag. As a *New York Herald* reporter observed:

. . . after the camp is escaped by the visitors Johnson discards his smile, forgets his wit and enters upon a tirade against the forces that command him to get into condition. The champion . . . is a different man when he is not showing off to the crowds, the followers, the curious, the hero worshippers who create an atmosphere which when absent almost seems to leave the negro much in the same condition as a lamp would be if the oil was taken therefrom. Johnson lives on applause. Without it he fades away to nothingness.

Like Muhammad Ali who compulsively boasted of being "the greatest"—"the prettiest"—Johnson would seem to have been the very essence of male narcissism; like Ali, who would refuse to be drafted into the U.S. Army in the mid-1960s to fight in Vietnam—"Man, I ain't got no quarrel with them Vietcong" was Ali's improvised, brilliant rejoinder—Jack Johnson incurred the wrath of the majority of his fellow citizens by declaring in an interview given in London in 1911, "Fight for America? Well, I should say not. What has America ever done for me or for my race? [In England] I am treated like a human being." Both men would be hounded by righteous white prosecutors, fined and sentenced to federal prison. (Ali's conviction would be overturned by the Supreme Court in 1971. Johnson served his full prison sentence.) Yet the parallel between Ali and Johnson breaks down when one considers their respective attitudes toward their profession, for Ali in his prime was a fanatically disciplined and dedicated boxer whose performances in the ring never failed to transcend the pettiness of his public persona, while Johnson appears not to have finally cared very much about boxing except as a means of celebrity and money-making. Johnson had a notorious penchant for making "deals" (in contrast to "fixing" fights), even when he was heavyweight champion. (The most tempting of deals for the better boxer is simply to carry his opponent through a preplanned number of rounds before knocking him out, for the benefit of gamblers and/or filmmakers, who paid more for more film footage in Johnson's day.) Once he'd achieved a modicum of success, Johnson ceased training seriously for upcoming fights and, sad to say, he managed to avoid leading Negro contenders just as, when Jack Johnson had been the leading contender for the title, the long-reigning Tommy Burns had managed to avoid him.

. . .

Geoffrey Ward has divided *Unforgivable Blackness* into two near-equal books: "The Rise" and "The Fall." Ironically, Johnson's "fall" begins in the immediate aftermath of his greatest victory, against Jeffries; it would seem to be inevitable that an individual so driven, for whom self-display is a kind of narcotic, should begin to self-destruct almost immediately after achieving his greatest success. Ward provides a dispiriting catalogue of increasingly pathological behavior on Johnson's part after 1910: heavy drinking, suicidal depression, compulsive gambling and womanizing, violence against his wife Etta, lawsuits, feuds, scandals played out in the media. Only two weeks after the luridly publicized suicide of Etta, Johnson appeared in public in Chicago with a very attractive, very blond eighteen-year-old, an act equivalent to tossing a lighted match into a gasoline drum. (Johnson was thirty-four.) Everywhere Johnson went in the next several years, but especially in the Chicago epicenter, a blaze of notoriety attended him; no other boxer except, in our time, the luckless Mike Tyson, has been demonized by the press so relentlessly. Though Johnson understood that boxing per se has nothing to do with race, only with the performances of often idiosyncratic individuals, he seemed not to wish to understand how, even as he used the press as a kind of magnifying mirror, the press was using, and exhausting, him.

The Negro pariah, increasingly under attack from both Caucasians and Negroes, somehow managed to escape being assassinated, lynched, or even injured at the hands of white racists, but he could not escape the toxic fallout of public notoriety. In 1913, his enemies literally conspired to trump up criminal charges against him for having allegedly violated the Mann Act (also known as the White Slave Traffic Act of 1909 that barred the "transportation of women in interstate or foreign commerce for the purpose of prostitution or debauchery, or for any other immoral purposes"). Though the law was intended to apply to traffickers in prostitution, not individuals involved in extramarital romances, the Chicago district attorney's office vigorously pursued a criminal case against Johnson based upon the biased and unreliable testimony of a white call girl who'd once been a companion of his:

To corroborate and amplify Belle's version of events, federal agents quietly fanned out across the country, interviewing prostitutes, chauffeurs, waiters, bellhops, Pullman porters, ex-managers, former sparring partners, looking for something—*anything*—that could be used to bolster their case that the champion had broken federal law . . .

Despite paying out bribes to individuals who might have influenced the outcome of his trial, Johnson was found guilty and sentenced to one year and one day in prison. Though he and his second wife, Lucille—the young blond woman whose presence in Johnson's life had provoked scandal—fled the country and lived abroad for several years, eventually, deep in debt, Johnson returned to the United States to (unsuccessfully) defend his title against the "Pottawatomie Giant" Jess Willard, a lumbering heavyweight with no evident gift for boxing except his size and a reach of eighty-four inches, and to serve his prison sentence in Leavenworth, Kansas, where, true to charismatic form, Johnson made friends not only among his fellow prisoners but among the prison administration, including the white warden who treated his celebrity prisoner with unexpected generosity. Johnson may have been on the downward spiral, an ex-champion in his early forties with no prospects of a title fight from the new champion Dempsey (who had overwhelmed the clumsy Pottawatomie Giant in a fight so bloody it would have been stopped within the first minute of the first round of a contemporary boxing match), yet his leave-taking from Leavenworth was newsworthy:

Six motion picture cameramen were on hand to capture the moment. Johnson was dressed as only he could dress: straw hat, exquisite tailored gray suit, blinding-white soft-collared shirt, bright polka-dot tie, gleaming patent-leather shoes . . . "There were four bands. Hundreds of people."

At least this is Johnson's account, from his "cheerfully fabulist" autobiography *In the Ring and Out*.

Like many ageing ex-champions, Johnson continued to seek the spotlight that, in his biographer's words, "gave his life meaning." He contracted to appear in a vaudeville company in which, as he boasted, "all the performers except myself were white." He was hired (and very well

paid) as a sparring partner for the cocky young Argentine heavyweight Luis Angel Firpo, and soon fired for playing to the crowds gathered in the gym. He toured the boondocks in degrading burlesque revues that called for him, the well-spoken Jack Johnson, to tell jokes in stage-darky dialect. He began drinking heavily. Lucille divorced him but, out of a seemingly endless supply of white women, a third wife, Irene Pineau, almost immediately materialized. At the age of fifty-seven, grudgingly impressed with the boxing skills of the young Joe Louis, Johnson offered to help make a champion of him but was viciously rebuffed by Louis's manager:

> "He cursed Johnson out," Louis recalled, "told him how he'd held up the progress of the Negro people for years with his attitude, how he was a low-down, no-good nigger and told him he wasn't welcome in my camp any longer."

To retaliate, Johnson would bet heavily on Max Schmeling to beat Louis in their first fight and, after Schmeling won, boasted so openly of his winnings that he had to be rescued by (white) policemen from a crowd of angry Negroes.

For the remainder of his life Johnson would ply his trade as the ex-first-Negro-heavyweight champion, with diminishing rewards. Well in to his sixties he sparred with young boxers, shadow-boxed for whatever public would pay to see him, and impersonated himself in a cellar sideshow off Times Square called Hubert's Museum and Flea Circus. A nightmare end for Jack Johnson, or so it would seem:

> To see Johnson in person, visitors had to pay a quarter . . . Yellowing newspaper clippings from Johnson's career were taped to a booth in which a bored hawker sat making change without looking up . . . Visitors pushed through a little turnstile, made their way down a flight of stairs, and took their seats in the dank, dimly lit cellar. One dreary act followed another—a sword-swallower, a trick dog, a half-man-half-woman . . .
>
> Johnson stepped smoothly onstage, wearing a blue beret, a blue tie, and a worn but sharply cut suit. He held a glass of red wine with a straw in it. He smiled and asked his visitors what they would like to know.

It's true that Joe Louis was a public relations dream, a gifted athlete who acquiesced, as Jack Johnson could never have done, to being made into a "good Negro"—i.e., marketable to a white public; yet in the way of one of those cruelly ironic fairy tales collected by the Brothers Grimm, Louis would find himself in the afterlife of his championship impersonating "Joe Louis" as a greeter at Caesars Palace in Las Vegas: more deeply in debt than Johnson, deeper in despair and sicker.[10] Despite Hubert's Museum and Flea Circus, Johnson seems to have remained supremely himself to the very end: he would die at the age of sixty-eight in an automobile crash outside Raleigh, North Carolina, at the wheel of his high-powered Lincoln Zephyr, reportedly speeding at more than seventy miles an hour. The reason for Johnson's speeding is said to have been indignation that, at a diner, he'd been told he could only eat at the rear.

AS THE philosopher is susceptible to sometimes disappearing into such abstraction that his subject can seem nugatory—quite literally "nothing"—so the historian at his most generous can assemble so many facts, details, quotations that the reader becomes lost in a plethora of "somethings." Since *Unforgivable Blackness* is likely to be the definitive biography of Jack Johnson, the absence of a chronology of Johnson's fact-filled life is unfortunate. Often, in medias res, it's difficult to figure out the year without consulting the index, to determine when a newspaper article appeared. Most readers of a boxing biography can be assumed to have more than a passing interest in boxing, yet Ward doesn't include a record of his subject's boxing career, a frustrating and inexplicable omission. (In sharply abbreviated form, Johnson's record is 113 fights: 79 wins, 12 draws, 8 losses, 14 no decisions. Compare Jack Dempsey with 80 fights: 61 wins, 7 draws, 7 losses, 5 no decisions, and 1 no contest; Joe Louis with 70 fights: 67 wins, 3 losses; Muhammad Ali with 61 fights: 56 wins, 5 losses.) Also, the biography ends somewhat too abruptly with Johnson's death and funeral: we feel the need for an epilogue to provide an overview of Johnson's legacy, historic and mythic. No sport is more mindful of its iconic past than boxing and at a time when even the outlaw figure of Sonny Liston is being revalued, Johnson merits this consideration.

In any case, *Unforgivable Blackness* is a significant achievement. Geoffrey Ward provides an utterly convincing and frequently heartrending portrait of Jack Johnson, "the man with the golden smile," for whom the ideal representation would be the Janus-face of simultaneous comedy and tragedy.

Notes

1. After Johnson lost the heavyweight title to Jess Willard in 1915, the title would be held by white boxers until 1937, when twenty-three-year-old Joe Louis became champion. The shrewd (white) managers of Joe Louis, who made his pro boxing debut in 1934 when the thorny memory of Jack Johnson still rankled in the public's memory, drew up a list of specific rules for Louis: he was never to have his picture taken with a white woman; he was never to go into a nightclub alone; he would be involved in no "soft" fights, and no "fixed" fights; he was never to gloat over a fallen opponent; he was to "live clean and fight clean." Arguably a greater heavyweight than Jack Johnson, certainly one with a more impressive record of victories over worthy opponents, Joe "The Brown Bomber" Louis became an American sports success of immense natural talent shaped and controlled by marketing strategies. Though Louis ended his career humiliated and broken, owing back taxes on even the "income" of two purses he'd naively donated to the war effort in the early 1940s, addicted to cocaine, and plagued by the paranoid, but not inaccurate, suspicion that the FBI had him under surveillance, yet in public memory he continues to occupy a mythic identity as the "good" American Negro heavyweight champion who beat the "Nazi" Max Schmeling in 1938. Though ironic in terms of Louis's personal life, that of the exploited Negro athlete, this entry from the *Encyclopedia of Boxing* is accurate: "[Louis's] exemplary behavior both in and out of the ring sharply raised the prestige of black boxers."

2. Since Muhammad Ali has become a totemic figure in the pantheon of American folk heroes, no one wishes to recall how in the 1960s and 1970s, a convert to the Nation of Islam ("Black Muslims" in the white press) and an outspoken critic of American culture, Ali was regularly booed at fights and chided, if not vilified, in print. TV commentators and numerous publications including the *New York Times* refused to call him anything other than "Cassius Clay." On his part, Ali was a vehement black racist who believed in the

subjection of Muslim women to Muslim men and an absolute division of the races: "A black man should be killed if he's messing with a white woman . . . [If a Muslim woman consorts with white men] then *she* dies. Kill her, too." (*Playboy* interview, November 1975).

3. In an era in which title fights were scheduled for twenty rounds, the fight with Burns was stopped abruptly in the fourteenth round when Sydney police officers, agitated that the Negro challenger was winning, entered the ring. Burns would afterward protest that, if the police hadn't interfered, "I might even have won because the big nigger was tiring fast." [p. 127] Contemporary title fights are twelve rounds. (Most fights are eight or ten rounds and all are closely monitored by ringside physicians, unheard-of in Jack Johnson's time.)

4. See Gerald Early, "The Black Intellectual and the Sport of Prizefighting": "Against black opponents the white yokels were not even really fighters; they were more like preservers of the white public's need to see Tricksters pay a price for their disorder." (*Speech and Power*, Vol. 1, 1992, edited by Gerald Early.) Ali is the supreme heavyweight Trickster even as, paradoxically, no one has been more purely devoted to boxing:

> [Ali] forced us to reimagine the ways an athlete moves through time and space; even in his waning years, he waged a battle against stylistic norms. As a youth he held his hands too low, and yanked his head straight back from blows (an amateurish move, the traditionalists grumbled) yet he so accelerated the pace of heavyweight fighting that scarcely anyone could keep up with him. With extraordinary self-consciousness, Ali relished the difficulty his dancing around and back created not only for his opponent, but also for ringside cameramen trying to keep him in the frame. As he aged, he sought the opposite extreme in posture and pacing: immobile along the ropes, head down and hands held low, he slowed the pace of major fights to an excruciating point, exhausting his foes . . . Ali was always the expert parodist, whether through his cartoonlike nicknames for his opponents' styles ("The Rabbit," "The Octopus," "The Washerwoman"), or through his exaggerated mirrorings of his foe . . . These moves gave Ali the illusion of omnipotence, even when he had to struggle.
>
> [Ronald Levao, "Reading the Fights,"
> *Raritan*, spring 1986]

5. Johnson had no Negro Trickster predecessors but of course he had Negro predecessors in the literal sense, foremost among them the West Indian–born heavyweight Peter Jackson (1861–1901). Jackson was the best Negro boxer of his era and very likely would have beaten John L. Sullivan if Sullivan, an avowed white racist, had granted him a title fight. (Sullivan was the reigning "Prize Ring" champion from 1882 to 1892, when boxers still fought bare-knuckled.) Even after Jackson fought James Corbett to a draw in a four-hour, sixty-one-round fight, Sullivan refused to fight him. Previously, Sullivan had refused to fight another leading Negro contender named George Godfrey. White champions commonly "drew the color line" against Negros out of a fear that, like Tommy Burns, they would be humiliated in the ring. Until the rise of Joe Louis in the 1930s, a white champion like Jack Dempsey could avoid Negro boxers through an entire career. For this reason, the history of boxing before Louis is not an authentic history. As Peter Jackson was the "shadow" champion during the reign of John L. Sullivan so the Negro Harry Wills was the "shadow" champion during the reign of Jack Dempsey. In his widely publicized pursuit of Tommy Burns, in which he enlisted the white press on his behalf, Jack Johnson broke the mold of Negro boxers like Jackson who behaved with public deference to whites. Johnson would have perceived that being a "good" Negro would get him no further than Jackson and Godfrey: being a "white man's Negro" wasn't for him. Negro athletes like Peter Jackson were extolled by such Negro leaders as Booker T. Washington and Frederick Douglass; the Negro historian James Weldon Johnson compared Peter Jackson favorably to Jack Johnson, noting that Jackson's deportment in public and chivalry in the ring had brought him the compliment from white sportswriters that he was a "white colored man." [Quoted in *King of the World* by David Remnick, p. 277]

6. White journalists were continually being surprised by Jack Johnson the "complex, mercurial man behind the grin." [p. 187] A Baltimore *American* reporter notes, in 1910:

> . . . once in his private quarters the negro became a changed man. He ordered one of his assistants to load the phonograph, and for an hour the hotel was filled with the strains of operatic music, vocal selections rendered by Caruso and others . . . Not once did a "ragtime" piece appear . . . In another corner there stood an immense bass viol. Somebody asked casually who played it, and Johnson said, "I do. Like to hear me?" [p. 187]

Another observer notes that Johnson is "no stranger in the world of books and writers":

> He browsed through books on all subjects—fiction, science, art, history; he has read them in three languages—English, French, and Spanish. He is conversant with works of Shakespeare . . . When discussing books and the names of Alexander Dumas and Victor Hugo are mentioned, Johnson becomes more alert than ever, for these are two of his favorite writers . . . While his schooling was interrupted before he reached high school, he has nevertheless attained an education of thoroughgoing character . . . He is a musician of no mean ability, his favorite instrument being the bass viol, which he plays in a talented manner.
>
> [quoted in Jervis Anderson, "Black Heavies,"
> in *Speech and Power* Vol. 1]

7. The remark is Dempsey's. For a detailed description of this famous fight see *A Flame of Pure Desire: Jack Dempsey and the Roaring '20's* by Roger Kahn, p. 399.

8. Though Johnson seems to have acknowledged immediately after the fight that he'd legitimately lost ("I met a young big boy and he wore me down. I didn't dream there was a man alive who could go fifteen rounds with me once I started after him" [p. 380]), he would afterward claim that he'd thrown the fight in a deal that would have allowed him to return to the United States without having to serve a prison sentence (for his 1913 conviction of having violated the Mann Act). The deal evidently fell through, since Johnson had to serve his sentence, and the mystery of the fight remains open to speculation. If Johnson was intending to lose, he put up a convincing fight for more than twenty rounds in the blistering Havana, Cuba, sunshine, before visibly tiring and losing his strength. The famous photograph of Johnson lying on his back on the canvas at the end of the twenty-sixth round [as if languidly lifting his gloved hand to shield his eyes from blinding sunshine] does have a fraudulent look to it, however. (Though Sonny Liston eerily replicated this scene in 1965, in the first round of his infamous rematch with heavyweight champion Muhammad Ali, knocked out by an infamous "shadow punch" that hardly looks powerful enough to have cost him the fight, Liston probably had not intended a postmodernist reference to his great predecessor.)

9. Seven decades later, in a Catskill training camp overseen by the legendary trainer Cus D'Amato, the sixteen-year-old Mike Tyson took note:

Tyson marveled at Jack Johnson, the most famous of black heavyweight champions, who caught punches with his open glove, talked to people in the stands during the fight, and laughed in the faces of his hapless opponents . . . He found out that among the fighters of the 1920s gold teeth were a status symbol, and had two of his upper front teeth capped in gold.

[*Mike Tyson*: Money, Myth and Betrayal
by Montieth Illingworth (1991), pp. 5–56]

10. The pathos of Joe Louis's later life is belied by the tone of his ghostwritten memoir, *My Life* (1978), in which the ravages of Louis's ill health, mental instability, and financial distress are adroitly glossed over. Though only in his early sixties, Louis has become an elderly, addled mascot in the employ of a gambling casino:

Yeah, I'm comfortable in Vegas. Don't have to get dressed up . . . just wear a sport shirt, of course, most times it's silk, cowboy hat or baseball cap, slacks, sometimes my cowboy boots . . . I see all my old friends when they come to entertain. Frank Sinatra and me go back a long time.

[*Joe Louis*: My Life (1978), p. 261]

Muhammad Ali: "The Greatest"

I was determined to be one nigger that the white man didn't get.

—Muhammad Ali, 1970

Boxing was nothing. It wasn't important at all. Boxing was just a means to introduce me to the world.

—Muhammad Ali, 1983

IN THE TWENTIETH CENTURY, AND PER-haps most spectacularly in the 1970s, sports has emerged as our dominant American religion. Through the excited scrutiny of the media, our most celebrated athletes acquire mythopoetic status; they are both "larger than life" and often incapacitated for life in the ordinary, private sense. To be a champion, one must only be a consistently better performer than his or her competitors; to be a great champion, like Muhammad Ali, one must transcend the perimeters of sport itself to become a model (in some cases a sacrificial model) for the general populace, image-bearer for an era.

Though he came of age as an extraordinary young boxer in the 1960s, and made his mark as a radical political presence during that decade, it was in the 1970s that Ali achieved greatness. The 1970s, following the inglorious end of the Vietnam War, is our decade of transition; a time of accommodation, healing and reassessment. Who would have thought

that Muhammad Ali's defiant repudiation of American foreign policy, in the mid-1960s considered virtually traitorous by some observers, would come to be, in the decade to follow, a widespread and altogether respectable political position? Who would have thought that the lone black athlete, like Ali, once ostracized by the media, would come to be emblematic of the "new" era in which, following Ali's example, athletes like Reggie Jackson (the first major league baseball player to sport a moustache since 1914) could express (or exhibit) themselves in essentially playful, theatrical gestures that had little to do with their utilitarian function as athletes? Who would have thought that such flamboyant, controversial gestures as Ali's penchant for declaiming poetry and the comical "Ali shuffle" would influence a new generation of blacks?—in music, where "rap" soared to prominence, and in the scathingly funny comic routines of performers like Richard Pryor; above all in basketball, where players of the caliber of Michael Jordan combined extraordinary skill, like Ali, with a personal sense of style? (Compare the modest, constrained public personae of Joe Louis, Ezzard Charles, Jackie Robinson of an earlier era in which the black athlete was given to know that his presence was provisional and not a right; his very career was a privilege that might be revoked at any time.) The phenomenon of media attention, and hype, accorded every turn of Ali's career was unlike any that preceded, just as the ever-increasing purses and salaries paid to professional athletes in our time are a consequence of Ali's role in the public consciousness. Perhaps free agentry in sports like baseball and football would have followed in due course, but not so swiftly in the 1970s (leading to the 1974 strike in football, for instance) without Ali's example. Ali is the quintessential "free agent" as his much-maligned predecessor Jack Johnson might have been, except for the overwhelming opposition of that era's white racism. And Ali was the Muslim pioneer through whose unwavering example such athletes as Lew Alcindor/Kareem Abdul-Jabbar were allowed to change their names and present themselves explicitly as members of a distinctly non-Christian and non-traditional religion.

Viewed from the perspective of the new century, the 1970s was a transitional period in which, in a sense, a New Era of sports was born. If the celebrity athlete with his astronomical contract is a permanent fixture of American public life, who but Muhammad Ali, once Cassius Clay of Louisville, Kentucky, was his progenitor?

. . .

AMONG BOXING historians and fans it will long be debated whether Ali, or Joe Louis, was the greatest heavyweight boxer in history. (And what of the undefeated Rocky Marciano?) It is beyond debate, however, that Ali as athlete, champion, and cultural icon has acquired a significance beyond sports that no other boxer has attained, nor is likely to attain. (Prior to Ali's ascendency in his fights with Joe Frazier, it was the vengeful, brilliantly triumphant Joe Louis of the Louis-Schmeling fight of June 1938 who most captivated the public's imagination. Having been defeated by Nazi Germany's "master race" athlete in 1936, the twenty-four-year-old Louis returned to knock out Schmeling in 124 seconds in the most famous boxing match in American history.) Muhammad Ali's meteoric rise to prominence as an extraordinarily gifted if idiosyncratic and willful young boxer in the early 1960s, culminating in his unexpected defeat of heavyweight champion Sonny Liston in 1964, happened to coincide with at least three historical developments unique to the era: the first, the enmeshed, expanding entanglement of American intervention in Vietnam which both was, yet was not, a traditional war and which was fracturing American society along lines of class, race, generations, and political and patriotic allegiances; the second, the rise of black separatist movements following (in fact, predating) the assassination of Martin Luther King, Jr., in 1968, and the awareness on the part of militant black leaders that since the civil rights victories of the 1950s, black advancement had been stalled; the third, the intensification of media influence and the growth of what might be called electronic mass marketing of "images" detached from content.

"Styles make fights," Ali's great trainer Angelo Dundee said, in reference to his dazzling young boxer's ring performances, but the insight applies to the mass replication of images generally. Cassius Clay/ Muhammad Ali soon revealed himself as a master of a new, radically iconoclastic style in public life. He refused to be self-effacing in the cautious manner of his black predecessors Louis, Ezzard Charles, Jersey Joe Walcott, and Floyd Patterson; the audacity with which he exulted in his blackness called to mind Jack Johnson, the controversial first black heavyweight champion (1908–1915), whose example black athletes (and their white trainers and managers) did not wish to emulate. (Compare the far more cautious yet perhaps not less difficult route of Jackie Robin-

son in the preceding decade.) Though complicated by issues of religion and race and "ego," the essential message of Cassius Clay/Muhammad Ali in the late 1960s and early 1970s was simple and defiant: *I don't have to be what you want me to be.*

No other athlete has received quite the press—accusing and adulatory, condemning and praising, seething with hatred and brimming with love—that Ali has had. From the first, as the young Cassius Clay, he seems to have determined that he would not be a passive participant in his image-making, like most athletes, but would define the terms of his public reputation. As sport is both a mirror of human aggression and a highly controlled, "playful" acting-out of that aggression, so the public athlete is a play-figure, at his most conscious and controlled an actor in a theatrical event. Clay/Ali brought to the deadly-serious sport of boxing an unexpected ecstatic joy that had nothing to do with, and may in fact have been contrary to, his political/religious mission. His temperament seems to have been fundamentally childlike; playing the trickster came naturally to him. "My corn, the gimmicks, the acting I do—it'll take a whole lot for another fighter to ever be as popular as Muhammad Ali," he remarked in an interview in 1975. "The acting begins when I'm working. Before a fight, I'll try to have something funny to say every day and I'll talk ten miles a minute . . . I started fighting in 1954, when I was just twelve, so it's been a long time for me now. But there's always a new fight to look forward to, a new publicity stunt, a new *reason* to fight."

At the same time, Ali is deadly serious about his mission as a member of the Nation of Islam; there is nothing playful or trickster-like about his commitment to the Muslim faith ("Muslims . . . live their religion—*we* ain't hypocrites. We submit entirely to Allah's will").

There has always been something enigmatic about Clay/Ali, a doubleness that suggests a fundamental distinction between public and private worlds. And what a testimony is Ali's career of nearly three decades to the diversity of media attention! In our time, in his sixth decade, long retired from the sport that made him famous and from the adversarial politics that made him notorious, Ali now enjoys a universal beneficence. He has become an "American icon" known through the world; a brand name symbolizing "success." He remains a Muslim but no longer belongs to the Nation of Islam; he no longer makes pronouncements of a political nature. He has become a mega-celebrity divorced, like all such

celebrities, from history; a timeless mass-cult contemporary of Elvis Presley and Marilyn Monroe.

Yet of course it was not always like this. There were years following Ali's refusal to be inducted into the U.S. Army, as a member of the Nation of Islam, when he was one of the most despised public figures in America; even, in State Department terms, a "possible security risk"! Boxing audiences didn't greet him with incantatory chants of "Al-*li*! Al-*li*! Al-*li*!" but with boos. It's rare to encounter an athlete who chooses to be a martyr for a principle; an athlete who has made himself into a figure of racial identity and pride. (It was always the hope, to become in time a stereotypical hope, that the black athlete like Joe Louis and Jackie Robinson would be a "credit to his race." What was not desired was racial confrontation and conflict.) The issue of race was always predominant in Ali's strategy of undermining an opponent's confidence in himself and, ingeniously, though sometimes cruelly, fashioning himself as the "black" boxer against the "white man's" Negro. Floyd Patterson, much admired by white America, was particularly susceptible:

> I'm going to put him flat on his back
> So that he will start acting black.

(In fact, Ali didn't put Patterson flat on his back, but humiliated him in a protracted, punishing fight.) Even as the brash twenty-two-year-old contender for the heavyweight title, he'd dared mock the champion Sonny Liston as an "ugly old bear"—an "ugly slow bear"—Liston, who'd so demolished Patterson! Years later, in 1975, Ali would relentlessly taunt Joe Frazier with remarks that would have seemed, from a white boxer, racist:

> Joe Frazier is a gorilla,
> And he's gonna fall in Manila!

Yet worse (or funnier): "Frazier's the only nigger in the world ain't got rhythm." Frazier, too, was fashioned by Ali into the white man's Negro; the boxer whom whites presumably wanted to win, therefore isolated from the community of blacks. Is this bad sportsmanship on Ali's part, a sly sort of racist tweaking of noses; is it Ali at his purposeful worst, or simply a manifestation of the man's enigmatic nature, the trickster-as-athlete?

Race has long been an American taboo. The very word "nigger" strikes the ear as obscene; in using it, particularly in the presence of whites, blacks are playing (or making war) with the degrading, demeaning historical context that has made it an obscene word, in some quarters at least. (In another context, the word can be a sign of affection. But this context isn't available to whites.) Ali, intent upon defining himself as a rebel in a white-dominated society, would make of every public gesture a racial gesture: defiance toward the white Establishment, alliance with the black community. The political issue of serving in Vietnam ("No Vietcong ever called me nigger" was Ali's most pointed defense) would seem to have been secondary to the more pervasive issue of black inequity in America, for which Ali would be spokesman, gadfly, and, if needed, martyr. In his *Playboy* interview of November 1975, Ali is quoted as saying that, following the teachings of the late Elijah Muhammad, founder of the Nation of Islam, he believes that the majority of whites are "devils" and that he anticipates a separation from white America: "When we take maybe ten states, then we'll be free."

By making race so prominent an issue in the late 1960s and early 1970s, Ali provoked a predictably hostile response from the Establishment, including the federal government. Though forbidden to leave the United States, he would be exiled within it; as a black Muslim he would be "separate" from the white majority. Indeed, among public celebrities of the America twentieth century only Charlie Chaplin and Paul Robeson, persecuted by right-wing politicians in the 1950s for their "Communist" principles, are analogous to Ali. The black athletes Jackie Robinson and Arthur Ashe, in their very different ways, Robinson in integrating major league baseball and Ashe in his activist phase in the public cause of AIDS education, acquired a profound cultural significance apart from their sports yet were never controversial figures like Ali. Considering the protracted violence of the 1960s, the assassinations of public figures and frequent killings and beatings of civil rights activists, it seems in retrospect miraculous that Cassius Clay/Muhammad Ali, the self-declared "nigger that the white man didn't get," didn't provoke violence against himself.

> Ali rode the crest of a new wave of athletes—competitors who were both big and fast . . . Ali had a combination of size and speed that had never been seen in a fighter before, along with incredible will

and courage. He also brought a new style to boxing . . . Jack Dempsey changed fisticuffs from a kind where fighters fought in a tense defensive style to a wild sensual assault. Ali revolutionized boxing the way black basketball players changed basketball today. He changed what happened in the ring, and elevated it to a level that was previously unknown. —Larry Merchant

The extraordinary career of Cassius Clay/Muhammad Ali is one of the longest, most varied and sensational of boxing careers. Like Joe Louis, Sugar Ray Robinson and Archie Moore, among few others in so difficult and dangerous a sport, Ali defended his title numerous times over a period of many years; he won, he lost, he won and he lost; beginning brilliantly in 1960 as an Olympic gold medalist and ending, not so brilliantly, yet courageously, in 1981. What strikes us as remarkable about Ali is that, while as the brash young challenger Cassius Clay he'd been ready to quit his first title fight, with Sonny Liston, in an early round (with the complaint that "something was in his eye"), he would mature to fight fights that were virtually superhuman in their expenditure of physical strength, moral stamina, intelligence and spirit: the long, gruelling, punishing fights with Joe Frazier (which, in turn, Ali lost, and won, and won); and the famous Rope-a-Dope match with then-champion George Foreman in Zaire, in 1974, which restored Ali's title to him. Never has a boxer so clearly sacrificed himself in the finely honed, ceaselessly premeditated practice of his craft as Ali.

This long career might be helpfully divided into three, disproportionate phases: the first, 1960–67, the "Float Like a Butterfly, Sting Like a Bee" Era when Ali's youthful boxing skills were at their zenith; the second, 1971–78, Ali's return after his three-and-a-half-year exile from boxing; and the diminished third, a kind of twilit epilogue ending with Ali's belated retirement at the age of forty. F. Scott Fitzgerald's cryptic remark, "There are no second acts in American lives," would seem to be refuted by the example of Ali; dazzling as he was as a young boxer, he becomes more interesting in his second phase as a boxer no longer young who must rely upon superior intelligence and cunning in the ring, as well as the potentially dangerous ability to "take a punch"; bringing to bear against his hapless opponents some of the psychic warfare we associate with actual warfare. That is, the wish to destroy the opponent's spirit before the body is even touched.

1960–1967. "Float like a butterfly, destroy like a viper" might have

been a more accurate metaphor for Cassius Clay/Muhammad Ali in these early fights. Not until the emergence of Mike Tyson at an even younger age in the mid-1980s would a young heavyweight boxer make such an impact upon his sport as this Olympic gold medalist turned pro after 108 amateur bouts. Born Cassius Marcellus Clay in Louisville, Kentucky, on January 17, 1942, grandson of a slave but reared in a comfortable, supportive black middle-class environment, the young Cassius Clay was like no other heavyweight in history: massive, perfectly proportioned, a Nijinsky with lethal fists and a manner both in and out of the ring that might be called inflammatory. By instinct, Clay knew that boxing is, or should be, *entertaining*. Boxing is, or should be, *drama*. From the campy pro wrestler Gorgeous George, he'd learned that people will buy tickets to see a boxer lose as well as to see a boxer win. Calling attention to oneself, cartoon- and comic-book-style, is a way of calling attention to the fight, and to box office revenue. The early disdain of boxing experts for "The Mouth" is certainly understandable in the light of boxing's tradition of reticent champions (like Louis); a boxer should speak with his fists, not his mouth. With adolescent zest, predating the insouciance of black rap music, Cassius Clay repudiated all this.

> This is the legend of Cassius Clay,
> The most beautiful boxer in the world today.
>
> He talks a great deal and brags indeedy
> Of a muscular punch that's incredibly speedy.
>
> The fistic world was dull and weary,
> With a champ like Liston things had to be dreary.
>
> Then someone with color, someone with dash,
> Brought fight fans a-runnin' with cash.
>
> This brash young boxer is something to see
> And the heavyweight championship is his destiny.

And much, much more.

Of course, the young boxer's arrogant verbosity and pre-fight antics were more than balanced by his ring discipline and boxing skill. From the

first, Clay attracted media attention as much for his style as for his victories. What was unique about Clay in the 1960s? Even after his wins against such highly regarded veterans as Archie Moore and Henry Cooper (whose face Clay savagely bloodied in a bout in England in 1963), the eccentricities of Clay's style aroused skepticism and sometimes alarm in commentators. A. J. Leibling described this bizarre heavyweight as "skittering . . . like a pebble over water." He held his gloves low, as a boxer is trained not to do. He leaned away from his opponent's punches instead of slipping them, as a boxer is trained not to do. He feinted, he clowned, he shrugged his head and shoulders in odd ways, even as he danced in a sort of sidelong way. He performed a "shuffling" movement to distract opponents and entertain spectators. In the words of Garry Wills, Clay "carries his head high and partly exposed so that he can see everything all the time . . . whips his head back just enough to escape a punch without losing sight of his man." In Hugh McIlvanney's prophetic words, the young boxer seemed to see his life as a "strange, ritualistic play" in which his hysterical rantings were required by "the script that goes with his destiny." Norman Mailer wrote extensively and with romantic passion of the young boxer as a "six-foot parrot who keeps screaming at you that he is the center of the stage. 'Come and get me, fool,' he says. 'You can't, 'cause you don't know who I am. You don't know *where* I am. I am human intelligence and you don't even know if I'm good or evil.'" Of the distinctive, idiosyncratic Cassius Clay style, his trainer Angelo Dundee said in an interview:

> He wasn't a guy who was led easily. You've got to remember the intricacies of training this kid. You didn't train him like the usual fighter. He resented direction, so I used indirection. I cast the illusion of him doing something when he wasn't. To get him to do what he should be doing.
>
> ["We Never Saw Muhammad Ali at His Best"]

What any boxer "should" be doing is winning, and Cassius Clay was perhaps no more inventive or flamboyant than he needed to be to rack up victory after victory to ever-increasing public acclaim.

Consider the first, shocking title fight with Sonny Liston (shocking because the seven-to-one underdog Clay won so handily and the seem-

ingly unbeatable champion ignominiously quit on his stool after six rounds): the younger boxer simply out-boxed, out-punched, out-danced, out-maneuvered and out-psyched his older opponent. What an upset in boxing history, on February 25, 1964! This fight is fascinating to watch, like a dramatized collision of two generations/two eras/two cultures; a fairy tale in which the audacious young hero dethrones the ogre exactly according to the young hero's predictions.

Yet what controversy followed when Cassius Clay announced that he was changing his debased "slave" name to "Muhammad Ali"; he'd been converted to the black militant Nation of Islam (more generally known as the Black Muslims) and was "no longer a Christian." With remarkable composure, the young athlete who'd seemed so adolescent was publicly and courageously re-defining himself as *black*. As virtually no other black athlete of great distinction had done, Ali was repudiating the very white political, social, and economic Establishment that helped create him. As, three years later, he would yet more provocatively define himself as a conscientious objector who refused to be inducted into the U.S. Army to fight in Vietnam, with the punitive result that he would be stripped of his title and license to box in the United States. (Interesting to note that the majority of white publications, including even *The New York Times*, as well as television commentators, refused through the 1960s to acknowledge Ali's new, legal name; as if the former Cassius Clay hadn't the right to change his name to Muhammad Ali—or to any name he chose. It might have been the quixotic hope that if they refused to sanction "Ali" in the media, his allegiance to the Nation of Islam, if not to *blackness* itself, might simply fade away.)

Between February 1964 and his ascension to heavyweight champion and April 1967 when he was forced into an involuntary exile, Ali successfully defended his title nine times. Widespread white disapproval of his new identity didn't discourage boxing fans from attending his spectacular fights. Among these, the May 1965 rematch with Sonny Liston proved even more disappointing and, for Liston, more ignominious, than the first fight: this time Liston quickly went down in the first round and stayed down, felled by what many boxing commentators saw as a "mystery punch" of Ali's that put Liston out of the fight even as an enraged Ali, adrenaline pumping, screamed for him to get up and fight.

(Did Liston throw the fight? Did Liston so fear Ali, he couldn't fight? The sight of Liston lolling on the canvas recalls the similarly fallen— and feigning?—Jack Johnson who lost his heavyweight title to the White Hope Jess Willard in 1915 in the twenty-sixth round of their marathon match. Yet Angelo Dundee would claim to have seen the punch, "a good right hand to the temple my guy threw from up on the balls of his feet . . . He was out. He was definitely out.") Liston, be- lieved to be mob-connected, would be found dead in 1970 in Las Vegas, allegedly of a drug overdose, possibly of murder. One of the shabbier and more sordid episodes in America's *noir* sport.

Other title defenses of Ali's, however, were hard-fought and legiti- mately won by the champion; brilliant displays of boxing to reach their zenith in November 1966 in a match with the veteran Cleveland Williams, as Ali, ever in motion, ever flicking his unerring left jab at his frustrated opponent, moving head and shoulders with the seemingly ca- sual aplomb of a dancer, unleashing the Ali shuffle, knocked Williams down several times with multiple punches before knocking him out in the third round. What deadly grace, what lethal beauty in motion! And what a mystery Ali's quicksilver ring style would have been without slow-motion replays! In great displays of boxing, as in few other sports, the unaided eye is simply inadequate to catch, let alone register and in- terpret, crucial moves. If there is a single fight of Ali's that best exhibits his "float like a butterfly, sting like a bee" style, it's this fight with Cleve- land Williams. And, unlike the great fights to come in the 1970s, this fight is short.

Soon afterward, Ali's early dazzling career would come to an abrupt end. Increasingly controversial as a result of his public commitment to the Nation of Islam (which was regarded by many whites and some blacks as a black-racist cult), Muhammad Ali drew a maelstrom of censure when, in April 1967, he refused to be inducted into the U.S. Army and, besieged by the media, uttered one of the classic, incendi- ary remarks of that incendiary epoch: "Man, I ain't got no quarrel with them Vietcong." He would be found guilty of "knowingly and un- lawfully refusing induction" in a Federal court in Houston, Texas, and given, by an elderly white judge, the stiffest possible sentence: five years in prison and a $10,000 fine. (Ali's mentor Elijah Muhammad served just three years for urging his followers to resist the World War II draft.) There would be years of appeals, enormous legal bills and continued

controversy, but Ali would spend no time in jail. Neither would he be allowed to box in the prime of his fighting life, a melancholy loss acknowledged by Angelo Dundee—"We never saw Muhammad Ali at his best." Not only did boxing commissions refuse to sanction the undefeated heavyweight champion to box, but the State Department, in a repressive tactic bringing to mind the persecutions of Charlie Chaplin and Paul Robeson in the 1950s, revoked Ali's passport so that he couldn't fight abroad.

1971–78. The Return. The Superfights. Then, with fairy-tale logic, as the Vietnam War wound down, a bitter and yet unresolved episode in our history, and the tide of public opinion shifted against the military, the U.S. Supreme Court overthrew Ali's 1967 conviction and he was reinstated as a boxer. Like a rogue elephant exiled to the periphery of his world yet always conscious of, and always uneasily observed by, that world, Ali returned in triumph—almost!—to reclaim his title. In this seven-year period belong Ali's greatest fights, and to say that they were unanticipated is not to disparage the younger boxer but to extol the older. In the intensely fought, physically exhausting fights with Joe Frazier and George Foreman, Muhammad Ali proved himself a great, and not merely a gifted and charmed athlete. After three and a half years of not boxing, though only twenty-nine, Ali was conspicuously slower and knew better than to dance away from his opponent; he would have to compensate for his lost agility with sheerly boxing (and punching) technique; he would have to train to take, and not exclusively give, punishment. That this was a deliberate strategy is important to note. As Ali said in an interview in 1975:

> I don't train like other boxers. For instance, I let my sparring partners try to beat up on me about eighty percent of the time. I go on the defense and take a couple of hits to the head and the body, which is good: You gotta condition your body and brain to take those shots, 'cause you're gonna get hit hard a couple of times in every fight. Meanwhile, I'm not gonna beat up on my sparring partners . . . If I kill myself punching at them, it'll take too much out of me. When you're fightin' as much as I have lately, you're supposed to be boxin' and doin' something every day, but I can't dance and move every day like I should, because my body won't let me. So I have to stall my way through.

If this sounds like a recipe for disaster it was also, for Ali, in the short run at least, a recipe for success. Indeed, it is the game-plan for the remainder of Ali's career, the strategy that would win him two of his epic fights with Joe Frazier and the legendary Foreman fight in which, miraculously, or so it seems, the younger, stronger and seemingly more dangerous Foreman would punch himself out on Ali's stubborn body in eight rounds, to relinquish the heavyweight title another time to Ali. As Ali's doctor at that time, Ferdie Pacheco, said:

> Ali discovered something which was both very good and very bad. Very bad in that it led to the physical damage he suffered later in his career; very good in that it eventually got him back the championship. He discovered that he could take a punch.

And take punches Ali did, for the next six years.

The great, extravagantly publicized matches of this period of Ali's career belong with the great sports events of all time. Frazier-Ali I (1971) (which attracted more viewers than any boxing match in history), Ali-Frazier II (1974), Ali-Frazier III (1975), and Ali-Foreman (1974) would seem to inhabit an archetypal realm of the spirit that transcends most sports events. The perilous, cathartic heights of Greek and Shakespearean tragedy come to mind when we consider these draining fights in which even the winners are irrevocably altered. (After fourteen rounds of the "Thriller in Manila" with Frazier in 1975, Ali, the winner, nonetheless described the experience as "The nearest thing to death.") Not surprisingly, these epic boxing matches excited media interest and drew to Ali's camp numerous commentators, some of them famous in themselves (like George Plimptom, Norman Mailer), who would spend more than a month in Zaire for the Ali-Foreman fight. (See the Academy Award–winning documentary *When We Were Kings,* and Norman Mailer's highly stylized coverage *The Fight.*) Not just Ali's stoical courage as an athlete, but Ali's ingenuity drew such attention. For even the aging Ali was a meta-athlete who conceived of his public appearances as theater, not merely, or wholly sport; Ali was a superb athlete, but he was also a superb actor, exhibiting "Ali" to the acclaim of millions. Watching Ali in what we might call his aging prime, we are reminded of Jean-Paul Sartre's remark *Genius is not a gift, but the way a person invents in desperate circumstances.* There is something of the

con-man in Ali, and his game is to make us want to believe in his inde-
structibility, even as, perhaps, Ali doesn't, or can't, believe in it without
qualification himself. Consider the Foreman fight. In *When We Were
Kings*, Foreman is repeatedly "dissed"; he is the opponent whom we are
invited to scorn, because he is not Ali, our hero. (In a sense, there is room
for only one boxer in the ring, if that boxer is Ali. He won't play fair in
seeking an audience's attention.) As in a fairy tale of heroes and villains,
Foreman, for all his gifts, is the villain. Even as we watch this astonishing
fight between an aging Muhammad Ali and a young and vigorous
George Foreman, reputedly one of the hardest-hitting heavyweight
punchers of all time, we are mystified: how did Ali do it? Granted even
his superhuman will, how did his body withstand such repeated, relent-
less blows? The Rope-a-Dope strategy is the very triumph of purposeful
masochism; yet such triumph inevitably carries with it irretrievable loss.
(Would Ali have wished to win over Foreman had he been able to antici-
pate his physical and mental deterioration—his "Parkinsonianism"—of
later years?) Wittily titled, the "Rumble in the Jungle," as if it were but a
cartoon or comic-book event, this fight which returned his title to him
surely contributed to Ali's taking into his body the "nearest thing to
death."

Following these remarkable fights, Ali would exult in being again
"King of the World"—"The Greatest." He had secured his position as
the most famous athlete of the 1970s, and perhaps of all time. He had
traded his health, it would develop, but such a trade would perhaps have
seemed worth it, at the time. Unlike the only undefeated heavyweight
champion in history, Rocky Marciano, Ali fought worthy opponents,
most of them younger than himself. He would defend his hard-won title
several times, against such opponents as Chuck Wepner, Ken Norton
(who would break his jaw), Jimmy Young (who would break his
eardrum), and Ernie Shavers; unexpectedly, he would lose on points to
the young Leon Spinks (with only seven pro fights to his credit) in 1978.
Though Ali would beat Spinks in their rematch, and announce his retire-
ment, he would be unable to resist returning to the ring; two years later
he would be beaten decisively, and painfully, by his former sparring part-
ner Larry Holmes. By this time Ali was thirty-eight and long past his
prime; his career had in effect ended with the 1978 loss to Spinks.

1978–1981. The Twilight Epilogue. Yet like many another former
champion (Louis, Ezzard Charles, Ray Robinson, Ray Leonard, Roberto

Duran et al.) Muhammad Ali would continue to fight, if not to box with any degree of his former talent. His final match, sanctioned not in the United States but in the Bahamas in crude, unprofessional surroundings (a cowbell was used in place of a defective ring bell) was with a mediocre twenty-eight-year-old Trevor Berbick who easily outscored a slow, heavy, plodding Ali on points. For there is a point at which even the ingenuity of desperation fails. (Berbick would have the distinction in 1986 of being spectacularly floored in the second round of his title defense by boxing's new prodigy, Mike Tyson, who would formally end the "post-Ali era.") As the English sportswriter Hugh McIlvanney noted, "Graceful exits are rare in professional boxing but few great champions have gone out more miserably than Muhammad Ali."

In 1981, this time permanently, Ali would retire with a record of 56 wins, 5 losses. But even in the waning years of his career he would be an emblem of the courage and stoicism of the aging athlete, so much a part of our contemporary scene. (Ironically, it would be Ali's old opponent George Foreman who would return to the ring as a "mature" boxer and captivate, in another era, the attention, and affection, of millions of viewers.)

He who was once the icon-breaker is now an icon.

Interview quotations and other material used in this essay have been drawn from *The Muhammad Ali Reader* edited by Gerald Early (Ecco Press, 1998); *In This Corner: Great Boxing Trainers Talk About Their Art* edited by Dave Anderson (Morrow, 1991); and *McIlvanney on Boxing* by Hugh McIlvanney (Beaufort Books, 1982).

IV.

(Re)Visits

The Vampire's Secret

(Re)viewing Tod Browning's
Dracula after Forty Years*

T HE PERVERSE IMAGES TO WHICH MEM-
ory accrues!

In this timeless and utterly silent void, very like the pit of darkness at
the base of the brain that opens, in sleep, to draw us through, there
moves the sombre, elegant, impeccably groomed figure of Count Drac-
ula: unnaturally white face, gleaming black hair, demonically luminous
eyes. And there is the large, hawklike, dreamily fluttering bat, no ordi-
nary creature but a concentration of malevolent intelligence or will. And
the graceful if inexplicable ballet of bridal-gowned female figures, Drac-
ula's trio of beautiful, mute wives who like their master rise from their
coffins when the sun sets. The conspicuously setting sun, too, is a strong
image, if more abstract—the surrender of the day's (reason's?) power to
control the forces of evil—evil "nature"—that surround us. And of
course there is the potent image of Christian sanctity, the Crucifix, from

*I'd first seen Tod Browning's *Dracula* when I was eleven or twelve years old, sometime in
the 1950s; I would not see it again until 1990, when I was invited to contribute an essay to
David Rosenberg's exuberantly titled *The Movie That Changed My Life* (1991), when I
was fifty-two.

which Dracula and his vampire-disciples shrink as if it were a blinding beacon of supernatural light.

Dracula as film and *Dracula* as novel: the "triumph" of Christianity over, as we say, the forces of evil. (Are all horror stories thus constructed, to provide us with this "triumph"?—the classic stories at least, before even genre became self-reflexive.)

In Tod Browning's *Dracula,* in which the celebrated European actor Bela Lugosi made cinematically immortal the mythopoetic figure of Bram Stoker's Dracula, all is enacted against a background of utter soundlessness: except for the sweetly seductive opening bars of *Swan Lake,* as the credits come on, the film has no musical score, no distractions from its spare, poetic, highly charged dialogue. (The film was made shortly after sound came into moving pictures; the further concept of providing sourceless music as background, to disguise a too-silent theatrical atmosphere, had not yet occurred to filmmakers.) In this, *Dracula* more resembles a dream than most surreal or fantastic films. Dream-like too, and eerily suggestive of that stylized, unvarying ritual that is the Catholic mass, is Dracula's every movement, premeditated as a dancer's, or, indeed, a Catholic priest's. The unfolding of fantastic events as if they were decreed by Fate is ideally suited to such silence, for rational comprehension is hardly the point here, only this emblematic experience, both primitive, as life feeding on life is primitive, and sophisticated, for, unmistakably, Bela Lugosi in evening dress and cape, the most studied and articulate of villains, *is* sophisticated. As Werner Herzog has said, what is film but an "agitation of mind." To subject it to intellectual analysis, let alone academic analysis, may be to misapprehend its true nature, and to endanger our openness to its magic.

Yet analysis is always a temptation, especially analysis many years after an initial experience. It may tell us, along with things we want to know, some things we don't.

SEEING THIS classic *Dracula* for only the second time in my life, a remarkable sixty years after it was made and released, and nearly forty years after I'd first seen it, in the long-razed Rialto Theatre in Lockport, New York, I am struck at once and during the days following by a storm of images—emotions—haphazard and teasing shreds of memory—it has stirred. Perhaps for many of us, for Americans of my generation most of all, it is film,

thus the visual/aural, that has the power of Proust's *madeleine* to summon forth memory. Not the privacy of narcissism, the taste in the (child's) mouth, but the communal awe of the darkened, hushed, churchlike movie theater, especially those movie theaters of old, that seemed to us places of legitimate wonder, and, indeed, were built to promote that fantasy; that swoon of expectation. *Dracula* plunges me into an obsessive consideration, not simply of the film, and the now-mythopoetic Dracula, and the novel of 1897 (which I first read in the early 1950s, no doubt immediately afer having seen the re-issued film, and have subsequently taught in university courses, and written about, in an essay titled "Wonderlands"); not simply of the ingenuity of its bold conceit (which has to do, in short, as for instance Lewis Carroll's *Alice* books in their entirely different way, with the nightmare evoked by Darwinian theories of survival of the fittest and natural selection, morally repugnant to Victorian traditionalists), but of countless seemingly forgotten personal matters, anxieties of my own, and revelations too, small quirky bits of no possible interest to anyone but myself, or perhaps my parents; indeed, incomprehensible to anyone else. (For instance, it is fitting that I saw *Dracula* at the Rialto Theatre, not the Palace: the Palace, on Main Street, formerly a vaudeville house, had loges, velvet draperies, mock-Egyptian ornamentation, even a pastoral mural on its high, high ceiling, and was, in a modest way, "palatial"—but the Rialto was small, unglamorous, in its later years frankly shabby, back off Main Street on the corner of Pine and Walnut, a place of second-rate Hollywood movies, re-issues, cowboy and Tarzan serials, children's Saturday matinees that transformed the place into a monkeyhouse. The Rialto was, in every sense of the word, *back-street*.) Perhaps because I've seen the film during a period of personal stress, when, as it's said, "ego defenses" are lowered, I feel unusually vulnerable to such incursions from the unconscious, from that shadowy region of the brain where our oldest memories reside.

The most striking insight the film has left me with—though now that I've seen it again, how transparent, obvious—is that the figure of Count Dracula as played so coolly by Bela Lugosi *is* priestly; his formal evening wear, high starched collar, ankle-length black cape suggest the vestments of a Catholic priest, as do his carefully choreographed movements, the precision with which he pronounces words, enunciates syllables, as if English were a language foreign to him—as of course it is. And what resonance in this, for, in Catholic ritual, the priest celebrating the mass drinks "the blood of Christ" (diluted red wine) out of a chalice, as the congregation prays, in

the moments before the dramatic (to some, those who truly believe, intensely emotional, sometimes intimidating) sacrament of Holy Communion, during which the communicants come forward to the altar rail, kneel, clasp their hands, tilt their heads slightly backward, shut their eyes and open their mouths and, discreetly, extend their tongues an inch or two so that the priest can place the consecrated wafer on the tongue and murmur, in the past in Latin, *Hic est corpus Christi*: This is the body of Christ.

We were instructed to allow the wafer to dissolve—never to chew it.

We were instructed it *was* the body of Christ, Who had died on the cross for our sins.

We would be instructed, in time, if our curiosity had a theological bent, that, indeed, the communion wafer must not be confused with a mere "symbol" of the body of Christ, it *is* the body of Christ: that's how we Catholics distinguish ourselves from Protestants, forever.

As I've indicated, if you were a Catholic, especially a young Catholic, who unquestionably believed in this miracle—in technical theological terms, the "transubstantiation of the Eucharist"—going to communion was not a casual matter. Not only outward behavior during the hours between Saturday's confession and Sunday's communion must be strictly regulated (you must fast, for instance, from midnight onward, regardless of how late a mass you attended on Sunday), but your every thought, and this means micro-, nano-, and wholly involuntary thoughts must be regulated. A single impure thought, profaning communion, could plunge you into mortal sin; if you died in a state of mortal sin you would go to hell, where your soul would be in torment forever.

Did I ever believe?—*can* anyone believe such things? I am tempted for romantic reasons to argue that, yes, I did believe, I was a true Catholic in those days, but in fact I remember myself too skeptical even as a child, a habit of mind I've inherited from my father; in church in particular I was too restless in my thoughts to pay strict attention to the mass—church was a place for cinematic day-dreams, an enforced calm. I could never make myself seriously believe that, in taking communion at the altar, beside the other communicants, I was being given the body and blood of Christ: this is a gulf, trivial to the non-Catholic, immense to those who have grown up in Catholic surroundings, that separates me as a former Catholic from other former Catholics, including my husband, who did believe.

Not that Roman Catholicism is the only religion in which "ritual cannibalism"—vampirism?—is or has ever been practiced. It is simply the

most elaborately reasoned of religions, the most politically powerful and traditional; the most "aesthetic." The very religion against which the Middle European "Nosferatu" (Romanian for "Un-Dead") of legend defined themselves, in opposition, as damned souls, or souls that would be damned, if their Christian adversaries could catch them unprotected during the day, in their coffins, and drive stakes through their hearts.

MY OTHER insight into the probable reason that *Dracula,* the film, made such a strong impression on me as a child has to do with the fact that Bela Lugosi, in his ethnic exoticism, reminded me of my grandfather John Bush, my mother's adoptive father, who had emigrated from Budapest to the Black Rock (Hungarian) neighborhood of Buffalo in the early 1900s. Grandpa Bush!—the very stereotype, physically, of the brawny, deep-chested blacksmith, a steel foundry worker as well, fond of hard cider and hand-rolled, foul-smelling cigarettes (Old Bugler was his tobacco); hardly a figure of Austro-Hungarian nobility, still less fin-de-siècle decadence of the kind so persuasively embodied by Lugosi.

My grandfather never saw Bela Lugosi on the screen, so far as I know—never went to the movies at all. Unlike my Grandmother Bush, he was able to read English, but his reading was constricted to the newspaper. At the time of the re-issuing of *Dracula* he was a worn-out, prematurely exhausted man though only in his sixties, soon to die of what would now be called an occupation-related condition (emphysema). It was Grandpa's wedding portrait that suggested his ethnic kinship with Lugosi, the set of the eyes, the heavy arched brows, the thick stiff black hair, a portrait taken when he was in his early twenties, and dashingly handsome, Magyar-exotic.

This old wedding portrait, long lost, of which I find myself thinking, so strangely and sentimentally haunted by, these days following my viewing of *Dracula* on our VCR.

ANYONE OPTING to see a movie after forty years risks discovering that the movie will prove disappointing, if not embarrassing. Nothing is ever as we remember it, for the very act of remembering is a kind of fiction, a selecting. And any film last seen in childhood will have altered considerably in the intervening decades.

In terms of contemporary film, certainly Tod Browning's *Dracula,* despite its classic status, is melodramatic and stagey. It seems, at times, rather more of a filmed stage play than a movie. Its presentation of visual horror, in contrast to the more subtle psychological horror which prose fiction can render, is a considerable challenge which, perhaps, the film doesn't meet. My initial response to this re-viewing is that the film moves too swiftly at the outset; did early audiences comprehend the vampire exposition handily flung out at them, by frightened Transylvanian peasants, on the eve of Walpurgis Night? (The eve of May day when witches were believed to emerge.) In a mode very different from the mock-Gothic, detail-heavy and systematically digressive novel by Bram Stoker, which is narrated from the viewpoint of numerous diarists and letter-writers, the film reveals its shocking secrets within the first few minutes, so that there is never any suspenseful doubt about the bestial nature of Count Dracula: we observe him and his three beautiful wives, dressed as for a formal evening, rising from their coffins amid a nervous scuttling of spiders and rats. Just what we've suspected of aristocrats! This famous scene is both unnerving and elegant as a ballet. How disturbing it must have been to a child like myself, unfamiliar with the conventions of vampire lore; for, if there is anything forbidden about adults in the night, in their beds, in privacy and secrecy, this vision of Dracula and his wives rising from their coffins would confirm it.

Amateur filmmaking—bluntly-edited scenes, abrupt shifts of perspective, transitions so clumsy they appear surreal—heighten the otherworldly effect of Browning's film. We see the initial movements of an action (Dracula rising from his coffin, for instance), then the camera cuts elsewhere, then back, and now Dracula is standing composed as if he's been there all along. The monster's later metamorphoses from bat to man—a bat hovering in the opened French windows of a young woman's bedroom—are equally striking. (If one doesn't peer too closely at the "bat" hovering in mid-air.)

The subliminal message is: Blink just once, and the vampire stands before you.

The film *Dracula* differs substantially from the novel, having been adapted from the popular play (in which Bela Lugosi made his debut as Dracula, learning his English dialogue phonetically); it has little of the novel's ponderous resonance but an air, in the concluding scenes in particular, of being under-rehearsed and under-written. Instead of Jonathan

Harker visiting Castle Dracula for business reasons we have the luckless Renfield, quickly overcome by his sinister host, and, by way of a blood-sucking scene we are not permitted to see (the screen fades discreetly as Dracula stoops over his fallen prey as in a homoerotic fantasy) becomes a slave of the vampire's for the remainder of his life. Back in London, after the storm-tossed channel crossing (a not-very-convincing "storm" sequence even by the standards of 1931), Renfield becomes the "zoöphagous" patient of the asylum director Dr. Seward; the man is mad, exhibiting the grimaces, grins and twitches that are the cinematic clichés of madness, yet he's mystically enlightened and even at times eloquent: his impassioned talk of life, life devouring life, life sucking sustenance from life, is a crude distillation of Darwinian theory, disturbingly contrary to Christianity's promise of spiritual redemption/bodily resurrection. In the film, Renfield devours flies and spiders to provide him with "blood"; in the more subtle novel, he feeds flies to spiders, feeds spiders to sparrows, and one day astonishes his keepers by eating the sparrows raw, and alive. Renfield's finest scene in the film is a speech of radiant madness made to Dr. Seward and Van Helsing, a report of Dracula's Luciferian promise to him: " 'Rats! Thousand of rats! All these I will give you, if you will obey me!' "

Life everlasting, as Christ has promised: *I am the resurrection and the life: he that believeth in me, though he were dead, yet shall he live.* (John 11:25.)

Once Dracula has relocated to London and becomes acquainted with the beautiful young women Lucy Westerna and Mina Seward, Dr. Seward's daughter, the tale becomes an erotic fantasy in which the Stranger—the Non-Englishman—seduces one too-trusting woman, and then the other, beneath the noses of their male keepers. (The men are Dr. Seward, Mina's fiancé Harker, and the scientist Van Helsing, a precursor of the "wise scientist"—as distinguished from the "mad scientist"—without whom horror and science-fiction films could scarcely exist.) The erotic triangle is a recognizable one: the "good" (gentlemanly, proper, Christian) man and the "evil" (sensuous, duplicitous, ethnically exotic, un-Christian) man compete for Woman (virginal, Christian and of the proper social class). Woman in herself is naturally passive and childlike; perhaps a bit stupid; the contest is solely among men of varying degrees of enlightenment and courage. Van Helsing emerges the victor, saving Mina for his friend Jonathan Harker; in another mode of the fantasy, Van Helsing would marry beautiful Mina himself.

In the novel, Lucy Westerna's seduction/victimization/gradual death is the focus of much narrative concern; in the movie, the young woman is dispatched quickly, after a single visualized nocturnal appearance of Dracula in her room. Lucy's subsequent career as a vampire (who preys upon small children) is sketchily treated, and the extraordinary scene in the novel in which Van Helsing and his friends drive a stake into her heart, in a lurid, prurient mock-rape, is omitted entirely. (So violent, brutal, erotically charged, and, indeed, horrific a scene could scarcely have been filmed in 1931, though it would be a delight for our special-effects movie technicians to prepare today.) So abstract is this *Dracula* in its depictions of vampire-assault and ritual vampire-killing, so greatly does it depend upon dialogue summary, it might be possible for an uninformed or a very young viewer to miss the point altogether. What *are* those people in evening dress doing to one another?

It is the subtle, suggestive, disturbing *appeal* of the vampire that makes of the Dracula legend a very different fantasy from, for instance, that of the werewolf or the golem (Frankenstein's monster being a species of golem), whose grotesque physical appearance is sheerly repugnant and could never be construed as "seductive." The most insidious evil is that which makes of us, not victims, or not victims merely, but accomplices; enthusiastic converts to our own doom. The way of the vampire is the way of an absolute addiction—for the taste of blood one might substitute virtually any other substance, legal or otherwise. One of the special strengths of the vampire, Van Helsing warns in the film, is that people will not believe in him—"rational" people—but it is primarily women who resist believing in his evil; like Lucy Westerna (whose name is transparently obvious—she suggests "Westernization," rebellious female doubt of patriarchal tradition), who becomes a vampire, and Mina Seward, who, but for the zeal of her male protectors, would have succumbed to the same fate. The beautiful blond actress Helen Chandler plays the role of Mina in the film as convincingly as one might do in so circumscribed a context; her one animated scene, when she is infused with a bit of Dracula's rich, centuries-old, Transylvanian blood, shows her surprising and exciting her staid English fiancé with an unexpected erotic intensity otherwise absent from the film. The struggle is not really between the forces of good and evil, nor even between Christianity and paganism, but between "propriety" and "the forbidden."

Dracula is, on the surface at least, a resolutely chaste film. If lovely fe-

male bodies are violated by Dracula, the actions are never visually depicted; no skin is punctured; the "two small holes" said to be discovered on the throats of victims are never shown. In the novel, Dracula's wives speak lasciviously of their bloodsucking as "kisses"—the most voluptuous scene in the entire novel occurs in Castle Dracula, as a beautiful young female vampire stoops over to "kiss" the semi-conscious Harker ("I closed my eyes in languorous ecstasy and waited—waited with beating heart")—but in the film Dracula's power seems primarily that of the master hypnotist, eyes gleaming, fingers outstretched like talons, capable of bending others to his will. His stylized movement as he bends toward a victim's throat only symbolically suggests a kiss, and only a psychoanalytic theorist, committed to seeing sexual imagery in all things, could argue that the vampire's "kiss" is a metonymical displacement for rape, or any physical, genital act. Is the vampire's "kiss" simply a "kiss"?—not on the lips, which might signal both complicity and adulthood, but on the throat, as a child is kissed, blessed, with no expectation of a response? Certainly the vampire legend, like many such classic-horror legends, has about it the air of the nursery. At their cores, these are cautionary tales for the infant in us all.

I note in passing how truly oblique this 1931 *Dracula* is: in a film in which blood is so crucial, no blood at all is ever shown on screen, except when Renfield, in Castle Dracula, accidentally cuts his finger as Dracula stares hungrily.

THE TRUE horror of Dracula, as I've suggested, lies in the man's will. He has an uncanny ability, which Bela Lugosi makes credible, to mesmerize his victims, thus to make them want *him*—this, one of the vampire's secrets, that the virtuous victim, who is us, can so readily be transformed into the evil accomplice-disciple. (As movie-goers are "seduced" by screen actors and actresses—otherwise, why movies at all?) Not mere destruction of the sort other, ugly, "monstrous" villains threaten, but the awakening of desire in the victim; an unholy, loathsome, yet clearly enormously exciting complicity in being damned. Civilization is a structure of artfully coded taboos, and taboos entice us to violate them, if for no other reason than to rebel against our parents, teachers, spiritual leaders who have indoctrinated us, or tried to, into the accumulated wisdom of the tribe. There is a yet more pernicious, be-

cause so romantic, sense that Dracula's interest in a woman is a consequence of her beauty. The most beautiful woman is the most desired woman, the most desired woman is not killed, but made a bride: this is her, and (our?) reward.

It's a matter of social class, too. The hapless little flowergirl, a street vendor, is a victim of Dracula's, but, unlike Lucy and Mina, *she* is merely killed. No mystery why.

The wish that desire of a brutal, primitive, Darwinian sort be rooted in physical attractiveness, thus in our individuality— this is surely one of mankind's most tragic, because infantile and enduring, fantasies, the secret fuel of sado-masochistic relations, in life as in art. To be raped—to be murdered—to be devoured—because we are *irresistible*: what solace! That we might simply be devoured, as Renfield devours his flies, for the "life" in us, and at once forgotten, is too terrible a truth to be articulated.

Art, by its selectivity, is always a matter of fabrication: thus its great value, its solace. *Lie to us,* we beg of our cruder fantasies, collective no less than private.

"THERE ARE far worse things awaiting man than death."

Dracula's enigmatic remark, made in Dr. Seward's drawing room, passes virtually unheard in that context, though it is perhaps the most disturbing idea in the Dracula-legend. In other versions of *Dracula,* for instance Werner Herzog's 1978 remake *Nosferatu the Vampyre,*[1] the isolated and tragic nature of the vampire is explored; the vampire is less villain than suffering victim of a curse; an oblique kinship is suggested between Dracula and the rest of humanity—for aren't we all blood-drinkers?—carnivores?—don't we all, in a myriad of ways, prey upon one another? This, the vampire's most startling secret, allows us to feel a tug of sympathy for Dracula, seeing that he is not really immortal or supra-natural, but trapped in flesh, condemned to forever feed upon the warm blood of living creatures. Tod Browning's film is of course a conventional one structurally, and does not explore this theme. As the film moves to its prescribed ending, scenes are accelerated, condensed; there is a chase scene of a sort, Dracula with Mina in his arms, Van Helsing and Harker in pursuit; as Dracula lies helpless in his coffin, Van Helsing, unassisted, quickly dispatches him with a stake through his heart, and

the story is over. Fear has been aroused, fear has been protracted, fear is now banished: THE END *is* truly the end.

Strange, and revealing of the habits of mind to which we are all heir, that images that may endure in the memory for decades can be discovered, upon a re-examination, to have been strung out like beads on an invisible yet always palpable "plot"—the tyranny, not just of genre, but perhaps of film generally. Its great, raw, even numinous power resides in *images*; its weakness is virtually always narrative, *plot*. There is a new theory of dreaming that argues that dream-images are primary, culled from the day's experiences or from memory and imagination; the dream itself, as a story, is a pragmatic invention to string together these images in some sort of coherent causal sequence. If this is true, it argues for an even closer relationship between film and dreaming than film theorists have speculated upon.

BUT *Dracula* isn't "the movie that changed my life"—there is no movie that changed my life. Though my imagination thrilled to film, no movie of my childhood or early adolescence made nearly so much of an impression on me as the books I'd read, and re-read (and may have tried to imitate).

Film, requiring an incalculable technology, would have seemed to any creative child of the era wholly beyond reach. But a book, held in the hand, finite, composed of inexpensive materials—it had seemed to me from earliest childhood that one could *make a book*.

Unlike books, however, films, comprised of images, among them the enormously inflated faces of men and women, have the power of lingering in the memory long after all intellectual interest in them has been exhausted. Nostalgia is sentiment; sentimentality; the "over-evaluation of the loved object" (Freud's churlish definition of romantic love). To be haunted by images out of one's remote past is possibly a form of self-love, preferable at least to self-loathing. *Why was I so moved by these images? What do these images mean?* Once we pass the proximate age of thirty-five we seem to be involved in a ceaseless, sometimes bemused and sometimes desperate search for the "self" we used to be, as if this might be a way of knowing who and what we are now; as if there was some integration of the psyche in the past, some mysterious wholeness now missing. (How doubtful that is.) Yet this re-viewing of a movie I hadn't

seen in forty years has become, for me, a kind of conduit into the past, which deflects me from analyzing it in mercly intellectual terms. I'm tugged by memory, as by gravity, to the old Rialto Theatre at the corner of Pine and Walnut Streets, Lockport, New York (where the city center hasn't changed very much, in the intervening decades, due partly to economic depression); as if these early memories are fated always to be stubbornly rooted in time, place. Especially place.

Like my earliest memories of prowling the countryside, abandoned houses and forbidden places, these memories of a child/young adolescent familiar with the streets of Lockport, now a student at North Park Junior High School in an outlying neighborhood of the city, seem to involve no "self"—no "person"—at all. It's as if I were an invisible presence, a floating optic nerve, avidly taking in what I saw, making no critical judgment, or none that I can remember; certainly no aesthetic judgment on a film like *Dracula*. (I don't even recall if I saw it alone or with friends. My sense of myself in those years is that I was nearly always alone. Is this true? Or memory's selectivity, the purposeful exclusions of "art"?) The film endures in my memory, but the girl who saw it has vanished.

Notes

1. Herzog's brilliantly cinematic remake is of the 1922 classic of the German silent screen, F. W. Murnau's Nosferatu. After writing this essay, I arranged to see the Murnau film, which is, as its reputation would have it, a remarkable work—a German translation of the very English Stoker novel into Gothic-folkloric terms, set in Bremen's old quarter, and with an opening sequence in Dracula's castle that makes comparable scenes in Browning's film seem stagey and low-budget by contrast. The Murnau Dracula is a bat only partway metamorphosed into a man, and is both comically ludicrous and terrifying; where, in Herzog, he acquires a tragic grandeur of a kind, in Murnau he is simply a monster, sub-human. Set beside this bizarre work of 1922, Browning's Dracula would be a distinctly inferior accomplishment apart from Bela Lugosi's performance, which sets a standard beside which all other vampire performances are invariably measured. (Frank Langella's Dracula of the 1970s is a sensuous-sophisticated remake in which the vampire is distinctly human, accursed like the Flying Dutchman, and perversely romantic in his fate. The break with the earliest Draculas, that of Stoker and Murnau, is complete.)

Don DeLillo's *Americana* (1971) Revisited

Young Man at the Brink of Self-Destruction (Review of *Americana*)

THE DUST-JACKET INFORMATION ABOUT Don DeLillo states only that he was born and lives in New York City, and that *Americana* is his first novel. A mysterious figure, therefore, when one considers the sophistication of this work—which is amazing for a first novel indeed.

Americana is about the wild and flamboyant disintegration of a young man, and his partial redemption. It is an ambitious, very readable recollection of a confused life, the narrator is evidently telling his own story to himself in a kind of exile on a Mediterranean island.

The narrative technique sometimes suggests the jumbled nature of his experiences, yet it is beautifully executed. There are patches of writing in this book that are really striking.

Superficially, *Americana* looks rather conventional. It brings together a number of preoccupations of American writers, especially young writers: the baffled assessment of one's family and, beyond that family, the American tradition (which is disintegrating); the rejection of the commercial, here represented by a bizarre group of television network exec-

utives; the pilgrimage to find the self, which takes the form of a lively "open road" sequence that begins in the East, ends somewhere in Texas, and ends ultimately on the island off the coast of Africa. But DeLillo has given to these themes a miraculous freshness. Nearly every sentence of *Americana* rings true, an insistence upon the authenticity behind the stereotypes of American life. DeLillo is a man of frightening perception.

David Bell is twenty-eight, though he seems both younger than twenty-eight, and older. He is a television executive working for a network that seems to be made up of utter madmen, and he is doing fairly well. DeLillo's satiric and comic sequences involving the television executives are brilliant; you understand that anyone who does well in this work, as David does, must be in bad shape. Much has been done with the craziness of American image-making and merchandising, but no one has done better than DeLillo, and yet this is only a small part of the concerns of his novel.

David is the son of a preposterously successful and enthusiastic advertising man and a strange, mystic, half-crazy woman who refuses to allow herself to be treated for cancer. David's mother, dead when the novel begins, is the center of his story, the magical core toward which he is constantly moving.

David's mother has said that "magic overwhelms everything" and that this magic renders the individual insignificant: David tries to re-create that magic in order to redeem himself, to prevent his own suicide.

The action of *Americana* covers only a few weeks, during which David attempts to put his life on film. He starts out on a cross-country trip, has some peculiar adventures, works on the film, which will eventually run a full week's time, trying to "explore parts of my consciousness" by a "certain juxtaposition of movies with realities."

If *Americana* comes to no completion, suggests no solution for its young hero's problems, it is only fulfilling its own promise of exploration without entrapment. It is a robust and intellectually exciting work, suffering only the usual defects of such writing—sequences that go on for too long, running on their own manic energy.

DeLillo is to be congratulated for having accomplished one of the most compelling and sophisticated of "first novels" that I have ever read.

Them
Revisited

THE POETIC EPIGRAM FROM JOHN WEB-
ster's tragedy *The White Devil* asks, ". . . because we are poor/Shall we
be vicious?" This is the question to which the novel *them* provides an ex-
tended answer.

Them is also imagined as an American epic in domestic terms, for
what is life, in essence, but an epic adventure? We set sail without know-
ing where we will end up; our destinations are more likely to be random
than chosen; of such chance, we hope to fashion Destiny. Yet the fact re-
mains, especially in youth, that anything can happen; and the exhilarat-
ing adventure of life is that, possibly, it will. *Them* is the chronicle of the
Wendalls, a family of distinctly American adventurers. There's an imme-
diate breathlessness to the narrative that begins with dreamy sixteen-
year-old Loretta on the eve of losing her virginity to her young lover,
losing her young lover to a bullet fired by her brother, yet gaining a hus-
band within the space of a few desperate hours. Even before Loretta
moves to the thunderous city of Detroit, there's a sense of urgency in the
very air, wayward and hopeful and hungry, the hunger for life, life at any
cost, in the face of virtually any risk. The percussive beat of a crude and
prospering American city runs through *them*: the fever pulse of Motor

City, U.S.A. (as Detroit was known at the time) and less formally, Murder City, U.S.A.

As violence is a kind of romance, bound up with the energies of youth, so romance is itself a kind of violence, a storm of the senses. For all its grittiness and the sordid depths to which Jules Wendall sinks in the months preceding the "race" riot of July 1967, *them* is a valentine to the Detroit of those vanished years; Detroit at the peak of its economic power, the quintessential American city; the world capital of motor vehicle manufacturing; to its inhabitants, a rhapsody of chemical-red sunsets, hazy-yeasty air, relentless eye-stinging winds; new-constructed expressways cutting through old, settled neighborhoods with the destructive fury of cyclones; over-passes, railroad tracks and shrieking trains, factories and factory smoke, the choppy, usually gunmetal-gray and greasy-looking Detroit River, the daunting length of Woodward Avenue out to Eight Mile Road and Ferndale, the first of the "white" suburbs; wide, littered Gratiot Boulevard, Grand River Avenue, John R., Outer Drive, Michigan, Cass, Canfield, Second Avenue, Third Avenue, Highland Park, Jefferson, Vernor, Fort, Jos. Campau, Dequindre, Freud (pronounced exactly the way it looks, "frood"), Beaubien, Brush, Randolph, Livernois, Six Mile, Seven Mile, Fenkell. Fenkell! Such blunt syllables, such spondees, are the very music of this Midwestern city; former inhabitants recite them together like poetry. How like an exiled ghost I continually revisit Detroit, prowling these streets, doomed to seek— what? The elusive treasure that Jules, Maureen, and their plucky mother Loretta sought without knowing what name to give it?

The essence of a place and a time. That magical conjunction of one's self and the larger, communal, mystical and unknowable soul.

THEM WAS intended as the third and most ambitious of a trilogy of novels exploring the inner lives of representative young Americans from the perspective of "class war"—a taboo subject in supposedly apolitical literary quarters. (But the term "war" in this context is only metaphorical—isn't it?) *A Garden of Earthly Delights* (1967) and *Expensive People* (1968) are the predecessor novels, the first set in various parts of the rural United States and in western New York and the second set in an affluent Detroit suburb called Fernwood. By 1971, however, the trilogy became a quartet: *Wonderland* thematically ends the informal series,

moving in time beyond the era of *them* and into the yet-uncharted, apocalyptic America of the late Vietnam War period when the idealism of anti-war sentiment had turned to cynicism and the counter-culture fantasy of egalitarianism and "love" had self-destructed. The original title of *them* was *Love and Money,* an ironic variation on such classic titles as *Pride and Prejudice, Crime and Punishment, The Red and the Black* (whose class-conscious hero Julien Sorel is a less idealistic, greedier and crueller Jules Wendall but clearly a spiritual kinsman), and it must have been that in the course of immersing myself in the Wendalls' lives, I saw that the title was too rawly thematic and reductive. For *them* is as much an ode to the American dream of re-visioning and re-making the self, the inexhaustibly pliant self, as about the conquests of love and money. The title *them* came to me as inspiration, with its sly suggestion that there is in fact a *them* and an *us*; in our democratic nation, a category of *them* at whom we can gaze with pity, awe, revulsion, moral superiority, as if across an abyss; a *them* not entirely civilized, yet eager to "rise" in class; a *them* that constitute the ideal, impressionable, ever-naive and ever-hopeful consumers of American dream-products. The *them* of the novel are poor whites, separated by race (and racist) distinctions from their near neighbors, poor blacks and Hispanics.

Of course as the daughter of rural-dwelling, working-class Americans, born at the end of the Depression, who'd grown up on a small and not very prosperous farm in western New York State, I felt an absolute allegiance with *them*; my presumption of *us* is ironic. Jules Wendall speaks for me at the novel's conclusion, chiding his sister Maureen who hopes to be saved by disappearing into the middle class, ". . . Aren't you one of *them* yourself?"

Few of *them*'s readers since its publication in 1969 have been *them,* because *them* as a class doesn't read, certainly not lengthy novels, but many of the novel's readers over the decades have been the daughters and sons of *them,* whom I think of as my spiritual cousins and whom I meet repeatedly in my travels: we're the first in our families to graduate from high school, to graduate from college and to enter, often with deeply ambivalent feelings, the enormous American professional class. All that distinguishes us is whether our parents are proud of us, or whether our "rise" in some way hurts and diminishes them. It's an irony of twentieth-century American social history that we who've been *them* must redefine ourselves as the properly prosperous American *us*. For

African-Americans whose parents or grandparents were Southern share-croppers, and whose ancestors were slaves, the leap across the abyss is particularly dramatic since it involves as well a conscious cultivation of a new "white" language. Yet we survive: Maureen in a Detroit suburb, pregnant and terrified of losing what she's gained (another woman's husband); Jules somewhere in California, confident that his violent, criminal life has been exorcised by the fires of the Detroit riot—"Every-thing that happened to me before this is nothing—it doesn't exist!—my life is only beginning now."

RE-READING THE Author's Note to *them,* decades after having com-posed it, I'm stunned at the author's assumption that an astute reader would recognize these earnest words as fiction; a postmodernist ap-pendage meant to guarantee the "reality" of an obvious work of artifice. In the 1960s, when literary experimentation was itself a convention, playful and mock-deceptive but in the service of a higher or more essen-tial truth, the Author's Note to *them* may or may not have been generally interpreted as the author intended, but by the end of the twentieth cen-tury, in an era of memoir and memoirist fiction, it would surely be inter-preted literally. And yet there can be no expectation of literal truth in the realm of the novel. As we approach the gravitational field of any work of the imagination, we must grant how reality begins to bend: even what is "real" will be transformed into something rich and strange, else the artist has not made it her own.

For all literary styles are conventions, and all literature is artifice; we may easily recognize myth, legend, fantasy, as a mode of art "not real" but symbolic; we are less likely to recognize the very art of realism as a convention, an authorial stratagem. When we choose to write in the re-alist mode, we hope for a *trompe l'oeil* effect by means of which both reader and writer suspend disbelief and accept without question the ar-tifice under creation. (Does it seem surprising that the writer must con-vince him- or herself, too? In fact, this is the first and most difficult stratagem in the creation of any art-work.) To make the ideal reader be-lieve not only in the verisimilitude of the writer's endeavor, but in its originality, worth, and "symbolic" significance; to make oneself as writer/reader believe; this is the great challenge of any effort of art, though it is rarely acknowledged or discussed. In composing *them,* I

drew upon source materials close at hand, for I knew much of Detroit intimately by the time of the outbreak of the riot in July 1967, and I saw how a novel might be structured that would lead, as in a vortex, to this cataclysmic event, beginning many years before in an entirely different era, before even World War II. It was happenstance that my husband and I were living in a residential neighborhood bounded by Seven Mile Road to the south and Livernois Avenue to the west that was at the periphery of looting and burning; I was subjected, like hundreds of thousands of other Detroit citizens, to every emotion associated with such social tumult, which registers in the mind as a break in sanity itself. *What is happening? How can this be happening? Will we be killed? Who will protect us?* In fact, the Michigan National Guard moved in to protect property and lives in this, the northwestern section of Detroit; the heart of the violence was miles away near the ghettoized, long impoverished core city of Detroit, as distant from the Caucasian/Jewish northwest sector as if it were in another country, but a country now become militant and crazed. Yet a stinging sulfurous smoke-haze would hang over the city for days, in the grip of a heat wave; the stink of burning things would seem to pervade the remainder of our lives in Detroit, and no one who lived through, or even near, the 1967 riot would ever feel that Detroit was a "safe"—or even "sane"—place in which to reside. (We too moved away, in 1968, to live for the next ten years in a kind of exile from America, across the Detroit River in Windsor, Ontario, Canada, where my husband and I would both teach at the University of Windsor.)

In the depiction of the riot and its aftermath, *them* was intended to be historically authentic, as in its surreal-documentary tracking of Detroit geography and the Land-of-Oz suburb of white privilege, Grosse Pointe, where Jules Wendall falls irrevocably in love. There's a brief cinematic sequence in Part III in which Maureen Wendall, lost in dreamy thoughts of plunder and appropriation, walks in the affluent residential neighborhood above Six Mile Road and the University of Detroit campus where I, too, walked, contemplating those large beautifully tended brick homes with their suggestion of idyllic lives within, seeing them with Maureen's yearning eyes; for though I was now living in one of these very houses, I yet felt a deeper allegiance with my fictitious character than I did with myself; such walks replicated the walks I'd made regularly as a young girl in certain affluent neighborhoods of Lockport, New York; feeling, like Maureen, not envy exactly, and not hatred, but "something like love."

Yet there are aspects of *them* that are, if not precisely un-real, less real than others: the Author's Note, for instance, about which I've been asked frequently. Of course, it does bear a glancing relationship to reality, but only a glancing relationship. I did teach English at the University of Detroit in the years 1962–67 and I did teach night school students who might have resembled "Maureen Wendall"—but of course Maureen is my invention, and her "voluminous" recollections and letters are my invention; my invention too, and a risky stratagem it certainly seems to me now, is the fictitious "Miss Oates" whom Maureen conjures up in her inevitably biased memory, as the night school instructor who gave her a failing grade. (I was not, in fact, "Oates" at the University of Detroit, but always "Smith": Joyce Smith, or Professor Smith. What is strange to me now is that in 1968–69 I would fantasize an earlier teacher-self unlike me in my actual classroom methods, one who would "fail" a student without much explanation and apparently little sympathy; a "Miss Oates" who drove the black Volkswagen my husband and I owned at that time, and who much admired Flaubert's *Madame Bovary* but was, in conspicuous ways, an entirely different person. The motive here, I think, must have been to suggest by this distorted portrait that the "Oates" in the novel isn't the historical "Oates"; yet, in so meticulously creating the portrait, as a curious masochistic re-appropriating of one's own now defenseless past self, I succeeded in displacing the historical "Oates" entirely; if I read these passages unskeptically, I naturally assume that the portrait is "Oates"; if "Oates" is me, this "Oates" must once have been me; though I'm reasonably sure that I wasn't this person, as I know that Maureen Wendall never lived, yet Maureen's testimony is so convincing, how can I doubt it . . . ? Aesthetically, such stratagems can't be faulted, for the imagination is boundless after all, and everything within the covers of a work of fiction is fiction; but morally, or perhaps practicably, this displacement of "reality" by an invention is of ambiguous worth. In more recent years, in such diverse works of fiction as E. L. Doctorow's *World's Fair,* Philip Roth's *Deception,* Paul Theroux's *My Other Life,* and others, protagonists boldly bearing the names of their authors similarly blur the line between reality and authorial invention.) So plausible was the Author's Note to *them* and so apparently convincing the characters of Maureen and Jules, readers still write to me asking me to forward mail to them; at readings, I'm asked how Maureen and Jules "are"; years ago, a woman wrote lengthy, emotional letters

confessing her love for Jules, though she insisted she wasn't unhappily married; an irascible, rather gullible reviewer fulminated in print, when *them* received the 1970 National Book Award, that the author didn't deserve the award because *them* wasn't fiction but "real." (How naive in any case, the notion that "reality" by itself can create a structure of language, *an artifice,* out of the very air, with no human agent involved.) With the passage of time I've come simply to say that the characters of *them,* like most of my fictional characters, are "composites": myself, and others. And this is so.

As a chronicler of American lives I have sometimes been criticized for not more explicitly judging my characters or indicating what the "moral" or message of my work is. Does *them* condone violence, theft, deception, the "viciousness" of the poor? Is Jules Wendall the pimp/murderer a hero? Can victories be salvaged out of the ruins of others' lives? These are questions the writer may ask herself, to which the work of fiction provides a complex, perhaps tragic answer. To immerse oneself in others' souls is an act of sympathy, however, and not censure; *them* is in fact a work of love, and like all those who love I have no wish to set myself up as a judge. A novel's meanings may be as myriad as its readers.

—1999

A Garden of
Earthly Delights
Revisited

"DARE YOU SEE A SOUL *AT THE WHITE*
Heat?"—this striking opening of one of Emily Dickinson's most enig-
matic, and perhaps most personal poems (#365), has always seemed to
me an ideal metaphor for the passion of writing. To experience the
White Heat is not at all the same as comprehending it, still less control-
ling it. One is "inspired"—but what does that mean, exactly? One is em-
powered, thrilled, fascinated, exhilarated and, in time, exhausted; yet
one can't be at all certain of the value of what has been created for oth-
ers, or even for oneself. Especially, the early white-heat-driven works of a
writer come to seem to the writer, over the passage of years, mysterious
in their origins, brimming with the energy of a youth not yet discour-
aged or daunted or even much aware of how any ambitious work of art
might be received by others. All writers look back upon their early cre-
ations with envy, if not always unalloyed admiration: how much strength
infused us then, for our having lived so briefly!

A Garden of Earthly Delights was originally written in 1965–66, pub-
lished in 1967, and has remained in print more or less continuously, as a
mass-market paperback in the United States and more recently as a Vi-
rago "Classic" in England. Yet, in rereading it, in preparation for the
Modern Library edition, which seems, in some quarters, a kind of can-

onization of a text, I was dissatisfied by it, and undertook a new edition in the summer of 2002. As a composer can hear music he can't himself play on any instrument, so a young writer may have a vision he or she can't quite execute; to feel something, however deeply, is not the same as possessing the power—the craft, the skill, the stubborn patience—to translate it into formal terms. In preparing *them* (1969) for a similar Modern Library edition in 2000, I rewrote some sections of that novel, revised others, and trimmed here and there, but did not feel the need to rewrite approximately three-quarters of the novel, as I have done here. In re-examining *Garden,* I saw that the original narrative voice had not been adequate to suggest, still less to evoke, the complexity of the novel's principal characters. The more complexity we acknowledge in others, the more dignity we grant them. The Walpoles—"Carleton," "Clara," "Swan"—were in fact far more than fictitious characters to me in 1965 to 1966, yet I failed to allow their singular voices to infuse the text sufficiently; the narrative voice, a version of the author's voice, too frequently summarized and analyzed, and did not dramatize scenes that were as vivid to me as episodes in my own life. The Walpoles are strong-willed individuals not unlike those with whom I'd grown up, or had known about as a child in an economically distressed farm community in western New York in the 1940s and 1950s; they are quirky, unpredictable, wayward, self-aggrandizing and self-destructive, with distinct and idiosyncratic voices of their own, and would be resentful of their stories being "told" by another. Though a social analyst might diagnose the Walpoles as victims of a kind, the Walpoles certainly would not see themselves in this reductive way, and as their chronicler, I have no wish to portray them as purely victims either.

Composing the original version of *A Garden of Earthly Delights* in 1965 to 1966 was very like my experience in composing *Expensive People* a year later: as if I had poured gasoline on my surroundings and lit a match to it and the flames that leapt madly up were somehow both the fuel of the novel and the novel itself. These "white heat" experiences are like waking dreams, consuming one's imagination, utterly fascinating, exhausting. The novel-to-be springs into a visionary sort of life like something glimpsed: an immense mosaic, a film moving at a swift pace. You "see"—but can't keep up with that pace. The novel opens before you like a dream, drawing you into it, yet it's a dream in which you are somehow participating, and not merely a passive observer. So swift and ob-

sessive was the original composition of *A Garden of Earthly Delights* for the young writer in her mid-twenties, it didn't dawn upon me, preposterous as it must sound, that "Carleton Walpole" might have been partially modeled upon my paternal grandfather, Carlton Oates; it did not occur to me that my grandfather, whom I had never met, an apparently violent and often abusive alcoholic who had abandoned his young family to destitution in Lockport, New York, in the early 1920s, and whose name was never spoken in our household, might have acquired a mythic significance in my unconscious, if one believes in "the unconscious" as a putative wellspring of creativity. If I had been asked why I'd named my character "Carleton" I would have had no answer except that it had sounded appropriate. (Readers have told me over the years that "Carleton" is a likely name for a man born in the Kentucky hills, whose ancestors emigrated from England in the previous century.) Only when I read biographical material about my family, in Greg Johnson's 1998 biography of my life titled *Invisible Writer* did the connection seem obvious, like the similarity between "Clara" and "Carolina" (my mother's name). How opaque we are to ourselves sometimes, while transparent as crystal to another!

Of course, a literary work is a kind of nest: an elaborately and painstakingly woven nest of words incorporating chunks and fragments of the writer's life in an imagined structure, as a bird's nest incorporates all manner of items from the world outside our windows, ingeniously woven together in an original design. For many of us, writing is an intense way of assuaging, though perhaps also stoking, homesickness. We write most avidly to memorialize what is past, what is passing, and will soon vanish from the earth. No more poignant words have been uttered than William Carlos Williams's lines *With each, dies a piece of the old life, which he carries . . .* ; if I had to suggest a motive for metaphor, certainly for my own decades'-long effort in the creation of metaphor, it would be something like this. A novel is so capacious, elastic, and experimental a genre, there is virtually nothing that it can't contain, however small and seemingly inconsequential. *A Garden of Earthly Delights,* my second novel, and my third book, is, like my first novel, *With Shuddering Fall* (1964), crammed with "real" life, predominantly landscapes and incidents, only slightly altered.

Migrant farm workers were often seen in western New York when I was growing up, especially in Niagara County, which is mostly orchard

and farmland. Seeing these impassive-looking men, women, adolescents and children being driven along our country roads in battered buses, I wondered at their lives; I could imagine myself among them, a sister to the young girls. (The migrant workers I saw were predominantly Caucasian.) I grew up on a small family farm in Millersport, where the crops required picking by hand: pears, apples, cherries, tomatoes, strawberries. (Eggs, too, another sort of hand-picking.) Months of our lives were given up to "harvesting"—if we were lucky and had something to harvest—and I can attest that little romance accrues to such farm work, still less to sitting self-consciously by the side of the road at an improvised produce stand hoping that someone will stop and buy a pint, a quart, a peck, a bushel basket of your produce. (Early conditioning for the writer's solitary yet cruelly exposed position in a capitalist-consumer society!) In re-reading *A Garden of Earthly Delights* I was surprised that relatively little first-hand picking experience is included; entirely missing is the kind of picking I did most, on ladders positioned in fruit trees, that could be treacherous. (Not just your shoulders, arms, neck and legs are strained, and not just you might fall, but you're easy game for stinging insects like bees and horseflies.)

My early editors at Vanguard Press were offended by the frequent profanities and crudeness of speech of the characters of *A Garden of Earthly Delights,* objecting particularly to Clara's speech. For even as a girl, Clara can be forcefully crude. Yet to me, such speech was more or less commonplace; not so much within the home (though my father Frederic Oates, sharing some of the characteristics of the fictitious Carleton, was not what one would describe as a speaker of genteel middle-class English) as outside, overheard as adult and adolescent speech. Strange to admit, the crude language of the characters in much of my fiction strikes a nostalgic chord with me; even the sudden flaring-up of bad temper and violence common to a world of the economically deprived doesn't seem to me ugly or morally disagreeable, only just authentic. In such worlds, men in particular speak and behave in certain "manly"—"macho"—ways. (How different—very different!—from the seemingly civilized world in which I have dwelled since 1978, in Princeton, New Jersey, where such mild profanities as "hell" and "damn" strike the ear as strident; as out of place as sloppily guzzling hard cider from a jug would be, in the way of Carleton Walpole.) Can one be nostalgic for a world in which, in fact, one would not wish to live, as for incidents one

would not wish to relive? The stab of emotion I feel at recalling my one-room schoolhouse in Millersport, so very like the schoolhouse Clara Walpole briefly attends, is difficult to analyze. I would not wish any child I know to endure such experiences, yet I could not imagine my own life without them; and I think I would be a lesser, certainly a less complex, person if I had been educated in a middle-class community, or had grown up in a supremely civilized community like Princeton. (It was in the schoolhouse and its desultory "playground" that I first grasped the principles of what Darwin might have meant by the strife of species, the strife of individuals within species, and the phenomenon of "survival by natural selection.") I did not live in a family so haphazard and impoverished as Carleton Walpole's, but I knew girls who did, among whom was my closest girlhood friend—who survived to become an individual of remarkable integrity and resilience. Though such terms as "survivors"—"victims of abuse"—have become clichés in our time, these terms did not exist in the era of *A Garden of Earthly Delights*; they have sprung from more liberal sentiments. In the past it was not uncommon in some quarters for men to beat their wives and children, and to remain morally as well as legally blameless. Sexual harassment, sexual molestation, and rape were not uncommon, but there was no adequate vocabulary to define them, and it would have been a rare case reported to police and a yet rarer case taken seriously by police. *A Garden of Earthly Delights* is a wholly realistic portrayal of that world, but it isn't a novel about victims so much as the ways in which individuals define themselves and make of themselves "Americans"—which is to say, resolutely not victims.

A Garden of Earthly Delights was imagined as the first of an informal trilogy of novels dealing with disparate social classes, focusing upon young Americans confronting their destinies. Though in my short fiction of the 1960s I rarely explored social and political themes in depth, focusing instead upon intimate emotional and psychological experiences, in my novels I hoped to evoke much larger, more grandly ambitious landscapes. My models were Balzac, Stendhal, Dickens, Flaubert, Mann, and Faulkner. When I moved to Detroit, Michigan, in the early 1960s—I would live there through the July 1967 riots, and beyond through months of exquisite civic tension—I was galvanized to believe that the writing of a novel should be more than a purely private, domestic, or even, contrary to the reigning Nabokovian imperatives of the day, apolitical and aesthetic; I wanted my novels to be realistic portrayals of individuals unique

in themselves and yet representative of numerous others of their genera-
tions and social classes. (Strange, that I had not read Dreiser! Not until
decades later would I read *An American Tragedy* and the more capably
executed *Sister Carrie,* whose resilient protagonist might have been an
older cousin of Clara Walpole.) My early fiction had been set in a some-
what surreal/lyrically rendered rural America ("Eden County") sug-
gested by my own background ("Erie County") in western New York;
after moving to Detroit, I began to write about individuals in cities,
though their ties, like my own, might be rural. I seem to have made an
early, curious identification with "Swan Walpole" since an incarnation
of this Hamlet-like character ("Hamlet-like," I mean, in my then-young-
writer's imagination) appears in one of my first-published stories "In the
Old World," a co-winner of the *Mademoiselle* short story competition
while I was an undergraduate at Syracuse University in 1959. In re-living
Swan Walpole's life, in my rewriting of much of *A Garden of Earthly
Delights,* I see him as a kind of alter-ego for whom the life of the imagi-
nation (he's a bookish child, in a world in which books are devalued) is
finally repudiated, as it was not, of course, for me, but rather more my
salvation, if "salvation" isn't too melodramatic a term. Swan is burnt-
out, self-loathing, and finally a suicide because his truest self has been
denied, and that "true self" would have been a writer-self, an explorer of
cultural and spiritual worlds. I would not have known in 1965 to 1966
how this young man's experience would parallel the ways in which
America itself would seem to have repudiated, in the 1970s, 1980s, and
1990s, even into the morally debased and economically ravaged twenty-
first century, a further loss of innocence of this nation at such odds with
its own ideals and grandiloquent visions. *Swan, c'est moi!* (But only in
fantasy.)

IN THIS new edition, which is slightly longer than the original, the prin-
cipal characters Carleton, Clara, and Swan are more directly presented.
The author's intention is not to narrate their stories so much as to allow
the reader to experience them intimately, from the inside. Though there
are no first-person passages or experimental sleights-of-hand, of a kind I
would employ in *Expensive People* and *them,* the Walpoles speak more
frequently; we are more frequently in their heads; lengthy expository
passages have been condensed, or eliminated. Very little in the plot has

been altered, and no new characters are introduced or old characters dropped. Clara and Swan move in their original zigzag courses to their inevitable and unalterable fates; Carleton moves more swiftly to his, a self-determined fate that more befits the man's character. In the new *A Garden of Earthly Delights* Carleton is acknowledged as more heroic than I had seen him originally, when I was so young. Clara is more sympathetic, and Swan more subtle and capricious in his spiritual malaise. (Swan and I share a predilection for insomnia, but not much else.) I knew little of nursing homes in 1965 to 1966, and now in 2002 I know all too much about them, since my elderly, ailing parents' experiences in the past several years, so the conclusion of *A Garden of Earthly Delights* is particularly poignant to me. How chilling a young writer's prophecies seem in retrospect! If we write enough, and live long enough, our lives will be largely *déjà vu,* and we ourselves the ghost-characters we believed we had created.

The effort of the rewriting was not to alter *A Garden of Earthly Delights* but to present its original characters more clearly, unoccluded by an eager young writer's prose. They seem to me now like figures in a "restored" film or figures seen through a lens that required polishing and sharper focusing. What remains is the chronicle of the Walpoles, my initial attempt at an "American epic." The trajectory of social ambition and social tragedy dramatized by the Walpoles seems to me as relevant to the twenty-first century as it had seemed in the late 1960s, not dated but bitterly enhanced by our current widening disparity between social classes in America. *Haves* and *have-nots* is too crude a formula to describe this great subject, for as Swan Walpole discovers, to *have,* and not to *be,* is to have lost one's soul.

—2003

On the Composition of *I Lock My Door Upon Myself*

FROM THE HIGH-PROWED, GRANDLY ugly iron bridges of my childhood whose rattling plank decks or, worse yet, open metal grid decks had the power to terrify, I would observe individuals at a distance in small boats, rowing, "bucking the choppy waves" as in the opening scene of *I Lock My Door Upon Myself,* and in the reprise of that scene in Chapter 35, and was seized with a sense of mystery underlain with apprehension: who were these strangers, these adults so confident, or perhaps so reckless, in their secret lives; what had brought them to this, that seemed to me as a child, and perhaps still seems to me, a romantic action, a gesture that might be playful, or adventurous, or simply what one does, living in the vicinity of a river? As a child I grew up virtually on a bank of the Tonawanda Creek, and within a few miles of the Erie Barge Canal and the notoriously treacherous Niagara River; even the canal, placid for much of its length through the countryside became, in Lockport, New York, where formidable locks allowed the waterway to drop sixty feet within a short distance, a scene of hissing, churning, cascading power. These very different waterways coursed through the fevered imagination of my childhood, and have found their inevitable place in much of my fiction and some of my poetry. All my upstate New York novels are traversed by canals, rivers,

creeks, like arteries. What these waterways "mean" is impossible for me to say.

For where works of non-fiction tend to begin with ideas, if not arguments, works of the imagination tend to begin with images. You find yourself "haunted" by something you've seen, or believe you have seen; you begin to create, with varying degrees of consciousness and volition, an entire world around this image, a world or more precisely an atmospheric equivalent of a world, to contain it, nurture it, enhance it, "reveal" it. But the revelation is likely to be purely emotional, purely *felt*.

IN MY exile of a kind in Princeton, New Jersey, where I wrote, in intervals of fevered inspiration, the forty-four prose pieces that make up this novella, in the spring of 1989 and in the emotional aftermath of my long novel *Because It Is Bitter, and Because It Is My Heart,* I was light-years from its origins; I was farther from the "Chautauqua River Valley" and from "Milburn, New York" than I could ever have imagined myself when I'd lived in the real-life equivalents of these regions, as a girl. (These are rural, northern Erie County and southern Niagara County, specifically a small farm in a crossroads called Millersport, New York.) In Princeton, I evoked upstate New York and the past; not my past exactly, but a past known to me through my parents and grandparents, by way of whom it had acquired a semi-mythical, legendary aura. Approximately, this is the world of my parents Carolina and Frederic Oates, who were born in 1916 and 1914 respectively; it's the world, too, of my father's mother, Blanche Woodside, who was not a recluse but whose life has always fascinated me, in its mystery and willful, perhaps even tragic subterfuge. (My grandmother was not Calla Honeystone, though Calla Honeystone is, for me, an emblem of my grandmother.) For the writer, family secrets throb with intensity and heat; you may never know what the secret literally *is*, only that it exists beyond your childhood comprehension. Obsessive speculation about family secrets has fueled many powerful works of fiction and poetry, where very likely the outright revelation of mere fact might have killed inspiration at its source.

All intensely realized works of the imagination are generated by personal emotion, personal experiences; but these are generally so encoded in the final work, given a formal resonance so lacking in real life, that the art-work breaks free of its biographical origins and comes to seem, even

to the creator, autonomous. Ours was not especially a family of secrets, yet all families harbor memories too painful, too embarrassing, perhaps too bizarre to be spoken of freely, and so they become not-acknowledged, and by degrees not-known. *I Lock My Door Upon Myself* is an attempt to replicate the fascination of contemplating a family secret, and its frustration. We want so desperately to *know*—what? Others' lives are forever veiled from us, we can only hope to honor them in their complexity and remoteness.

I LOCK MY DOOR UPON MYSELF is formally bracketed by two images: the rebellious lovers in a rowboat on the swift-flowing Chautauqua River, bent upon romantic self-destruction; and the children returning home from school along a country road in the early dark, in winter, carrying lanterns that resemble, from a distance, fireflies. The one is an image of self-consuming passion, the other an image of reassuring conformity, predictability. The river image is swift-moving and lethal, the lantern image seems to promise the comfort of a kind of ritual, that will be repeated. Both images, of course, are ephemeral, and have happened, as Calla Honeystone tells her granddaughter, "a long time ago."

Henry James described the novella as the "blessed form." It is also a very difficult, even hazardous form, neither a novel in miniature nor a pumped-up short story, but something quite distinct, if indefinable. My sense of the novella is that of a rapturously extended prose poem driven by a narrative; the more suspenseful the narrative, the more dreamlike and obsessive the atmosphere of the novella. All prose fiction aspires to make the reader think *This is real!* but to succeed in this, the writer must so hypnotize him- or herself, must so wholly enter the atmosphere of the fiction, that he or she believes utterly in its reality. The ideal for fiction, it has always seemed to me, is to render physical settings (landscapes, cityscapes, houses, interiors) with such oneiric clarity, you never doubt their actual existence, and enter them as if they were your own. As a fiction writer I'm unable to write, nor even to wish to write, without a vividly evoked visual world. For what would be the pleasure of it, what would be the point? Writing is transmitting by way of language a kind of reportage of emotion, and emotion must be linked to its specific place, time, drama. Otherwise it's merely notional, and can't move us.

The cover art, Fernand Khnopff's masterpiece of Belgian surrealism whose full title is *After a Poem by Christina Rossetti: I Lock My Door Upon Myself* (1891), is rather more Pre-Raphaelite in its symbolism than Upstate New York, yet the atmosphere, the mood of resigned introspection, and the brooding young woman herself, are beautifully evocative and expressive of Calla Honeystone's strange fate. Mutinous in girlhood, a celibate and a recluse in adulthood—who could imagine such a reversal of expectations? Yet in the "old world" of rural upstate New York it wasn't so rare that women and men of older generations might live out decades of their lives within a single household, just as it was fairly common that people lived out their entire lives within the radius of a relatively few miles, never leaving home, in a sense. There were tales of individuals—not exclusively women, but mostly women—who became recluses (the clinical term today would be "agoraphobics") and who never left their houses voluntarily. Calla Honeystone isn't an agoraphobic, and I didn't intend her portrait to be a psychopathological one, exactly. She withdraws from the world out of hurt, anger, stubbornness, and a need to do penance, but her isolation seems to her granddaughter to be a sign of "madness"—by which the granddaughter, the narrator, really means the distance between herself and Calla, an unnavigable leap across an abyss.

"It was a happening"—as Emily Dickinson's younger sister, Lavina, said of the poet's gradual withdrawal from life outside her father's household in Amherst, Massachusetts, that has become so much a part of literary American legend. Biographers have quoted a niece of Dickinson who recounted how the poet took her upstairs to her bedroom and made a gesture as if locking herself in with her thumb and forefinger closed on an imaginary key, saying, "It's just a turn—and freedom, Matty!" So too Calla Honeystone might have summed up her life of interior exile—*just a happening* that nonetheless strikes us as utterly mysterious yet in some way emblematic of all of our lives.

—May 2002

Private Writings, Public Betrayals

THERE IS NO MORE POIGNANT MOMENT
in American literary history than that recorded by Nathaniel
Hawthorne in June 1853, when he was forty-nine and had been married
to his wife Sophia since 1842:

> I burned great heaps of old letters and other papers a while ago,
> preparatory to going to England. Among them were hundreds of
> Sophia's maiden letters—the world has no more such; and now they
> are all ashes. What a trustful guardian of secrets fire is! What should
> we do without Fire and Death?
>
> [from *The American Notebooks*]

When I first read this passage, imbued with the romance of adolescence,
I wanted to protest: How could Hawthorne have burnt his wife's irre-
placeable letters? With no sign of regret, remorse, or loss, Hawthorne
had so revered his fiancée when they were courting, he was said to wash
his hands before touching her letters, and he considered them "too sa-
cred to be read in the midst of people." (See Arlin Turner, *Nathaniel
Hawthorne: A Biography*.) For her part, the genteel Sophia, after
Hawthorne's death, scrupulously excised from his letters anything of a

private, amorous, sensuous nature, inking out all references to bosoms, kisses, pillows, arms. (These chaste excisions scholars, in their zealous scholarly way, have long since restored, with no mind for Mrs. Hawthorne's wishes.) The Hawthornes' devotion to each other, and to the idealized image of each other they presented to the world, would seem to be a powerful rebuke of the debased and exploitative nature of intimacy in our time in which lovers routinely betray each other in salacious "memoirs" (the most despicable of which must be James Hewitt's memoir of his love affair with Princess Diana, at a time when Diana was distraught over her failing marriage with Prince Charles) and by the peddling of intimate love letters (the most recent, fourteen letters by J. D. Salinger, written in the 1970s to his much-younger lover Joyce Maynard, auctioned off by Sotheby's in June 1999). No doubt, through the millennia lovers have betrayed one another, but the mass-marketing of such betrayals, at high prices, is a relatively new development in what we call civilization.

Romance is a turbulent surf that, withdrawing, leaves behind a tangle of debris in its wake. Without the shimmering aura of love, mere words can be . . . mere words, and embarrassing. Without the stratagems of art, which are rarely spontaneous and unmediated, even the most heartfelt utterances not only sound banal, but are banal. It may have been that the consummate artist Nathaniel Hawthorne, re-reading his wife's "maiden" letters, decided to burn them as much for aesthetic as for personal reasons; for nothing leaves us more exposed and vulnerable, like a mollusc pried out of its shell, than heartfelt declarations, especially when examined by a neutral eye. It's a rare love letter like those dashed off by Virginia Woolf to her flamboyant lover Vita Sackville-West, which are likely to be as brilliant as her prose, or those teasingly enigmatic little notes composed by Emily Dickinson for her more intimate friends, both female and male, that transcend the ephemeral occasion of their composition and endure as art. Usually, love letters are painful to read, especially after love has died; should we succumb to the temptation to read them, we are made guilty voyeurs. The collector who buys Salinger's letters will require, like all voyeurs, a convincing rationalization for his or her behavior.*

The issue of private writing and public writing, and the distinction between them, is fundamentally an ethical one, and like most ethical issues

*In fact, these letters of J. D. Salinger, purchased at auction by an anonymous bidder, were returned to Salinger in a heartening gesture of gallantry.

in this Era of Law it's become a legal conundrum; in the absence of any consensus regarding "ethical" behavior, whether it's the right to die, or abortion rights, or the right to privacy, we turn to the law. Usually, as in this instance, the law is confusing and contradictory. Under American copyright law you own the words you've written in a personal letter; but the letter recipient owns the physical piece of paper and the symbols typed or written on it. (In a controversial ruling by a Federal appeals court in Manhattan, handed down when Salinger sued a prospective biographer in the mid-1980s to block him from so much as paraphrasing Salinger's letters, the very essence or idea of a letter can be copyright, a radical interpretation of the law.) The paradox is that while one is forbidden to publish any letter without the letter-writer's permission, or the permission of his or her estate, one can sell the letter itself; it can be offered for auction at Sotheby's, which involves not only a public auction but a public exhibit of the private letter preceding the auction. One might argue reasonably that such a public exhibit constitutes "publication," for doesn't it violate the writer's rights over his or her material, assuming that these rights have been protected by the law? The complications are endless, a battlefield rife with spoils for ambitious lawyers.

When Lord Byron broke off their scandalous love affair, Lady Caroline Lamb took a delicious revenge in her roman à clef *Glenarvon* by writing about the affair and including, thinly disguised, Byron's love letters to her. (It was Lady Caroline who said famously of Byron that he was "mad, bad, and dangerous to know," which could not have failed to increase her sales.) More cruelly, Robert Lowell included intimate letters from his wife Elizabeth Hardwick, from whom he was separated, in his book of poems *For Lizzie and Harriet*; the poet's defense of such exploitation as of his confessional art generally was the blunt query, "Why not say what happened?" (Why use one's imagination to disguise personal history in the time-honored guise of art?) Anyone who confides in any writer risks being transmogrified into art if he or she is sufficiently interesting; the best protection is to be dull, bland and predictable.

Writers must write out of passion, and the more powerful the passion the more powerful the drive to write. The considerate, canny writer is one who disguises his source material.

Conversely, anyone with a modicum of a public identity must know that he or she is continually at risk in behaving impulsively in this rapacious era of memoirs, taped conversations, and wiretaps; to commit

one's most intimate feelings on paper, in letters, is the height of naïveté, or hope. Immanuel Kant's great moral imperative—that we should behave at all times in such a way that our actions might constitute an imperative for all human beings—might be modified as a warning: we should assume that any confidence made to anyone, verbally or in writing, no matter in what private, precious circumstances, will possibly be betrayed, if only inadvertently. When personal letters of mine written to a former friend were first offered for sale, some years ago, I reacted with shock, hurt, and disappointment; and embarrassment, that I seem to have made a fool of myself, in writing openly and impulsively (and without revising) to one who thought so little of me, and may have intended exploitation from the first. (These were not love letters. They were appeals to be understood, made to a former friend who'd not only turned against me for having resisted his demands that I advance his literary career by writing highly favorable reviews of his work, but who had at first elliptically and then openly threatened my life. I was confronted with the dilemma we all face in such circumstances: to take the threat seriously? not to take the threat seriously? to somehow seem to take the threat seriously, while not really taking it seriously? to try to believe what seems frankly unbelievable?—that anyone should take us seriously enough to wish to hurt us.) I never knew the specific fate of these heartfelt but, to me, somewhat shameful letters, and I don't want to know.

Eventually I came to view such "betrayals" in a philosophical light. The former friend seems to have sincerely believed, from his point of view, that I was deserving of punishment for having failed to advance his career; to him, it was irrelevant that countless others had similarly failed to advance his career. Where one might reasonably blame oneself for shortcomings, there are those who aggressively, if somewhat unrealistically blame others, and the former friend was in that category. I've come to see that it isn't possible to predict the course of human relations. In writing to my ex-friend in Detroit, I could not have foreseen the use he would put my desperate letters, any more than I could have foreseen the use he'd wished to put to our friendship. The act of writing and sending a letter is an act of generosity even if, in retrospect, it might seem reckless. Why regret generosity? Why regret impulsiveness, one's misjudgment of others?

The inevitable discovery that someone is selling letters you'd written in trust is simply to discover the oldest of human truths: there are those

who don't cherish us as we'd cherished them, and had wished to be cherished by them.

And then, what of the letter-writer's complicity in "betrayal"? Mutual acquaintances expressed astonishment at my naïveté in being drawn into an exchange of letters over a period of weeks; even after being told I shouldn't write any more letters, I continued, and in all must have written a dozen. *Pleading on my own behalf! Wishing to be understood, and forgiven.* But no one forced me to write these letters. No one forced J. D. Salinger in the spring of 1972 to initiate an epistolary relationship with an eighteen-year-old college freshman; no one forced the fifty-three-year-old writer, at the height of his fame, to seduce her through words, and to invite her to live with him in rural New Hampshire. (In her memoir *At Home in the World,* Maynard notes that this ill-advised move, which involved her dropping out of school though she was an A-level student, was aided and abetted by her ambitious and seemingly amoral parents; with the shrewdness of a panderess out of a Colette novella, Mrs. Maynard chose a schoolgirl costume for her daughter to wear when she left for New Hampshire. No matter that Joyce Maynard was sexually inexperienced and anorexic, in photographs more resembling a fourteen-year-old than an eighteen-year-old: these were literary-Lolita years.)

Everyone who offered an opinion on the subject—and there were many—were highly critical of Joyce Maynard for selling Salinger's letters to her, for money she claimed to need badly. My initial feeling was one of disapproval, too, until I thought: why not? Surely it is Joyce Maynard's choice to sell the letters, since they belong to her. (One would have to concede that she earned them.) And it seemed to me unfair, and unjust, to value one "life" over another: to denigrate Joyce Maynard as a way of elevating the reclusive J. D. Salinger. We might be sympathetic with Salinger's futile efforts to safeguard his privacy, as we might be sympathetic with anyone's efforts, but that Salinger happens to be a writer with a reputation that surpasses Joyce Maynard's should be irrelevant. Selling love letters at Sotheby's signals, at the worst, the ironic end of a fantasy of idealized love. To paraphrase Robert Lowell ("Yet why not tell what happened?"), why not sell what happened?

Pilgrimage to Walden Pond: 1962, 2003

I went to the woods because I wished to live deliberately, to front only the essential facts of life, and see if I could not learn what it had to teach, and not, when I came to die, discover that I had not lived.

—Henry David Thoreau, Walden, *1854*

READING HENRY DAVID THOREAU'S *Walden,* that unique and so very American compendium of wit, common sense, a young man's erudition and rhapsodic poetry, when I was fifteen years old in a farming community in western New York State, was perhaps the most dramatic reading experience of my life. I can vividly remember the circumstances: in my cramped and low-ceilinged bedroom in the old farmhouse, beyond bedtime and into the early hours of the night. As an adolescent I had trouble sleeping (the lofty term "insomnia" had not yet been coined in my vocabulary), so (secret) reading was both my remedy and my reward. In early adolescence we're primed for life-altering experiences, and Henry David Thoreau was mine. A kindred spirit, a remarkable voice! Echoing what I'd have wished to think were my own thoughts, in brilliant speech: "As if you could kill time without injuring eternity"—"Any fool can make a rule and every fool will follow

it"—"What demon possessed me that I behaved so well?" At fifteen I became an immediate convert to Thoreau, whose skeptical temperament resembled that of my father, Frederic Oates, though it would be nearly a decade before I actually made a pilgrimage to the ponds and woods outside Concord, Massachusetts, that so inspired him.

Not until 1962 did I visit Walden, with my then-new, then-young husband. We were prepared for "inevitable" disappointment: a disparity between our romantic anticipations and a blunt reality; prepared, like well-educated ironists, to be disillusioned. So it was a shock, in a way, at least a kind of magic, that the familiar roadside landmarks and grinding busyness of suburban Boston would yield within an hour to the seemingly vanished world of mid-nineteenth-century New England: scrupulously maintained (i.e., zoned) Concord, Thoreau's birthplace, and nearby Walden Pond and the surrounding woods and meadows memorialized by Thoreau in *Walden* and in the immense, uncompleted and posthumously published journal. Was it possible, after a century and a half, that so little had changed?

A pilgrimage to Walden involves hiking around the pond to the modest site where, in 1845, then an independent-minded young man of twenty-eight, Thoreau built his roughhewn ten-by-fifteen log cabin for a cost of $28.12. The land was owned by his older friend and mentor, the most distinguished of New England men of letters, Ralph Waldo Emerson, who encouraged Thoreau to experiment with living a poet's contemplative life and writing of it in journal form, instead of merely talking about doing so. Thoreau lived at Walden more or less continuously from July 1845 to September 1847, with numerous visits back into Concord, but *Walden* is artfully constructed to seem the journal of a single intense year.

Not only did Walden Pond and its environs appear to be essentially unchanged since 1845, in 1962, it hadn't changed decades later when we visited it in 2003. Proof that, with good intentions and good legislation (Walden Pond State Reservation is a registered national landmark managed by the State of Massachusetts) oases of nature can be preserved.

Shall I not have intelligence with the earth? asks Henry David Thoreau. *Am I not partly leaves and vegetable mold?*

A pilgrimage to Walden is a pilgrimage, of course, into the ideal. To one with a satirical inclination, it's a pilgrimage into sheer nostalgia. For the past is after all *past,* even when it appears to be *present,* as (vigilantly

preserved) Nature. No more than the older, tubercular Thoreau (who died at the age of forty-five, in 1862) could have re-entered the paradise of Walden, can we re-enter it: "nostalgia" is a state of mind, never an actual place. Yet there is a spiritual value in symbolic gestures and rituals which we can't resist.

"Walden" has become symbolic of a highly refined, one might say a highly artificial state of mind: a roughhewn Yankee analogue and refutation of, let's say, Europe's classy sites (Buckingham Palace, Versailles). "Walden" inspires both attentiveness to the outside world and a radical inwardness: we are provoked to consider what relationship we can have with another person, if we haven't the right relationship with humanity; and what relationship with humanity we can have if we haven't the right relationship with the world that contains humanity.

These questions deepen with time. These questions come to be the very koans of our civilized lives, demanding, not absolute answers, but the dignity of sustained, collective concentration.

The first time we visited Walden was mid-summer, the second, more ideal time was in early fall when some of the leaves had begun to turn. Like all good pilgrims we hiked around the pond (which will seem to most visitors more of a lake than a pond, measuring a little more than two miles around) noting the wind-rippled surface and how, as Thoreau notes in *Walden,* the surface changes color depending upon your perspective: varying shades of blue in deeper water, dark green near shore, pebble-colored elsewhere. Yet the water itself is, in Thoreau's words, "so transparent that the bottom can be easily discerned at the depth of twenty-five or thirty feet." The legend of Walden Pond in Thoreau's time was that it was "bottomless"—but ever-skeptical Thoreau, self-appointed chronicler of Concord's ponds and waterways, measured it at a depth of 202 feet at its deepest point. (Thoreau's typical concentration upon the particulars of nature, as well as the precision and beauty of his chiseled prose, distinguished him from his contemporaries, like Emerson, who wrote rhapsodically of Nature in the abstract, yet seemed hardly to *see*. These were men who propounded sermons out of stones, with not much notion of what stones were.)

Why return to *Walden,* as to Thoreau's Walden itself? Why these unabashedly romantic pilgrimages into Nature, for some Americans a kind of religious retreat involving physical hardship and even danger? I think it must be the call of like to like: what remains of wildness in us drawn to

the "wild" that still exists, in however a maintained/preserved landscape. I think it must be in defiance of history, in the twenty-first century a grindingly politicized and apocalyptic history in which the individual voice, however eloquent, human, "good" is shouted down. How miserable Thoreau would be, in present-day America! For here was a despiser of politicians who supported the abolitionist John Brown ("I do not wish to kill or be killed but I can foresee the circumstances in which both of these things would be by me unavoidable"). Most astonishingly, Thoreau also remarked, in *Walden,* "Nature is hard to be overcome but she must be overcome."

As we prepared to leave Walden Pond this more recent time, I seemed to know that we would not be returning. How I knew this, why I knew, I could not have said. It came over me with a sense of melancholy, a foreboding of loss. I wanted to memorize the scene before me: wind-rippled pond, pine trees, silence. I was hearing my mother's voice, a few years before her rapid aging and death, quietly telling me over the phone that she and my father would not be making the trip to visit us that fall, and probably not ever again: "Everything has to come to an end."

But when I told my husband that very likely we wouldn't be returning to Walden again he said, in a voice somewhere between bemused and annoyed, "You always say that about everywhere we go. Why?"

Acknowledgments

To all the following, acknowledgments and thanks are due. I am particularly grateful to Lindsay Duiguid of the *Times Literary Supplement* and Barbara Epstein of the *New York Review of Books*. And special thanks to Greg Johnson for his sharp, sympathetic eye.

Most of these pieces have been retitled and revised since their original publication in the following:

"Uncensored Sylvia Plath" appeared in the *New York Times Book Review,* 2000.

" 'Restoring' Willie Stark" appeared in the *New York Review of Books,* 2001.

"Catherizing Willa" appeared in the *Times Literary Supplement,* 2001.

"Merciless Highsmith" appeared in the *New York Review of Books,* 2001.

" 'Glutton for Punishment': Richard Yates" appeared in the *Times Literary Supplement,* 2002.

" 'Not a Nice Person': Muriel Spark" appeared in the *Times Literary Supplement,* 2001.

"Irish Elegy: William Trevor" appeared in the *Times Literary Supplement*, 2000.

" 'Our Cheapened Dreams': E. L. Doctorow" appeared in the *New York Review of Books*, 2000.

" 'Despair of Living': Anita Brookner" appeared in the *Times Literary Supplement*, 1999.

"An Artist of the Floating World: Kazuo Ishiguro" appeared in the *Times Literary Supplement*, 2000.

" 'City of Light': Robert Drewe's *The Shark Net*" appeared in the *New York Review of Books*, 2000.

"L.A. Noir: Michael Connelly" appeared in *The New Yorker*, 2000.

"Ringworm Belt: Memoirs by Mary Karr" appeared in the *New York Review of Books*, 2000.

"Evolutionary Fever: Andrea Barrett's *Servants of the Map*" appeared in the *New York Review of Books*, 2002.

" 'New Memoir': Alice Sebold's *Lucky*" appeared in the *Times Literary Supplement*, 2003.

"Property Of: Valerie Martin's *Property*" appeared in the *New York Review of Books*, 2003.

"Programmed by Art: David Lodge's *Thinks . . .*" appeared in the *Times Literary Supplement*, 2001.

"Ghosts: Hilary Mantel" appeared in the *New York Review of Books*, 2003.

"An Endangered Species: Short Stories" appeared in the *New York Review of Books*, 2000.

"News from Everywhere: Short Stories" appeared in the *New York Review of Books*, 2003.

"Mythmaking Realist: Pat Barker" appeared in the *New York Review of Books*, 2003.

"Crazy for Love" appeared in *The New Yorker*, 2003.

"Amateurs: Anne Tyler's *The Amateur Marriage*" appeared in the *New York Review of Books*, 2004.

"Memoirs of Crisis: Ann Patchett's *Truth & Beauty*" appeared in the *New York Times Book Review,* 2004.

"Emily Brontë's *Wuthering Heights*" appeared as the introduction to the Oxford University Press edition, 1999.

" 'Tragic Mulatta': *Clotel; or, The President's Daughter*" appeared in the *New York Review of Books,* 2001.

"Ernest Hemingway" was published by the Folio Society, 1999.

" 'You Are the We of Me': Carson McCullers" appeared in the *London Review of Books,* 1999.

"Remembering Robert Lowell" appeared in *Salmagundi,* 2003.

" 'About Whom Nothing Is Known': Balthus" appeared as the introduction to *Vanished Splendors: A Memoir by Balthus* (Ecco/Harper-Collins, 2002).

"In the Ring and Out: Jack Johnson" appeared in the *New York Review of Books,* 2004.

"Muhammad Ali: 'The Greatest' " appeared in *SportsCentury* (New York: Hyperion, 2000).

"The Vampire's Secret: (Re)viewing Tod Browning's *Dracula* after Forty Years" appeared in *The Movie That Changed My Life* edited by David Rosenberg (Viking, 1991).

"Don DeLillo's *Americana* (1971) Revisited" appeared in the *Detroit News,* June 27, 1971.

"*Them* Revisited" appeared as the afterword to the Modern Library reprint, 2000.

"*A Garden of Earthly Delights* Revisited" appeared as the afterword to the Modern Library reprint, 2003.

"On the Composition of *I Lock My Door Upon Myself* " appeared as the afterword to the Ontario Review Press edition, 2003.

"Private Writings, Public Betrayals" appeared in the *New York Times,* 1999.

"Pilgrimage to Walden Pond appeared in *New York Magazine,* 2004.